LIGHT AND LENS

LIGHT AND LENS: PHOTOGRAPHY IN THE DIGITAL AGE

Robert Hirsch

AMSTERDAM • BOSTON • HEIDELBERG • LONDON NEW YORK • OXFORD • PARIS • SAN DIEGO SAN FRANCISCO • SINGAPORE • SYDNEY • TOKYO Focal Press is an imprint of Elsevier

Acquisitions Editor: Diane Heppner Associate Editor: Asma Palmeiro Developmental Editor: Stephanie Barrett Publishing Services Manager: George Morrison Project Manager: Kathryn Liston Assistant Editor: Doug Shults Marketing Manager: Christine Degon Veroulis Cover and Interior Design: Maria Mann Illustrator: Greg Erf

Focal Press is an imprint of Elsevier 30 Corporate Drive, Suite 400, Burlington, MA 01803, USA Linacre House, Jordan Hill, Oxford OX2 8DP, UK

Copyright © 2008, Elsevier Inc. All rights reserved.

No part of this publication may be reproduced, stored in a retrieval system, or transmitted in any form or by any means, electronic, mechanical, photocopying, recording, or otherwise, without the prior written permission of the publisher.

Permissions may be sought directly from Elsevier's Science & Technology Rights Department in Oxford, UK: phone: (+44) 1865 843830, fax: (+44) 1865 853333, E-mail: permissions@elsevier.com. You may also complete your request on-line via the Elsevier homepage (http://elsevier.com), by selecting "Support & Contact," then "Copyright and Permission," and then "Obtaining Permissions."

Recognizing the importance of preserving what has been written, Elsevier prints its books on acid-free paper whenever possible.

 (∞)

Library of Congress Cataloging-in-Publication Data

(Application Submitted)

British Library Cataloguing-in-Publication Data A catalogue record for this book is available from the British Library.

ISBN: 978-0-240-80855-0

For information on all Focal Press publications, visit our website at www.books.elsevier.com

09 10 11 12 10 09 08 07 06 05 04 03

Printed in China

Front cover: © Larry Schwarm. Burning Tree with Ryder Sky, Chase County, Kansas, 2001. 29 × 29 inches. Inkjet print. Courtesy of Robert Koch Gallery, San Francisco.

Back cover: © Nathan Baker. Photography Studio, from the Series People at Work, 2004. 40×50 inches. Inkjet print. Courtesy of Schneider Gallery, Chicago, and Robert Koch Gallery, San Francisco.

Working together to grow libraries in developing countries www.elsevier.com | www.bookaid.org | www.sabre.org ELSEVIER BOOK AID International Sabre Foundation

Dedication

To my wife, Adele Henderson, and my mother, Muriel Hirsch, for their love and support. In addition, to all the artists, writers, and teachers, past and present, who have influenced and inspired my own endeavors.

"Here the ways of men part: If you wish to strive for peace of soul and pleasure, then believe; If you wish to be a devotee of truth, then inquire."

Friedrich Nietzsche

© Brian Ulrich. Indianapolis, IN, 2004. 40 × 52 inches. Chromogenic color print. Courtesy of Rhona Hoffman Gallery, Chicago; Julie Saul Gallery, New York; and Robert Koch Gallery, San Francisco.

Contents

	Preface	xiii
	Artist Contributors	1
C	When We Males Distance A Consistent of Visual Ideas	3
Chapter 1	Why We Make Pictures: A Concise History of Visual Ideas	
	The Grammar of Photography	5
	The Evolution of Photographic Imaging	5
	Determining Meaning	6
	BPS: Before Photoshop	6
	The Digital Imaging Revolution	14
	New Media	16
	Questions about Photo-Based Imagemaking	16
	Additional Information	31
Chapter 2	Design: Visual Foundations	33
	Learning to See: Communicating with Design	33
	Beginner's Mind	33
	The Design Process	34
	The Nature of Photography: Subtractive Composition	34
	Departure Point	35
	Attention Span and Staying Power	35
	Photography's Privilege	36
	The Language of Vision	37
	Photography's Native Characteristics	38

	Design Principles	
	Visual Elements	
	References	
CHAPTER 3	Image Capture: Cameras, Lenses, and Scanners	
	The Role of a Camera	
	What Is a Camera?	
	How a Camera Imaging System Works	
	Digital Cameras	
	Types of Cameras	
	Choosing a Camera	
	Camera File Formats	
	Opening Files	
	The Lens System and Exposure	
	Digital Camera Features	
	Camera, Lens, Monitor, and Sensor Care	
	Scanners	
	Frame Grabber	
	Storing Digital Images	
	Living Photography: Authorship, Access, and the World's Largest Picture Book	113
Chapter 4	Exposure and Filters	117
CHAFTER 4		
	Exposure Basics Filtering the Light	
CHAPTER 5	Seeing with Light	
	Natural Light	
	The Time of Day/Types of Light	
	Artificial Light	

	Basic Lighting Methods	
	Lighting Accessories	
CHAPTER 6	Observation: Eyes Wide Open	
	How We See	
	Why We Make and Respond to Specific Images	
	The Effects of Digital Imaging	
	Aesthetic Keys for Color and Composition	
	Figure-Ground Relationships	
CHAPTER 7	Time, Space, Imagination, and the Camera	
	In Search of Time	
	The Perception of Time	
	Controlling Camera Time	
	Imaging Software Solutions	
	References	
CHAPTER 8	Digital Studio: Where the Virtual Meets the Material World	
	Displaying the Image File: Transferring Image Files for Display, Web, or Print	
	Working with a Digital Negative: The Original Capture	
	True Resolution and the Real World	
	Making Photographic-Quality Prints	
	Images and the Computer Workstation	
	Software and Imaging Applications	
	Basic Digital Imaging Categories and Tools	
	Common Toolbar Icons from Photoshop	
	The Computer as a Multimedia Stage: Moving Images	
	The Internet and the World Wide Web	
	The Digital Future	258

TABLE OF CONTENTS

	Technical References	259
	Manufacturers' Websites	260
CHAPTER 9	Presentation and Preservation	263
	Digital Retouching and Repair	263
	Archival Presentation	263
	Digital Archives	276
	References for Digital Archives	280
	Digital Print Stability	280
	Camera Copy Work	282
	Presenting Work on a Disk	284
	References	285
CHAPTER 10	Seeing with a Camera	289
	The Framing Effect: Viewpoint	289
	Selective Focus	294
	Contrast	294
	Dominant Color	296
	Harmonic Color	299
	Isolated Color	300
	Monochrome Images	302
	Perspective	304
	Quiet or Subdued Color	308
	Highlights and Shadows	308
	Attraction and Repulsion	309
	Counterpoints and Opposites	310
CHAPTER 11	Solutions: Thinking and Writing about Images	313
		314
	A Thinking Model	318
	The Photograph as a Matrix	325

	Size Matters	
	Communicating Cultural Knowledge	
	The Image Experience: Photographic Meaning Is Unstable	
	Writing about Images	
	Essentials of Image Discussion	
	John Cage's Rules	
	References	
CHAPTER 12	Photographer on Assignment	
	Making Portraits: Who Am I and Who Are You?	
	Fauxtography: Photography's Subjective Nature	
	Picturing Social Identity	
	Interior Experience: The Significance of Daily Life	
	Fabrication for the Camera: Directorial Mode	
	Time-Honored Themes	
	The Display: Another Picture Reality	
	Text and Images	
	Artists' Books and Albums	
	Artists' and Photographic Books: References	
	Self Assignment: Creation and Evaluation	
	Addendum I: Safety: Protecting Yourself and Your Digital Imaging Equipment	
	Ergonomic Workstations	
	Monitor Emissions: ELF/VLF	
	Eyestrain	
	Proper Posture/Lower Back Problems	
	Carpal Tunnel Syndrome	
	Taking Breaks	
	Neutral Body Positioning	
	Change Your Working Position	

TABLE OF CONTENTS

Addendum II: Careers	381
The Working Photographer	381
Getting Started	382

Index	
-------	--

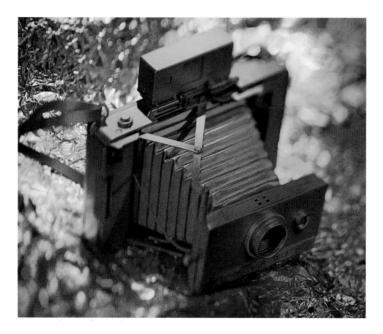

Utilizing photography's two fundamental ingredients — light and lens — Henrich pays homage to the old Polaroid 60-second analog capture technology by means of a digital scanning back on a 4×5 inch view camera. The colorfully expressive look was created at the time of exposure using only the camera's swings and tilts in combination with red, blue, and green light sources (RGB) — no digital retouching was involved.

© Biff Henrich. No title, 2001. 20 × 24 inches. Inkjet print.

Preface

"Those who attain to any excellence commonly spend life in some single pursuit, for excellence is not often gained upon easier terms." Dr. Samuel Johnson (1707–1784).

The widespread acceptance of digital photography necessitates a rethinking about how beginning college-level photography courses are structured and taught. With this in mind, *Light & Lens* has been designed from the ground-up with a fresh attitude about teaching introductory photographic imaging. *Light & Lens* meets challenges of this transitional time by clearly and concisely stressing the fundamental, "forever" aesthetic and technical building blocks necessary to create thought provoking digitally based photographs. The methodology is practical, explaining how theoretical principles directly relate to imagemaking by presenting the means to realize one's ideas with digital photography.

Light & Lens pursues the conceptual stance that camera vision is the primary skill of a photo-based imagemaker, by highlighting composition, design, and light as the strategic elements of photographic seeing. By concentrating on the camera as the initial and principal imagemaking tool, emphasis is placed on how to observe and use cameras to capture visual ideas. Once these skills are mastered, one is then prepared to tackle post-capture software techniques. *Light & Lens* does this by thoughtfully presenting how to use the four essentials that comprise every camera image: aperture, focal length, focus, and shutter speed. Digital single-lens reflex cameras (DSLRs) are emphasized because of their versatility and manual control, but attention is also given to how resourceful photographers can utilize pointand-shoot and cell phone cameras, as well as scanners, to effectively capture images.

Light & Lens is an adventurous idea book, featuring numerous classroom-tested assignments that have been gathered from a variety of photographic educators. These exercises encourage readers to critically explore and make images from the perspective of *the photographers' eye*, one whose foundation is centered on solid ideas and aesthetics rather than technological ability. Ideas are the dominant and driving guideposts; methods are learned and implemented to achieve one's vision. Technical information is presented to foster an understanding of the basic principles affecting how digital images can be formed and revised. By concentrating on the thought process

PREFACE

behind the creation of successful photographic images, *Light & Lens* will not be rapidly outdated nor overwhelm readers with complex and ever-changing technical matters.

Since digital imaging software programs can be complex and changeable, *Light & Lens* takes the tactic of succinctly covering key imaging methods, but it is not a software handbook or a camera manual. Companion ancillary materials, available from Focal Press and other sources, serve students' detailed technical needs. Terms are discussed and defined upon their first appearance in the book so the surrounding framework supplies the needed background information. There are few references to the analog darkroom, as these initially have little relevance to most beginning students who have grown up in a digital environment. When appropriate, additional sources of information and supplies are provided at the end of a topic.

That said, the spectacular and rapid technological transformations that continue apace mean that whatever digital imaging skills one learns as a college freshman will need updating before graduation. To successfully deal with this cycle of change, it is essential for imagemakers to develop and deploy a set of long-term learning skills, including how to utilize online information and tutorials, blogs, listservs, pod casts, and imaging software Help sections to stay abreast of the changing technology.

Discussions about contemporary issues affecting digital imagemaking, from appropriation and copyright to webblogs and "mashups," are integrated throughout the book. Artistic and cultural references, from polymath Leonardo da Vinci to comedian Stephen Colbert, are intermingled as well, for meaning is derived from a cultural framework. Different goals and roles of photography are contrasted to reveal how a various approaches can shape both the "what" and the "how" of an image and a multitude of interpretations.

Light & Lens brings together a compilation of my combined experiences as an imagemaker, curator, educator, and writer, with additions from numerous other photographic educators who are credited throughout the text. Chapter 1 begins with a historic analysis of why and how pictures have been made and concludes with an extended series of questions and answers that routinely asked at this stage of photographic education. Then the text moves into a discussion about design as the visual foundation of imaging (Chapter 2). A chapter dealing with fundamental image capture strategies utilizing cameras and scanners follows (Chapter 3). Next, technical matters of exposure and filters are covered (Chapter 4). This is followed with Chapters 5-7 that explain the qualities of light, observation, and methods of expressing time and space. Chapter 8 takes on the fundamentals of the digital file as captured by the camera, displayed on a monitor, and outputted as a print. Chapter 9 provides coverage of how to present and preserve your work. A chapter covering how to see and dynamically use your camera is offered in Chapter 10. A subsequent chapter (Chapter 11) conveys lively methods and exercises to help one become a critical visual problem-solver and evaluator, and how to succinctly talk and write about the ideas that form your work. Finally a series of assignments are given in Chapter 12 to help expand your ideas and vision. The book concludes with addendums on health and safety issues plus career options. Each chapter is divided into discrete units that facilitate easily finding topics of interest. This arrangement also encourages readers to browse around and discover their own ordering structure of the material.

xiv O

Light & Lens's curated contemporary art program consists of inspiring examples by 190 international artists plus well-structured illustrative visual aids, whose common dominator is that each became digital at some point during the creation and distribution process. These images were collected through an open international call for work, which was followed up by inviting selected artists to participate.

After reviewing thousands of images certain trends emerged. Many imagemakers are moving away from single, still images and embracing the fluidity and cinematic character of interconnected moments, which blur the boundaries between moving and still images and expand traditional concepts of photographic time and space, even when the final result is one image. In a post-9/11 world, more imagemakers are looking outward, to broader, less personal issues dealing with security, the war in Iraq, climate change, and nature disasters. There is also a much wider interest in science, as evidenced in images derived from microscopes, telescopes, and satellites or the referencing of scientific processes. From a technical viewpoint, there is a dramatic rise in makers using a scanner as a camera. New digital printers are allowing photographers to straightforwardly increase the physical size of their prints, giving them a sense of scale and wall presence that easily competes with painting. The results of this research are an image program that reflects the ingenious thinking of today's digital imagemakers.

In addition to the work of widely recognized international artists, I have included exceptional images by emerging and under-recognized artists, whose coherent bodies of work are often too nonconformist for mainline venues. All the outstanding visual examples provide models for points of departure. These photographic works reminder us that all images are not equal and some pictures do communicate more broadly and significantly than others. As visual paradigms, they provide important guidelines to appreciate and understand visual culture, but are in no way intended to be prescriptive. Readers are encouraged to learn the rules and standards, but not to hesitate to set them to the side or do the opposite anytime they interfere with an inventive vision.

Additionally, to inject the voices of the photographers into the project, I distilled their statements about their vital aesthetic and technical choices into to the image captions to provide readers with insight and motivation about the creation process.

This exciting time of photographic evolution from analog to digital can be unsettling for some. Ultimately, it is important to utilize the advantages that digital imagemaking provides. With its capability for limitless shooting, immediate feedback, in-camera programming, and post-capture image modifications, along with archival desktop printing and online publishing, digital imaging allows us to realize Henry Fox Talbot's dream of every person being their own imagemaker and publisher.

For *Light & Lens* I specifically requested the expertise of Professor Greg Erf of Eastern New Mexico University, whom I have known since 1988, to construct the chapter on the Digital Studio (Chapter 8). Over the years, we have established a strong professional relationship, using the Internet to discuss, write, and teach about photography. By Greg's calculation, he has never deleted his inbox; we have shared over 15,330 emails since 1994. This calculates to over 3 emails a day, and the digital pipeline between New Mexico and New York is still going strong. Greg and I have worked together to develop and teach a History of Photography course online (www.enmu.edu/photohistory), write columns for *Photovision* magazine, collaborate on *Exploring Color Photography: From the Darkroom to the Digital Studio* as well as on *Light and Lens*, and various other activities (see: www.negativepositive. com), which accounts for our email volume. I chose to work with Greg Erf because of his varied expertise in photography and digital imaging. Greg has been teaching photography for over 20 years and is recognized as one of New Mexico's leading photographers. Linda Durham Contemporary Art, Santa Fe, New Mexico (www. lindadurham.com) represents his work.

Greg bridges the gap between silver photography and digital photography. His personal work (www.gregerf.com) utilizes a vintage 11×14 inch view (film-format) camera, and his teaching almost exclusively involves digital photography and computer animation. This combination roots Greg historically in the language of imagemaking as he and I endeavor to sort out and define the new language of digital photography.

Our working process first entailed jointly creating a chapter outline. Then Greg wrote the drafts while I acted as editor and rewriter. Next, the process of researching, reviewing, and writing additional material began. Numerous drafts were volleyed back and forth until we were satisfied. Plus, Greg created all the splendid illustrations that superbly illustrate our digital collaboration. Additionally, Greg also acted as a reader and advisor for many of the other chapters.

ACKNOWLEDGMENTS

I want to thank all the people at Elsevier's Focal Press who have offered their cooperation, time, knowledge, and support of *Light* &

Lens, including my editors Stephanie Barrett and Diane Heppner; Asma Palmeiro; Kathryn Lister, my production editor; Carol Leyba, my copy editor; and Keith Shotak, my indexer; for their thoughtful efforts in bringing this project into being. I also want to thank Lauren Braun, who assisted with the art program, caption writing, and manuscript preparation.

This book is about transmitting knowledge and would not have been possible without the generosity of numerous individuals, especially the artists who have allowed me to reproduce their work (see artists' credit page in the front of the book for a list of all the participating imagemakers).

In this spirit, the *Light and Lens* artists have generously agreed to make their images available as a **FREE**, low-resolution download to qualified instructors for classroom use by registering at http://textbooks.elsevier.com

I am indebted to the following individuals who read countless pages and made innumerable suggestions that greatly improved the working manuscript.

Barry Andersen, Northern Kentucky University Michael Bosworth, Villa Maria College Dennis DeHart, SUNY Buffalo State College Bill Davis, Western Michigan University Debra Davis, University of Toledo Greg Erf, Eastern New Mexico University Myra Greene, Rochester Institute of Technology Keith Johnson Liz Lee, SUNY Fredonia Stan Strembicki, Washington University I want to thank the following photographic educators who generously allowed me to incorporate some of their most successful assignments and teaching observations into the text:

Michael Bosworth, Villa Maria College Kathleen Campbell, Appalachian State University Dennis DeHart, SUNY Buffalo State College Bill Davis, Western Michigan University Debra Davis, University of Toledo Collette Fournier, SUNY Rockland Community College Myra Greene, Rochester Institute of Technology Keith Johnson

Joseph Labate, University of Arizona

Liz Lee, SUNY Fredonia Kathleen Robbins, University of South Carolina Graham Revell, Cavendish College, London Betsy Schneider, Arizona State University Larry Schwarm, Emporia State University Fred Scruton, Edinboro University Laurie Tümer, Northern New Mexico College John Valentino, Southeastern Louisiana University

Robert Hirsch Buffalo, NY USA www.lightresearch.net

Oropallo deconstructs and enhances images to investigate the seduction and power that is evoked by gesture and pose. Oropallo layers images of contemporary women in provocative costumes, borrowed from the Internet, with opulent 18th-century portrait paintings of men. These traditional portraits were often contrived to convey not merely a likeness of the sitter, but also a sense of his importance and authority. Attributes such as nobility and dignity were portrayed through stance, gesture, and attire, and portraits often involved elaborate costumes and props. Through this re-employment of the vast symbolism of classic portraiture, Oropallo's hybrid image suggest issues of gender, costume, fantasy, potency, power, and hierarchy.

© Deborah Oropallo. *George*, from the series *Guise*, 2006. 60 × 40 inches. Inkjet print. Courtesy of Gallery 16 Editions and Stephen Wirtz Gallery, San Francisco.

Artist Contributors

Koya Abe, Terry Abrams, Bill Adams, Theresa Airey, Thomas Allen, Mauro Altamura, Barry Andersen, Jeremiah Ariaz, Shannon Ayres, Darryl Baird, Nathan Baker, Olaf Otto Becker, Paul Berger, Laura Blacklow, Colin Blakely, Ethan Boisvert, Michael Bosworth, Susan Bowen, Deborah Brackenbury, Richard Bram, Kristi Breisach, Priscilla Briggs, Dan Burkholder, Edward Burtynsky, John Paul Caponigro, Ellen Carey, Samantha Casolari, Catherine Chalmers, William Christenberry, Kelli Connell, Gina Conner, Raquel Coulter, Gregory Crewdson, Binh Danh, Frank Danto, Debra A. Davis, Jen Davis, Tim Davis, William Peter Davis, Dennis DeHart, Thomas Demand, Francois Deschamps, Louis DiGena, Dornith Doherty, Doug Dubois, Arthur During, Christine Emmer, Jill Enfield, Mitch Epstein, Greg Erf, Susan E. Evans, Katya Evdokimova, Bill Finger, Robbert Flick, Kelly Flynn, Jennifer Formica, Collette Fournier, James Friedman, Barry Frydlender, Adam Fuss, Stephen Galloway, Ann Ginsburgh Hofkin, Jonathan Gitelson, Gary Goldberg, Carol Golemboski, Linda Adele Goodine, Jill Greenberg, Andreas Gursky, Marcella Hackbardt, Gary Hallman, Toni Hafkenscheid, Adam Harrison, Adele Henderson, Biff Henrich, MANUAL (Hill/Bloom), Robert Hirsch, Jenny Holzer, Barbara Houghton, Allison Hunter, Robert Lowell Huston, Ellen Jantzen, Simen Johan, Keith Johnson, Nicholas Kahn, Kevin Andrew Kaminski, Thomas Kellner, Marie R. Kennedy, Kay Kenny, Robert Glenn Ketchum, Atta Kim, Martin Kruck, Andrew Steven Kuypers,

Joseph Labate, Chris LaMarca, Sally Grizzell Larson, William Larson, Erik Lauritzen, Evan Lee, Liz Lee, Sebastian Lemm, Douglas Levere, Michael Light, Adriane Little, Jonathan Long, Joshua Lutz, Loretta Lux, Scott McFarland, Martha Madigan, Stephen Marc, Didier Massard, Dan McCormack, Thomas McGovern, Amanda Means, Diane Meyer, Robin Michals, Marilyn Minter, Brandon Montoya, Steven P. Mosch, Brian Moss, David Mount, Vik Muniz, Bea Nettles, Dale Newkirk, Pipo Nguyen-duy, Lori Nix, Simon Norfolk, Carrie Notari, Sue O'Donnell, Suzanne Opton, Deborah Oropallo, Bill Owens, Robert and Shana ParkeHarrison, Martin Parr, Jeannie Pearce, John Pfahl, Colleen Plumb, Robert Polidori, Kathleen Pompe, Carolyn Porco (Cassini Project), Sabrina Raaf, James Rajotte, Holly Roberts, Lisa M. Robinson, Joyce Roetter, Damon Sauer, Anne Savedge, Joseph Scheer, Betsey Schneider, Larry Schwarm, Fred Scruton, Richard Selesnick, Andres Serrano, Paul Shambroom, Susan Shaw, Matt Siber, Kerry Skarbakka, Mark Slankard, Stafford Smith, Helene Smith-Romer, Marc Snyder, Ursula Sokolowska, Jerry Spagnoli, Nancy Spencer, Doug & Mike Starn, Jim Stone, Stan Strembicki, Luke Strosnider, Steven Taft, Sheila Talbitzer, Ron Tarver, Calla Thompson, Jessica Todd Harper, Terry Towery, Laurie Tümer, Brian Ulrich, Paolo Ventura, Cara Lee Wade, Chris Walker, Kara Walker, Jeff Wall, Garie Waltzer, Al Wildey, Kristen S. Wilkins, Jeffrey A. Witt, Lloyd Wolf, Beth Yarnelle Edwards, Jody Zellen.

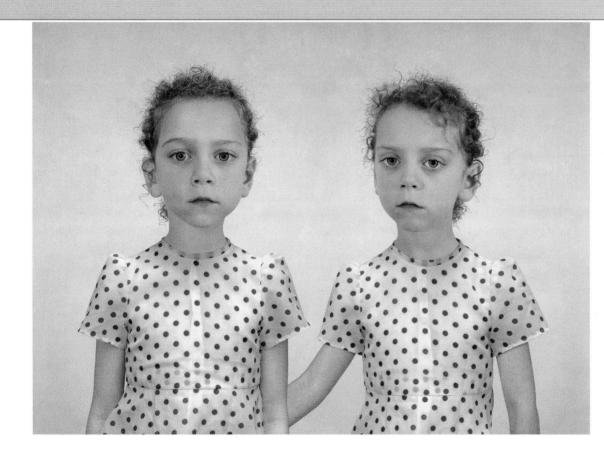

Circumspectly using the artifice and light of master painting as sources, Lux creates mesmerizing images of enigmatic children who have been superimposed in front of her painted backgrounds and appear trapped in time between two worlds. This double paradoxical tension between the past and future, the painterly and the photographic, the ideal and the absurd, the real and the fake challenges our sentimental visions of childhood.

© Loretta Lux. Sasha and Ruby, 2005. 19-5/8 × 25-5/8 inches. Dyedestruction print. Courtesy of Yossi Milo Gallery, New York.

Chapter 1

Why We Make Pictures: A Concise History of Visual Ideas

he human desire to make pictures is deep-rooted. Forty thousand years ago, Cro-Magnon people made paintings of large wild animals, tracings of human hands, as well as abstract patterns on cave and rock walls. Now, instead of colored oxide and charcoal, people can use a camera. What propels this picture-making impulse?

The fundamental motive for the vast majority of picture making is the impulse to preserve — to document and therefore commemorate specific people and events of importance. Artists use images expressionistically to articulate and conceptualize who they are and what they think of the world. Others make pictures for commercial reasons, while some create informational systems or visualize the unseen with scientific imaging. Regardless of purpose, they all make photographs because words cannot always provide a satisfactory way to describe and express our relationship to the world. Pictures are an essential component of how humans observe, communicate, celebrate, comment, express, and, most of all, remember. What and how we remember shapes our worldview, and photographs can provide the stimulus to jog one's memory. Poet Billy Collins sums up this human process of memory, and indirectly the importance of images as keepers of the flame, in his poem *Forgetfulness*:

The name of the author is the first to go followed obediently by the title, the plot, the heartbreaking conclusion, the entire novel which suddenly becomes one you have never read, never even heard of . . .

Making pictures matters because it is part of our human nature to want to shape the ordinary into the special and define our relation-

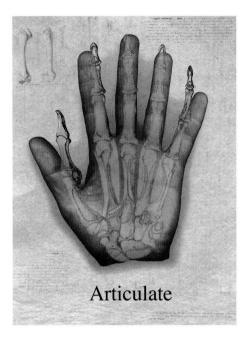

1.1 "This series questions what defines an image as a photograph, and in fact, asks what is a camera? In my work there is no distinction between a 'pure' photograph and a digitally created image, as the medium of photography has been built upon the practice of change, especially in relation to technological advancement. In this series, the only instrument used for creation was a flatbed scanner (as camera), and another traditional artist tool — the hand — within the photographic editing environment."

© Liz Lee. Observational Drawings: Hand, 2004. 22-1/2 × 30 inches. Inkjet print.

ship to the world. Pictures can provide a concrete, yet individualistic structure of visual data to build upon. It is this personal participation — the doing, the activity itself — that can ease the loneliness of life by helping us to feel capable of expression, validating us as individuals, and assisting us in finding a sense of well-being.

Photographs can serve a multitude of purposes. Although we are conditioned to believe that the purpose or function of a photograph is to provide a commentary or text about a subject, that need not be the case: it may have nothing to do with making a concrete statement, answering a specific question, or even being *about something*. Rather, it can be something uniquely in and of itself. A photograph may be enigmatic, or it may allow a viewer access to something remarkable that could not be perceived or understood in another way. It is analogous to what Isadora Duncan, the mother of modern dance, said: "If I could explain to you what I meant there would be no reason to dance."

Think of a photograph as a conversation among the photographer, the subject, and the viewer. During such a conversation, the participants not only exchange words but also formulate meaning based on the context of how the words are spoken, to whom they are spoken, the body language of the participants, and the environment in which the conversation takes place. When the participants think about a specific subject or image, a distillation and refinement of meaning becomes possible. Such thinking involves the creative interaction among the participants in a visual conversation and can lead to definition. Definition allows us to acknowledge, take responsibility, and act to solve a problem, respond to the aesthetics, or reach a conclusion about what an imagemaker deemed significant.

In the first decades of the 20th century, Albert Einstein's concepts of relativity and quantum mechanics — ideas that showed that the classic Newtonian concept of physics with its absolutes was no longer absolutely true — began to influence how people, especially artists, depicted and interpreted their world. People began to see that a fluid interaction between the observer and the observed offers dif-

4 0

ferent frames of reference to create meaning. This can occur through symbolic manipulation (mathematical, verbal, and visual) and a reliance on analogy, insight, and myths to draw attention to the significant elements in an otherwise chaotic flow of sensory input. Such a process involves the artist, the object, and the viewer in an ongoing reciprocal dialogue of creation and interpretation. As the artist/photographer Man Ray once said, "Perhaps the final goal desired by the artist is a confusion of merging of all the arts, as things merge in real life."

THE GRAMMAR OF PHOTOGRAPHY

The fundamental grammar of photography is based on how a camera utilizes light and form to record an image that is then interpreted through societal visual codes that have evolved over centuries of imagemaking. Learning how to operate a camera, gaining an awareness of how light can reveal or suppress a subject's attributes, and then making a print or other form of visual presentation are the first steps one must master to transform an abstract idea into a physical (photographic) reality. This text introduces basic camera methods and visual construction blocks, gives examples of how and why other photographers have applied them, provides basic working procedures, and encourages readers to experiment and make modifications to the process to achieve their own results. Once a basic understanding of picture-making is obtained, control over the process can begin. To acquire the maximum benefit from this book, the reader should begin thinking about how photography can be used to construct a meaningful expression. This puts process in service of concept to create meaningful content. This can occur when the heart and the mind combine to form an idea from the imagination and find the

most suitable technical means of bringing it into existence (see Chapter 11).

THE EVOLUTION OF PHOTOGRAPHIC IMAGING

Since 1839, when Louis-Jacques-Mandé Daguerre made public the first practical photographic process (the daguerreotype), people have been discovering new photographic materials and methods to present the way they see the world. The daguerreotype gave way to the wetplate process which in turn was supplanted by flexible roll film. Now the chemical processes of the wet darkroom have been replaced by the electronic digital studio, which opens photography up to a more cinematic approach of using moving images and sounds. Additionally, as mainline photographic practice evolves into digital imaging, images that were never actually photographed can exhibit perfect photographic credibility. As such digital images become commonplace, photography's traditional role as the recorder of outer reality is being challenged.¹ As digitally constructed images become the norm — as in filmmaking that combines live action and digital animation — such images may no longer be clearly distinguishable from the pre-digital concepts of illusions of motion generated by hand-

¹ Originally photography provided an automatic mechanical method for transferring what was seen in nature into a two-dimensional form of Renaissance perspective. This indexical characteristic gave people the illusion that photographs were stand-ins for reality. Photography proved so able at reality substitution that people came to believe that this was photography's sole purpose. The photographer was supposed to act as a neutral observer, an operator of an automatic machine, and allow the camera to do its work of accurately recording the subject.

1.2 Enfield created a technical dialogue between the 19th and 21st centuries by using an 8×10 inch view camera with a 5×7 inch back to expose a collodion wet-plate, which she scanned and output as an inkjet print. Artistically, the process of making a portrait with a view camera (in this case the exposure was 45 seconds) also generates an extended exchange between the sitter and the photographer. Here the subject's natural movement injects a sense of his inner spirit in a manner similar to Julia Margaret Cameron's innovative portraits from the 1860s.

© Jill Enfield. Douglas, 2005. 13 × 19 inches. Inkjet print.

drawn methods. Ironically, this digital yet highly manual construction of images, long out of favor in mainstream photography that stressed the purity of the photographic process, is now at the forefront of practice. Regardless of one's personal destination or that of the photography itself, individuals can begin their journey by grasping the importance and value of still images as fundamental building blocks, for the still image allows us to meditate on a subject in our own time. It is this very limitation of not being dynamic, but static in time and space that gives still images their power.

DETERMINING MEANING

People are meaning-makers who seek significance in things, and learn from others, past and the present, how to accomplish it. Our notions about how we understand images have also undergone substantial changes, as we have come to realize that there are no neutral photographs. All depictions have a particular bias. Photography has three distinct kinds of bias. The first bias comes from the people who create and manufacture the commonly used photographic systems, which include the cameras, lenses, consumable supplies, and ancillary equipment that the vast majority of photographers relies on to physically produce a photographic image. These companies set up the physical boundaries and the general framework within which most photographers operate. The second predilection comes from the prejudices of the photographer who uses these systems to create specific images. Every photograph reveals the "photographer's eye" - a combination of the subject, the photographer, and the process. The third predisposition is the life references that viewers bring in determining what a photograph means to them. In the end, who we are, what we believe, where we live, and when we live define what we can see and how we see it.

BPS: BEFORE PHOTOSHOP

Long before Photoshop, methods that could alter a photographic image after the shutter had snapped were widely practiced and accepted as appropriate for achieving artistic and commercial goals. Early photographic practitioners regularly modified their working

6 0

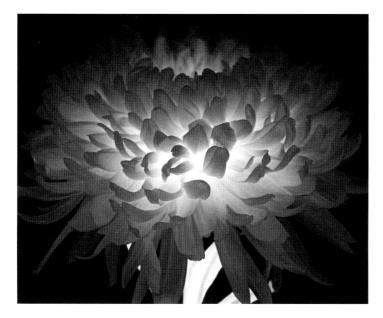

1.3 © Amanda Means. *Flower #61*, positive, 1997. 30 × 30 inches. Inkjet print. Courtesy of Gallery 339, Philadelphia.

methods to accommodate their aesthetic and technical requirements. Miniature painters painted directly on daguerreotypes and calotypes (paper prints) to meet the demand for color reproductions, setting the precedent of hand-applied synthetic color. In the 1840s, William Henry Fox Talbot sometimes chose to wax his paper calotypes (the first negative/positive process) after development to make them more transparent. This increased their visual detail, gave them heightened contrast, and made them easier and faster to print. In 1848, Gustave Le Gray introduced a waxed paper process in which the wax was incorporated into the paper fibers before the paper was sensitized.

1.4 To visualize the organic, luminous images that evoke the power that drives our world, Means places flowers inside her 8×10 inch view camera and projects them outward onto photographic paper attached to a wall. "The resulting prints are tonally negative which gives the flowers a mysterious inner glow, because the light is coming through the petals, from within the flower. I scan my original prints and then invert them in Photoshop, which vastly increases the possibilities for controlled manipulation within."

© Amanda Means. *Flower #61*, inversion, 2006. 30 × 40 inches. Inkjet print. Courtesy of Gallery 339, Philadelphia.

This chemically and physically altered the speed and tonal range of the paper negatives and produced a different result from the waxed calotype. Photographers such as Charles Nègre and David Octavius Hill and Robert Adamson used a pencil on calotype negatives to alter tonal relationships, increase separation between figure and background, accent highlights, add details or objects not included in the original exposure, and remove unwanted items.

Combination Printing

Combination printing from multiple negatives became fairly common in the mid- to late 1800s. The collodion, or wet-plate, process that became the major commercial photographic method of the 1850s had a low sensitivity to light, which resulted in long exposure times that made group portrait making difficult. The wet plate's limited sensitivity to blue and ultraviolet light made it impossible to make naturalistic, full tonal range landscapes. If the exposure for the subject or landscape was correct, the sky would be grossly overexposed, and when printed it would appear at best as a mottled white. Combination printing was developed to overcome such inherent technical problems. Separate exposures were made for the subject and the sky and, through the use of masking, printed on a single piece of paper. This technique received a great deal of notice with Oscar Gustave Rejlander's Two Ways of Life (1857): a tableau vivant (living picture) or staged image of a group of people arranged to represent a scene or incident that was created by combining 30 negatives. Through the photographs and writings of Henry Peach Robinson in Pictorial Effect in Photography (1869), combination printing became the method of choice for serious photographers of artistic intent.

The Advent of Straight Photography

Major objections to these working methods were raised in Peter Henry Emerson's *Naturalistic Photography* (1889), which particularly attacked the concept of combination printing. Emerson called for simplified working procedures and "selective naturalistic focusing."

1.5 Utilizing the tableau vivant, Witt digitally composites himself as a character to explore his own anxieties, desires, humor, and trepidations. This format, which references the ability of the subconscious mind to combine elements from different events and places, allows Witt to transform the everyday into the uncanny. Here he ironically evaluates himself, a form of behavior modification that gets one to "police" oneself.

© Jeffrey A. Witt. Evaluation, 2005. 12 × 18 inches. Inkjet print.

This visual approach was supposed to allow the imaginative photographer to more closely replicate human vision, in which some things are seen clearly and sharply while others are less clear.

Emerson thought it was the photographer's obligation to discover the camera's own codex. He saw photography as a blending of art and science. He stated that through one's selection of framing, lighting, and selective focusing, good images could be made. Emerson emphasized photographing subjects in their natural surroundings without any of the artificial manipulations of the combination printers. He

8 0

came under heavy attack for these ideas and recanted with *The Death of Naturalistic Photography* (1890), but the seeds of what would evolve into "straight" photography had already been sown, and its most significant mark in photographic history had not yet arrived.

The Pictorialists

The 1890s was the heyday of many hand printmaking methods, such as gum printing, which demonstrated how innovative photographers could control their medium in the same manner that artists working in other mediums, especially painting, could. This type of printing was favored by the Pictorialists and championed through the work and writing of Alfred Maskell and Robert Demachy in Photo Aquatint, or The Gum Bichromate Process (1897). The Pictorialists stressed the atmospheric and formal effects of the image over that of the subject matter. Composition and tonal values were of paramount concern. Soft-focus lenses were used to emphasize surface pattern rather than detail. Pictorialists did not want to be bound by the tyranny of exactitude. These expressive printmakers favored elaborate processes to show that photography was not a mere mechanical process, but could be controlled by the hand of the maker and therefore was a legitimate visual art form. The Pictorialists' attitudes and procedures dominated much commercial portrait and illustrative work throughout the first part of the twentieth century, with an emphasis on constructing beauty as opposed to finding it in nature.

The Photo-Secessionists

In the United States, the Pictorialists were followed by the Photo-Secessionists, under the leadership of Alfred Stieglitz. In their quest to have photography recognized as an art form, they experimented with a wide variety of inventive printmaking methods.

Sometimes I catch a glingese of him in the fragments of strangers caught on my age.

1.6 "When I was a small girl, I imagined that my perfect other, my doppelganger perfect friend, lived in my house. I could speak and play with him, but never see him. As I grew older, he became the perfect father, brother, or boyfriend. As I entered puberty, I began to fear that I would never meet him, and, if I did, how he would change my life. This is a story about that transitional period in childhood when gender moves from a reflection of self to the other. Working with Photoshop allowed for greater enhancement and utilization of images that would otherwise not work for the final gum bichromate process. For instance, before Photoshop negatives, color originals could not be used, as the traditional film was insensitive to large parts of the spectrum."

© Kay Kenny. *Dreamland Speaks When Shadows Walk*, #7, 2004. 22 × 15 inches. Gum bichromate print. The text reads: "Sometimes I catch a glimpse of him in the fragments of strangers caught in my eye."

The Arrival of Straight Photography

Influenced by avant-garde artists such as Pablo Picasso, whom Stieglitz showed for the first time in the United States at his "291" Gallery, Stieglitz began to promote a straight photographic aesthetic in the final issues of his publication, *Camera Work*, as exemplified in Paul Strand's photographs made around 1916.

Strand had successfully incorporated the concepts of painterly abstraction directly into the idea of straight, sharp-focus, nonmanipulative photography. Strand believed that photography's raison d'être was its "absolute unqualified objectivity" and that this could be found by investigating photography's own inherent characteristics. The emphasis of the art of photography switched from post-exposure methods to creating the image in the camera at the moment of exposure and maintaining a much narrower range of simplified printmaking techniques.

Modernistic Approaches

Documentary

Modern documentary photography practice developed during the 1930s in the pioneering work of Jacob Riis in the slums of New York City and Lewis Hine's depictions of immigrants arriving at Ellis Island and children being forced to work in inhuman conditions instead of attending school. Documentary photographs provide evidence, often in a narrative form, of real people, events, and places for the purpose of communicating information or delivering a message. This style was exemplified during the Great Depression when the Farm Security Administration (FSA) hired photographers such as Walker Evans,

1.7 Although not a traditional documentary, *World in a Jar: War & Trauma* (consisting of 850 individual jarred images) pays homage to the documentary tradition and expands the genre into a postmodern form. It does this by reworking historical images and original material to examine visual cultural memories involving loss, popular culture, religion, tragedy, and wickedness over the past 400 years. "It is a Socratic process that allows me to engage in a philosophical dialogue with other times, places, and makers, following the principle there is no correct first version of how an image should look. I am not redefining an image as much as I am inquiring into metaphysical contradictions and opposing social forces that swirl around each image. I am asking each picture a question while examining the orgin of the image and the way its meaning has changed over time."

© Robert Hirsch. World in a Jar: War and Trauma (installation detail), 2004. $4 \times 2 \times 50$ feet. Mixed media. Courtesy of Big Orbit Gallery, Buffalo, NY.

Dorothea Lange, and Arthur Rothstein to survey conditions in rural areas of the United States. Their photographs portray the dignity and suffering of poverty-stricken farm families. At the same time, the appearance of illustrated news magazines in the United States and Europe such as *Life* and the *Picture Post*, created a demand for photojournalistic photographs. Such photojournalists as Robert Capa and Margaret Bourke-White vividly recorded important people and dramatic events of the period through the World War II traumas of D-Day and the liberation of concentration camps.

Straight Photography and Previsualization

Edward Weston's artistic work starting from the 1930s represents the idea of straight photography through the use of what has been referred to as "previsualization" or "visualization." By this concept, Weston meant that he knew what the final print would look like before releasing the camera's shutter. The idea of visualizing the end result ahead of time would bring serious printmaking full circle, back to the straightforward approach of the 1850s, when work was directly contact-printed onto glossy albumen paper. Weston simplified the photographer's working approach by generally using natural light and a view camera with its lens set at a small aperture. He produced a large-format negative that was contact-printed (no enlarging) with a bare lightbulb. Photographic detail and extended tonal range were celebrated in a precise black-and-white translation of the original subject on glossy, commercially prepared paper. By eliminating all that he considered unnecessary, Weston strove to get beyond the subject and its form and uncover the essence or life force of "the thing itself." This philosophy rejected major post-exposure work as unholy and only done by those who were not good enough to get it right for the camera. By the 1950s, photographers such as Aaron Siskind expanded these ideas by incorporating the concepts of Abstract Expressionism, which gave rise to nonrepresentational photography.

Group f/64 and the Zone System

In 1932, a band of California-based photographers, including Weston, Ansel Adams, and Imogen Cunningham, founded Group f/64. Their primary goal was to create photographs of precise realism without any signs of pictorial handwork. The name of the group reflects the fact that the members favored a small lens aperture that enabled them to achieve images with maximum detail, sharpness, and depth of field. They concentrated on natural forms and found objects that were representative of the naturalistic West Coast style.

The ideas from Group f/64 were refined and expanded by Ansel Adams in his Zone System method. The Zone System is a scientifically based technique for controlling exposure, development, and printing to give an incisive translation of detail, scale, texture, and tone in the final photograph. Adams's codification of sensitometry and its accompanying vision continues to set the standard for pristine wilderness landscape photography. The Zone System, as taught by Minor White and others, was so popular and successful that it dominated serious photographic practice throughout the 1960s and 1970s.

Postvisualization

The images and writings of William Mortensen — as in his 1934 essay "Fallacies of Pure Photography," which rejected the doctrine of the straight print and the singular aperture as being mechanistic offer a pre-digital counterpoint to Group f/64's philosophy. A master craftsman, Mortensen taught imagemakers that they have the right to manipulate their negatives and/or prints to achieve their visual goals. Many of his procedures can now be readily accomplished in Photoshop.

Social Landscape and the Snapshot Aesthetic

The idea that serious photography must involve previsualization was challenged in the 1950s by Robert Frank and William Klein's intuitive use of a small 35mm Leica camera in available light situations that disregarded journalistic standards of construction and content matter. Their use of blur, grain, movement, and off-kilter compositions gave photographers a new structure for discovering new content and creating innovative, formal ways of making photographs through the picture-making process. This approach to photographing the social landscape in the 1960s was summed up by street photographer Gary Winogrand's remark: "I photograph to find out what something will look like photographed." The social landscape is a personalized response to life that incorporates the informal artistic qualities of the snapshot to comment on "people and people things."

Diane Arbus used what was commonly known as the *snapshot aesthetic* to challenge the definition of what it means to be human and confront us with the "secret" that nobody is "normal." The snapshot aesthetic refers to the practice of professional photographers intentionally adopting the immediate and spontaneous conventions of the family snapshot into their photographs.

The Alternative Scene

The mid-1960s was a time of experimentation in many aspects of Western society: questioning how and why things were done, trying new procedures, and eliciting fresh outcomes. A rising interest in countercultural ideas sent many photographers back into photographic history to rediscover alternative techniques and encouraged new directions in imagemaking. A revival of historical methods surfaced with the national recognition Jerry Uelsmann received for his

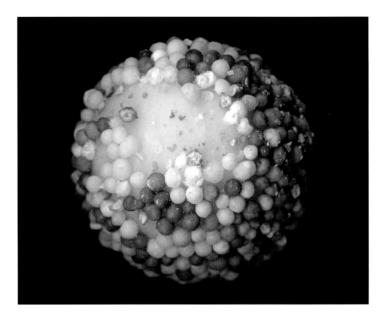

1.8 Schneider updates Winogrand by wanting to "see what things look like scanned. By using a scanner as a camera, I am able to render a degree of detail only previously available with a view camera. Sugar is a basic pleasure. I make pictures of candy with the hope of creating images which function both viscerally and conceptually, evoking nostalgia and desire and at the same time provoking repulsion at the consumption, greed, and indulgence of contemporary society. The images are printed relatively large on glossy paper to reinforce the superficial appeal of candy — colorful and promising instant gratification."
© Betsy Schneider. *Gum Ball*, from the series *All for Your Delight*, 2006. 40 × 30 inches. Inkjet print.

use of combination printing, and this spread to nonsilver approaches like cyanotypes and gum printing. The concept of post-visualization, in which the photographer could continue to interact with the image at any stage of the process, was reintroduced into the repertoire of acceptable practices. Photographers such as Robert Heinecken, Ray

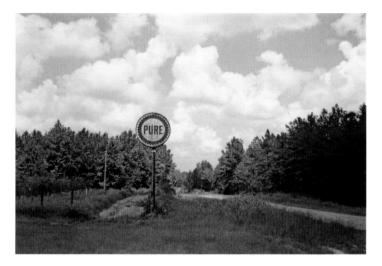

1.9 Since the early 1960s, Christenberry has used a Kodak 127 Brownie camera to plumb the regional identity of the American South, focusing primarily on Hale County where he came of age. Christenberry's ritual documentation of "home" evokes pensive memories and scrutinizes scenes that unwaveringly record the physical changes brought about by nature and time without evoking nostalgia, establishing a connection between the past and the present. Each fleeting and simple structure can be considered a sculpture, an anxious agent for aging, decay, fragility, insecurity, and shifting purpose, as well as a signifier for the closing of a way of life.

William Christenberry. Pure Oil Sign in Landscape, near Marion, Alabama, 1977. 3-1/4 × 4-13/16 inches. Chromogenic color print. Courtesy of Pace/MacGill Gallery, New York.

Metzker, Bea Nettles, and John Wood rejected the notion of a single, fixed perspective and actively sought alternative viewpoints.

The Rise of Color Photography

In the 1970s, the alternative innovations challenged the dominance of the straight, black-and-white print as the fine art standard. This paved the way for such photographers as William Christenberry, William Eggleston and Stephen Shore, whose color images of ordinary scenes ushered in the acceptance of artistic color photography, which is now taken for granted.

Postmodernism

Beginning in the late 1970s, postmodernist beliefs that questioned the notion of a single author and the authenticity of any work gave rise to a new genre based on "appropriation" (the borrowing, reuse, and recontextualization of existing work) by artists such as Richard Prince and Sherrie Levine. During this era, Cindy Sherman made a series of photographs, Untitled Film Stills (1977-1980), that featured and thus questioned female stereotypes based on 1950s film advertisements; in these photographs Sherman was the model, make-up artist, set designer, and photographer. Sherman's work exemplifies a movement by women and minorities to picture their own identity rather than having it imposed by society. Another example of this is Carrie Mae Weems's photographic work, which explores issues about who we are and how we got to be that way from the perspective of African-American culture and experience. By the 1990s, postmodernism had also challenged the notion of separate, specific boundaries for different media and encouraged the cross pollenization of mediums, giving rise to new and widespread use of installations that incorporated photographs, three-dimensional and found objects, projected images, and sound.

Electronic Imaging: New Ways of Thinking

Digital imaging started to surface in the scientific community during the mid-1950s, when Russell A. Kirsch made one of the first digital

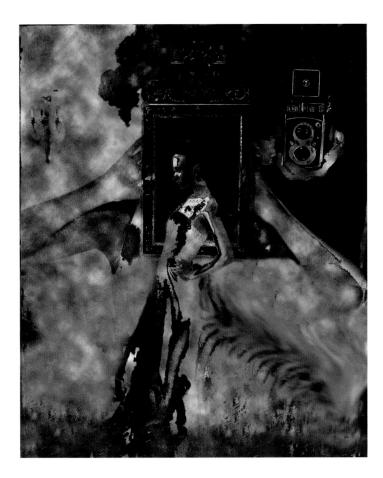

images. Along with other scientists working at the National Bureau of Standards, Kirsch created an early digital scanner. By the 1960s, the National Aeronautics and Space Administration (NASA) was using digitized images produced from its *Surveyor* landing craft in 1966 and 1968 to formulate never-before-seen composite photographs of the moon's surface which were of great interest to artists and the

1.10 Wade addresses the role that the media plays in the woman's beauty crisis by making a photogram of a page taken from a fashion or wedding magazine and then applying the alternative Mordancage process in which an acid bath allows her to selectively remove areas of the image. Then the image is allowed to oxidize and produce a corrosive effect to which she adds oil paint. Next, the original magazine and Mordancage images are scanned, combined, and manipulated in Photoshop. The result is "a manufactured grotesque based upon the idea that women put their bodies, and thusly, their psyches through torturous measures trying to live up to the elusive thing that is beauty."

public. Yet it was not until the late 1980s, with the advent of affordable home computer graphics workstations, that digital image manipulation became a viable means for creating photographs. Digital image manipulation has removed the burden of absolute truth from photography. By doing so, it has revolutionized how images are created and generated a conceptual shift from a medium that records reality to one that can transform it. In the late 1960s, Sonia Landy Sheridan incubated the notion of a Generative Systems Department at the School of the Art Institute of Chicago. It was conceived to provide artists and scientists the opportunity to investigate new means of image production that included electrostatic photocopy machines, video, and computer-generated images, and it offered its first course in 1970. What followed erupted into an explosive new set of technical possibilities that has enabled a vast extension of new and diverse visions to be seen.

THE DIGITAL IMAGING REVOLUTION

Digital imaging technology has made it easier and quicker to take and transmit images around the world and to change our notions about

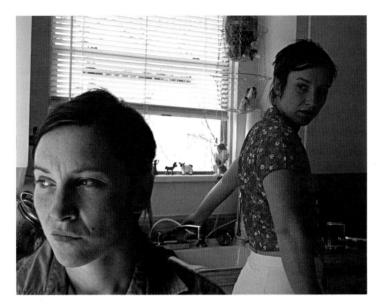

1.11 "This work represents an autobiographical questioning of sexuality and gender roles that shape the identity of the self in intimate relationships. These images were created from scanning and manipulating two or more negatives in Photoshop to create a believable situation, which is not that different from accepting any photograph as an object of truth. These images reconstruct private relationships I have experienced, witnessed in public, or watched on television. The events portrayed look authentic, yet have never occurred. By digitally creating a photograph that is a composite of multiple negatives of the same model in one setting, the self is exposed as not a solidified being in reality, but as a representation of social and interior investigations that happen within the mind."

© Kelli Connell. Kitchen Tension, 2002. 30 × 30 inches. Chromogenic color print.

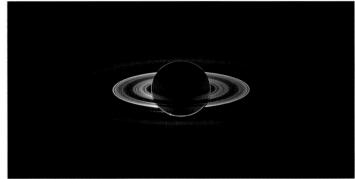

1.12 Carolyn Porco, Cassini Imaging Team leader says: "There has yet been no greater visual survey of a planetary system in the outer solar system than Cassini's imaging of the bodies in the Saturn environment. The enchanting beauty and visual clarity of our images have earned the attention and admiration of people all over the world, and our scientific discoveries, some of them quite startling, have revolutionized our understanding of everything Saturnian. This panoramic view was created by combining 165 images taken by the Cassini wide-angle camera over nearly three hours on September 15, 2006. Color in the view was created by digitally compositing ultraviolet, infrared and clear filter images and was then adjusted to resemble natural color." Such space images made by astronauts and unmanned remote controlled cameras have had a noticeable influence on photographic practice. For more information see http://ciclops.org.

© Cassini. In Saturn's Shadow, 2006. Variable dimensions. Digital file. Courtesy of Cassini Imaging Team and NASAJPL/SSI.

photographic truth. During the 19th century, people believed the stationary camera was a reliable and automatic witness. The photographer's job was to make "every person" views, photographs that acted as stand-ins, witnessing a scene and depicting what you would have observed had you been an eyewitness. This gave people confidence that photographs were accurate representations of truth. Digital imaging has destroyed this unwritten arrangement between photographers and audiences by giving imagemakers the ability to seamlessly alter the picture of "reality." In the 21st century, seeing is no longer believing. The public's confidence in the accuracy of photographs has been eroding as news providers modify photographs without informing their readers. It began in 1982 when *National Geographic* editors "moved" the Egyptian Great Pyramids at Giza closer together to accommodate the vertical composition of their cover. Unethical photojournalists have lost their jobs because they were caught "Photoshopping" images before transmitting them to their editors for publication. Such undetectable changes have made audiences more skeptical about the accuracy of all photographs.

Now digital imaging tools are so readily available and easy to operate that both amateurs and professionals use them daily. Such computer power can be seen in the work of American Nancy Burson, who uses digital morphing technology to create images of people who never existed, such as a composite person made up of Caucasian, Negroid, and Asian features. Such pictures have no original physical being and exist only as digital data, showing us how unreliable images can be (see Figure 1.14).

NEW MEDIA

Digital imaging is an exciting evolutionary step in photographic imagemaking and marks the end of the darkroom as the primary place for making photographic images. Digital data makes it possible for photographers to forge new links among people, places, and events. Photographers no longer just capture a slice of time, but can manipulate it to enlarge our ideas about what makes up reality. Many digital cameras can record sound and short segments of moving images. These changes make photography less rigid and objective and more flexible and subjective. This transformation offers us new possibilities for imaging and for understanding the world in new and different ways. For instance, it has opened up an entirely new category of work known as *new media*, which refers to interdisciplinary works that utilize new electronic media. New media can include video, online art, interactive components with motion, sound, and touch that allow a work to change or be changed before one's eyes. In turn, this computer technology has produced new devices and uses for photographic images, such as podcasts and video blogs (AKA vblogs), which rely on the Internet for posting and receiving digital files containing sound and moving images. These transformations tell us that the important thing about a photographic image is not "how" it is made, but "what" it has to communicate.

QUESTIONS ABOUT PHOTO-BASED IMAGEMAKING

Over the past ten years, I have been collecting and responding to conceptual questions posed by students about photographic practice. The following series of questions and answers are designed to present a larger overview of fundamental concepts, images, and issues that can inform creative work. By thinking through these questions, readers can expand and deepen visual potential and latent interests rather than following a current style or trend. The responses provided do not preclude other answers. They offer an initial pathway to form the basis of a discussion, to provoke, and in turn to help readers formulate their personal thoughtful solutions. Additionally, I would encourage people thinking about a life in the visual arts to actively seek out and establish their own foundation of inspirational sources

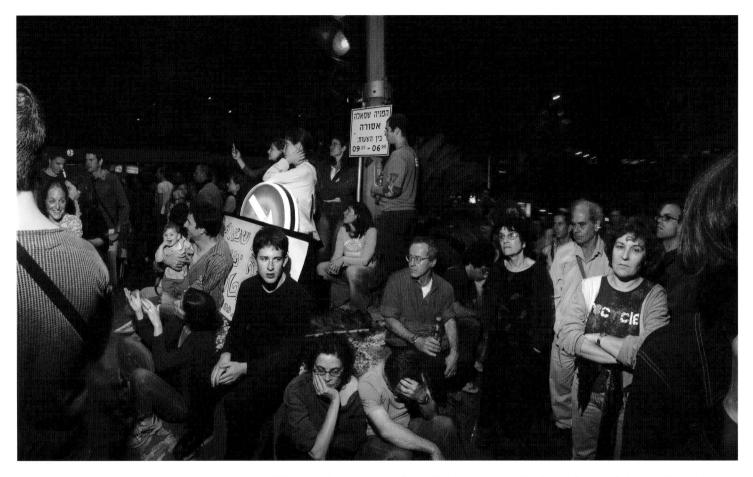

1.13 Frylender's images, which address the complexities of life in Israel, are indicative of how digital imaging has altered the definition of photographic truth by mimicking and therefore undermining traditional photojournalistic methods. Although they appear to be a seamless representation of an event, they are actually the antithesis of "cyclopean" photography. This image is the result numerous images that Frylender assembled into a single, time-compressed cinemascopic frame, which delivers a synthesis of the event based on many different vantage points and moments in time. "It's not one instant, it's many instants put together, and there's a hidden history in every image."

Barry Frylender. Last Peace Demonstration, 2004. 50 × 78 inches. Chromogenic color print. Courtesy of Andrea Meislin Gallery, New York.

1.14 Huston photographed twenty people in his photography class under identical conditions and then merged them together to create one universal class face. "I worked to achieve an image that was not sided towards one person more than another. Clothing, buttons, necklaces, hair, eyes, nose, and every other facial distinction that one views everyday was given the utmost concern and detail to produce an image that shared the collective characteristics of twenty people." (See Chapter 12, Human User Fusion assignment.) © Robert Huston. Universal Class Face, 2006. 10×7 -1/2 inches. Inkjet print.

from art, literature, philosophy, and science that can act as guideposts in their creative activities, motivation, and growth.

1. How does one become a photographer?

Since past photographs inform future photographs, looking at photographs and other visual material should be a primary activity. Look at what drives your visual curiosity. Look at the classics. They have

1.15 Walker's film project employs a series of montages using animated cutpaper marionettes to draw a picture of the nascent Antebellum South that is at times darkly menacing and at others disturbingly comical. The vignettes, which render all people black, conjure up an absurdist sideshow about the African-American experience that shifts between the metaphorical and the believable while maintaining an engaging realism of expression and gesture. The soundtrack features popular turn-of-the-century music and the artist's own narration.

© Kara E. Walker. 8 Possible Beginnings Or: The Creation of African-American, Parts 1–8, A Moving Picture (video still), 2005. Courtesy of Sikkema Jenkins & Co., New York.

been preserved because their artistic, conceptual, and technical content serves as a model that has proved useful over time. Look at contemporary work that is grappling with new and different ways of expressing ideas. Read, study, and practice different methods of photography, not for the sake of technique, but to discover the means to articulate your ideas. Don't make technical learning your priority. 1.16 "As a photo-based artist, I see myself as the link between two realities — the one outside of the camera and the one that begins once the photograph has been taken. Rather than documenting or capturing the moment, I want to show what is not immediately visible. Inspiration comes from my fascination with the informational processes of the mind and in popular theories of physics. String Theory describes the existence of up to 26 dimensions and parallel universes that might be outside of our perception. I use a combination of analogue photography and digital editing [removing spatial references] for they enable me to create images that have the sensibility of drawings or paintings while retaining photography's reference to the outer world."

Form an idea first. The German artist Joseph Beuys said it best: "Once you've got an idea, the rest is simple." Step back from the familiar to better understand it. One peril facing photographers is a lack of commitment that translates into indifference in their work. Talking, thinking, and writing about photography are vital components of understanding the process, but these activities do not make one a photographer. Ultimately, to be a photographer one must act and fully engage in the process of making photographs (usually lots of them).

2. Why is photography important?

In disaster after disaster, survivors report their most irreplaceable objects are their snapshots. This reveals the crux of why people photograph: to save and commemorate a subject of personal importance. An image may be a memory jog or an attempt to stop the ravages of time. Regardless of motive, this act of commemoration and remembrance is the essence of photography.

What does this mean in terms of developing an artistic practice? There are more options than ever to pursue. Whether the images are

found in the natural world, in a book, or online, part of an imagemaker's job is to be actively engaged in the condition of "looking for something." How this act of looking is organized, its particular routines, astonishments, uncertainties, and quixotic complexities, is what makes a photographer unique.

1.17 Actively photographing New Orleans since 1982, Strembicki asked himself: "How does an artist approach the making of fine art when confronted with a natural disaster such as Hurricane Katrina? I only went into public buildings looking for symbols of loss and gravitated to found photo and wedding albums. These were something everyone had and understood. I brought along a macro lens and made copy photographs on location, taking nothing with me but images. We make strange rules as artists." © Stan Strembicki. *Found Photo Album*, Lower 9th Ward, from the series *Post Katrina New Orleans*, 2005. 17 × 24 inches. Inkjet print. Courtesy of Philip Slein Gallery, St. Louis.

3. Why is it important to find an audience for your work?

Part of a photographer's job is to interact and stimulate thinking within the community of artists and their world at large. Without an audience to open a dialogue, the images remain incomplete and the artist unsatisfied.

4. What can images do that language cannot do?

An accomplished photographer can communicate visual experiences that remain adamantly defiant to words. The writer Albert Camus stated, "If we understood the enigmas of life there would be no need for art." We know that words have the power to name the unnamable, but words also hold within them the disclosure of a consciousness beyond language. Photographs may also convey the sensation and emotional weight of the subject without being bound by its physical content. By controlling time and space, photo-based images allow viewers to examine that which attracts us for oftenindescribable reasons. They may remind us how the quickly glimpsed, the half-remembered, and the partially understood images of our culture can tap into our memory and emotions and become part of a personal psychic landscape that makes up an integral component of identity and social order.

5. What makes a photograph interesting?

A significant ingredient that makes a photograph interesting is *empathy*, because it provides viewers with an initial toe-path for cognitive and emotional understanding of the subject. Yet the value of a photograph is not limited to its depiction of people, places,

1.18 Talbitzer uses herself as the subject to produce tangible evidence of the human condition that is unseen or indescribable. "For me words fail the complexity of the human emotional landscape. This failure is why my images exist. They communicate complicated feeling using symbolism that is both personal and universal and free from the burden of concrete meaning. What makes me human is also what makes viewers human. I cultivate that connection with heavily manipulated images that still appear photographically true while obviously defeating that truth."

@ Shelia Talbitzer. Untitled #5, from the series Curio, 2006. 45 \times 30 inches. Inkjet print.

things, and feelings akin to those in our life. An engaging image contains within it the capacity to sensitize and stimulate our latent exploratory senses. Such a photograph asserts ideas and perceptions that we recognize as our own but could not have given concrete form to without having first seen that image.

6. How is the meaning of a photograph determined? Meaning is not intrinsic. Meaning is established through a fluid cogitative and emotional relationship among the maker, the photograph, and the viewer. The structure of a photograph can communicate *before* it is understood. A good image teaches one how to read it by provoking responses from the viewers' inventory of life experiences, as meaning is not always found in things, but sometimes between them. An exceptional photograph creates viewer focus that produces attention, which can lead to definition. As one meditates on what is possible, multiple meanings may begin to present themselves.

The result is that meaning, like the weather, is local; viewers interpret images based on their own understanding of the world, which in turn is based on their private agendas, historic context, and sense of time.

7. How can photographers know and define beauty and truth in the 21st century?

Beauty is the satisfaction of knowing the imprimatur of this moment. Although beauty and truth are based in time and may exist only for an instant, photographers can capture a trace of this interaction for viewers to contemplate. Such photographs can authenticate an experience and allow us to reflect upon it and gain deeper meaning.

During the past 25 years, issues of gender, globalization, identity, race, and sexuality have been predominant because previously they

had been neglected. In terms of the practice of digital imaging, the artistic ramifications have been the overriding concern. But whether an imagemaker uses analog silver-based methods to record reality or pixels to transform it, the two greatest issues that have concerned imagemakers for thousands of years — beauty and personal truth — have receded into the background, especially in academic settings, where irony has been the major form of artistic expression.

Beauty is not a myth, in the sense of just being a cultural construct or creation of manipulative advertisers, but a basic, hard-wired part of human nature. Our passionate pursuit of beauty has been observed for centuries and should not be ignored simply because it can't be scientifically measured. The history of ideas can be represented in terms of visual pleasure. In pre-Christian times, Plato recognized the three wishes of every person: "to be healthy, to be rich by honest means, and to be beautiful." More recently, American philosopher George Santayana postulated that there must be "in our very nature a very radical and widespread tendency to observe beauty, and to value it."

Although elusive, there are certain visual patterns that can be observed that define a *personal truth* (a conclusion beyond doubt). When we recognize an individual truth, it may grab hold and bring us to a complete stop — a total mental and physical halt from what we were doing — while simultaneously producing a sense of clarity and certainty that eliminates the need for future questioning and reinforces the genuine voluble role that art plays in our lives.

8. What are the advantages of digital imaging over silverbased imagemaking?

Practically speaking, you don't need a physical darkroom with running water and expensive enlarging equipment that exposes you to the

1.19 "The natural world, as observed and recorded by the camera, rarely measures up to our conception of its inherent power or raw beauty, depending on which ideological filter we use to endow the image with meaning. Because we lack the ability to truly replicate this world — and in the face of our failure to fully dominate it — we are left instead to imitate it, to sift through our ever-accumulating debris to fabricate fictions worthy of our collective ambitions. The imaginary kingdoms here, though brimming with fantastic narratives and colorful characters, are mere allusions to the histories they represent. Their world is not of the lens, but rather a fertile proposition of possibility culled from the artifacts of well-intentioned merchants of delight."

© Sally Grizzell Larson. Number 7, from the series Thread and Carbon, Oil and Steel, 2006. 35×35 inches. Chromogenic color print.

dangers of handling chemicals. Conceptually, as in silver-based photography, digital imaging allows truth to be made up by whatever people deem to be important and whatever they choose to subvert. While analog silver-based photographers begin with "everything" and often rely on subtractive composition to accomplish these goals, digital imaging permits artists to start with a blank slate. This allows imagemakers to convey the sensation and emotional weight of a subject without being bound by its physical conventions, giving picture-makers a new context and venues to express the content of their subject.

9. What are the disadvantages of digital imaging?

The vast majority of digital images continues to be a reworking of past strategies that do not articulate any new ideas. Manufacturers promote the fantasy that all it takes to be an artist is just a few clicks of a mouse or applying a preprogrammed filter. The challenge remains open: to find a native syntax for digital imaging. At the moment, this appears to be one that encourages the hybridization and commingling of mediums.

On the practice side, having a tangible negative allows one to revisit the original vision without worrying about changing technology. One could still take a negative that William Henry Fox Talbot made to produce his first photographic book, *The Pencil of Nature* (1843–1846) and make a print from it today. In 150 years, will there be a convenient way for people to view images saved only as digital files? Or will they be technically obsolete and share the fate of the computer floppy disks that contain data that most people can no longer access?

One does not have to be a Luddite to continue making analog prints. One reason to keep working in a variety of analog processes is that digital imaging tends to physically remove the maker from the photographic process. This is not a romantic notion or a nostalgic longing for the ways of the past. Often what is lost is the pure joy of being alone in a special dark room with an orange glowing light — the exhilaration of being physically creative as your body and mind work together to produce a tangible image. The act of making an analog photograph is a haptic experience that does not occur while one is seated in a task chair. The smell of chemicals, the sensory experiences of running water as an image emerges in the developing tray from a white nothingness — such things are missing in making digital images. A silver-based photograph never looks better than when it is seen still glistening wet as it emerges from the washing process. And regardless of how long one has been making prints in the darkroom, there is still that small magical thrill that your photograph "has come out" and now can have a life of its own.

10. How can I find something interesting to photograph? Although photography is exceptional at capturing the surface of things and not as effective at getting below it, don't automatically assume that the physical subject of an image always reveals its content. Meaning is not always linked to the subject matter being represented. Photographs that affect people may have nothing to do with the apparent subject matter, and everything to do with the subsequent treatment of that subject. This realization creates limitless potential for subject matter.

Light and shadow are vital components of every photograph. This was recognized early in the medium's history by William Henry Fox Talbot's image *The Open Door*, 1843, which demonstrated his belief that subject matter was "subordinate to the exploration of space and light." The quality of light striking a subject can reveal or conceal its characteristics, which will make or break a photograph. Light may

be natural or artificial, but without the appropriate type of light, even the most fascinating subjects become inconsequential. Ultimately, light is a principal subject of every photograph which imagemakers must strive to control and depict. As Talbot stated, "A painter's eye will often be arrested where ordinary people see nothing remarkable. A casual gleam of sunshine, or a shadow thrown across his path, a time-withered oak, or a moss-covered stone may awaken a train of thoughts and feeling, and picturesque imaginings." This is the realization that the subject in front of the lens is not always the only subject of the photograph.

11. Hasn't it already been done before?

To accept the notion it has all been done before is to embrace clichés. The problem with clichés is not that they are erroneous, but that they are oversimplified and superficial articulations of complex concepts. Clichés are detrimental because they encourage photographers to believe that they have done a sufficient job of recording a situation when in fact they have merely gazed at its surface. The simple act of taking a photograph of Niagara Falls or a pepper is no guarantee that one has communicated anything essential about that subject. Good photographers provide visual clues and information about their subject for viewers to contemplate. They have learned how to distill and communicate what is essential to them about their subject. By deeply exploring a theme and challenging clichés, photographers can reconstruct their sight of distorted, neglected, or other contextual issues that surround a subject and its meaning and gain a fresh awareness and understanding.

12. What if I'm not in the right mood to make photographs? Responding to life with joy and sorrow is part of the human condition. At times when pain and suffering are inescapable, it is important to

remember that this is part of the process by which we acquire knowledge. This does not mean that one must be in discomfort to make art, but stress can be channeled into a creative force if it produces a sense of inquisitiveness and an incentive for change. Thinking through making pictures can allow us to place our pain in context. The images we make can help us understand its source, catalog its scope, adapt ourselves to its presence, and devise ways to control it. There are things in life, once called wisdom, which we have to discover for ourselves by making our own private journeys. Stress can open up possibilities for intelligent and imaginative inquiries and solutions that may otherwise have been ignored, overlooked, or refuted.

13. What happens when I have difficulty figuring out how to photograph a subject?

When you get stuck and cannot find a solution to your problem, try changing your thinking patterns. Instead of forcing an issue, go lie down in a quiet and comfortable dark room, close or even cover your eyes, and allow your unconscious mind a chance to surface. Some people may take a bath or go for a walk. The important thing is to find something that will change the pattern of your brainwaves. Anecdotal history indicates that the following can be an excellent problem-solving method: turn off the cognitive noise and allow your internal "hidden observer" to scan the circumstances, and then return to your normal state with a possible solution. Keep paper and pencil handy.

14. Why is it important to understand and be proficient in your medium?

Understanding the structure of the photographic medium allows one the freedom to investigate new directions. Upon first viewing, an image may appear to be exciting and magical; however, the photograph needs to be objectively evaluated. To do this, one must have the expertise of craft to understand that photograph's potential. Mastery of craft allows one the control to be flexible, to sharpen the main focus, and discard extraneous material. This evaluation process requires you to reexamine and rethink your initial impulse and jettison inarticulate and unadorned fragments, and allows you to enrich and refine them by incorporating new and/or overlooked points of view. An artist who invests the extra time to incubate fresh ideas, learn new technical skills, try different materials, and experiment with additional approaches can achieve a fuller aesthetic form and a richer critical depth. This procedure is often attained by reaching into a different part of ourselves than the one we display in our daily demeanor, in our community, or in our imperfections.

15. Why is it important to make your own photographs? The physical act of making a photograph forces one into the moment and makes you look and think more than once, increasing your capacity for appreciation and understanding. This not only allows you to see things in new ways, but can also be physically and psychologically exhilarating. It reminds us that life may be absurd but it is not mediocre, even if our daily conception of it is. Making your own images allows photographers to forge their own connections between the structure of the universe and the organization of their imagination and the nature of the medium. Consider what artist and teacher Pat Bacon says: make work . . . make it often . . . make it with what's available!

16. How much visual information do I need to provide a viewer to sustain meaning?

There are two basic stylistic approaches for transmitting photographic information. One is an open approach in which a great deal of visual

data is presented. It allows viewers to select and respond to those portions that relate to their experiences. The second method is the closed or expressionistic form. Here the photographer presents selected portions of a subject with the idea of directing a viewer toward a more specific response. Photographers need to decide which technique is most suitable for a particular subject and their specific project goals. Approaches shift depending on the project situation, but generally it is helpful to keep a constant approach throughout one body of work. Consciously selecting a single stylistic method for a series also provides a basic template for organizing your thoughts and producing work that possesses a tighter focus of concentration.

17. How much of my output is likely to be "good"? The American poet and writer Randall Jarrell wrote an apt metaphor that can be applied to other forms of artistic inspiration: "A good poet is someone who manages, in a lifetime of standing out in thunderstorms, to be struck by lightning five or six times; a dozen or two dozen times and he is great." When Ansel Adams was photographing on a regular basis, he said he was satisfied if he made one "good" image a month. Much of any artistic practice is working through the process. Good artists take risks but also recognize that not everything they do is for public circulation. Situations that provide constructive and challenging criticism can be beneficial in helping to resolve a project. Over time, skillful artists can learn to edit and critique their own work, presenting only their most thought-out solutions for public consideration. Keep in mind what Henri Cartier-Bresson said: "It's seldom you make a great picture. You have to milk the cow quite a lot and get plenty of milk to make a little cheese. Hmmmm?"

18. How do photographers explore complex relationships of time, space, and scale and their role in generating meaning?

The process of making pictures involves keeping an open mind to single and serial image constructions, narrative and non-narrative formats, in-camera juxtapositions, and post-camera manipulations. How does changing the sense of scale, the size you expect something to be, affect viewer reaction? Does the unusual scale evoke humor, mystery, or horror? How does this make you rethink the subject? Consciously ask yourself questions like these: How does image size affect viewer response? How would changing to black-and-white or color affect the image's emotional outcome? Examine how one photograph may modify the meaning of the image next to it. Consider what happens if text is added to an image. How can meaning shift with a title as opposed to leaving a photograph untitled? What is the most effective form of presentation, and what is the appropriate venue?

19. Why study the history of photography?

History is how we define ourselves based on what we make of the past, which determines our future relationships. Being grounded in photographic history allows an imagemaker to see what has already been done. Photographs are built upon other photographs. Look at the work of other imagemakers who have covered similar ground and ask: What did they do that allows you to connect to their work? What would you do similarly? What would you do differently? Photo history also offers an opportunity to learn the basic skills needed to critically examine photographs: description, interpretation, and evaluation. Going forward from a foundation of knowledge, the imagemaker is in a position to carry out the Irish writer Oscar Wilde's

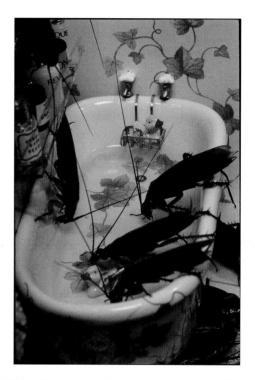

1.20 What William Wegman did with dogs, Chalmers does with cockroaches. Chalmers orders roaches from a biological supply company, tends and feeds the creatures, and then casts them roles in a series of elaborately constructed theatrical set pieces which she photographs in the manner of a family portrait photographer. Chalmers's images transform roaches into surreal projections of human manifestations, giving them a mythology that evokes both curiosity and revulsion in what looks like stills from a diminutive horror film.

 \bigcirc Catherine Chalmers. Drinking, from the series American Cockroach, 2000. 60 × 40 inches. Chromogenic color print.

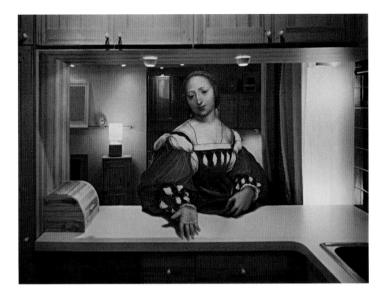

1.21 Abe explores and re-images two apparently different periods and art traditions. "What they have in common is 'display,' a key concept for both of these visual sources and an underlying concept for art and visual history. Visual technology and installation systems have been developed to create displays for the ideas of perception and desire. When the display becomes the primary object the medium becomes secondary; its value depends upon its ability to translate the idea into a visual physicality. The effect is a merging of art disciplines into a single focus of display. Categories of art become unimportant as classifications, but represent only different ways of display. This characterizes a fundamental shift in the history of art. Through the concept of display this project investigates the dynamics of art history and its future."

© Koya Abe. Digital Art Chapter 3: Display, After Läis of Corinth, 2005. 30 × 40 inches. Chromogenic color print.

aphorism: "The duty we owe to history is to rewrite it" — or in the photographic sense, to re-image it.

20. What are the limitations in studying the images of others?

The French novelist Marcel Proust stated, "There is no better way of coming to be aware of what one feels than by trying to recreate in oneself what a master has felt." While viewing the work of others can help us understand what we feel, it is our own thoughts that we need to develop, even if it is someone else's picture that assists us through this process. This also involves gaining an understanding of the visual and media culture that makes up our social environment. Regardless of how much any image opens our eyes, sensitizes us to our surroundings, or enhances our comprehension of social issues, ultimately the work cannot make one aware enough of the significance of our predilections — because the imagemaker was not you. Looking at work can place one at the threshold of awareness, but it does not constitute cognizance of it. Looking may open deep dwelling places that we would not have known how to enter on our own, but it can be dangerous if it is seen as material that we can passively grab and call our own. Many of us become photographers because we have not found pictures that satisfy us. In the end, to be a photographer, you must cast aside even the finest pictures and rely on your internal navigational devices and make your own images.

21. Can too much knowledge interfere with making photographs?

The answer is both yes and no. Beware of those who do not think independently, but rely upon established aesthetic, theoretic, or technical pedigrees as guides to eminence. You do not have to know all the answers before you begin. Asking questions for which you have no immediate answers can be the gateway for a new dynamic body of work. Do not get overwhelmed by what you do not yet know. Acknowledge that there is always more to know and learning should be a life-long process. Use your picture making as a discovery process, but do not allow the quest for data to become the central concern or a deterrent to making pictures. Knowledge of a subject can offer points of entry for visual explorations. Learn what you need to begin your project and then allow the path of knowledge to steer you to new destinations.

22. Is it necessary to explain my photographs?

Yes, it is vital to give viewers a toehold to your work with an artist's statement. This process also allows a photographer to learn if the audience agrees with the stated intentions of the work. However, while useful, an artist's intention offers only a single perspective for understanding work. By remaining open to different interpretations, imagemakers may discover meaning in the work that was not their conscious mind.

Enigma also remains an essential quality of art making. English painter Francis Bacon, whose work was strongly influenced by photography, believed that the power of a work lay in its ability to be alluring yet elusive. Bacon thought that once an image could be explained, sufficiently approximated in words, it became an illustration. He believed that if one could explain it, why would one go to the trouble of painting it? According to Bacon, a successful image was by definition indefinable, and one sure way of defining it was by introducing a narrative element. For centuries, storytelling was the backbone of Western art, but it was the bourgeois coziness and shallow academic conventions of 19th-century narrative painting that made storytelling anathema to the aesthetic vocabulary of modern art. Bacon took the existential position that his pictures meant nothing, said nothing, and he himself had nothing to say. Bacon believed that painting was the pattern of one's nervous system projected on the canvas. He claimed he wished to "paint like Diego Velázquez but with the texture of a hippopotamus skin," achieving the tonal subtly inspired by the Spanish master who encompassed the rough, grainy immediacy of a news photo. He sought to exalt the immediacy of camera vision in oil, like a portrait in the grand European manner.

23. What is the role of critics and critique?

"Unless you are one critic in a hundred thousand," wrote the critic and teacher Randall Jarrell, "the future will quote you only as an example of the normal error of the past." The real importance of criticism is for the sake of the work that it criticizes. Good critics do not set up rigid agendas and templates or try to impose their own prescriptive notions, but allow the work and the experience of it to set the general expectations to which the criticism conforms. The only thing we know about the future is that it is not what we think it will be, and therefore we should try to remain open to forthcoming possibilities.

24. What is the role of theory in relation to contemporary photography?

It is a matter of perspective and priority. Do you want to be concerned with the object of study or with constructing a cohesive conceptual system? At its best, postmodernism's agenda of inclusion creates a permissive attitude toward a wide range of interpretive possibilities. At its worst, it encourages a nihilistic solipsism where all expression resides in an undecidable haze of indeterminate value. As a student, one does not expect to learn and unlearn photography all at once, but regardless of one's personal inclinations, one should become informed about past and present artistic theory, from John Ruskin to Jacques Derrida.

25. What do good teachers teach?

Good teachers instill a sense of responsibility, generosity, and discipline. They encourage students to be curiously critical, to find the means to accomplish their goals by working autonomously, and to be respectful of others with the goal of building a practice.

26. How do photographers earn a living?

Living as an artist depends on what you want to do and how much money you require. Less than 1 percent of artists can live on what they earn from their artwork. Do not expect to get a full-time teaching job in higher education even if you are willing to work for years as an adjunct faculty member at numerous institutions. However, there are career opportunities in arts and cultural organizations as well as in primary and secondary education. Take advantage of being a student to do an internship that will give you first-hand experience in an area you would like to work within. Successful internships can lead to entry-level jobs. The visual arts community is still a relatively small field. Hard work and networking skills can benefit you and the organization that you serve in terms of letters of reference and bridges to your future that are at present unimaginable (see Addendum II Careers).

27. Which equipment is the best?

It doesn't matter. Every camera is fine; it's how you use it. Travel photographer Peter Adams said, "Photography is not about cameras, gadgets and gismos. Photography is about photographers. A camera didn't make a great picture any more than a typewriter wrote a great novel."

28. Can creative efforts in other fields inspire your work? Absolutely. Einstein was fascinated by Mozart and sensed an affinity between their creative processes, as well as their personal histories. As a boy, Einstein was a poor student and music provided outlet for his emotions. At 13, he discovered Mozart's sonatas and the result was an almost mystical connection. He played the violin with passion and often performed at musical evenings. He also empathized with Mozart's ability to continue to compose magnificent music even in very difficult and impoverished conditions. In 1905, the year he discovered relativity, Einstein was living in a cramped apartment and dealing with a difficult marriage and money troubles. That spring he wrote four papers that changed the world. His ideas on space and time came in part from aesthetic discontent. It seemed to him that asymmetries in physics concealed essential beauties of nature; existing theories lacked the "architecture" and "inner unity" he found in the music of Bach and Mozart. In his struggles with the complex mathematics that led to the general theory of relativity of 1915, Einstein often turned to Mozart's music for inspiration. Scientists have described general relativity as the most beautiful theory ever formulated, and Einstein himself emphasized the theory's beauty. The theory is basically a personalized view of how the universe ought to be. Amazingly, the universe turned out to be more or less as Einstein imagined and revealed spectacular and unexpected phenomena such as black holes. What more could any artist ask for?

29. Now it is your turn. Add a question and answer to this list.

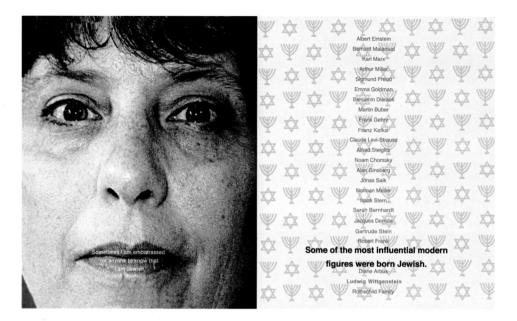

1.22 "Due to the current tensions in the Middle East and my cultural background, I was moved to make a limited edition book probing the relationship of personal history to political issues. I work on books rather organically; that is, I get an idea and make a loose mock-up based on the information and pictures I gather. I constantly change pages as I create the book. Using a computer is particularly advantageous for this methodology, as I can virtually collage, move, alter the size or re-do both text and images with relative speed. I have used family photos, historical images, web pictures, and objects placed on a scanner to create the digitized imagery, which I have altered in size, color, cropping, and detail, either at the point of scanning or while using Photoshop before printing." Text in left panel reads: "Sometimes I am embarrassed for anyone to know that I am Jewish." Text in right panel reads: "Some of the most influential modern figures were born Jewish: Albert Einstein, Bernard Malamud, Karl Marx, Arthur Miller, Sigmund Freud, Emma Goldman, Benjamin Disraeli, Martin Buber, Frank Gehry, Franz Kafka, Claude Levi-Strauss, Alfred Stieglitz, Noam Chomsky, Allen Ginsberg, Jonas Salk, Norman Mailer, Isaak Stern, Sarah Bernhard, Jacques Derrida, Gertrude Stein, Robert Frank, Diane Arbus, Ludwig Wittgenstein, Rothschild Family.

© Laura Blacklow. Confessions of a Jew, Double Page (from artist book by the same title), 2003/04. 6-1/2 × 5-1/2 inches. Inkjet prints.

Additional Information

- Adams, Ansel. *The New Ansel Adams Photography Series*. Boston: Little, Brown, 1981.
- Adams, Robert. Why We Photograph: Selected Essays and Reviews. New York: Aperture, 1994.
- Beckley, Bill (ed.) with David Shapiro. Uncontrollable Beauty: Toward a New Aesthetic. New York: Allworth Press, 1998.
- Davis, Keith. An American Century of Photography: From Dry-Plate to Digital. The Hallmark Photographic Collection, Second Edition, Revised and Enlarged. Kansas City, MO: Hallmark Cards in Association with Harry N. Abrams, 1999.
- Frizot, Michel (ed.). A New History of Photography (English version). Cologne: Könemann, 1998.
- Gardner, Howard. The Disciplined Mind: What All Students Should Understand. New York: Simon and Schuster, 1999.
- Hirsch, Robert. *Seizing the Light: A History of Photography*. New York: McGraw-Hill, 2000.
- Newhall, Beaumont. *The History of Photography From 1839 to the Present*. Museum of Modern Art: New York, 1982.
- Rosenblum, Naomi. A World History of Photography. Third Edition. New York: Abbeville Press, 1997.
- Stiles, Kristine, and Peter Selz (eds.). *Theories and Documents of Contemporary Art: A Sourcebook of Artists'* Writings. Berkeley and Los Angeles: University of California Press, 1996.
- Szarkowski, John. Looking at Photographs: 100 Pictures from the Collection of the Museum of Modern Art. New York: The Museum of Modern Art, 1973.
- Warner Marien, Mary. *Photography: A Cultural History*. Second Edition. New York: Prentice Hall, 2006.

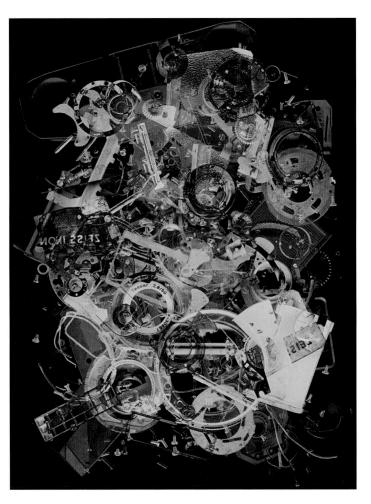

1.23 © Evan Lee. Every Part from a Contaflex Camera, Disassembled by the Artist During Winter, 1998. 2006. 50 × 38 inches. Inkjet print. Courtesy of Monte Clark Gallery, Vancouver/Toronto.

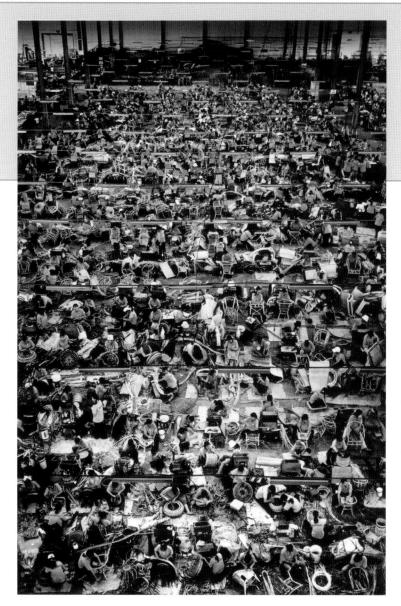

Gursky's big, bold, colorful images, often made from a high viewpoint, are extraordinarily precise and rich in detail. This gives his works a highly textured feel while revealing an internal geometry of the subject. His choice of subject matter favors late capitalist society and systems that include enormous industrial plants, apartment buildings, hotels, office buildings, and warehouses, which minimize the importance of the individual. Gursky makes no pretense about objectivity. He digitally manipulates his images — combining discrete views of the same subject, deleting extraneous details, enhancing colors — to create a kind of "assisted realism," making him a leading representative of our contemporary Zeitgeist by the art establishment.

 \odot Andreas Gursky. *Nha Trang, Vietnam,* 2004. 116 × 81-1/2 inches. Courtesy of Matthew Marks Gallery, New York, VG Bild-Kunst, Bonn, and Artists Right Society (ARS).

Chapter 2

Design: Visual Foundations

LEARNING TO SEE: COMMUNICATING WITH DESIGN

When it comes to photographic imagemaking, people have plenty of questions about cameras but don't often ask about how best to accomplish their visual goals. What determines the success of an image is not the camera, but the knowledge of the person operating the camera. The principal job of a photographer is looking, which defines all photographic processes. Good photographs are made by learning to see. Good photographers become skilled at following their eyes and seeing things others overlook. Imagemaking is 10 percent what we encounter and 90 percent how we respond. A good photograph creates a memory in a viewer by communicating an experience to another. Good images are powerful shaping tools that don't just communicate facts, but create facts by generating their own history — past, present, and future — that can stand alone as a statement. Good

photographers organize and synchronize their visual material by managing the visual disorder within the confines of the photographic space. The arrangement of objects within a pictorial space determines the degree to which a photograph communicates. Visual order revolves around understanding composition, which Edward Weston said "is the strongest way of seeing" a subject. The foundation of composition is the design process.

BEGINNER'S MIND

Beginner's mind is a Zen Buddhist concept that refers to maintaining an attitude of openness, eagerness, and lack of preconceptions when studying a subject, even at an advanced level. The phrase was also the title of Zen teacher Shunryu Suzuki's book, *Zen Mind*, *Beginner's Mind* (1970), which reflects his saying: "In the beginner's mind there are many possibilities, in the expert's mind there are few." Make the

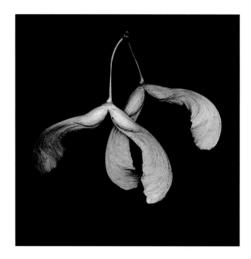

2.1 "These pieces were inspired by the idea of creating a new kind of icon; one that is not manufactured due to a religious or moral construct, but rather one that celebrates the simplicity of the here-and-now of nature. The surprising visual power behind their elegant simplicity transforms the natural objects into metaphors. I see these objects both taxonomically, displaying the beauty of the natural form, as well as metaphorically, describing what else the natural form can signify. To make these images, I replaced the lid of the scanner with a piece of black felt and then arranged the object underneath the tent of felt, directly onto the glass of the scanner. The felt absorbs extraneous room light so the only light to reach the object is from the scanner itself."

© Marie R. Kennedy. Couple, 2006. 20 × 20 inches. Inkjet print.

most of the innocence and simplicity of the first inquiry when one's mind is ready to accept and to doubt and is open to all possibilities. It allows you the chance to see things as they are and intuitively realize the core nature of what you are observing, thereby providing an excellent point of departure. Take advantage of digital imaging's instantaneousness to capture your first responses to a subject, but don't hesitate to rephotograph or rescan after studying your first results.

THE DESIGN PROCESS

Design involves all the visual elements that make up a composition. The design process is the act of organizing all these parts into a coherent whole for a specific purpose. A good photographic image is an extension of the photographer and creates a response in a viewer. A good photograph engages and sustains a viewer's attention and elicits a response. When these criteria are met, the design can be considered effective. The making of effective photographs can be enhanced by first understanding the nature of the photographic process. Design is like a muscle; it swells, strengthens, and becomes more flexible with exercise.

THE NATURE OF PHOTOGRAPHY: SUBTRACTIVE COMPOSITION

Making camera photographs involves the practice of subtractive thinking. Anything touched by light can be photographed; thus the camera is an arbitrary and indiscriminate instrument. This leads many beginners to overcrowd their pictorial space with too much information. This can generate a visual chaos in which the idea and motivation behind the pictures gets lost. The critical power of a photographer is in choosing of what to leave out of a picture. Photographer Ray Metzker said, "The camera is nothing but a vacuum cleaner picking up everything within range. There has to be a higher degree of selectivity." In the act of making photographs, selectivity is all. Since the camera makes no objections or judgments about what it records, it is the photographer who creates the reality, making all photographs simultaneously true and false.

Use subtractive composition by going directly for what you want to include in the picture and subtracting all that is not necessary, even if it means eliminating elements that interest you. Concentrate on communicating one thing well while bearing in mind the idiom: "Keep your eye on the prize." Stay focused. Don't get distracted by other pretty bits of information in the scene. Compositions suffer when you dilute your message with unneeded visual distractions. Eliminate visual clutter. Concentrate on communicating one thought by having a point of departure. Instead of trying to make a picture that communicates three ideas, make three images that each communicates a single concept.

This subtractive method of putting the picture together can help you learn the basic visual vocabulary, which leads to producing images you desire. A good photographer is like a magician who knows how to make all the unwanted objects on stage disappear, leaving only what is necessary to create striking images. Do not assume everything that happens to you is going to be interesting to someone else. Selectivity also applies to the ideas that make up your pictures. Some ideas are better than others. Ansel Adams said, "There is nothing worse than a sharp image of a fuzzy concept." Simplify, simplify, simplify. Imagine being a sculptor of images who chips away at a monolithic block of reality until only what is absolutely necessary remains and then relies on each viewer to fill in the missing pieces to complete the meaning. When you compose, fill your frame by getting close to what is most important to you. Compositions are weakened when important subject matter is too small for viewers to see. Think about what photojournalist Robert Capa said: "If your pictures aren't good enough, you aren't close enough."

DEPARTURE POINT

Think about what you want to do before you do it. When you pick up a camera to do something deliberate and specific, the possibility of capturing the significant and the useful is greater than if you stand on the corner hoping and waiting for something to occur. Avoid being the photographer Irish playwright George Bernard Shaw described, who, like a codfish, lays a million eggs in the hope that one might hatch. Prepare your mind in advance and start in a specific direction, but remain flexible and open to the unexpected. Look for the fortune cookie that reads: "Intelligence is the door to freedom and alert attention is the mother of intelligence."

ATTENTION SPAN AND STAYING POWER

Before satellite radio, cell phones, giant screen televisions, the Internet, and iPods, educated people devoted time to read books — long and complicated books such as Adam Smith's 900-page tome, *The Wealth of Nations*, which revolutionized economic thought and theory when it was published in 1776. That is no longer the case. In our media-saturated climate, imagemakers compete in a no-time mentality of multitasking and channel surfing. This makes it critical for imagemakers not only to initially grab viewers' attention, but to keep it as long as possible by producing work that continues to say something over time. Photographic staying power has almost nothing to do with the technical means of producing a photograph, for the truth is found in how we visually express our thoughts and feelings about

2.2 Stone's departure point is "starting conversations with strangers to satisfy my curiosity and to accumulate images." When seen in a grouping Stone's images become a map of himself that ironically reflects the larger sociological matter of intent versus actual achievement.

© Jim Stone. Frank's Awesome Tie Dye, Pineville, Missouri, 2002. 24 × 30 inches. Inkjet print.

a subject. When the expression of something of significance is communicated, an image can be said to possess meaning.

PHOTOGRAPHY'S PRIVILEGE

Photography is omnipresent in our society, so when you go out with a camera people will often give you a unique privilege, some leeway,

2.3 In this series, a response to the Boom and Bust Nevada lifestyle as seen from the viewpoint of roadside venues erected during the 1940s–late 1950s, Lauritzen uses color and juxtaposition to catch and hold viewer attention. "People drove across Nevada at night due to the heat and no air conditioning in most cars. In response to this mass relocation west, small way stations were built, with the necessities for getting across the Nevada deserts. This was the BOOM of Nevada's roadside commerce. Then, in the mid 1960's: BUST! The Interstates arrived and the way stations 'just up and left' — their owners leaving everything behind to rush to their next hopeful strike. Nevada inhabitants live and work on tenuous foundations. We are a State truly on wheels, always looking for and then moving to the next Boom!"

© Erik Lauritzen. *Green Bug*, from the series *Stop the Car Dad*, 2005. 16 × 20 inches. Inkjet print.

in that they too have directly experienced the photographic process. Learn to use this shared understanding to your advantage, not as an excuse for irresponsible or unethical behavior, but to make the images you want to make without exploiting the subject. With the appropriate approach, you can get people to act in your picture, to get out of your picture, to hold equipment, or to just leave you alone. It all depends on the attitude that you project to others and your interpersonal skills in getting people to cooperate.

THE LANGUAGE OF VISION

In ancient Greece, Socrates spoke of the eternally beautiful geometric forms. Over time these forms have codified into an analytical system that has tremendously influenced imagemaking. This language of vision utilizes light, color, contrast, line, shape, pattern, texture, similarity, and movement. Through these formal visual elements, one can make images that convey and enlarge our ideas of what is worth looking at, what we have the right to observe and make pictures of, and how we interpret pictures. Photographic imagemaking can transform any object and make it part of our experience by changing it into something that can be fixed and studied later at your convenience. Influential photographers understand the visual process and its tools, allowing them to express the ideas and stories that resonate in their time. Photographers with vision push out the boundaries of the language, invent new means for the rest of us to use, and create images that affect how we know the world.

The design principles, such as variety, scale, balance, and emphasis, control the representation of the overall structure of any composition. The visual elements such as line, shape, color, and texture organize and embody the detail and content within the structure.

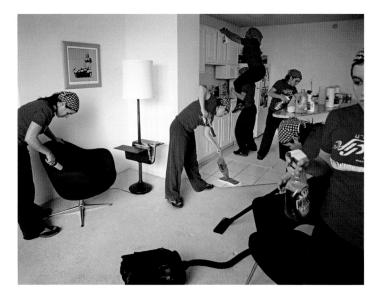

2.4 "I begin by selecting a subject, and spend time with him or her — asking about their job, and watching them work. After collecting information about the scenario for the photograph, I set up the camera and begin to direct the person throughout the space, asking them to act as if they were actually working while striving to find a balance between humor and esteem. The rhythm that results from hours of contemplation while constructing an image in Photoshop has shown me that the process of actually taking the picture is only the beginning: gathering components you might say. Digital technology offers me an opportunity to fine tune and perfect my images so that they most successfully convey the idea I want to communicate, and this has become an indispensable aspect of my work."

© Nathan Baker. *Maid Service*, 2003. 40 × 50 inches. Inkjet print. Courtesy of Schneider Gallery, Chicago and Robert Koch Gallery, San Francisco.

37

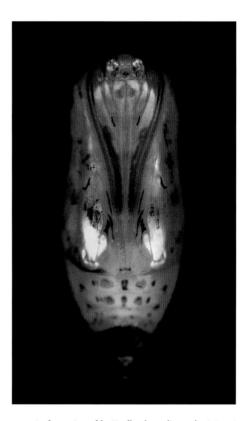

2.5 This image, part of a series of butterfly chrysalises, depicts actual metamorphoses. Fuss's detailed chrysalises, magnified hundreds of times and presented vertically on velvety black backgrounds, appear more extraterrestrial than butterfly-like. The delicacy and fragility of the encased body are distinctly present. Fuss's solemn and darkly luminous, human-sized blow-ups of butterfly chrysalides call to mind a sarcophagus while showing us a moment just before a new kind of life begins. His unspoken subject has been called the evolution of the human soul, a watcher who experiences our singular lives, from whom meaning emanates, and from whom we perceive our true self.

 ${}^{\odot}$ Adam Fuss. Untilled, 2003. 72 \times 44 inches. Inkjet print. Courtesy of Cheim & Read, New York.

Together, these principles and elements provide the basic tool set that needs to be mastered to communicate photographically.

PHOTOGRAPHY'S NATIVE CHARACTERISTICS

Theoretically, a "line is a line" regardless of the medium, but a line painted on canvas is different from a line made photographically. Why? Any visual element photographically represented has more inherent real-world content because of its foothold in concrete reality. Imagine the world before photography. In her book Photography and Society (1974), photographer Giselle Freund observed, "Before the first press pictures, the ordinary man would visualize only those events that took place near him, on his street or in his village. Photography opened a window. As the reader's outlook expanded, the world began to shrink." Even if the subject is unfamiliar, the visual language of photography and its connection to reality is immediately recognizable. Therefore, a line created by a street curb in a photograph creates a much different meaning from a line painted on canvas because of all its real-world associations. One is not better or worse than the other, but they are different. It is this intrinsic difference that imagemakers must come to terms with and understand to succeed photographically. One should keep inquiring into photography's native characteristics and how its direct, realistic connection between the subject being pictured and the resulting image can be applied to achieve one's desired outcome. Try dipping into the history of photography to compare and contrast how important imagemakers such as modernist Paul Strand and constructivist Aleksandr Rodchenko had highly divergent ideas about how to organize their visual space.

2.6 "The photographs in *NextNature* are inextricably linked to the plants and forests from which they came. I present these materials life size, emphasizing the primary physical reality in a format that references the magnitude of the forest floor. The works are composed on a large lightbox and then photographed straight down using a high-resolution scanning back in the place of film, enabling me to show an astonishing visual clarity at large scale. This allows me to make images that are less metaphorical in their representation and more direct, which in turn supports a sense of 'matter-of-fact-ness' in the work."

© Stephen Galloway. *Scatter* from the series *NextNature*, 2004. 40 × 76-1/4 inches. Chromogenic color print.

DESIGN PRINCIPLES

Unity and Variety

Unity and variety are visual twins. Unity, also known as harmony, is a state of forming a complete, consistent, and pleasing whole that is planned and controlled by the imagemaker. Variety refers to a similar class of subject that is somehow diverse or different. A composition devoid of a unifying principle will generate a chaotic or haphazard response to what has been photographically represented. A completely unified composition without variety is often boring and monotonous. Unity controls variety, but variety provides the diverse visual pull within unity that keeps things visually intriguing. Effective compositions usually have a balance between these two qualities — a variety of elements held together by a unifying device.

The repetition of pattern, shape, or size plus the harmony of color and texture are visual ways of creating unity. The more complex

a composition is, the greater the need for a unifying device. A more subtle method is continuation, such as when a line or the edge of an object leads a viewer's attention from one area of a composition to another. Consider a checkerboard pattern or grid that is completely unified and therefore static. Vary the color, size, or texture of the pattern and it immediately becomes dynamic. In photography, contrast is a major method of controlling variety — light against dark, large against small, smooth against rough, hard against soft. Dramatic lighting, known as *chiaroscuro*, emphasizes these contrasting gradations of light and dark values in two-dimensional imagery, while soft lighting minimizes these differences.

Emphasis

Most photographs need a focal point or points to provide visual emphasis. These are elements that attract the eye and act as a visual climax, stressing a key point or points within the composition.

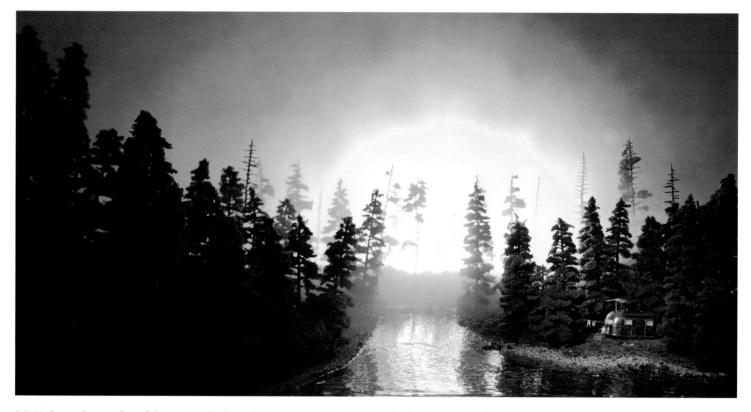

2.7 "I play on the nostalgia of the romantic landscape tradition, suggesting that the natural environment is rife with hidden dangers. At first glimpse, the mundane image appears little more than the quotidian photograph. Upon further examination, something seems amiss. These are not real landscapes but miniature recreations of real-life situations. Here a sweet little trailer is in the path of an oncoming wildfire, its inhabitants too preoccupied watching their TV to notice." The glowing warm colors and their association with beautiful sunsets draw the viewer's eye into the composition, only to discover that what is being depicted is the awesome destructive power of a fire.

© Laurie Nix. California Fire, 2002. 40 × 70 inches. Chromogenic color print. Courtesy of Miller Block Gallery, Boston.

40

2.8 By building scale models and casting himself as all the characters, Adams fabricated an elaborate parody of a grandiose political poster, featuring a mixture of clashing political and artistic themes and styles. "Rather than cover up or reject the influence of digital imaging, I suggest digital manipulation that was not done. Instead of a fake photograph of a real scene, it's a real photograph of a fake scene [made with an 8×10 inch view camera], in which authenticity, illusion, and apparent digital manipulation create a maze of puzzles and paradoxes. There are often clues to the illusions, such as reflections of the backs of cardboard characters and extra figures lying around the set. But their being dubious documents of illusions is fully in keeping with the other contradictions and deceptions in the piece."

© Bill Adams. Billboard 2006, 2006. 29 × 32 inches. Chromogenic color print.

Without emphasis, your eye tends to wander and is never satiated. Focal point devices to keep in mind are color, contrast, depth of field, isolation, light, placement, perspective, and size. One is often played off against another; for example, a limited depth of field may be used to isolate the primary subject. Secondary points of interest, known as *accents*, can direct the eye to parts of a composition that have less visual value than the primary focal point, but are still important for understanding the work. Yet sometimes an imagemaker will purposely create an ambiguous composition without a single focal point by deploying a multiplicity of points; this draws attention to the entire surface of the work instead of its individual elements.

Scale

Scale and proportion are interrelated and both refer to size. Scale indicates relative size or extent in comparison to a constant standard, that is, relative to the size something "ought to be." By showing objects larger or smaller than normal, a viewer is made to see the

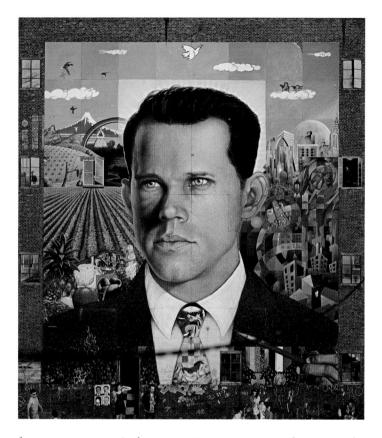

form in a new way. Such juxtapositions encourage audiences to take a fresh look at the subject. A classic example is the *diminutive effect*, which is visible when a human figure is arranged in conjunction with a massive natural or human-made site such as the Grand Canyon or a Gothic cathedral. Dadaist and surrealist artists often employed scale as a way to make the familiar strange and the strange familiar. Varying the focal length of your lens is a good initial way to experiment with scale.

Proportion

Proportion involves the relationship in size or shape between one thing and another or between the parts of a whole within a composition. Shapes are proportional to the area they occupy within the composition. Proportion is linked to ratio. The proportions of a subject are considered correct or normal if the ratio of one component to another is acceptable. For example, when making a portrait, if the circle formed by the head is 3 inches in diameter on a 6-inch background, it will be more disproportional than if it were placed on a 12-inch background. Correct proportion is generally based on what society considers real, normal, or ideal and can change from one generation to the next.

The Golden Mean

The ancient Greeks developed a set of ideal proportions called the Golden Mean, which they converted into ratios that could be applied to draw the perfect body or build the perfect architectural structure. The Golden Mean, AKA the Rule of Thirds is the proportion arising from the division of a straight line into two, so that the ratio of the whole line to the larger part is exactly the same as the ratio of the larger part to the smaller part. Mathematically, it is a ratio of 1 to 1/2 $(\sqrt{5} + 1)$, a proportion that is considered to be particularly pleasing to the eye and can be found in natural growth patterns in nature. Its modular repetition has facilitated its use throughout the history of design. The Golden Mean can be a good starting point, but just because something is disproportional to a subjective ideal does not make it flawed. On the contrary, uniqueness is often attention getting. This means that deliberately changing a composition's proportions can be a good method for creating impact. The position of the camera and the distance of the subject from the lens are the easiest ways to

2.9 In a makeshift studio, Goldberg formally photographed members of the Dallas Cowboys during training camp. By posing the subject with his muscular legs in the foreground, Goldberg was able to make use of our innate sense of human proportion to generate viewer interest while conveying a sense of strength and athleticism.

Gary Goldberg. Ebenezer Ekuban, from the series Dallas Cowboys, 2000. 18×12 inches. Inkjet print.

manipulate proportion. Digital imaging software allows for extensive post-camera modifications to be made in the areas of proportion and scale. All these factors control how the meaning is constructed. Garry Winogrand observed, "Photography is about finding out what can

42 0

EXERCISE The Golden Mean: A Basic Approach to Good Composition

To concentrate more fully on the frames and its edges, we are going take on an assignment developed by Graham Revell at Cavendish College, London, and Betsy Schneider of Arizona State University which sets aside usual subject matter and instead concentrates on detritus. Detritus, from Latin detritus, from deterere "wear away," is any matter produced by erosion, such as gravel, sand, silt, or rock. It also refers to debris or waste of any kind; rubbish, litter, scrap, flotsam and jetsam, rubble; remains, remnants, fragments, scraps, dregs, leavings, sweepings, dross, scum, trash, and garbage; plus organic matter produced by the decomposition of organisms. For this assignment, you are to interpret the word detritus and make photographs following the steps below. You can be literal or metaphorical in your interpretation.

- Build an image using the principle of the Golden Mean, a rectangle whose dimensions are 1 unit × 1.62 units. If your camera permits, set its framing aspect ratio to 1 × 1.5. The aspect ratio is the relationship of the frame's width to its height. The traditional 35mm aspect ratio is about 3 units wide × 2 units high.
- 2. Use the grid pattern in your camera's viewfinder to divide your frame into thirds, which will aid in locating the "sweet spots" in which to place your center of interest. Do not divide the frame into four equal quarters as this tends to produce static compositions. Steer clear of placing your principal point of interest in the dead center of the frame.

- 3. Intentionally lead your viewer's eye through the frame by supplying a visual path that leads a viewer to your center of interest. Use a shape such as a diamond, oval, or pentagon to make your path. Make your path link the top, bottom, and sides of your composition, and provide an entrance to and an exit from the picture space. Traditionally, the entrance is at the bottom of the picture. The exit is usually an area that is less visually important. A door, window, or patch of sky can give a viewer's eye a place to stop and rest; providing a subtle exit. If your path begins to lead your eye out of the frame, adjust it, using other design elements to lead the viewers' eye back to your path.
- 4. Simplify. Eliminate details that complicate your composition. Delete anything that does not express your message clearly and concisely. Keep modifying, combining, and deleting until you are satisfied.
- 5. Pay attention to the figure/ground relationships by bringing the positive and negative space into balance.

Keep in mind that Western societies read from left to right, which tends to make the left side of the frame more prominent than the right. We also read from top to bottom, making the top of the frame more noticeable than the bottom. The corners of a rectangle act as visual anchors, which is why book page numbers are traditionally found in the lower left and right corners. The center of

Exercise

The Golden Mean: A Basic Approach to Good Composition—continued

the frame does not necessarily have the importance that many take for granted, especially in a printed format where the center is the gutter.

6. Do the opposite. Now that you have tried this exercise, reverse all the instructions and compare and contrast the results. Apply your findings to your next picture-making opportunity. Educator Joseph Labate of the University of Arizona takes this a step further by having his students intentionally make "bad" and "good" photographs that are technically the same, and then has the class analyze the differences.

happen in the frame. When you put four edges around some facts, you change those facts."

Balance

Balance is the visual weight or equilibrium of the objects within a composition. Balance is instinctive and determined by imagining a center axis running through the picture plane with the expectation that there will be some equal distribution of visual weight on either side. Think of the axis as a fulcrum on a seesaw, where it is necessary to maintain equilibrium or crash to the ground. Perfectly balanced pictures tend to be boring, so it is usually helpful to have a certain degree of imbalance to generate visual tension and movement within a composition. Some key categories of balance to consider are:

• Asymmetrical balance: A composition that has equal visual weights, but whose forms are disposed unevenly. For instance, a smaller shape positioned near the composition's outer edge

may balance a large shape near the center of a composition. Asymmetrical balance is active, dynamic, and exciting.

- *Symmetrical balance:* If you were to draw a line through the center of this type of composition, both sides will be an equal mirror image. Symmetrical balance tends to be calm, dignified, and stable.
- *Radial balance:* This occurs when a number of elements point outward from a central hub, such as the spokes of a bicycle wheel. It is readily seen in nature, such as in snowflakes and the outward growth pattern of flowers. Radial balance can be explosive, imply directional movement, and indicate infinity. It can often be revealed photographically through the use of close-ups.
- *Balance through color and value:* The weight of a color can become the focal point in a picture. Warm colors (red, magenta, yellow) tend to advance and/or have more visual weight than cool colors (blue, green, cyan). The majority of a landscape is composed of

2.10 In the spirit of Man Ray's surrealistic photograms, Tarver set out to create images to evoke spacescapes that could have been captured from the Hubble space telescope. "I am intrigued by the idea of creating universes from tiny objects or in the words of poet William Blake, 'See a world in a grain of sand... and hold infinity in the palm of your hand.' " To realize his goal, Tarver scanned detritus, transforming "grains of sand into stars, seashells into swirling galaxies, and blueberries into planets."

@ Ron Tarver. Dual Galaxies, 2006. 13 \times 12 inches. Inkjet print. Courtesy of Sande Webster Gallery, Philadelphia.

2.11 "Placement of the image frame is the most important factor in the creation of an image; every image involves elimination [subtractive composition] to one degree or another. Most of my images are hyperconscious of the border. The border defines the images; I use it to control the visual flow in an image. I'm drawn to images that suggest the spaces that exist beyond them. In this image the mountains at the horizon were digitally eliminated by replacing them with sky, which allows the recession of space to continue indefinitely. Cracks in the earth were digitally eliminated to form the path that delivers a sense that what is left unseen is greater than what is seen."

John Paul Caponigro. Path, I, 1999. Variable dimensions. Inkjet print.

cool colors. Warm colors appear mainly as accents (birds and flowers). A small amount of red can be equal to a large area of blue or green. Much of the landscape in the American West is an exception. There are few trees and the predominant colors are the warm earth tones. During fair weather daylight hours, the amount of a cool color can be regulated by varying the proportion of sky included in the frame. The time of day and weather conditions also affect the amount of cool and warm colors, as the color of the light changes.

- *Balance through contrasts in value:* The contrast between dark and light also provides a resting point for the eye. A darker, smaller subject will have the visual weight of a lighter, darker one. Since a black subject against white background generates a stronger contrast than gray against white, a smaller amount of black is necessary to visually balance a larger amount of gray.
- *Balance with texture:* Any visual texture possessing a varied dark and light pattern has more visual attraction and weight than a smooth untextured one; thus, a small textured area can balance a large area of smooth surfaces.

EXERCISE

Balance

Once you have familiarized yourself with these categories of balance, conduct some personal tests by making different horizontal and vertical compositions of a static scene and reviewing them on your camera monitor to see which one delivers the results you are after.

Rhythm

Rhythm is a strong, regular, repeated pattern that forms a harmonious sequence or correlation of colors or elements, which usually develops from organizing the space between objects. This rhythmic flow, which is accomplished by repetition, acts as a unifying device for the composition and is often used to suggest movement. Alteration of large and small areas of negative (dark) space within a composition generates this sense of motion.

- *Alternating rhythm:* This sense of rhythm consists of successive patterns in which the same elements reappear in a regular order. A common example of this alternating theme can be seen in the columns of a classic Greek temple. Photographically, alternating light against dark areas or using complementary colors, such as green and red, is a way to create this effect.
- *Progressive rhythm:* This is produced through the repetition of a shape that changes in a regular manner, generating a sequential pattern. It is frequently accomplished with a progressive variation of the size of a shape, through its color, value, and/or texture.

VISUAL ELEMENTS

Once you comprehend the basic design principles and overall structure, you are ready to make use of the visual elements within this construct.

Line

Lines, per se, do not exist in nature. A line is a human abstraction invented for the simplification of visual statements to symbolize ideas.

2.12 Utilizing both pre- and post-capture methods, a zoom lens, and the Photoshop crop tool, Abrams eliminated visual distractions so the rhythm that attracted him to the scene could be captured and communicated. In addition, he selectively darkened and sharpened the image to further emphasize the repetition and symmetrical rhythm in the boats.

© Terry Abrams. Fishing Boats, Morocco, 2005. 15 × 20 inches. Inkjet print.

Nature contains mass (three-dimensional form), which is portrayed photographically by the use of line as contour (a line that creates a boundary and separates an area of space from its background). A line carves out areas of space on either side of it. Any line, except one that is straight, creates and describes a shape. Closing a line creates a shape.

The direction of a person's gaze or gesture can suggest a line. A line can also be implied by positioning a sequence of visual points

2.13 "Bushwick is a neighborhood about to end. Founded in 1638 by the Dutch who bought it from the Canarsie Indians, today Bushwick is being actively redrawn by real estate agents intent on changing its Hispano-American make-up into a place with luxurious lofts and upscale restaurants and shops. While this is a great for the economy and the face of the neighborhood, it isn't so great for those who live here now and have fought to create a safe environment in a place formerly renowned for its danger and violence. To realize this image I choose my camera's Vivid option, which enhances saturation, contrast, and sharpness to produce vibrant images with intense red, green, and blues to highlight the lines that represent the dynamic life spirit of the current residents."

© Samantha Casolari. Bushwick Series VII, 2006. 11 × 14 inches. Inkjet print.

for the eye to automatically or subconsciously connect. Psychic lines occur when we forge a mental connection between two points; usually when an object looks or points in a particular direction, our eyes will follow and draw an invisible line. Digital software allows imagemakers to alter the quality of lines, rough and smooth, thick and thin, to reinforce emotional and/or expressive qualities in the final composition.

Lines can be flowing, majestic, or undulating. Lines can convey abstract or symbolic concepts. They can show you contour, emphasis, form, pattern, texture, and directional movement. The direction of lines can also reinforce the mood of a picture. Horizontal lines can express calmness, dignity, and magnificence, implying repose and stability. Vertical lines indicate an up and down flow that implies a smooth and continuous motion. Commonly, diagonal lines are made up of objects or shapes that fit into a pattern. Learn to look for these patterns and incorporate them into your composition. Diagonal lines, being neither horizontal nor vertical, are placed at angles within a composition. They are dynamic and indicate action, energy, and movement.

Shape

A closed line creates a shape, which is an area having a specific character defined by an outline, contrast, color, value, or texture that is different from the surrounding area. It is often the chief structural compositional element, as it enables a viewer to immediately recognize a face, a structure, or an object in a picture. Shape usually refers to flat, two-dimensional elements, while mass or volume indicates three-dimensional objects. The shape of such objects as rocks and seashells can themselves be intriguing. A combination of different shapes can provide variety. For example, an outdoor scene can be made more attention-grabbing by contrasting the sharp, jagged shape of a fence with the soft, smooth curves of clouds and hills. Shape can be used to create a frame around a subject. For instance, if a photographer composes a picture of a person in a doorway, the doorway serves as a natural frame that directs the viewer's eye to the person. Interplay between shapes can form repetitive patterns that help unify a composition. The shapes of shadows or silhouettes can create fascinating effects. Shapes also play a role in producing visual texture, as they help create the illusion of physical, three-dimensional surface qualities.

There are four basic shapes:

- **1.** Geometric shapes include the circle, rectangle, square, and triangle.
- **2.** Natural shapes imitate things in the natural world: animal, human, and plant.
- **3.** Abstract shapes are shapes that have been altered to reduce them to their fundamental essence. Natural sources for abstract shapes are often recognizable, even when they have been simplified and transformed by omitting non-essential elements. Artificial sources can be intriguing and mysterious, as viewers must work to discover meaning where there is no obvious narrative.
- **4.** Nonobjective shapes do not correspond to anything in the natural world. Usually, we cannot put specific names on these pure forms. These original shapes primarily delight the eyes and the emotions, but not the intellect, for they do not convey traditional storytelling narratives. They represent the intuitive and the subjective, not the empirical and the rational part of our being and may connect with our innate urge to form connections with other objects and experiences.

2.14 "Using a macro lens, I capture microcosms of the organic world but depict them as macrocosms that are at once alive and not alive. My objective is to produce images that have no obvious or discoverable precedents in art yet have the intensity of realistic depictions of both the ordinary events of everyday life and powerful experiences like birth and death. Having no narrative content to present and no concepts to illustrate, the work leaves viewers free to interpret the images as they wish, without restraint."

© Ethan Boisvert. Zipper, 2006. 24 × 16 inches. Inkjet print.

Space

Space is the area between and surrounding the objects in an image. Space can be used to draw attention to the main subject, to isolate details, and to establish meaning. However, large amounts of space may detract from a picture's compositional focus. As a starting guideline, limit the amount of blank space to no more than a third of the photograph. As you gain experience, experiment with this ratio, even to the point where the blank space is the most predominant element of the composition (see Figure 2.15). The appropriate placement of a subject within a picture space can help to convey scale. For instance, placing a small subject next to a large subject can help a viewer gauge their relative size.

There are four kinds of photographic space:

- **1.** Actual space is the two-dimensional area enclosed by the borders of the camera's viewfinder and the surface on which the image later appears. Three-dimensional spaces are inside and around or within an object.
- **2.** Pictorial space is the illusionary sense of depth that we see in two-dimensional work such as photography. It can vary from appearing perfectly flat to receding into infinity.
- **3.** Virtual space exists within the confines of a computer screen. It may or may not exist in any concrete form. It may be manipulated: compressed, stretched, and/or rearranged differently from how the camera initially recorded the scene(s).
- **4.** Positive and negative space refers to how dark/black areas and light/white objects can be used to organize and define

2.15 These images were made by scanning well-known, historical photographs from textbooks and then digitally removing all information except the solitary individual, who becomes the sole occupant of the visual space "isolated from her/his context and any intended meaning. These anonymous people may be in a famous picture, but in the original their image exists solely as the non-identified bystander or a figure that is part of the overall composition and form of a photograph. By physically dissecting the image to reverse the figure/ground relation, by making the anonymous person the sole occupier of the picture plane, I deconstruct and flip the image's hierarchical authority. The issue is to construct a model that reveals the unacknowledged and by extension (and metaphor) considers alternate histories and people. These people, who have been unknowingly photographed, who are part of the photographer's composition, are the anonymous and the unrecognized. They are/were part of the great mass of humanity who exist(ed), whose lives become fodder for others' use, who are the faceless artifacts of culture, the target, the statistic, the unrecognized. This work prioritizes their individual existence."

© Mauro Altamura. Untitled (after Ben Shahn 1, New York 1936), 2005. 24 × 20 inches. Chromogenic color print.

compositional space. Positive and negative space is also known as *figure-ground*. You may want to ask yourself, how much space is around my subject? Where is my subject within the compositional frame, and as you look through the viewfinder, which is more important, the subject or the background?

Texture

Two-dimensional texture generates the visual appearance, consistency, or feel of a surface or a substance. In photographic practice, texture refers to the tactile quality of the image surface. As a rule, smooth textures tend to produce cool sensations, and rough textures

EXERCISE 4×4

Imagemaker and educator Debra Davis has her University of Toledo classes learn about spatial concepts by confining their physical and visual space. The idea is to create a visual narrative, in a sequence of at least six images, while remaining in a 4×4 foot space. This space can be literally or mentally defined. Your visual space may move from the floor, up the wall onto the ceiling, or enter a cave or niche in the mountains.

There is a great deal of information to be found in 4 feet of space. The image sequencing makes one aware of how your photographs relate one to another and to the group of images as a whole. Look closely and engage with your chosen subject. Try a variety of angles, viewpoints, and physical positions: lie on the ground, stand on something, choose a variety of focal lengths, or get in close — explore! (see Chapter 10). make for warm sensations. Texture and pattern are intertwined. A pattern on a piece of cloth gives us a visual sense of texture, letting us sense the differences in the surface with our eyes, even though it does not exist to the touch. For our purposes, we need to be familiar with tactile texture and light texture.

Tactile texture refers to actual changes in a surface that can be felt. Such textures can be rough, smooth, hard, soft, wet, or dry, and they possess physical three-dimensional characteristics. Examples of this can be found in the making of collages (see Chapter 7).

Variations in light and dark produce a visual texture, which is two-dimensional. Our eyes and brain generate this illusion, this suggestion of a tactile quality. The phenomenon is produced by spatial variations of stimuli, such as the relationship of color placement and tonal value within the composition. Additionally, depth of field can play a role in determining the sense of an image's visual texture.

The subtle use of background texture can produce a visual play between the subject and its surroundings, thus keeping the viewer's eye moving around within the composition. A careful application of background texture can also be useful in creating a visual separation between the subject and its environment, thus making the subject stand out from its setting.

Pattern

Pattern is the unifying quality of an object. It is the interplay between shape, color, and space that forms a recognizable, repetitive, and/or identifiable unit. Pattern can unify the composition, establish a balance among diverse elements, or create a sense of rhythm and/or movement.

2.16 Johnson has been photographing the way that humans create, destroy, and recreate landscapes. Here visual texture brings the elements of irony, incongruity, humor, and the color of people's man's imprint into play. Johnson does this by physically moving into a scene and capturing the layered play between the overlapping lines and colors that optically advance and recede simultaneously. This creates a floating, abstract meditation that is anchored by the square within a square and pays homage to Josef Alber's series "Homage to a Square".

© Keith Johnson. *Bermuda Square*, from the series *Re: Man (ufactured) Space*, 2004. 30 × 30 inches. Inkjet print.

The major difference between texture and pattern is degree. The key distinction is whether a surface awakens our sense of touch or design. Every texture makes a pattern, but not every pattern produces a texture. Pattern can possess visual texture, but not every texture contains a distinct pattern. A single weathered board has texture, but an entire row of weathered boards creates a pattern. Pattern can be found in the repetition of design. In a pattern, no single feature dominates. Its distinctive look is made possible by its repetitive quality and generally serves well as a background.

Surprises regularly occur when working with pattern. When compositional elements are placed in repetition with other elements over a large area, they form new elements that may not be anticipated or showcase the unexpected. These are often the result of negative/

EXERCISE

The Kitchen and Visual Design

At the beginning of the 20th century, the Clarence H. White School of Photography fostered the careers of many photographers. One of the school's assignments was to create a still life made from objects found in a kitchen. John Valentino of Southeastern Louisiana University updated this project: Use photographic means to create a series of still-life images from items found in a common kitchen that underscore your understanding of at least three design fundamentals, such as line, shape, and texture. Don't forget the interior of the refrigerator and the kitchen drawers. background space (the space around the design or weaving through it). The shapes fashioned by the interplay of the negative space become intriguing in and of themselves. Within the pattern, these new shapes become apparent and begin to dominate so that the space or spaces can be the prevailing visual factor.

2.17 What began as an art installation turned into a serious biodiversity project. Compelled by the moths he was collecting and by the sheer number of different species, Scheer decided to document each species where he lives. This has expanded to specimens from the whole world in an effort to link art and environmental activism, facilitate new visual access to nature, and reveal the surprising beauty of moths with all their preposterous hair and scales. Scheer's high-resolution scans also offer new ways of reading the natural world by incorporating an effect of hyper-real vision that allows us to see structures and textures of the insect that the naked eye cannot discern.

 \odot Joseph Scheer. *Grammia virgo*, 2002. 34 × 46 inches. Inkjet print. Courtesy of the collection of William and Rachel Tippet.

Symbolism

A symbol is anything that stands for something else. Usually a symbol is a simplified image that, because of certain associations in a viewer's mind, represents something that is not readily seen: a more complex idea, event, emotions, state of mind, relationship, or system. Lines that form letters, words, or musical notes are symbols. Photographs are symbols. A photograph of a person is not that person, but a representation of the person. It stands for the person, which makes it a symbol. Symbolism holds a vast power for imagemakers because it allows the communication of enormously complicated, often abstract ideas with just a few lines or shapes. Symbols provide us the means for sorting information and drawing inferences which can help us to communicate more effectively. Photography is a sign language and symbols are its shorthand. Learn to recognize and use the signs to communicate your ideas.

The following categories of symbols are offered to get you thinking about what they can represent. Symbols are not absolute terms. They are fluid and have multiple readings based on factors such as cultural background, economic status, geographic location, gender, psychological state, and political, religious, and sexual preference. Symbols are highly complex, and each image requires its own reading. Reading and decoding images is a diverse and variable process. Based on personal experiences, different people will give a variety of readings; moreover, your own interpretation may expand or change over time. The following symbols and some of their possible meanings are provided only as a portal of departure.

General Symbol Categories

The following are some common general symbols:

- Commercial symbols visually dispense information and/or advertise a service or product to be sold. Examples include three balls symbolizing the pawnbroker, the red-and-white pole signifying a barbershop, international road signs, and logos for corporations such as Apple Computer, Shell Oil, MTV, Coke, and McDonald's, which have also become cultural icons.
- Cosmic symbols include yin and yang (yin: feminine, dark, cold, mystery, wetness; yang: masculine, light, heat, dryness) and the zodiac (the forces believed to govern the universe). Historically, the four "humors" within the body (blood = sanguine, meaning amorous, happy, or generous; phlegm = phlegmatic, meaning dull, pale, or cowardly; choler (yellow bile) = choleric, meaning violent or vengeful; and melancholy (black bile) = melancholic, meaning gluttonous, lazy, or sentimental) were widely used as symbolic shorthand to describe a person's temperament. These ruling passions were thought to give off vapors that ascended to the brain, where they influenced an individual's physical, mental, and moral characteristics. The perfect temperament was thought to be one in which none of the four humors dominated.
- Cultural symbols are shorthand representations of mythological, religious, or cultural concepts that have changed over time and geographical location and are used by various groups of people to symbolize or "stand for" something significant in their culture. For instance, St. Nicholas, who can be traced back to 3rd-century Turkey, has had numerous incarnations from a tall, serious European to the current fat and jolly Santa Claus, which has become highly commercialized and nonsectarian.

2.18 "Inspired by the proliferation of very tall signs in the American Mid-West, Floating Logos draws attention to this often overlooked form of advertising. Elimination of the support structure in the photographs allows the signs to float above the earth. In some cases the ground is left out of the image to further emphasize the disconnect between the corporate symbols and terra firma. Making the signs appear to float not only draws attention to this type of signage but also gives them, and the companies that put them there, an otherworldly quality."

© Matt Siber. Burger King, from the series Floating Logos, 2004. 40×32 inches. Inkjet print.

- Magical symbols can be traced back to cave paintings of animals that may have been used to help ensure a successful hunt. Tribal masks were employed for getting the desired results in battle, love, and the search for food. Masks let the wearers both disguise themselves and represent things of importance, allowing people the freedom to act out situations according to the desires of their inner fantasies. The Christmas tree can be traced back to the ancient use of evergreen trees that were thought to keep away witches, ghosts, evil spirits, and illness, and to guarantee the return of the sun. It was also a Roman agricultural and fertility symbol, which has been transformed into a glowing emblem of capitalist plenty.
- Patriotic and political symbols in the United States include the bald eagle (made the national bird in 1782, it symbolizes strength, courage, freedom, and immortality); the American flag (red, white, and blue); the Statue of Liberty (a gift of international friendship from the people of France to the United States in 1886, it is one of the most universal symbols of political freedom and democracy); Uncle Sam (a personification of the United States with a white goatee and star-spangled suit, it is an invention of 19th-century artists and political cartoonists); and the Democratic (donkey) and Republican (elephant) political parties. At a glance, they provide a wealth of information and express certain political and social points of view.
- Personal symbols are created by artists to meet their individual requirements. Some photographers whose works contain personal symbols include Man Ray, Lázsló Moholy-Nagy, Barbara Morgan, and Jerry Uelsmann.

2.19 This image was created in response to Roetter's bout with Lyme's disease, which affected her brain. Here the artist combined a scan of her brain with reflecting particles of paint to try to understand the process. "I felt as if I was symbolically energizing my brain — creating an aesthetic healing process.
© Joyce Roetter. *Self-Portrait, SPECT Scan, #10,* 2005. 16 × 20 inches. Mixed media. Courtesy of the Santa Fe Community College Foundation Collection, New Mexico.

- Psychological symbols offer a system for investigating the conscious and unconscious processes of the human mind. Sigmund Freud's *The Interpretation of Dreams* and Carl Jung's *Man and His Symbols* are two watershed works dealing with these ideas. Filmmakers such as Ingmar Bergman, Francis Ford Coppola, and Martin Scorsese have emphasized the psychological side of human nature in their works.
- Religious symbols, such as the cross, the Star of David, and the Buddha stand for the ideas behind the religion such as faith,

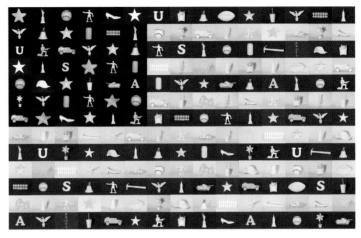

2.20 Challenged by an assignment given by her professor, Bill Davis at Western Michigan University, to use color in a grid design to structure a social or political message that could also emphasize the relationships between color as form and pattern, Breisach undertook an exploration of objects and ideas that are symbolic of American culture. Taking photographs in a makeshift garage studio using a variety of lights and backdrops, she "produced variances in background and object color, causing the overall flag image to look worn and aged, thus emphasizing my observation that many of icons have stood the test of time and are likely to remain 'American' in the future. Also, the same variances emphasize the patchwork aspect of the overall flag, suggesting that, standing alone, these objects might not seem emblematic or American, but when pieced together create an iconic representation of American culture." (© Kristi Breisach. *All Things American*, 2006. 19-1/4 \times 32-1/2 inches. Inkjet print.

generosity, forgiveness, hope, love, virtue, and the quest for enlightenment.

• Status symbols indicate the status or station in life of the owner or bearer: cars, clothes, electronic devices, military insignia, and wedding rings are a few examples. Lately, "branding," the placement of brand name products within television and film scenes along with wearable logos, has become a prevalent means of marking status within popular culture.

• Traditional patterns have been woven into our visual arts for thousands of years. While a pattern may remain the same, each group who uses it alters its context and meaning. The swastika is a good example of how this works. It has been used as an ornament by the American Indians since prehistoric times. It has appeared as a symbol through the old world of China, Crete, Egypt, India, and Persia. In the 20th century, its meaning was hijacked and perverted, from one of well-being to that of death, when the German Nazi Party adopted it as the official emblem of the Third Reich.

Shapes and Their General Symbolic Associations

Shapes can also have symbolic meaning. Some possible interpretations follow:

- The circle is associated with wholeness, perfection, heaven, intellect, the sun, unity, eternity, the celestial realm, and, of course, our Earth.
- The maze delineates a complex puzzle, the endless search, confusing information, or a state of bewilderment.
- The rectangle often denotes the rational and secure. It is used to ground concrete objects.
- The spiral can illustrate a continuous directional winding or flow, the evolution of the universe, orbit, growth, deepening, cosmic motion, the relationship between unity and multiplicity, spirit, water, and continuing ascent or descent.

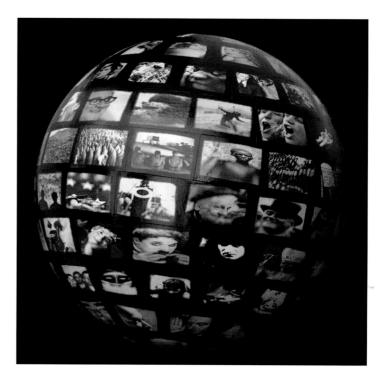

2.21 This project juxtaposes elements of historical images that have been reworked to scrutinize the tragic and comedic visual records that made up the 20th century. Individual images were adjusted to fit the tapering, triangular gore patterns used to fabricate the original globe in Photoshop; then they were printed and collaged with archival paste onto the surface of the globe.
© Adele Henderson and Robert Hirsch. *Globes of Our Time*, 2006. 16 inch diameter. Mixed media.

- The square may represent firmness, stability, or the number four.
- The triangle can represent three forces in equilibrium, such as communication between heaven and earth, fire, the number

three, the trinity, aspiration, movement upward, a return to origins, sight, and light.

Color Symbolism

Along with shapes, color has symbolic associations that have come down over time in Western cultures.

- Blue signifies sky, thinking, the day, the sea, height, depth, heaven, innocence, truth, psychic ability, and spirituality.
- Green represents the earth, fertility, sensation, vegetation, water, nature, sympathy, adaptability, and growth.
- Orange shows fire, pride, and ambition.
- Red portrays sunrise, birth, blood, fire, emotion, wounds, death, passion, anger, excitement, heat, physical stimulation, and strengthening.
- Yellow indicates the sun, light, intuition, illumination, air, intellect, royalty, and luminosity.
- Violet marks nostalgia, memory, and advanced spirituality.

Common Symbols and Some Potential Associations

Think about these symbols and how their connotations can be applied in your work.

- Air symbolizes activity, masculinity, creativity, breath, light, freedom, liberty, and movement.
- Ascent indicates height, transcendence, inward journeying, and increasing intensity.
- Centering depicts thought, unity, timelessness, spacelessness, paradise, the Creator, infinity, and neutralizing opposites.

- The cross portrays the tree of life, axis of the world, ladder, struggle, martyrdom, and orientation in space.
- Darkness connotes the time before existence, chaos, and the shadow world.
- Descent shows unconsciousness, potentialities of being, and animal nature.
- Duality suggests opposites, complements, and pairing.
- The earth suggests femininity, receptiveness, solidity, and mother.
- An eye connotes understanding, intelligence, the sacred fire, creativeness, and the power of vision.
- Fire represents the ability to transform, love, life, health, control, spiritual energy, regeneration, the sun, God, and passion.
- Food represents abundance and thankfulness to nature for providing what is needed to sustain life.
- A lake represents mystery, depth, and unconsciousness.
- Light stands for the spirit, morality, all, creative force, the direction east, and spiritual thought.
- The moon symbolizes the feminine and fruitfulness.
- Mountains demonstrate height, mass, loftiness, the center of the world, ambition, and goals.
- The sun indicates the hero, knowledge, the divine, fire, the creative and life force, brightness, splendor, awakening, healing, and wholeness.
- Unity signifies spirit, oneness, wholeness, centering, transcendence, harmony, revelation, supreme power, completeness in itself, light, and the divinity.
- Water denotes feminine qualities, life, and the flow of the cycles of life.

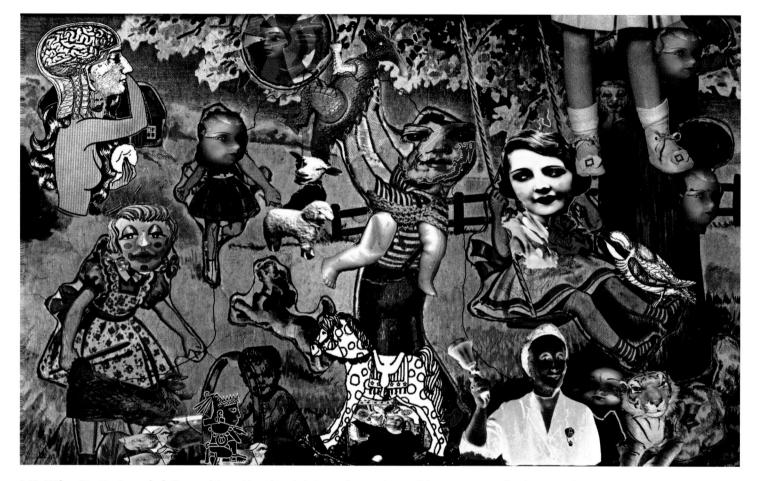

2.22 "When Max Ernst remarked, 'For me doing art is a struggle between the conscious and the unconscious. The play versus the intentions is something I am dedicated to' — he eloquently described my working process of utilizing chance, synchronicity, absurdity, humor, and a balance of conscious and unconscious. By combining scanning and Photoshop, I was able to transform a found children's puzzle into a personal version of Seurat's *A Sunday Afternoon on the Island of La Grande Jatte* (1884–86). The content is nothing but a Kafka scenario that defines a fixed interpretation."

© Helene Smith-Romer. The Harry's Family at Ragdale, 2004–05. 11 × 14 inches. Inkjet print.

EXERCISE

Personal Symbol Interpretation

Now that you have read about symbols and some of their possible meanings, add your own symbols to the lists provided. Consider how Western culture defines these symbols and how other cultures might interpret them differently. Discuss some of the symbols with a member of an older generation to see how the meaning may have shifted over time.

Next, choose some of your favorite pictures (made by you or someone else) and make a list of the symbols you discover in these images. Write a description that decodes their meaning for others to ponder. Then visit an open source image website, such as www.flickr.com, and look for "tags" (keywords or categories that imagemakers use to label the content of their images), which identify areas of symbolism that interest you and examine how others have visually expressed these ideas. To finish, purposely use what you have discovered about your personal use of symbols as your point of departure to make three new images that possess staying power and post them to an open source image website designed for young artists such as http://www.saatchi-gallery.co.uk/ stuart (AKA Stuart).

Some believe that the meaning of a work is determined strictly by the intentions of the author (known as intentionalism). You should keep in mind, however, that viewers are under no obligation to accept a maker's stated meaning. Although the opinion of a maker can and should help provide clues for understanding the work, an imagemaker's interpretation should not be the only factor in determining the meaning or setting the standard for other interpretations. Think of what Marcel Duchamp, a cofounder of the Dada group said: "It is the spectator who makes the picture."

REFERENCES

- Biedermann, Hans. Dictionary of Symbolism: Cultural Icons and the Meanings Behind Them. New York: Meridian, 1994.
- Cirlot, J. E. A Dictionary of Symbols. Second Edition. New York: Philosophical Library, 1971.
- Fontana, David. The Secret Language of Symbols: A Visual Key to Symbols and Their Meanings. San Francisco: Chronicle Books, 2003.
- Dondis, Donis A. A Primer of Visual Literacy. Cambridge, MA, and London: The MIT Press, 1973.
- Hornung, C. P. Hornung's Handbook of Design and Devices. Second Edition (1946); reprint, New York: Dover.

Jung, C. G. Man and His Symbols. Garden City, NY: Doubleday, 1964.

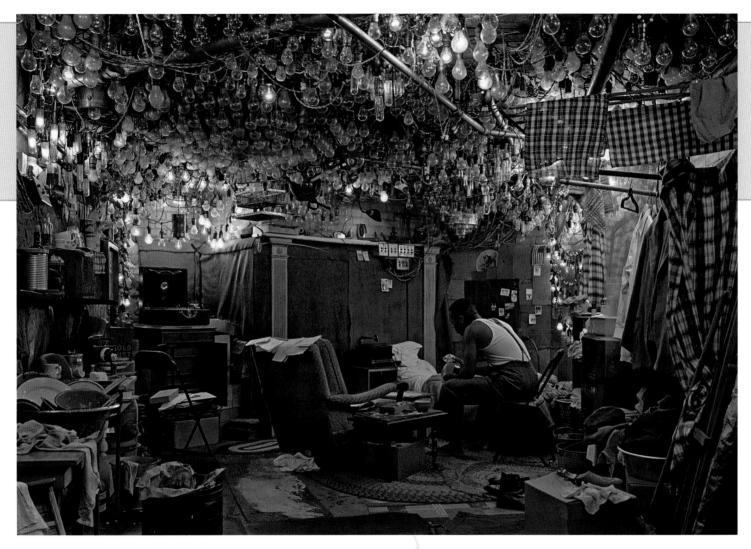

Wall represents a well-known scene from Ralph Ellison's 1952 classic novel *Invisible Man.* Wall's version shows us the New York City cellar room, "warm and full of light" in which Ellison's black narrator lives, including the ceiling that is covered with 1,369 illegally connected light bulbs. Energy and light, stolen from the electric company, illuminate not only the character's basement dwelling, but also the truth of his existence. There is a parallel between this hidden, subterranean place of light in the novel and Wall's own photographic practice. Ellison's character declares: 'Without light I am not only invisible, but formless as well.' Wall's use of a light source behind his pictures is a way of bringing his own "invisible" subjects to the fore, so giving form to the overlooked in society.

© Jeff Wall. After "Invisible Man" by Ralph Ellison, the Prologue, 1999–2000. 68-1/2 × 98-1/2 inches. Duratran in lightbox.

Chapter 3

Image Capture: Cameras, Lenses, and Scanners

THE ROLE OF A CAMERA

The camera is the key component of photographic vision. The role of the camera has been to make an "acceptable" and recognizable depiction of the visible world based on established visual conventions. The early camera, called the *camera obscura*, was an optical drawing device designed to imitate the visual ideas of perspective and scale that were formulated during the Renaissance. Cameras and lenses leave their fingerprints all over the basic characteristics of the final photographic image, including field of view, sharpness, tonal range, and noise. Because the camera plays such a vital role in the formation of the final picture, photographers should select a camera that supports their specific visual goals. No single camera can produce acceptable results in every situation. This is because the standard of what is acceptable is dependent on a variety of factors, including the subject being photographed, the audience, the purpose for which the picture is being made, and the desires of the photographer. Photographers should learn about the differences among cameras, their strengths and their limitations, so they can make intelligent choices for achieving the desired outcome; and, when possible, they should experiment with different types of cameras. Street photographer Garry Winogrand observed: "A photograph can only look like how the camera saw what was photographed. Or, how the camera saw the piece of time and space is responsible for how the photograph looks. Therefore, a photograph can look any way. Or, there's no way a photograph has to look (beyond being an illusion of a literal description)."¹

The camera's design is a basic part of the photographer's visual language. Although a camera may shape the construction of an image, it is the private individual response to a situation that gives an image its power. It is up to each photographer to understand and apply a camera's capabilities, to learn its characteristics, and to know when to use different cameras to achieve the desired results.

WHAT IS A CAMERA?

This chapter describes the key camera components and covers the four essentials that make up every camera image: aperture, focal length, focus, and shutter speed. The digital single-lens reflex camera (DSLR) is the nucleus of discussion, but its fundamental principles can be applied to any camera, including point-and-shoot digital and cell phone cameras (which are selling at twice the rate of all digital cameras combined) and scanners. Cell phone cameras are becoming omnipresent, giving individuals the ability and power to record and transmit out into the world whatever is happening in their presence. During historic events, such as the hanging of Saddam Hussein in 2006, the images can have worldwide consequences.

A traditional camera, from a room-size camera obscura to the latest hand-held digital, is essentially a light-tight box. A hole (aperture) is made at one end to admit light, and light-sensitive material is placed inside the box opposite the hole. The camera's purpose is to enable the light to form an image on the light-sensitive material, in this case a light-sensitive sensor. This can be accomplished in a variety of ways, but most new digital cameras have the same basic components:

• A lens that focuses the rays of light to form a sharp image on the light-sensitive sensor.

3.1 Recognizing that more images are being made with cell phone cameras than any other means, Sony Ericcson commissioned Martin Parr to photograph while traveling with their equipment. The images from the resulting project, *Road Trip*, were posted to a website along with tips by Parr on how to make better cell phone photos. Additionally, the public was invited to upload their cell phone images to the site.

© Martin Parr. *Singapore*, from the series *Road Trip*, 2005. Digital file. Screen shot from www.sonyericcson.com/k750/. Courtesy of Sony Ericsson Mobile Communications.

- An optical viewing system and/or monitor for image composition and review.
- An electronic shutter mechanism that prevents light from reaching the image sensor until the shutter is released. The shutter opens for a measured amount of time, allowing the light to strike the sensor. When the time has elapsed, the shutter closes, preventing any additional light from reaching the sensor.
- A light-sensitive sensor that electronically records the image created by the light onto a memory card. The inside of a camera must be completely dark so that rays of light reach the sensor only through the aperture.

- A control data-panel display that shows the camera's functions including aperture, shutter speed, battery life, flash, focus, sensitivity, white balance, and metering modes.
- A Mode dial that allows control over camera settings, including aperture, shutter speed, flash, and camera menus. The camera may also have programs designed for specific situations such as close-ups, landscapes, and portraits.
- A Sensitivity setting (ISO equivalency) that controls the light sensitivity of the sensor by electronically amplifying the signal.
- A memory card and memory card slot.
- An image advance mechanism to automatically go to the next free space on the memory card.
- A light metering system built into the body of the camera that measures the intensity of the light and then automatically sets the exposure. Cameras generally have numerous exposure modes, including a manual setting.
- A small built-in electronic flash, which can be controlled automatically or manually, depending on the camera.
- Battery to power all the camera functions.
- A tripod socket.

HOW A CAMERA IMAGING SYSTEM WORKS

Photography begins and ends with light. There are five principal steps in making a photographic image: (A) capturing light rays, (B) focusing the image, (C) exposure (also known as *image capture* or *capture*), which records the image on the sensor array and stores it on a memory card, (D) processing the digital image, and (E) making a print or displaying the image on a screen (see Figure 3.2).

DIGITAL SINGLE LENS REFLEX (DSLR) CAMERA

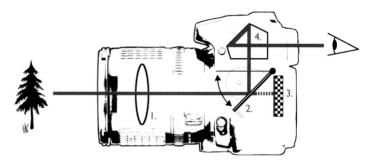

3.2 How a DSLR camera works with light.

A typical imaging system requires integrating many elements into confined space.

- **1.** *Lens:* Light passing through the lens forms an image, which is inverted (laterally reversed).
- **2.** *Mirror with reflex action:* The mirror stays in the down position for focusing and framing of a scene. When the shutter button is depressed, the mirror instantly retracks upward, allowing the digital image sensor to capture the image.
- **3.** *Digital sensor array:* The image sensor converts light into digital information (pixels), which are measured in megapixels (1 million pixels equals 1 megapixel).
- **4.** *Pentaprism:* A five-sided reflecting prism is used to internally reflect a beam of light by 90 degrees twice. The pentaprism, together with the mirror, creates an exact reflection of what is seen in the viewfinder. The pentaprism also corrects (turns around) the lateral orientation of the image.

DIGITAL CAMERAS

The first commercial digital cameras debuted in the 1980s. They were expensive and produced images that were not as good as those made by inexpensive film cameras. Today, advances in electronic technology have resulted in digital cameras that equal or surpass the quality of film cameras. They have also become affordable and now outsell film cameras. Their ease of use, ability to make acceptable images in a wide variety of situations, new features, and the elimination of certain film camera design elements, such as a prominent shutter speed dial, f-stop clicks, depth-of-field guide on the lens barrel, and in some cases even the traditional optical viewfinder, permit a streamlined way of working that was not previously possible. Most digital cameras share common components, which are discussed below. However, it is essential for you to read your specific camera manual to learn the specific camera architecture and how the manufacturer has set up the controls and features. There is a danger in letting a camera make all its preprogrammed decisions for you: that is, the resulting images tend to share a certain "cookie-cutter" sameness due to the loss of quirky, individual decision making.

Digital Observations

What is the best way to make images your own? Once you become familiar with your camera's basic functions, you can start customizing its functions to reflect your personal aesthetics and shooting requirements. Digital technology offers new tools for observing and thinking. It can be an enabling technology, permitting more people to create and then circulate images via the Internet, which is doubling in size every year. In the past, professional photojournalists and their

3.3 The Abu Ghraib prison (20 miles/32 km west of Baghdad) was known as a place where Saddam Hussein's government tortured and executed dissidents. It achieved additional infamy when cell phone camera photographs made by guards portraying abuse of Iraqi detainees by the U.S. military circulated on the Internet. Here a hooded prisoner had wires attached to his hands and genitalia and was reportedly told that he would be electrocuted if he fell off the box he was standing on. When this image became public, U.S. officials stated that the wires were not actually electrified. This was later denied by the person in the photograph, who stated in an interview that the wires were electrified and had been used to give shocks.

© Unknown photographer. Prisoner Being Tortured, Abu Ghraib Prison, 2004. Digital file. Screen capture from the internet.

networks of commercial distribution provided the photographs the public would see — for example, of any given war. Now, digital imaging allows soldiers themselves to document and tell their uncensored stories of war. The grainy, amateur snapshots made of prisoners being abused by the guards in Abu Ghraib prison in Iraq, distributed by email and eventually on the Internet, were deemed so powerful that the U.S. government tried to suppress them (see Figure 3.3). Changes in who is making and circulating pictures is evolving with the widespread use of web logs (blogs) and alternative news and open reference websites. The character of imagemaking and its distribution is challenging old photographic approaches and creating new, fresh, and diverse ways of seeing, understanding, and knowing our world.

Image Sensors: CCD and CMOS

Digital cameras generate images by focusing a scene through a lens, like a traditional film camera. When a photographer makes an exposure with a digital camera, the focused image is captured with a sensor, often a charge-coupled device (CCD sensor), and a postagestamp-size electronic wafer that converts light into electrical current. It is positioned where the film would normally be in a conventional camera. Complementary metal-oxide semiconductor (CMOS sensor) technology is another type of digital camera sensor that performs the same function. CCD and CMOS are the most common types of light-sensitive chips used for image gathering. The CCD is composed of many light-sensitive photocells. When light strikes these cells, the properties of the light, such as brightness and color, are converted into electrical signals and broken down into pixels (picture elements). These tiny squares of color are represented in binary form using combinations of the digits one (1) and zero (0) and are known as *bits*. Bits are the smallest units into which the camera is able to digitally divide the visual information. The bits are arranged in a grid pattern, like squares on a sheet of graph paper, and are recorded onto a memory card in the camera. CCD sensors are devoted to light capture only and rely on the onboard camera computer to complete the imaging process into bits. CMOS sensors include light sensors with digitization circuits so that the chip directly outputs digital bits to the camera computer, requiring less camera circuitry.

An image sensor has millions of tiny light-sensitive cells called *silicon photodiodes* (SPDs), also known as *photosites*, arranged in a grid. Each SPD accumulates an electrical charge according to the amount of light that strikes it. When an exposure is made, the lens focuses light on the sensor, and each cell, which has either a red, green, or blue filter (known as *RGB*) in front of it, measures the intensity of the light that falls on it. Every position on the grid is recorded as a solid-toned picture element, or pixel, with its color, brightness, and position given as a binary series of ones (1) and zeros (0). Each pixel corresponds to an SPD on the sensor (see following section on pixels).

Color Filter Array: Bayer Filter Mosaic

Color accuracy and rendering are determined by the color filter array (CFA) pattern. A CFA is a grid pattern of tiny color filters placed over the sensor so that individual RGB filters match up with individual SPDs. Some cameras use three different filters that rotate in front of a single sensor. Others have a fixed color filter array over each individual single sensor.

The most common CFA pattern is the Bayer, used in most singlechip digital cameras. A Bayer filter mosaic is a CFA for arranging RGB color filters on a square grid of photosensors. Each sensor pixel is covered by RGB colored filters. The combinations of these three RGB colors result in an accurate reproduction of the images' actual colors. Each filter allows only red light, green light, or blue light to pass through to its SPD. There are twice as many green filters as there are red or blue filters, because the human eye is more sensitive to green light. Each pixel contains a single primary color and is missing the other two colors. Through a process known as *interpolation*, a mathematical method of creating missing data, the camera guesses the absent color information in each pixel by examining nearby pixels and thus is able to generate accurate colors.

Once an image is recorded (digitized), imaging software can be used to select and alter the color, brightness, and position of any pixels.

Pixels

A pixel, short for picture element, is essentially an electronic point with a given color and brightness value (data) that is the smallest component of a digital image. A typical digital image is composed of an array containing millions of pixels. A million pixels are known as a *megapixel*. When the sensor grid is made up of millions of these tiny pixels, it is perceived by your eye in continuous tones, just as it would with a film-based photograph. The more pixels the image contains, the sharper the image and the higher its resolution (amount of detail).

Image Resolution

Image resolution describes the amount of detail any particular image can display. The measurement of image resolution varies dramatically and is specific to a specific medium, such as inkjet/laserjet printing, TV/video, film or computer monitors. In any digital medium, higher numbers translate into higher resolving power or ability to reveal image detail. Television/video uses the number of scan lines to determine image resolution. Film and photography utilize an analog standard in which lower numbers indicate higher resolving power. Computer monitors use dot pitch. Digital cameras use pixels per square inch (PPI), and inkjet/laserjet printing technology uses dots per square inch (DPI). Regardless of the medium, accepted resolution standards are dependent on the ability of the human eye to resolve or see detail and the quality of the equipment and materials being used.

PPI: Pixels per Square Inch and Digital Camera Resolution

Digital cameras can capture images in different resolutions. Lowresolution images are appropriate for display on a website, but not for making photographic-quality images. A 6-megapixel digital camera refers to the maximum number of pixels (PPI) such a camera is capable of capturing. The PPI is the number of pixels displayed in the image file, which directly refers to image resolution. Digital cameras have capture settings that can be set to less than the maximum PPI. For example, most digital cameras have image size or PPI settings usually described as large, medium, and small. The *Large* setting represents the maximum allowable image resolution for that particular camera and will always produce a larger image file than the *Small* setting. Hence, a 10-megabyte image file created with the *Large* setting will always contain more pixel information than a 1-megabyte image file created with the *Small* setting. A 10-megapixel camera using the *Large* setting might have a PPI setting of (width) $3888 \times$ (height) 2592, which will have sufficient resolution for 11×14 inch photographic-quality prints, which is usually adequate for most amateurs. A *Small* setting might be adequate only for use on the Web. A computer with image processing software can reassemble the PPI from large, medium, and small image files for printing, emailing, or posting to a website. It is always best to shoot "large" and reduce the PPI for the Web or other uses, rather than to shoot "small" and increase PPI to print, because the resulting quality will be less than optimal.

DPI: Dots per Square Inch and Printer Resolution

DPI, dots per square inch, refers to printer resolution. In general, the more dots the printer can physically produce per linear inch, the better and sharper the image. DPI and PPI are both key controlling factors in producing high-quality photographic prints, but ultimately it is the printer resolution or DPI setting that has the greatest effect on the final image resolution. Looking at a photograph on paper is an analog experience because our eyes convert value and detail into recognizable shapes. Hence, it is the number and size of the dots physically applied to the paper that give a viewer the final visual experience.

The Differences between PPI and DPI

Although PPI and DPI control image quality in similar ways, they are very different, and it is critical that these distinctions be clearly understood. PPI refers to pixel density or pixel dimensions and is usually measured in pixel height and width. For imagemaking purposes, think of PPI as digital information that only relates to the resolution

Box 3.1 PPI and DPI Mantra PPI = Input/camera

DPI = Output/printer

of your camera's capture mode, and DPI as it correlates to the resolution of your printer's output. The mantra to remember is: For PPI, think of your camera; for DPI, think of your printer. (See Box 3.1 and Chapter 8 for more information about PPI and DPI.)

Visual Acuity and 300 DPI

Visual acuity is the capability of the human eye to resolve detail, but this power of human vision to recognize fine detail has limits. When it comes to digital imaging, the point where dots, lines, and spaces are seen by the human eye as continuous tone is approximately 300 dots per inch (DPI). This is why photographic printers, known for high-quality output, have resolutions of 300 DPI and higher. There are many variables, such as individual differences in visual acuity, lighting conditions, and viewing distance, but generally 300 DPI is considered acceptable for replicating continuous tone. An 8×10 inch digital print at 300 DPI and viewed at 12 inches (30 cm) easily allows the dots to be seen as a continuous tone to the average eye. As prints are made larger, the standard viewing distance increases, which theoretically means the DPI could be reduced and the average eye would still see it as a continuous tone (see Figure 3.4).

Printers create images in a variety of ways. Depending on the way a printer lays down its dots on a page, a print made at 200 DPI on one printer can look finer than a print made at 400 DPI on another. Regardless of what printer you use, 300 DPI has become the common standard that photographers and publishers use for making image files for general reproduction. Those with a more demanding critical eye, such as professionals intending to greatly enlarge their digital files and still maintain continuous tone quality at close viewing distances, will require higher DPI output, such as 600 to 8000 DPI (see Box 3.1).

As previously discussed, printing at 300 DPI is the standard for photographic quality, so be careful not to let inkjet printers rated at 1440/2880/4800 DPI impress you. Inkjet printers rely on technology that applies many tiny droplets of color for each dot. Manufacturers are literally counting each and every one of those minuscule droplets, which can be misleading. Visually, a dot is a dot regardless of whether one dot is composed of a cluster of eight minuscule color droplets and another is not. Some manufacturers count the eight minuscule droplets as separate dots to inflate their DPI figures. Inkjet technology is changing rapidly; droplets are getting so small that their blending on the page obscures the individual droplets altogether. This improvement in inkjet printer technology does offer better color control, but only has a minimal impact on actual image resolution.

TYPES OF CAMERAS

Digital cameras are the most direct method of capturing images for digital manipulation or printing. Combining the mechanics of cameras and the technology of scanners, digitally captured images may be stored on a disk within the camera and later transferred to a computer, or the camera may be directly connected to a computer and the image transferred as the picture is taken. Exposure times in digital cameras can vary from a fraction of a second to several minutes.

3.4 Dots to continuous line.

Digital cameras come in two styles: the all-in-one digital camera and the professional-level scanning back. Scanning backs connect to traditional, larger-format cameras. The camera makes the exposure, and the scanning back converts the image into digital data. (These are used to make high-end professional images and will not be covered here.) The sensor stores images as electronic data, which can be downloaded into a computer. In the computer, a digital imaging software program allows changes to be made to the image, which can be saved and then printed or transmitted via email as a digital file or posted on a website. Often digital images are never printed and remain strictly as electronic information.

Compact Digital Cameras

Compact digital cameras, also known as *point-and-shoot cameras*, have become the choice of casual photographers. Compacts are called pointand-shoot cameras because their functions are automatic and they simply require users to compose the scene and press the shutter release. Basic inexpensive point-and-shoot cameras have a fixed focus, which relies on a small aperture and a wide-angle lens to ensure that everything within a certain range of distance from the lens (about 6 feet to infinity) is in acceptable focus. Other point-and-shoot cameras may have a limited focusing range indicated on the camera body. With these, the user guesses the distance to the subject and adjusts the focus accordingly. On some cameras, the focusing range is indicated by graphic symbols (head-and-shoulders; two people standing upright; one tree; mountains). Such lightweight point-and-shoot cameras have a viewing system that is separate from the lens. Generally, the viewfinder is a small window above or to one side of the lens. More expensive compact cameras have a rangefinder; an angled mirror behind the lens reflects a second image of the subject into the viewfinder. To focus, a person looks through the viewfinder and adjusts the focusing mechanism until the two images come together. The focused image in the viewfinder differs slightly from the image on the sensor or film. This difference is called *parallax error*. To help correct for parallax error, the viewfinder has lines that frame the subject area seen by the lens.

Compact digital cameras may have a monitor instead of a viewfinder, or both. Many make use of an electronic viewfinder (EVF). An EVF relies on a miniature monitor inside the back of the camera. The photographer looks at the monitor through a small window and sees the scene from the same viewpoint as the lens. Thus, parallax error is avoided. Compact digital cameras usually have many features and creative controls, including variable focal length zoom lenses, automatic focus, and software programs to cover situations such as close-ups and nighttime exposures. Some even permit Wi-Fi (short for wireless fidelity) picture transmission which sends pictures directly from a camera to a computer without wires. Higher-quality digital cameras have greater resolution (the amount of image detail the camera is capable of recording), which results in sharper images.

Digital Single-Lens Reflex Cameras

Digital single-lens reflex cameras (DSLRs) are the most common type of camera used by professional and serious photographers because they allow one to look at a subject directly through the lens. A mirror mechanism between the lens and the sensor reflects the image onto a viewing screen. When the shutter release button is pressed, the mirror rises out of the way so that the light makes an exposure on the sensor. Thus, the photographer sees the image almost exactly as it is recorded on the sensor, and parallax error is avoided.

Single-lens reflex cameras are heavier and more expensive than other digital models. DSLRs are more versatile than compacts, with most offering both manual and automatic controls and the ability to utilize a variety of interchangeable lenses. Their standard lens can be replaced with lenses that change the size and depth relationships of objects in a scene. Such lenses include wide-angle lenses, telephoto lenses, macro lenses, and zoom lenses. Professional and proconsumer DSLRs offer numerous creative controls and feature larger and more accurate imaging sensors which provide for greater picture resolution, less noise, and more color accuracy.

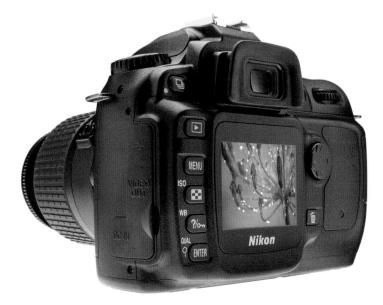

3.5 Nikon DSLR Courtesy of Nikon Inc. USA.

There are also special-use DSLRs capable of taking photographs in the ultraviolet and infrared light spectrums, which have been designed for use in the science, medical, law enforcement, and fine art fields.

Other Camera Types

Medium-format cameras are often preferred by professional photographers because their larger sensor or digital back can capture bigger files (more pixels) and thereby provide more precise and detailed images than their smaller counterparts — though at more expense, bulk, and weight. Medium-format cameras can also be shot in a variety of aspect

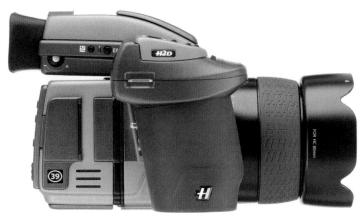

3.6 Hasselblad medium-format DSLR with digital back. Courtesy of Hasselblad USA.

ratios — that is, the ratio of its longest dimension to its shortest dimension — which differs depending on the camera or frame insert used. The most common aspect ratios are 6×4.5 cm (also known as 645, or rectangular) and 6×6 cm (also known as 2-1/4, or square). Other frequently used aspect ratios are 6×7 cm, 6×9 cm, and 6×17 cm (panoramic). *Panoramic* refers to any high aspect ratio (1.85 or greater) or wide-screen image or film format, which is especially suitable for scenic, horizontal landscapes. Some cameras have a switch that allows you to switch between different aspect ratios.

View cameras, such as the 4×5 inch, 5×7 inch, and 8×10 inch, have many additional adjustments that give serious photographers more creative control in setting up their compositions. They provide a lot of perspective control, but do require a tripod. Most such cameras use large digital backs or sheets of film to capture images of the highest resolution.

3.7 "I use my camera's built-in panorama mode to shoot and then stitch the images together to represent my interest in the appearance and meaning of our persistent attempts to dominate nature — the human impulse to impose geometric structure upon perceived chaos — and in nature's equally relentless attempts to absorb our imprint into its own larger order. In this particular image, I wanted the rising sun to appear exactly in the center, shining directly into the lens, so I started with the sun directly at my back, which allowed me to include my shadow as a point of self-reference, and work my way back around to the beginning. I utilize this bookend approach as a way of creating a sense of slightly distorted symmetry."

© Steven P. Mosch. Tabby Ruins #3, Spring Island, SC, 2002. 1-1/2 × 16 inches. Inkjet print.

Digital camera backs, designed for commercial applications, are available for 645, 2-1/4, and 4×5 film cameras, and their sensors offer unparalleled digital image capture. The digital back simply replaces the conventional film back.

Instant cameras use self-developing film, capable of delivering an image in under a minute and have largely been replaced by inexpensive digital cameras.

Disposable cameras offer an inexpensive way to experiment with different imagemaking devices, including waterproof, underwater, and panorama models.

Panoramic cameras are specifically designed to create images with exceptionally wide fields of view by means of a high aspect ratio, in which the length of the image is

much greater than its height. The lens of a true panoramic camera rotates to scan a scene, which is captured on a wide sensor or on film. The broad sweep of the rotating lens records the scene with minimum distortion and is useful for photographing expansive landscape and large groups of people. True panoramic images capture a field of view comparable to, or greater than, that of the human eye — about 160×75 degrees. There are software programs that will "stitch" images made with wide-angle lenses into panoramas. In addition, there are digital cameras that offer different aspect ratios, including panoramic (see Figure 3.7).

Sequence cameras make a series of exposures over a specific amount of time, on either one frame or on consecutive frames. *Stereo cameras* have twin lenses, 2-1/2 inches apart, which allow imagemakers to work with the illusion of depth.

Toy cameras, such as the Holga, challenge the accepted standards of image quality and encourage playfulness and simplicity.

Underwater cameras have a watertight seal or special housing that allows them to be used when swimming, snorkeling, or scuba diving (see Figure 3.8).

Pinhole cameras do not have a lens and can be made out of an oatmeal box or a coffee can. The light producing the image passes through a small aperture, which can be made with a small sewing needle. The shutter usually consists of a hand-operated flap of heavy, black tape to cover and uncover the pinhole. Pinhole cameras need much

3.8 "I explore the relationship between people and water. I am interested in the distortions caused by reflection and refraction of light, as well as the color and texture of the water itself. The drenched people inside the watery world create an insular and timeless environment of immersion. After scanning the negatives, I put this image together using layer masks and adjustment layers to make it seamless. I elongated the figures to make them have an eerie effect. My goal was to show a group of similarly attired, but diverse colors of clothes on people who are gathered together. My hope is that viewers will make connections with current events, such as Muslim women wearing the chador or other coverings, or with ideas such as the types of clothes worn by women in Margaret Atwood's book, *A Handmaiden's Tale* (1985)."

© Anne C. Savedge. Gathering, 2006. 24 × 40 inches. Inkjet print.

longer exposure times than conventional cameras because of the small aperture; typical exposure times can range from a few seconds to more than an hour.

Pinhole cameras with CCDs are sometimes used as spy cameras for surveillance work because of their small size. A pinhole drilled into a camera body plate cap that screws into the camera's lens mount

3.9 Spencer made this 1-second exposure by putting a pinhole body cap on her DSLR in place of a lens. "To use a pinhole body cap on my digital camera, I set the camera to the Manual exposure mode and find the correct exposure by trial and error. For me, the white horse is an archetype representing power, transience, and freedom. The black horse that appears in the shadow of the neck of the white horse was a gift from the pinhole gods. I didn't see it until I printed the image."

© Nancy Spencer. White Horse, Black Horse, 2006. 10 × 15 inches. Inkjet print.

in place of a lens can convert a digital camera into a pinhole camera (see Figure 3.9). Precision-made pinhole body caps are commercially available from sources such as the Pinhole Resource (www. pinholeresource.com) and fit many cameras, including view cameras. To prevent dust from getting on the sensor, you hold the camera face down and quickly change to the body cap.

Homemade cameras can be specifically constructed to meet your own unique way of seeing (see Figure 3.10).

3.10 Taft made this 15-second exposure with a self-made camera that uses a lens and bellows connected to a converted flatbed scanner powered by a laptop computer. This arrangement allows Taft to move the lens board during exposures, "almost like playing an accordion and experimenting with anamorphosis [distortion]." Taft also added an infrared filter to the lens to take advantage of the scanner's high sensitivity to the infrared spectrum. Depending on the direction of the movement relative to the direction in which the scan head travels, image segments are either stretched or compressed, while stationary objects remain unaffected.

© Steven Taft. Kandice, 2006. 6-3/4 × 7-3/4 inches. Inkjet print.

Spy or *hidden cameras*, commonly found in banks and stores, are used to make still or video recordings of people without their consent or knowledge. They have also been used in "reality" television shows to capture unsuspecting people in unusual or embarrassing situations.

A *web camera* or *webcam* is a real-time camera whose images can be accessed using the World Wide Web (WWW), instant messaging, or with a computer video-calling application. Generally, a digital camera delivers images to a web server, either continuously (streaming) or at regular intervals. Today, webcams provide views into homes and buildings as well as views of bridges, cities, and the countryside. Webcams also monitor traffic and weather and are used by police for public safety and surveillance purposes.

Camera phones are the fastest-growing kind of digital camera. Their incorporation into mobile phones and other personal digital assistants (PDAs) allows one to take and transmit still or video images with a few keystrokes.

Multimedia cameras merge media boundaries with features such as digital still cameras, video recorders and players, plus MP3 players, all in a single device.

Additionally, photomicrographs can be made by means of a special apparatus that permits a camera to be attached to a microscope. Telescopes equipped with a clock drive and a camera-body attachment mount can be used to make images of the sky at night. Intriguing results can also be obtained by simply pressing the camera lens up to the eyepiece of either instrument and then reviewing and adjusting after each exposure (see Figure 3.11).

When the opportunity presents itself, it's a good idea to work with a camera format different from the one you normally use and compare

3.11 To make her birding images, Pearce places her digital camera next to the telescope eyepiece without an adapter "to encourage some lens feedback and odd reflections. Mode is set to aperture priority, and exposure is determined through the lenses of both the camera and telescope. The resulting capture is presented in a circle with a variety of colored vignetted edges. Why birds? I have a fascination with their ability to adapt using their amazing navigation skills, and they are omnipresent in myths, fairytales, and symbolism. Besides, they are just cool to watch and allow me to take the time to relax."

© Jeannie Pearce. Female Blackbird, 2006. 16 × 16 inches. Inkjet print.

the resulting images. Become aware of how the camera itself affects what you look at and how you see, and then interpret the results.

CHOOSING A CAMERA

Before choosing a camera, ask yourself: (1) How will I use this camera? (2) What types of pictures do I plan to take? (3) What will I do with the pictures? (4) How much can I afford to spend? These factors allow one to determine the resolution, size, ease of use, degree of creative control desired over the camera, and cost. Unless there are special circumstances or requirements, everyone should consider a digital camera because of their ease of use, the portability of your pictures as electronic data, and the convenience of organizing, controlling, and storing them electronically.

CAMERA FILE FORMATS

Any digital file uses a binary code to electronically record data, whether it is an image or text, which allows it to be stored, processed, and manipulated in a computer. Although all images are written in binary code, there are a variety of file formats for capturing and storing images. Each format has a unique method of translating resolution, sharpness, value, and color of a digital image, and each has its uses, advantages, and limitations. For this reason, it is important to select the file format that is best for your particular needs before making any images, as changes made later to the original format can result in loss of image quality (see section on Major Image File Formats).

Most digital cameras provide several file format options, such as JPEG, TIFF, and RAW, plus a range of quality settings in a variety of resolutions such as low, medium, and high which can be set to meet the needs of a particular situation. One must know the differences

between various file formats and quality settings, as well as the final print size, to get the desired results.

Image Compression Algorithms: Lossless and Lossy

To select the right file format for the image quality you need, it is essential to understand image compression. Compression algorithms, a set of mathematical program instructions, are designed to reduce the original file size to create extra storage space or to speed up file transfer over a network. Digital cameras can compress images to save file space on the memory card.

There are numerous file compression types, but they all fit into two basic categories: lossless and lossy. Lossless compression uses an algorithm that allows a compressed file to recover all the original data when the file is uncompressed. Lossy compression, by contrast, permanently reduces a file's size by eliminating redundant data or data not visible to the average eye, and this data cannot be recovered. The loss of image quality in lossy compression is proportional to the amount of compression. Most lossy file types give you options for setting the amount of compression. Different file types are best for different applications (see Box 3.2, Other Major File Types).

Major Image File Formats

Quality cameras can save images in three file formats: JPEG (compressed), TIFF (uncompressed), and RAW (unprocessed), which are explained below.

JPEG

JPEG, which stands for "Joint Photographic Experts Group," is the default file format used on most digital cameras because it allows for

Box 3.2 Other Major Digital File Types

- GIF stands for Graphics Interchange Format and is a lossy format primarily used for the Web. GIF is excellent for flat color graphics but is not ideal for photographs.
- PNG, or Portable Network Graphics, format was designed to supplant the older GIF format. A lossless file format with good compression, its two major uses are the World Wide Web and image editing. It is a substitute format for many of the common uses of the TIFF format.
- EPS is short for Encapsulated PostScript. EPS files were designed for saving high-resolution documents, illustrations, and photographs for electronic prepress for page layout software in the printing industry.
- PICT is encoded in Macintosh's native graphics language. PICT files are lossless, can be opened on the Windows platform, and can be saved in most software applications.
- BMP is the standard Windows image format. It is lossless and designed for pictures or graphics.
- Program-specific file types, such as Photoshop (.psd) or Illustrator (.ai), are native file formats that contain the maximum amount of information about an image for use in its own native program. Sometimes these native files are much larger than similar common file formats because the program-specific features are saved only in native file formats. When saving an image to a common file format, which is sometimes called a non-native file format, the image's layers may have to be combined, and certain formatting information may be eliminated.

the maximum number of pictures per megabyte of camera memory. JPEG is a compression format that uses *Basic*, *Normal*, and *Fine* settings on the camera to manage both the amount of compression and the resulting image quality. Do not confuse JPEG settings, which control image quality through compression, with the image size settings *Large*, *Medium*, and *Small*, which control document size.

JPEG is an excellent file format, but images cannot be restored to their original file size because information has been permanently eliminated. The JPEG image file format uses a lossy compression scheme and is commonly used for low-resolution, continuous-tone images on the Web. JPEG compression also allows the creator to decide the trade-off between file size and image quality: higher quality means larger file size, and smaller file size means lower image quality. JPEG files should not be opened and resaved multiple times because images will slowly deteriorate (due to the lossy compression scheme) and become soft and pixilated. Compression is like crushing an eggshell and gluing it back together. During the rebuilding process, tiny pieces are lost, the glue smears, and the shape is not quite smooth. The more you crush, the more noticeable the defects: abrupt color and highlight gradations, loss of sharpness, jagged lines, and swirling patterns are a few such problems, known as artifacts. It is always best to go back and work from your original file format (RAW, TIFF, PSD [Photoshop file]) when remaking JPEG files.

TIFF

An acronym for Tag Image File Format, TIFF saves a file without compression and is the current standard in the graphics and printing fields and in cases where an image needs to be examined digitally in detail. The TIFF format is used to exchange files between applications, computer platforms, and for high-quality printing. Lossless compression options are available for TIFF files, but generally are not used because many high-quality output devices will only accept uncompressed TIFF files. Even compressed, TIFF files are much larger than inherently compressed GIF or JPEG files. TIFF is known as an interchange format, easily opened on any platform, and is considered one of the most universally accepted high-resolution file formats.

RAW and Post-Processing

The RAW file format is a type of import/export format rather than a storage format. RAW files are made up of unprocessed sensor data. The RAW file format can be considered a pure "digital negative" because it contains unmanipulated binary files with information pertaining only to individual pixels from the image sensor. When a RAW image format is saved (shutter released), only the sensor data is saved; there is no post-processing for color balance, color palette compression, size, white balancing, or sharpening that is required with other file formats. The data is not formatted for a specific application, and the main advantage of these files is that they are uncompressed and smaller than TIFF files. All image processing is done later using computer imaging software; this allows for unparalleled control over the interpretation of the image in terms of tonal rendition, color balance and saturation, and detail rendering (noise reduction and sharpening). Professional photographers prefer making and using the RAW file format because its pure, unprocessed pixel data gives them the most flexibility and control when converting to other file formats (see Chapter 8's section on Working with RAW File Formats).

DNG

When the RAW format was introduced, it came not from a central source, but rather from various DSLR makers who produced their own competing proprietary systems and software. Since their specifications are not publicly available, not every RAW file can be read by a variety of software applications. The Digital Negative (DNG) format is Adobe's attempt to solve this vexing situation by introducing an open format that they hope will be universally adopted by the camera manufacturers (see Chapter 8's section on Working with RAW File Formats).

OPENING FILES

Regardless of the type of file you are working with, all computer files have what are called *file headers*, which is the portion of the file that tells the computer what the file is, what program created it, the date it was created, and so on. Although the files themselves can easily go back and forth between various computer systems, the file headers do not always properly work. When one double-clicks on a file, the computer reads the header and attempts to guess what to do with the file. Sometimes it guesses wrong. If you have trouble opening a file, open it within the application.

Once an image file is downloaded to your computer and opened, digital imaging software can be used to change size, colors, contrast, and other image characteristics. Software can also be used to drastically alter and/or combine images or to create a new image that did not previously exist in reality.

THE LENS SYSTEM AND EXPOSURE

The heart of the digital camera is its lens, which is made of opticalquality glass shaped to bend light rays to form an image. The camera lens system collects light rays coming from a subject in front of the camera and projects them as images onto a sensor, at the back of the camera. In this way, the lens gathers enough light to make an exposure in only a fraction of a second. Without a lens, an exposure could be several minutes long, and it would not form a sharp image. The lens also determines the field of view and influences the depth of field in the scene.

A similar effect, known as a *mirage*, can occur naturally. For instance, people standing on the shore of Lake Erie in Cleveland have been known to see the distant sweep of the Canadian shore some 50 miles away. This is the result of an atmospheric inversion, in which a layer of cold air blankets the lake, topped by layers of increasingly warm air. When this happens, it can cause the light that filters through these layers from across the lake to bend, forming a lens that can create the illusion of distant objects. The air has to be extremely calm for the mirage to appear. If the wind blows, it distorts or dissolves the image.

Aperture

A key component of the lens system is the aperture, which is an adjustable opening created by an adjustable diaphragm, usually an overlapping circle of metal leaves. The aperture determines the amount of light entering the lens and on most cameras can be controlled either automatically and/or manually. When it is widened (opened), it permits more light to pass through the lens. When it is closed (stopped down), it reduces the amount of light passing through the lens. The various sizes of an aperture are called *f-stops*. On most adjustable cameras, the f-stops range from 1.4 or 1.8 to 22 or 32. DSLRs generally have the ability to set the aperture opening at any

point in the aperture range of the lens, such as f/8-1/2 or f/13. The selected aperture generally appears inside the viewfinder and/or in the data-panel readout display. The smaller the f-stop number, the larger the size of the lens aperture. Like shutter speeds, each f-stop lets in either twice as much light as the preceding setting or half as much light as the next higher setting. For example, if you open up the setting from f/11 to f/8, the aperture admits twice as much light into the camera. If you stop down the setting from f/11 to f/16, the aperture lets half as much light into the camera (see Figure 3.12).

Aperture/F-Stop Control/Shutter Control/Exposure Modes

The Aperture priority mode allows one to choose the aperture while the camera controls the shutter speed. The Shutter priority mode allows one to choose the shutter speed while the camera controls the aperture or f-stop. The Program mode automatically sets both the aperture and shutter speed. The Manual mode allows one to set both the aperture and shutter speed through an exposure display in the viewfinder and/or in the data-panel readout display.

A camera's built-in light meter automatically determines exposure by selecting a combination of f-stop and shutter speed based on similar situations in the camera's internal database. Shutter speeds control exposure by varying the duration of time the shutter is open. Typically, DSLR cameras have shutter speeds that range from 1/4000 second to 30 seconds. Faster shutter speeds are used to ensure the image is sharp when either the cameraperson or the subject is moving. F-stops control exposure by letting in greater or lesser amounts of light. Smaller f-stop numbers, such as f/2.8, let in more light, thus requiring a faster shutter speed (less light) to obtain a proper

3.12 The relationship between shutter speed, f-stops, and exposure. This illustration shows seven different combinations of f-stop and shutter speed that all equal the same exposure for an outdoor photograph made during a cloudless mid- to late afternoon day. In any given situation, there are many combinations that can provide an accurate exposure. An exposure of f/2.8 at 1/2000 second is technically the same as f22 at 1/30 second, although the resulting images would not appear the same due to the differences in depth of field and shutter speed.

exposure. F/22 lets in much less light than f/2.8, thereby requiring a much longer exposure or duration of time. Modern DSLR lenses have f-stops that range, on average, from f/1.2 to f/32.

Depth of Field

Changes in the size of the aperture affect the overall sharpness of the picture. As the aperture becomes physically smaller, the area of sharpness in front of and behind the point of focus becomes greater. This area of acceptable sharpness is called *depth of field* (see Figure 3.14). It extends from the nearest part of the subject area in focus to the farthest part in focus. A small aperture, such as f/11 or f/16, gives more depth of field than a large aperture. For example, a landscape photograph made with a small aperture, f/16, will have great depth of field, bringing subjects both in the foreground and in the background in focus. As you open up the aperture, the area in focus becomes shallower. At f/2 or f/4, the subject will be in focus, but objects in the foreground and background may be soft, not in sharp focus. For instance, a close-up photograph of a person's face may have a shallow depth of field (with the background behind the person visible but out of focus).

Digital cameras have smaller image sensors and smaller lenses than 35mm film cameras. The smaller sensors and lenses tend to create a much smaller circle of confusion, which is the circle of light formed by the lens in which the light rays are unfocused. The smaller the digital sensor, the smaller the circle of confusion, and therefore smaller the area with unfocused light rays. This can make it almost impossible to obtain a shallow depth of field (the range of distance between the nearest and farthest points from the camera that is rendered acceptably sharp). For instance, many digital cameras make it extremely difficult to create the soft-focus background that is de rigeur in portraiture and nature photographs. To attempt shallow depth of field, use your lens's longest focal length and largest f-stop possible. The smaller image sensors and lenses of inexpensive and proconsumer digital cameras will dramatically increase the depth of field, which can make a digital f/4 the equivalent of f/22 on a 35 mm film camera. This can be controlled with post-capture software filters such as Lens Blur (see Chapter 4's section on Digital Filters and Plugins).

3.13 "This work looks at how humans live with animals, how they define us, and how we define them in relation to us. I explore simulation, consumption, destruction, and reconstruction of the natural world while seeking to understand how the human connection to the rest of nature is often developed through assimilation and appropriation. Under existing fluorescent lights, I squatted to be at the pig's eye level and opened my lens to the widest aperture so their eyes would be sharp and everything else would fall out of focus."

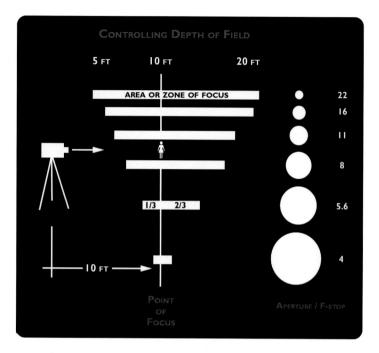

3.14 Depth of field and the zone of focus. Focusing on a subject creates a "point of focus," which is always in focus regardless of the f-stop or aperture used. The point of focus begins a zone of focus, and it radiates from that point, moving both in front of and behind the subject. Figure 3.14 shows that the zone of focus is not evenly distributed from the point of focus (10 feet) but is distributed one-third toward the camera and two-thirds behind the point of focus (subject). Also, as the camera gets closer to the subject, the amount of inherent depth of field drops off at any f-stop.

F/22 gives the greatest depth of field, often referred to as *extended depth of field*. All subjects within this zone of focus will be sharp, with equal prominence, and thus will visually live within the same contextual space. F/4 gives the shortest depth of field, referred to as

Box 3.3 Hints to Control Depth of Field

To create images with limited depth of field, get very close to your subject (2–4 feet) and use the large f-stops such as f/2, f/2.8, f/4, or f/5.6. This will put the background out of focus, thus emphasizing the main subject.

To create images with extended depth of field, move back from the main subject (8–15 feet) and use the small f-stops such as f/8, f/11, f/16, or f/22. All subjects within this zone of focus will visually relate to one another because of their equal prominence.

Remember: To maintain proper exposure when adjusting the f-stop in manual mode (M), be sure to change the shutter speed. Use aperture preferred mode (AP) when experimenting with apertures.

Hold the camera absolutely still when using f/16 or f/22, as the shutter speed may drop below 1/30 of a second, and any camera movement will affect overall sharpness.

limited depth of field. A short or limited depth of field helps isolate a subject from the background or foreground, giving it more visual emphasis.

Focal Length

What Focal Length Establishes

Lenses are described by their focal length, which is the distance in millimeters (mm) between the lens and the image it forms on the sensor or film when it is sharply focused at infinity (the farthest possible visual distance). Focal length determines the angle of view — how

much a lens sees — which controls what portion of a scene will be captured. The portion that gets recorded is also dependent on the size of the sensor or film. The lens's focal length determines the magnification, that is, the size of the image that the lens forms.

The Focal Length Rule

As the focal length of a lens increases, its angle of view decreases because the magnification increases, which results in the object's becoming larger in size. Focal length also affects perspective. As the focal length and magnification of a lens increase, the image becomes more compressed, resulting in less visual distinction and separation between the foreground, middle ground, and background.

35mm Film Camera Equivalencies

One often sees 35 mm film camera lens equivalencies given to digital camera lens focal lengths. This can be traced back to 1924 when Leica Camera, formally Ernst Leitz, invented the first practical 35 mm handheld camera that used roll film capable of recording 36 exposures. These first Leica cameras utilized existing 35 mm-wide movie film manufactured by Eastman Kodak, which produced a 24×36 mm recording area when exposed between the film's sprocket holes. Historically, this 24×36 mm image area has been used to determine the angle view or look associated with any normal, wide-angle, or telephoto lens used over the years with the traditional 35 mm film camera (see the section on Types of Lenses).

Angle of View

The expected angle of view or look associated with normal, wideangle, or telephoto lenses has changed with digital photography because the image sensor in most cameras is smaller than the historical $24 \times 36 \,\mathrm{mm}$ recording area, making the focal length of digital camera lenses numerically longer (more telephoto) than their film camera equivalents. For example, a 50 mm lens, having an angle of view of about 47 degrees, was considered to be the normal lens for a 35 mm film camera. If your digital camera has an image sensor that is smaller than the customary $24 \times 36 \,\mathrm{mm}$ recording area, the DSLR lens will effectively become more telephoto, creating a smaller angle of view (see the next section on Calculating the Picture Angle). Camera manufacturers do produce expensive, full-frame DSLRs whose image sensors are equivalent to the 35 mm film size, making their angle of view the same as the 35 mm film cameras. Table 3.1 shows some typical angles of view from 35 mm film format designations and their equivalent digital designations.

Calculating the Picture Angle Factor/Sensor Equivalency

Unless the image sensor in your digital camera is the exact size of a comparable film format, the image area covered by your digital lens will differ from that of a 35 mm film camera. The smaller sensor size of most digital cameras gives them a narrower angle of view (more telephoto), essentially cropping (reducing) the area of view. A "crop" or picture angle factor has been developed to provide a lens millimeter equivalency between the full-frame 35 mm film format lenses and any size digital sensor. By multiplying the sensor equivalency by the 35 mm film camera lens size, one can determine the new digital focal length of a film lens when used on a particular digital camera. For instance, a 50 mm lens combined with an image sensor having a picture angle factor of 1.6 becomes an 80 mm lens ($50 \times 1.6 = 80$).

Angle of View	35mm Film SLR	DSLR (1.6X)
(114°–94°) Super Wide Angle	14mm-20mm	8.7 mm-12.5 mm
(84°–63°) Wide Angle	24 mm-35 mm	15 mm-21.8 mm
(47°) Normal Lens	50 mm	31 mm
(28°–8°) Telephoto	85 mm-300 mm	53.1 mm–187.5 mm
(6°–3°) Super Telephoto	400 mm-1000 mm	250 mm-625 mm

 Table 3.1 Angle of View Equivalency Table

As there is no standard sensor size, the angle of view at any given focal length will vary from camera to camera, depending on the size of the sensor. If the same 50 mm lens is combined with an image sensor that has a picture angle factor of 1.5, it then becomes a 75 mm lens ($50 \times 1.5 = 75$).

When a 35 mm film camera lens is used on a DSLR that does not have a full-frame 24×36 mm sensor, the focal length of the lens increases by a specific factor (X) that is determined by the size of the sensor, which in turn reduces its angle of view and thereby makes the lens more telephoto. Based on 35 mm film SLR lens standards, Table 3.2 shows what millimeter lens is needed to maintain the same angle of view with a DSLR lens, based on a DSLR having a crop/ picture angle factor of 1.6X. Check your camera manual to determine its exact sensor size, which will give you the proper picture angle factor.

This proper picture-angle factor also applies to DSLRs that will accept older film camera lenses. For example, suppose you want to determine the digital equivalency of a 24mm wide-angle film lens that is compatible with a DSLR that has a crop/picture angle factor

Table 3.2 Focal Length Conversion Table

35 mm Film SLR		DSLR (1.6X)
14 mm-20 mm	=	21 mm-30 mm
24 mm-35 mm	=	36 mm-52 mm
50mm, Normal	=	75 mm, Normal
85 mm–300 mm	= ,	127 mm-450 mm
400 mm-1000 mm	=	600 mm-1500 mm

of 1.6. You would multiply 1.6 by 24 mm and discover that this lens now becomes a 38 mm lens on this digital camera, giving it a narrower angle of view and thus a more telephoto effect. To calculate what lens you would need to create the same wide-angle view as the 24 mm lens did on a film camera, you would divide 24 mm by 1.6, which shows you that a 15 mm film lens is required. When using a film SLR lens on a DSLR camera, what is seen in the viewfinder is directly captured by the digital sensor. What you see is what you get, and

82 0

there is no need to mentally crop the picture, but you will notice that the angle of view or the look has changed.

Focusing the Image

In addition to concentrating the incoming rays of light, the camera lens serves to focus them on the sensor. As light rays pass through the aperture into the camera, the lens bends them so that they form a sharp image. The sharpness of the image depends on the distance between the object and the lens and between the lens and the sensor. DSLRs have a focusing control that changes the lens-to-sensor distance, either automatically and/or manually, thereby allowing a sharp image of the subject to be formed at various distances. Inexpensive cameras may have a fixed focus or zone control that sets the focus for predetermined close-up, portrait, or landscape distances. With a manual focus camera, you select the part of the scene you want to be sharpest and adjust the lens barrel to obtain that result.

DSLR cameras use ground-glass viewing screens to show you how your picture will appear. Light coming through the lens strikes a translucent piece of glass that has been ground. This ground glass creates a surface on which the photographer, looking through the viewfinder or monitor on the back of the camera, can see and focus an image. The lens barrel can be automatically and/or manually controlled until the image appears at the desired level of sharpness. Ground-glass focusing can be aided by a microprism: a small circle in the center portion of the viewfinder that appears dotted until the image is focused. Sometimes a split-image focusing aid is used instead, whereby the image appears to be slightly out of register until it is focused. Rangefinder cameras rely on split-image focusing, which operates by superimposing two images of the same scene.

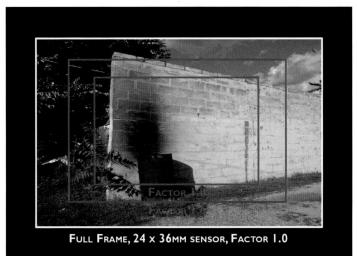

3.15 Image Factors Sensor Equivalency: Full-frame image sensors compared with smaller image sensors. The white rectangle shows what a full-frame DSLR or 35 mm film camera will record. The inner red frames show what a DSLR having a smaller digital sensor and corresponding image factors of 1.6X and 1.8X will record. This factor (which can be found in your camera manual) is sometimes called the *crop factor*, but no cropping is involved. The angle of view visible in the camera viewfinder will only be more or less than one expects.

Autofocus Modes

The majority of DSLRs have two focusing modes: Manual and Autofocus. Most DSLRs either have an active (infrared) autofocus (AF) or a passive autofocus system, which automatically focuses on objects at a certain distance from the lens. Active autofocus sends out a beam of red light that the camera uses to measure and set the distance of the subject. In passive autofocus, light that is naturally

reflected by the subject is used to read the contrast of a scene and set the focus. Some cameras have an eye-activated autofocus system. Move your eye to the viewfinder and the camera focuses on whatever it is pointing at, based on your AF zone selections (see below), which can be turned off to prevent it from focusing every time something is near the viewfinder.

DSLRs usually have a variety of autofocusing zones. In singlearea focus, the camera focuses on a subject in the selected area only; in area focus, the camera uses information from multiple focus areas to determine the focus; and in closest-subject focus, the camera automatically selects the focus area that has the subject closest to the camera. Pressing the shutter release button halfway down will lock autofocus at a specific distance. Autofocus options often include Single-servo and Continuous-servo focus settings. Single-servo locks the focus at the time of exposure. Continuous-servo allows the camera to focus constantly while the shutter-release button is pressed halfway, which is useful when photographing moving subjects. The downside of continuous focus is that it drains the battery faster and can be noisy. DSLRs offer an AF Assist Lamp, which flashes a small amount of light as a focusing aid, allowing the autofocus to function in lowlight situations. Some cameras have specialty modes, such as face detection (FD), which gives precedence to the faces in an image, ensuring that they come out looking crisp and well lighted. The camera can pick out faces in a scene and is not thrown off by eyeglasses.

Types of Lenses

The lens defines the fundamental image characteristics of magnification, angle of view, and perspective; hence, lenses are designed for different purposes. A change in focal length allows you to come closer to the subject or to move away from it and therefore also has an indirect effect on an image's perspective. DSLR cameras typically use interchangeable lenses. Inexpensive cameras, such as in cell phones, often have fixed focal-length lenses, but the vast majority of all digital cameras come with either an interchangeable or fixed zoom lens that allows the focal length to be varied.

Zoom Lenses

In pre-digital times, most cameras came with a fixed focus lens, which required the photographer to physically move to change the distance between the camera and the subject. Today, most digital cameras have a zoom lens that covers the physical distance for you by combining a range of focal lengths into a single lens, providing both wide-angle and telephoto coverage. When using film cameras, photographers were aware of the focal length (angle of view) of the lens they were using. With digital cameras' different sensor sizes, little attention is paid to focal length, due to the lack of a standard formula for focal length to angle of view. Instead, we simply adjust the focal length as we compose the scene. Once photographers wrote down their exposure information to learn what combinations of aperture and shutter speed worked best for them in certain situations. Today's digital camera lens does not have an aperture ring. Instead, this information is shown in its data display. Now digital cameras automatically record the exposure information — lens focal length, aperture, shutter speed, and other camera functions of each exposure - for later reference (see later section on Metadata). This abundance of data is rarely analyzed because the automatic features on digital cameras can deliver good results 99 percent of the time. Nevertheless, the optical

characteristics of lenses remain the same as in the past, and having a conscious awareness of their qualities can be useful in making stronger compositions and creating a more personal vision.

Normal Lens

In traditional 35 mm film photography, lenses with a focal length of 50 mm are referred to as "normal" because they work without reduction or magnification and generate two-dimensional images in a manner camera manufacturers considered similar to how humans see a scene with our naked eyes, which encompasses a picture angle of about 47 degrees. The straightforward optical qualities and minimal amount of distortion of a normal lens allows the formation of what was considered a natural photographic representation of the size relationships of the subjects that make up a composition.

A DSLR with a 35mm equivalent size sensor also continues this tradition of using a 50mm lens as its normal focal length. However, most DSLRs use a smaller size sensor, which needs a shorter focal length lens, somewhere in the range of 31 to 38mm, to produce the same angle of view (47 degrees). This is because the smaller sensor multiples the focal length of a 35mm lens by about 1.5X, 1.5X is the sensor factor and can vary.

There are digital camera lenses designed to reduce the size of the image-forming circle as compared with regular 35 mm lenses. This decreases the telephoto effect and thereby allows for wider angles of view; plus, it trims down a lens's size and weight. For instance, a 12 mm digital lens used on a camera with a sensor factor of 1.5X would have an angle of view of 99 degrees. Check your manufacturer's website for details.

Wide-Angle Lens

Wide-angle lenses (short focal length) capture a broader view of a scene than a standard lens does by making subjects appear smaller than they would with a normal lens. A wide-angle focal length is handy for large scenes and in locations where it is not possible for one to move back far enough to photograph the entire scene. Wide-angle lenses encourage a photographer to step into the scene to fill the frame. Getting closer to your subject gives the composition a sense of involvement, by placing the viewer inside the action rather than at a distance from it.

Wide-angle lenses capture more subject detail by providing greater depth of field (the area of acceptable sharpness) at any given f-stop than a normal or telephoto lens. For instance, if you set your zoom lens to its widest focal length, focus on a subject 6 feet away, and stop down to f/11, it should render everything from about 3 feet to infinity in acceptable sharpness. This can be a very effective device in making dramatic near-far compositional relationships. For example, a landscape composition would have the predominant features in the foreground and a wide expanse in the background both sharply in focus. A moderately wide-angle focal length is an excellent starting place for environmental portraiture, compositions of people and their surroundings, because it has broader coverage than a normal focal length and produces minimum distortion, thus allowing both the people and the immediate area to be in critical focus. A wide-angle focal length allows one to photograph in confined interior spaces and to take in multi-story buildings. However, one must pay attention to the distortion of straight lines that can occur from "barrel distortion" with wide-angle lenses, which can be corrected (if desired) by careful composition or later with imaging software. An extremely wide-angle

focal length offers tremendous depth of field, thus permitting one to get very close to a subject and produce exaggerated size relationships, unusual perspectives (due to distortion), and an intimate viewing experience which can be intentionally used to generate visual interest.

Because most pocket digital cameras have image sensors smaller than the 35 mm standard (which enhances the telephoto capabilities of the lens at the expense of reducing wide-angle coverage), an auxiliary wide-angle lens attachment is usually required to achieve wideangle capabilities.

Telephoto Lens

Telephoto lenses (long focal length) have a narrower picture angle than a normal lens and make subjects appear larger. Telephoto lenses have less depth of field at any given aperture than normal or wideangle lenses, allowing the subject to be sharp while the foreground and background are out of focus, making the subject clearly stand out. The limited depth of field means that focus is critical. Unlike wide-angle lenses that stretch space, telephoto lenses compress visual space, making subjects appear closer together than they really are. This can be useful in creating visual interest through unusual perspective. On the down side, telephoto lenses magnify lens movement so they require faster shutter speeds (see the shutter speed rule) or blurring will result. Telephoto lenses tend to be bulky, heavy, and are not as fast, having a higher starting aperture, than other lenses and often require a tripod or other support.

A telephoto is useful when it is not possible to get physically close to a subject, allowing photographers to take detailed pictures of distant subjects. A short telephoto focal length is excellent for

3.16 "I photographed the miniaturized interiors of my sister's old dollhouses with an ultra-wide-angle lens to suggest that they may be intimately occupied by the viewer. The scenes are intended to evoke deep unconscious fears and desires and explore tensions between childhood innocence and aggression. Gigantisized artifacts, elements, and unseen destructive entities act out against the unassuming environments. These transgressions reference adult anxieties that emerge early in life — desires for power and control; fears of natural disasters; domestic violence; understanding of our own potential for destruction; and the unknowable terrors that threaten to invade the tranquility of our insulated spaces of domesticity."

 \odot Mark Slankard. *Bathroom with Twin Pop*, from the series *Minor Invasions*, 2005. 12 \times 18 inches. Chromogenic color print (Duratran).

portraiture. It permits a photographer to stand back from the subject and delivers a highly naturalistic rendition of the human face, avoiding the distortion typical of shorter focal lengths which exaggerate whatever is closest to the lens, usually the nose and chin. Wide-angle focal lengths also tend to stretch the shape of the human head, giving it an unnatural appearance. A longer focal length is good for tight compositions of small objects because you don't have to be right on top of the subject to fill the frame. The extra working space also leaves room for the placement of artificial lighting or the use of flash. A longer focal length is commonly used to capture close-range sports action. Wildlife photographers regularly use extremely long focallength lenses to make close-up views of distance animals.

Special-Use Lenses

A macro lens, which is used in extreme close-up photography, focuses on subjects from a close distance, often allowing small subjects to be photographed 1:1. Most digital cameras have a Macro mode, which facilitates close-up work (see Chapter 9).

A *fisheye lens* has a super-wide angle of view — up to 180 degrees. It produces tremendous depth of field and extremely exaggerates the differences in size between subjects that are close to the camera and those that are farther away.

A *perspective control lens* shifts up, down, or sideways to correct for perspective distortion caused by parallel lines, such as on buildings, which tilt toward each other if the camera is tilted. Such a lens works properly only with a DSLR.

Ultimately, there is no such thing as a "normal" lens. Normalcy depends on how one sees the world. Some prefer wide-open expanses while others like a tighter, narrower view. Vision is not fixed. It can change depending on the subject or the maker's state of mind. When possible, you should experiment by using different focal lengths or physically changing the camera-to-subject distance to see how it affects your composition and the results you desire.

Shutter

Along with aperture, the shutter is the other key component of the imaging system, for it controls the amount of time (shutter speed) that the light-forming image strikes the sensor. Typically, DSLRs allow exposures as long as 30 seconds to as fast as 1/8000 of a second in small increments of time such as 1/60, 1/80, 1/100, or 1/125 of a second. They usually have a B (bulb setting), which allows the shutter to remain open as long as the shutter release button is held down. DSLRs may use a combined mechanical and CCD electronic shutter that turns the sensor off and on to control exposure time.

Shutter Speed Control

Shutter speeds can be controlled through the Shutter Priority mode: you choose the shutter speed via the command dial, and then the camera automatically selects the aperture. Or you can set it in Manual mode. The selected shutter speed generally appears in the data-panel readout display.

As the shutter speed increases, the amount of light reaching the sensor decreases. For example, a shutter speed of 1/125 of a second lets in twice the amount of light as a shutter speed of 1/250 of a second and half the amount of a shutter speed of 1/60 of a second. Slow shutter speeds will allow moving objects to blur, while high shutter speeds can be used to freeze motion.

Box 3.4 Shutter Speed Rule

Using a shutter speed equal to or greater than the focal length of the lens will help to ensure sharp, shake-free exposures.

To avoid blurry images caused by camera shake, follow the *shutter speed rule*: Use a shutter speed equal to or greater than the focal length of the lens. For example, when photographing with a 125 mm focal length, use a shutter speed of 1/125 of a second or higher.

Shutter Lag

Shutter lag is the time difference between when the shutter is pressed and when the camera actually captures the image, a gap of time that often makes you miss the moment you wished to record. Shutter lag is due to the camera having to calculate the exposure, set the white balance, focus the lens, charge the sensor, and transmit the capture data to the circuitry of the camera for processing and storage. It is more pronounced with smaller inexpensive cameras, whereas highquality DSLRs have little or no shutter lag.

Camera Movement

Sometimes dim lighting conditions prevent one from following the shutter speed rule. To make imagemaking possible in such instances, many digital cameras offer an optical image stabilization option, which helps eliminate blurry photographs caused by camera movement. This feature works by means of a built-in gyro sensor that detects any hand movement and relays a signal to a tiny microcomputer inside the camera, which instantly calculates the compensation needed. A linear motor then shifts the lens as necessary to guide incoming light from the image straight to the CCD.

Shutter Modes

The shutter may be programmed for different shooting modes. *Single frame* takes one photograph each time the shutter release button is

pressed. *Continuous* records photographs at faster rates, such as three frames per second, while the shutter release button is held down. *Self-timer* automatically fires the shutter about 10 seconds after the shutter release button is pressed, which is good for self-portraits or to reduce camera shake. The camera is usually placed on a tripod or a flat, level surface when in this mode. Some cameras also have an optional delayed remote control feature, which fires the shutter with a hand-held remote control. Some allow multiple exposures in one image, with the ability to automatically compensate for the multiple exposures. The selected shooting modes appear in the data-panel readout display.

In addition, many cameras offer Motion Image, which records short bursts of low-resolution moving images. Many cameras with this feature also have a microphone for recording audio when using the motion and still image recording features and a speaker to listen to the audio recorded on your motion and still image recording segments as you play them back on the monitor screen.

Determining Exposure

Proper exposure chiefly depends on (1) the lighting, (2) the subject, and (3) the desired depth of field. Each of these factors may require an adjustment in aperture size or shutter speed. You need to choose a combination of settings that will meet all your requirements (see Chapter 4).

The amount of light in a scene affects both shutter speed and aperture size. On a cloudy, overcast day, you would reduce the shutter speed and increase the f-stop. On a bright, sunny day, you would use a fast shutter speed and a small aperture. 3.17 The walking sequence was made using the camera's continuous shutter mode during the late afternoon on the winter solstice. "The principal function of the woman in a grid of multiple frames is to draw us into the landscape. We see her through the monoptical eye, the conventions of a moving (digital) camera which follows behind. Layered with the set of walking images is the representation of a kind of parallel, 'perfect' world, in this case the numeric world of the daily Sudoku puzzle, starting at 100% opacity in the upper left to 20% in the last walking image."

© MANUAL (Suzanne Bloom and Ed Hill). Solstice 12.21.05/Daily Sudoku 12.21.05, 2006. $34-1/2 \times 35-3/4$ inches. Inkjet print. Courtesy of Moody Gallery, Houston, TX.

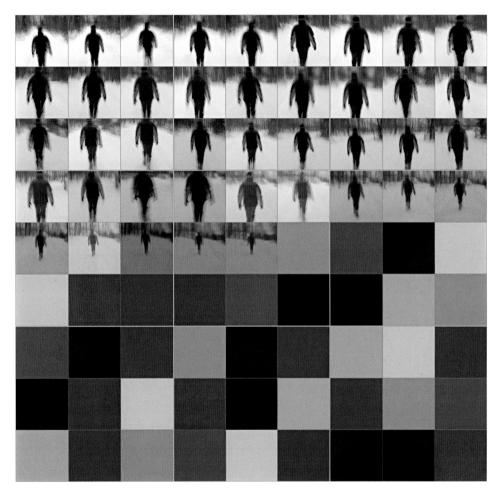

The type of subject to be photographed may require an adjustment in the shutter speed, and depth of field may determine the aperture size. If the subject is moving, you must increase the shutter speed to stop the action. If you want greater depth of field in your photograph, you need to select a small aperture. If you adjust either the shutter speed or the aperture size, you must also adjust the other to maintain the proper exposure. A fast shutter speed stops the action, but it also reduces the light reaching the sensor. To make up for this reduction in light, you should increase the f-stop. Similarly, a small aperture increases depth of field, but reduces the amount of incoming light. Therefore, you should change to a slower shutter speed.

Suppose you want to photograph your dog on a sunny day. A suitable exposure might be a shutter speed of 1/125 and an aperture of f/11. If your dog is moving, you might increase the shutter speed to 1/250. This speed is twice as fast as 1/125, and so half as much light will reach the digital sensor. You should make the aperture twice as large by setting it at f/8.

You may want the photo to include a bone on the ground in front of your dog, and also the bushes in the background. To make sure these extra subjects are in acceptable focus, you can increase depth of field by reducing the aperture size. At a setting of f/16, the sensor will receive half as much light as it did at f/11. You should also change the shutter to the next slowest speed, doubling the length of the exposure time. At a slow shutter speed, however, movement by your dog or the camera may cause blurring to occur. A better option in this situation might be to retain the faster shutter speed and increase your ISO setting. For details, see Chapter 4, Exposure and Filters.

DIGITAL CAMERA FEATURES

Resolution

When choosing a digital camera, the key feature to consider, after optical quality, is the resolution that is measured in millions of pixels, known as *megapixels*. Generally, 1-megapixel digital cameras can create 2×1 inch prints at 300 PPI, without cropping, which are almost

Resolution, Megapixels	Digital Sensor Size, PPI	Largest Print Size at 300 PPI, Approx.
3.3 MP	1536 × 2048	4×7 inches
6.1 MP	2000 × 3008	6×10 inches
8.2 MP	2448 × 3264	7 imes 11 inches
10 MP	2592 × 3872	8×12 inches
14 MP	3024 × 4536	11×15 inches
20 MP	3712 × 5248	12×18 inches
39 M P	5412 × 7212	16×22 inches

Table 3.3 Camera Resolutions, Sensor Size, andMegapixels

indistinguishable from 100 ISO 35 mm film. Digital cameras with 3 and 4 megapixels can make indistinguishable prints up to 5×7 or even 8×10 inches. Cameras with 5 or more megapixels have no problem producing 8×10 inch prints that are almost indistinguishable from film. The main advantage of choosing a digital camera with more megapixels is it allows you to crop more freely to produce high-quality 8×10 inch prints from selected areas of your image file. The camera only records resolution measured in megapixels (see Table 3.3).

The resolution of digital cameras is a gauge for comparing the image sharpness or detail. Digital resolution is determined by the number of light-sensitive pixels that convert light into electrons in the camera's image sensor. On a computer screen, a pixel is one of the tiny points of light that make up the image. The greater the number of pixels, the higher the resolution. On a digital camera, a pixel is a photodiode that records the color and brightness of the light

As technology advances and sensor size grows past traditional film sizes sensors will be called by their real dimensions like film has been since its invention. No more encrypted conversions like 4/3" or 1.6 factor. Just real dimensions!

3.18 This figure illustrates the relative size of several standard sensor sizes in both compact and single-lens reflex (DSLR) digital cameras today. Inexpensive compact digital cameras of fewer than 5 megapixels have very small digital sensors. These small sensors are often given an imperial fraction designation such as 1/3, 2/3, or 4/3. This type of measurement originates from the 1950s, during the time of early video imaging vacuum tubes for television. Trying to infer a relationship between the fraction and the actual diagonal size of these small sensors is futile, and we accept these sensors as small and capable of producing only 4 × 6 inch photographic-quality prints.

that hits it. For instance, a resolution of 1600 \times 1200 indicates that the digital camera produces images at a maximum of 1600 horizontal pixels by 1200 vertical pixels, or 2.1 megapixels, compared with 20 million pixels for 35 mm color transparency film. DSLRs offer a selection of image sizes such as Large (3000 \times 2000 pixels), for making 11 \times 14 inch prints; Medium (2250 \times 1500 pixels), for making 8 \times 10 inch prints; and Small (1500 \times 1000 pixels), suitable for email attachments or web pages. Pro-consumer DSLR sensors are compared directly with the size of 35 mm film and have either a 1.5X, 1.6X, or 1.8X factor. Some high-end professional models have a digital sensor of 1X, which means the sensor is the same size as the image area of 35 mm film (24×36 mm). When the sensor size becomes larger than 35 mm film, sensors are then designated by their actual millimeter size. See Hasselblad's medium-format camera with a sensor size of 36 × 48 mm, shown earlier in Figure 3.6; it costs more than many full-sized automobiles!

Larger sensors are much more expensive to make, which sometimes makes largesensor cameras cost-prohibitive even to professional photographers. Squeezing more pixels into a smaller-sized sensor has an adverse effect by increasing noise (see Figure 3.20). Manufacturers engage in a constant balancing act between cost, sensor size, and number of pixels. Fewer pixels in a larger sensor size will always create less noise or unwanted artifacts. This advantage is always offset by an increase in cost.

Monitor

The vast majority of digital cameras has a monitor on the back of the camera, which shows the image that the lens focuses on. Some can be moved in a variety of positions, thus increasing the framing options by letting one compose while holding the camera above your head or below your waist. When not in use, the monitor should be kept clean and protected with a detachable, transparent monitor cover. Some digital cameras have both a monitor and an optical viewfinder. Others have only a monitor or electronic viewfinder (EVF) (see Chapter 4).

Compact and superzoom cameras and some DSLRs have a "live" monitor that is active whenever the camera is turned on. This allows one to compose an image without using an optical viewfinder, which has been eliminated on many cameras, and also lets you see previously recorded images in the camera's memory card so you can review your work as you make it. Monitors on most DSLRs are not live and only allow you to view previously made exposures. However, an after-market live screen can be added to the eyepiece of most DSLRs.

Composition guidelines can be displayed in the monitor and/or in the viewfinder. These thin horizontal and vertical lines make it easier to compose and/or to hold the cameral level. Monitors can quickly drain batteries; therefore, many DSLRs have a battery-saving option control that allows you to turn the monitor off or to program the length of time the monitor stays on. Video screens, whether in cameras, cell phones, laptops, or electronic billboards, have become de facto windows of the digital age, and many people prefer using the screen to compose their images. Instead of peering through the keyhole of a viewfinder, a monitor allows one to hold a camera at arms' length, which invites more interaction with the subject while promoting more opportunities for creative compositions. On the down side, certain monitors (LCDs, or liquid crystal displays) can be difficult to see in bright light or at certain angles; they use a great deal of battery power and are not an accurate guide of color, tonal values, or focus. In the end, choosing between an optical viewfinder or a screen comes down to a matter of personal preference and the type of picture-making situation you find yourself in (see section in Chapter 4 on Using a Camera Monitor).

Monitor Playback Mode and Histogram

The monitor can display an image both while it is being recorded and afterward when the playback button is pressed. The playback mode offers other options, such as viewing all the images on the memory card as well as all the shooting data, from exposure information to image size, plus the histogram of each image. A histogram is a graph that shows the distribution of the tones in the image, known as *brightness range* (see Chapter 4, Figure 4.2). The horizontal axis corresponds to pixel brightness, with dark tones to the left and bright tones to the right. The vertical axis shows the number of pixels of each brightness in the image. The monitor allows for single-image playback and multi-image thumbnails, typically in groups of four or nine images. There are controls that allow you to zoom in and enlarge an image. Selected images can be deleted and/or protected from erasure.

92 0

3.19 "Observing how digital photographers evaluate the quality of their images by looking at the histogram to see the distributions of highlights, shadows, and mid-tones brought to mind Ansel Adams's Zone System. Then my thoughts turned to the language of histograms - the "peaks," "spikes," and "valleys" that compose these small charts. In them I saw landscapes, and I began to connect them to Adams's love of natural form and photographic technology. I acquired a book of Adams's favorite images, scanned the images, and evaluated the histograms, looking for a variety that alluded to a simple, graphic landscape form. Using screen capture, I "grabbed" the histograms and then reopened them in Photoshop where I resized them to a suitable print quality. Lastly I paired the histogram with the title of its original Adams image and added "(2006)" to the ends of the titles to denote that this was a contemporary re-envisioning of Adams's work. Digital technologies have not only changed the way photographs are made and how photographers work, but they've given us new tools with which to reinterpret the history and aesthetics of the medium. The works of the past are not finished; new interpretations are waiting to be made. Digital technologies continue to influence the way photographers work today; so too can they change the works of past image-makers."

© Luke Strosnider. Dune, White Sands National Monument, New Mexico, circa 1942, from the series Ansel Adams/New Landscapes, 2006. 11 × 17 inches. Inkjet print.

See Chapter 4 for details about how to use the camera monitor to help determine proper exposure.

Various camera menus can also be displayed. These include the Setup menu for basic camera programming, including formatting of memory cards and setting the date and time; the Shooting menu which controls such functions as noise reduction and image optimization; the Custom Setting menu which controls the fine details of the camera's operation, from grid display to whether the camera makes a noise when the shutter is depressed or not; and the Playback menu which offers options for managing the images stored on the memory card and for playing pictures back in various formats such as automated slide shows. The monitor can be programmed to turn off automatically to save battery power.

Metadata/EXIF

Metadata (also known as *shooting data*) is the data that describes the data recorded by the camera that gives details about the shooting conditions for each exposure, which is attached in a file that uses an industry standard awkwardly known as the EXIF. Typically, metadata records the shooting information such as the camera model, serial number, time stamp, the aperture and shutter speed, lens focal length, sensitivity, white balance, and whether the flash was used. It is also usually possible to add keywords, copyright, GPS coordinates, and other information useful when later searching for files. Metadata can usually be accessed via the Playback mode in the monitor after each exposure and later during image processing.

Optical and Digital Zoom

Digital cameras are equipped with optical zoom, digital zoom, or both. Optical zoom physically magnifies the subject by moving the lens elements to the desired magnification. Regardless of whether the zoom is set at wide-angle or telephoto settings, the resolution of the image remains the same.

Digital zoom electronically magnifies the image by increasing the number of pixels until the desired magnification occurs using interpolation. Interpolating is a set of mathematical algorithms automatically applied when the original pixel dimensions are changed for resizing. For instance, an image can be increased from 1000 pixels to 2000 pixels by generating a new pixel by using the average of the value of the two pixels on either side of the one to be created. Digital zoom constructs, or interpolates, pixels to zoom in on a subject, which results in loss of surrounding pixels and decreased resolution and degrades the overall image quality because the program "guesses" or makes up information that was not in the original.

Digital ISO/Sensitivity

Digital cameras allow users to adjust for different lighting conditions by changing the aperture and the shutter speed. Digital cameras use the ISO (International Standards Organization) designation to describe sensitivity to light and the resulting effect on an image. Typical ISO numbers are 50, 100, 200, 400, 800, and 1600. The higher the ISO number, the more sensitive the CCD is to light, allowing pictures to be made in low light conditions without a tripod or flash. Increasing the ISO also amplifies digital noise (see the next section: Digital Aberrations).

To compensate for varying light levels, digital cameras adjust the electrical gain of the signal from the sensor. Increasing the gain amplifies the power of the signal *after* it has been captured on the image sensor. The ISO of any individual frame can be changed. For example,

one frame can be exposed outside at ISO 100 while another frame may be exposed indoors at ISO 800. ISO can be selected manually or automatically, where the camera automatically varies the sensitivity to ensure proper exposure and flash levels.

Digital Aberrations: Noise, Banding, Blooming, and Spots

Increasing the ISO has side effects. The higher the ISO setting, the greater the likelihood that pictures will contain "noise" in the form of randomly spaced, brightly colored pixels. Digital noise occurs most often in brightly lit or dark scenes where some pixels function incorrectly, resulting in "dead" or "hot" pixels. Hot pixels are bright white, whereas dead pixels lack all color. Using ISO 400 and higher or working in dim light may degrade the image quality with noise. Noise is a factor with all digital cameras, but it is reduced with higher megapixel cameras (see Figure 3.20). Many digital camera manufacturers suggest turning off "image sharpening" features, as these will exacerbate the noise problem (see section on Sharpening Mode). Imaging software programs usually have a Noise filter that can help reduce noise by discarding pixels that are too different from adjacent pixels.

Banding, unpredicted bands that appear in areas with no detail, is also more likely to occur at a higher ISO. Blown-out highlights that lack all detail and have spread or "bloomed" into adjacent image areas are caused by overexposure; this is known as *blooming*. Bracketing and exposure compensation are recommended to keep blooming in check. Most DSLRs can be custom programmed to automatically carry out these tasks.

94 0

DSLR cameras are designed for use with interchangeable lenses, and foreign matter can enter the camera when lenses are changed. Once inside the camera, foreign matter can adhere to the sensor or its low-pass filter, which is designed to help prevent moiré (an interference pattern of irregular, wavy lines). Dirt can adhere directly to the sensor and may appear as spots in images taken under certain conditions. These spots can be eliminated with imaging software. To reduce the chance of this occurring, point the camera down when changing lenses, try not to change lenses in dusty conditions, and use a clean body cap when there is no lens attached to the camera body. Check your specific camera manual for cleaning instructions.

White Balance

Digital cameras can automatically or manually adjust the color balance of each frame electronically, according to the color temperature of the light coming through the lens. One image can be white balanced for daylight, while the next one can be white balanced for incandescent (indoor) light. Better cameras have a larger variety of settings for different lighting sources; these can include any of the following: daylight, cloudy, shade, incandescent, and fluorescent (see Table 3.4). High-end digital cameras also offer white balance bracketing for mixed lighting sources. Learning how to adjust and control the white balance can mean the difference between capturing a spectacular sunset or having the camera automatically "correct" it down to gray sky.

Metering Modes

DSLRs have outstanding metering capabilities and options. Most offer *Matrix metering*, which uses the sensor to set exposure based on a

Table 3.4 Common Digital	White Bal	ance Controls
----------------------------------	-----------	---------------

Control	Description
Auto	White balance is automatically measured and adjusted.
Preset	White balance is manually measured and adjusted in the same lighting as the subject (a gray card is recommended as a target). This is useful under mixed-light conditions.
Daylight	Preset for daylight. Subsets let you make the image either more red (warm) or blue (cool).
Incandescent	Preset for incandescent (tungsten) light.
Fluorescent	Preset for fluorescent light. May have subsets for FL1 (white), FL2 (neutral), or FL3 (daylight) fluorescent lights. Check the camera owner's manual for the correct setting designations.
Cloudy	Preset for cloudy or overcast skies.
Shade	Preset for shade.
Flash	Preset for flash photography.
Bracket	Makes three different white balance exposures (selected value, reddish, and bluish).

variety of information from all areas of the frame, which is effective where the composition is dominated by bright and dark areas; *Centerweighted*, where the camera meters the entire frame but assigns the greatest weight to the center area, which is excellent for portraits; and *Spot*, where the camera meters a small circle (about 1 percent of the frame), which is helpful when the background is much brighter or darker than the subject. In particular modes, such as Aperture or Shutter Priority, the metering mode determines how the camera sets

the exposure. In certain programs, such as Closest subject, the camera also selects the metering mode (Spot).

Aspect Modes

Some digital cameras allow you to select from different shooting aspect ratios, such as 16:9, 3:2, or 4:3, which alter the width and height of the image frame. For instance, the 16:9 mode allows you to make dramatic, wide panoramic images.

Color Modes

Digital cameras have image-processing algorithms designed to achieve accurate color, but there are variables within these programs and within the scene that may produce distinct color variations. Professional cameras offer a range of application modes. For instance, one mode might be optimized to set the hue and chroma values for skin tones in portraits. A second mode could be Adobe RGB gamut–based, which gives a wider range of color for output on color printers. A third mode could be optimized for outdoor landscape or nature work. Lastly, there can be a black-and-white mode.

Image Enhancement Modes

Digital cameras have programming modes that automatically optimize contrast, hue (color), outlines, and saturation based on the scene being recorded. Standard exposure modes include *Normal*, suggested for most situations; *Vivid*, which enhances the contrast, saturation, and sharpness to produce more vibrant reds, greens, and blues; *Sharp*, which sharpens outlines by making edges look more distinct; *Soft*, which softens outlines to ensure smooth, natural-looking flesh tones; *Direct Print*, which optimizes images for printing "as is" directly from

Table 3.5 Major Image Enhancement Modes			
Enhancement Mode	Use		
Normal	Suggested for most situations		
Vivid	Enhances the contrast, saturation, and sharpness to produce more vibrant reds,		

	sharpness to produce more vibrant reds, greens, and blues
Sharp	Sharpens outlines by making edges look more distinct
Soft	Softens outlines to ensure smooth, natural-looking flesh tones
Direct Print	Optimizes images for printing "as is" directly from the picture file
Portrait	Lowers contrast and softens background details while providing natural-looking skin color and texture
Landscape	Enhances saturation and sharpness to produce more vibrant blues and greens
Custom	Customizes color, contrast, saturation, and sharpness
Monochrome	For black-and-white images

the picture file; *Portrait*, which lowers contrast and softens background details while providing natural-looking skin color and texture; *Landscape*, which enhances saturation and sharpness to produce more vibrant blues and greens; and Custom, which allows you to customize color, contrast, saturation, and sharpness. Additionally, some cameras provide a monochrome image profile for making black-and-white images, which often can be tweaked to adjust sharpness, contrast, filter effects, and toning (see Table 3.5). 3.20 Images were shot on an overcast day with a man seated inside a darkly lit pickup truck. ISO was set to 1600 for greater depth of field during flash exposure. Higher ISO settings allowed for more detail in surrounding ambient light areas not affected by flash.

ISO 1600 WITH NOISE REDUCTION WITH SOME LOSS OF SHARPNESS

ISO 1600, NOISE IS MOST APPARENT IN THE SHADOWS

Sharpening Mode

Sharpening increases the contrast of pixels around the edges of objects to amplify the image's apparent definition or sharpness and is most noticeable around the borders of light and dark areas. Digital photographs appear somewhat soft in focus because the image formed by the sensor is mosaic in nature, like classic tile pictures found in ancient Pompeii. Most digital cameras interpolate this mosaic into a smooth picture, but sharp edges get slightly blurred during the process. Some cameras sharpen the image as part of their software; others allow you to control the degree of sharpening (if any) you want the camera to do. Usually, however, you'll want to fine-tune this process in your imaging software program as part of your processing. Many imagemakers prefer not to have the camera do any sharpening, but choose instead to precisely sharpen only as needed with their imaging software, as oversharpening can excessively accentuate pixels, calling attention to them and thereby making an image appear exceedingly "digital."

DSLRs typically offer an array of sharpening modes including *Auto*, in which the camera automatically adjusts sharpening according to the subject, with results varying from image to image; *Normal*, where all images are sharpened by the same amount; *Low*, where images are sharpened by less than the standard amount; *Medium Low*, where images are sharpened by slightly less than the standard amount; *Medium High*, where images are sharpened by slightly more than the standard amount; *High*, where images are sharpened more than the standard amount; and *None*, where images are not sharpened at all.

Noise Reduction

Noise, in the form of randomly spaced, brightly colored pixels, may appear in an image capture when using an ISO of 400 or higher or in exposures of one second or longer. Quality cameras offer different levels of noise reduction levels: *Normal*, *High*, *Low*, and *Off.* Typically, noise reduction comes at the expense of sharpness. Cameras with excellent noise reduction capabilities are excellent when photographing in available or low-light situations. It is advisable to test your camera before using the noise reduction settings in critical situations, so you will know what to expect. Noise reduction software is also available for post-capture work (see Figure 3.20).

Image Stabilization

Many digital cameras with long (telephoto) focal-length zoom lenses have optical image stabilization or a variant such as anti-shake. Some systems are built into the camera body, while others are incorporated into each lens and are designed to deliver sharper pictures by counteracting camera shake.

Image-stabilized cameras and lenses use two tiny gyros that process camera movement and send a signal via a servomotor to move lens elements, a prism, or the sensor plane in the opposite direction that the camera moves. Basically, when you move one way, it moves the other way. This helps steady the image projected onto the sensor, which compensates for high-frequency vibration, such as hand shake that becomes noticeable during long exposures and when using long focal lengths.

Typically, optical image stabilization can allow you to take handheld shots at almost two shutter speeds slower than recommended. This is very useful when photographing moving subjects in low-light conditions or when panning and/or using long focal lengths (see Chapter 6). Stabilization gives huge improvements in sharpness between 1/2 of a second and 1/15 of a second with normal lenses and good results with telephoto lenses up to 1/500 of a second.

Flash

Most DSLRs have a small, built-in electronic flash that can be used effectively when subjects are 3 to 15 feet from the camera, focal lengths are no wider than 28 mm, and there is inadequate natural light. These little onboard units are good for fill flash, which can add a controlled amount of artificial daylight-balanced electric flash light to properly expose backlit subjects, bring out a subject that is in the shadows, or add a catch light to a subject's eyes. It is also referred to as flash-fill, fill-in flash, and balanced-fill flash. Most DSLRs can perform this function automatically and some allow manual override for custom results (for details see Chapter 4, Electronic Flash). DSLRs are often equipped with a "hot shoe" which will automatically synchronize very wide-angle lenses and larger optional flash units that cover greater distance.

Most DSLRs have a choice of flash sync modes, which allow the flash to synchronize with the shutter so that the flash goes off while the shutter is fully open. These modes include *Front-curtain sync*, used in most general, dim-lighting situations or when the subject is back-lit; *Red-eye reduction*, which fires a small light about 1 second before the flash, causing the pupils in the subject's eyes to contract and thereby reducing the red effect sometimes caused by flash; *Slow-sync*, which is used with long shutter speeds to record both the subject and the background in low-light conditions or at night, usually with a tripod; *Slow-sync*, where the flash fires just before the shutter closes, producing a stream of light following a moving subject, usually with a tripod; *Slow rear-curtain sync*, which records both subject and background; and *Off*, where the flash will not fire so exposure can be made with available light only. In certain shooting modes, such as

3.21 Owens is widely known for his book *Suburbia* (1972) which presents an ironic tension between the idealism of his subjects who view their suburban homes as the realization of the American Dream and the detached superficiality of this lifestyle. This humorous image is part of a new documentary project showing the New Suburbia with a focus on the daily life of people in north Texas. It was made using his camera's built-in flash to bring out the detail in the statue of the longhorn cow in the foreground.

© Bill Owens. *Model Home, Plano, TX*, from the series *The New Suburbia*, 2006. Dimensions vary. Digital file. Courtesy of James Cohan Gallery, New York.

Automatic, the flash will pop up and fire automatically when the program senses there is not enough light.

Memory Buffer

Higher-end digital cameras have a memory buffer for the temporary storage of images, allowing shooting to continue while the images are

3.22 "This series of digitally enhanced images is based on notions of *familiarity, presence, artifice, and location* provoked by manufactured tourist imagery, especially 19th-century painted backdrops of exotic locations, and its significance on our perceptions of personal experiences. The location within the images has been constructed to simultaneously resemble nowhere and everywhere; this apparent recognition frames the encounter, attempting to construct nostalgia for a place never visited. The figure is artificially placed in the Xcape to reinforce the significance or insignificance of the vista by reenacting the posture of gazing meaningfully toward it. Here the model was photographed on nine separate occasions and locations utilizing natural lighting in conjunction with slow and rear flash."

© Martin Kruck. Xcape #6, 2005. 70 × 118 inches. Inkjet print.

saved to the memory card. The camera will hold a number of these files in the buffer, depending on the quality (size) of the file. When the buffer is full, the shutter is disabled until enough data has been transferred to the memory card to make space for another image. This recording time can be as short as a few seconds or as long as many minutes and depends on the type of camera buffer and the speed of the memory card.

Removable Camera Memory Storage

Digital cameras have a limited amount of internal storage capacity and use removable memory cards to store images. When the removable memory card becomes full, the data can be transferred to a computer or to a printer for output. After the images have been transferred, the card can be formatted, which deletes any data it may contain, and reused. Formatting should be done in the camera. You should not remove the card or battery or unplug the AC adapter during formatting or the card may be permanently damaged. Be certain all your images have been properly downloaded and backed up before reformatting the card for future use. There are numerous reusable types and sizes of removable memory; your selection will primarily be based on the latest technology and your working equipment.

Firmware

A DSLR's operations are controlled by a computer program, known as *firmware*, which usually can be upgraded with improvements and new features by contacting the camera manufacturer's website.

Software: You Press the Button and the Camera Does the Rest

In-camera software programs make use of a digital camera's built-in computing power to allow you to edit images without downloading them to a computer. In the spirit of the old Kodak motto "You press the button and we do the rest," camera manufacturers now provide in-camera options such as red-eye correction and cropping; a skylight effect or warm filter; a way to combine multiple images into a single panorama; a sepia or cyanotype blueprint tone; a filter to convert an image into what the manufacturer calls a "cartoon or pop art masterpiece à la Andy Warhol;" a "slimming function" that makes people appear thinner; "Revive Shot" in which one can photograph old pictures and have the camera remove any distortion and adjust faded colors; a feature that corrects "plunging lines" in wide-angle shots of buildings that would normally make the subject appear to be tilting backward; a "pre-shot" function that allows one to place their subjects in front of any background; and lastly, "Instant Advice" from the camera, which tells you how to improve your picture — and the list is rapidly expanding. Quality cameras save these changes as a separate file, so the original capture is untouched.

Battery

All DSLR operations require electric power in the form of a rechargeable battery supplied by the camera manufacturer or by disposable batteries inserted into a special battery holder. Some cameras can be operated with an AC adapter. This can be useful when using the camera for extended playback operations, such as viewing images on a television, but is not practical for the vast majority of picture-making situations. Battery life depends on the number of frames shot and how you operate the camera. Using the monitor, the flash, repeated autofocus operations, slow shutter speeds, keeping the shutter release button pressed down, and taking RAW photographs all reduce battery power. Cold temperatures will also greatly diminish battery life (see section on Battery Care in Cold Conditions). It is advisable to have fully charged or fresh batteries at all times. Many photographers buy a second rechargeable battery so one can be charging while the other is in use or so two batteries will be available in the field.

3.23 New in-camera and post-capture software programs have facilitated the making of panoramas. Unlike most people who make panoramas, Kaminski does not use a tripod as he bicycles in the small towns he photographs to give himself time to discover things that normally go unnoticed. "My eyes are able to span an entire region like a panoramic, freeing me from the restriction of looking through a compact car window. I was able to explore by foot, allowing me to investigate more freely. To create my panoramas, I take three to four images at a slightly different angle at each site to span the area. I then stitch them together in Photoshop to form one seamless image. This method allows me to create unusual angles, vantage points, and distortions in my pictures, thus extending my vision of each place." © Kevin A. Kaminski. *Stripped Down*, 2006. 7-3/4 × 31-1/2 inches. Inkjet print.

Battery Choices

Battery life depends extensively on age, usage conditions, type, brand, and camera. Digital cameras are dependent on battery power, but not all batteries perform well in digital cameras. Nickel-metal hydride (Ni-MH) and lithium ion (Li-ion) rechargeable batteries deliver the best results in a variety of conditions. Ni-MH and Li-ion batteries are designed for high-demand devices, like digital cameras, and do not exhibit the memory effects seen with other rechargeable technologies. Memory effect is when a battery remembers how full it was when it was last recharged and does not go past that point the next time it is charged. This problem can be reduced by completely draining the battery before recharging to insure the longest charge. Regardless of type, one of the best strategies to prolong battery life is to use them. Otherwise, they will lose their capacity to hold a charge.

Among nonrechargeable batteries, look for batteries that are intended for use in

cameras, which unlike flashlights or radios, require short bursts of high energy. Lithium batteries perform extremely well in cameras, as do photo-flash grade alkaline batteries.

Battery Care in Cold Conditions

Batteries do not perform well in cold weather. At temperatures of 20 degrees F (-6.7 degrees C) or less, there is a danger that all battery-powered equipment will become sluggish. Outdoors in winter, your batteries give out in less than half the time they ordinarily last in more temperate conditions. Check the batteries for all your camera gear before going out into cold conditions and carry spares. Shutters are affected first, with shutter speeds slowing and producing exposure errors. For instance, if a battery-powered shutter is off by 1/1000 of a second, and if you are attempting to stop the action of a skier speeding downhill at 1/1000 of a second, then the exposure would be off by one f-stop. This would not present a serious problem unless you are shooting above 1/125 of a second. In cold conditions, make use of the middle and slow ranges of shutter speeds whenever possible to avoid this difficulty.

When working in cold weather, carry a spare battery in an inside pocket, where your body heat can keep it warm. When it is time to swap, put the "dead" cells in that pocket to warm them up. If necessary, you can put that battery back in the camera, as it often will be good for a few more shots after it has warmed. Among disposable batteries, lithium batteries have the best cold-weather performance, with an operating range of -40 degrees C to +65 degrees C. If the batteries appear to have expired, do not dispose of them until they are warmed up and tested again.

CAMERA, LENS, MONITOR, AND SENSOR CARE

First and foremost, read your camera's manual and visit the manufacturer's website to get answers to questions that specifically relate to your camera.

Keep the outside of your camera clean by wiping it with a clean, dry cloth. Do not use abrasive or harsh cleaners or organic solvents on the camera or any of its parts.

Box 3.5 Battery Care

- Only use a supplier-specified AC adapter with your camera, as a different adapter or one with a different voltage could damage your camera and battery.
- Do not to touch the battery terminals with metallic objects.
- Replace the battery only with the same or equivalent type.
- Do not recharge a battery for longer than the specified period of time.
- Do not continue charging a battery if it does not recharge within the specified charging time, as this could cause it to become hot, explode, or ignite.
- Remove the battery from the camera when it is stored for long periods of time.
- Keep batteries out of the reach of children and animals.
- Store the battery in a dry cool place and attach the battery cap.
- Do not place a battery on or near fires, stoves, or other high-temperature settings.
- Do not place the battery in direct sunshine, or use or store the battery inside automobiles during hot weather, as this can cause a loss of performance and shortened life expectancy or cause the battery to generate heat, explode, or ignite.
- Discontinue use of a battery if, while using, charging, or storing the battery, it emits an unusual smell, feels hot, changes color, changes shape, or appears abnormal in manner.
- Dispose of used batteries according to the manufacturer's instructions.
- Utilize battery-recycling programs.

Box 3.6 General Battery Tips

- Turn off your camera when not in use.
- Limit the use of your monitor, which rapidly drains batteries.
- Do not mix new batteries with used ones. Replace all batteries simultaneously.
- Do not mix rechargeable and nonrechargeable batteries.
- Do not mix alkaline, nickel-metal hydride (Ni-MH), or nickel-cadmium (Ni-Cd) batteries.
- Do not mix different grades or brands of batteries.
- Do not recharge any battery that is not marked "rechargeable."
- Do not attempt to rejuvenate a battery by heating it.
- In cold weather, keep your camera inside your jacket.
- Occasionally clean the battery contacts and compartment components with a clean pencil eraser.

Keep your lens clean. Get a lens cleaning kit that includes a blower brush (also known as a *bulb brush* — an ear syringe will work too) to blow away grit; a lens cleaning cloth to wipe the lens and a small Ziplock plastic bag to keep it in; and lens cleaning solution to use sparingly on the cloth when necessary. Most lenses have special surface coatings that can be damaged by careless handling. Check your lens after each use, and clean it only if it is dirty. Begin by blowing off any loose dirt with the blower; then brush gently to remove any that won't blow away. If there is any dirt or fingerprints remaining, use a photographic lens tissue or a clean, soft, dry cloth made of microfiber (which is washable). A clean piece of a cotton t-shirt or a soft handkerchief can also be used. Paper towels, napkins,

and facial tissue should never be used to clean any lens. Never wipe a dry lens. Either breathe lightly onto your lens to form a mist, or moisten the cleaning material with a photographic lens cleaner. Wipe gently, placing the fluid on the lens cleaning paper, not directly onto the lens. Only use a lens cleaner intended for cameras. Do not use alcohol or eyeglass solutions, as they could damage your lens. Protect your lens by leaving a UV filter in place at all times and using a lens cover when it is not in use.

Your monitor screen should be cared for in the same manner as a lens.

Keep the image sensor clear. Always point a DSLR down when changing lenses. Avoid changing lenses in dusty or wet conditions. Do not leave the camera body open. If necessary, use a body cap to cover the open lens mount. Some cameras have a feature that shakes the dust off its sensor, preventing image specks in your images that require imaging software to correct. Others require a careful manual cleaning.

Protect equipment plugged into an electrical outlet from power surges, called *spikes*, which occur when the electrical power to your equipment is restored after an interruption. These surges can damage the sensitive circuitry in your camera, computer, and peripherals. Surge suppression devices are designed to protect your equipment from such a spike.

Protection against the Elements

Simplify your camera operations as much as possible. Remove any unneeded accessories that cannot be operated with gloves, or add accessories that permit easier operation. If possible, preset as many camera adjustments as possible before going outside. Avoid using

Box 3.7 Top 10 Camera Maintenance Tips

- 1. Regularly clean the outside of the camera with a clean, dry cloth.
- 2. Do not subject your camera to knocks, vibration, magnetic fields, moisture, smoke, water, steam, sand, and/or chemicals including suntan lotion.
- 3. Handle all moving parts of the camera with care and don't touch the inside of the camera.
- 4. Keep the sensor clear.
- 5. Turn the camera off before removing or disconnecting the power source or a cable, or removing the battery or memory card.
- 6. Keep your camera dry and free from condensation.
- 7. Avoid storing or using your camera in dirty, dusty, or humid places.
- 8. Avoid extreme temperatures, such as in direct sunlight for prolonged times or in a car when it is hot.
- 9. When not in use, store your camera according to the manufacturer's recommendations.
- 10. If your camera falls into the water or gets seriously wet, wipe it off and contact a camera repair technician as soon possible.

thin gloves so that your skin does not come in contact with the cold metal and you can operate the camera with ease. Metal parts can be taped to prevent this from happening. Do not breathe on the lens outside to clean it because your breath might freeze on it.

When bringing a camera in from the cold, let it warm up before using it so condensation does not damage its working gear. Condensation can be avoided by placing the camera in an airtight plastic bag and squeezing out the air. This prevents the camera from being exposed to the warmer temperature. Condensation forms on the outside of the bag instead of on the lens and camera body. After the equipment has reached room temperature, remove it from the bag.

Dust and sand can easily damage camera equipment, so protect it before going out. When you return, inspect your lens, and if you see any dust and salt particles, clean it with lens tissue liberally moistened with lens cleaner. Unmoistened tissue drags abrasive dust or salt grains along the highly polished lens surface, possibly causing scratches or abrasions. To dislodge sand, blow the outside of camera body and lens, not the inside, with blower brush or compressed air (using a small, portable, compressed-air canisters).

power accessories or the monitor screen to conserve power. Do not take a camera that has condensation on it out into the cold until the condensation has evaporated, because it may freeze. The camera will cease operating, and the inner components will be ruined. Once outside, avoid touching unpainted metal surfaces with ungloved hands, face, or lips because your skin will stick to the metal. Wear

Box 3.8 Digital Camera Ground Rules

- Format memory card in camera only.
- Shoot highest quality files possible.
- Download using card reader to computer; verify files.
- Back up files on a second hard drive.

3.24 "In this series I am photographing grand and gorgeous failures of light to sync up to its supposed functions: Braille billboards, odd elaborate shadows behind figurative sculptures, spring pear blossoms arc-lit into oblivion, neon koans to no one. I am interested in light that obscures as it illumines, that overstates and overblows, and in some cases, that fails to appear at all. You can sift through any photographer's amassed images and find moments when the light shifts from something that describes to something that is described; moments when the photographer has seen — or better, understood — the light." Made on a cold wintry night, Davis's technical challenge was making a 45-second exposure using his 4×5 inch view camera.

© Tim Davis. *Searchlights*, from the series *Illuminations*, 2005. 55 × 44 inches. Inkjet print. Courtesy of Greenberg Van Doren Gallery, New York.

SCANNERS

Scanners are input devices that digitize information directly from printed or photographic materials in a method similar to photocopiers. Aside from a digital camera, scanners are the most common means of getting images into a computer. The most common scanners use a line of CCD cells to record one row of the image at a time, which the scanner then assembles into a grid that digitally reconstructs your original image. Light is reflected off or through an image or object and interpreted by light sensors. Color scanners use RGB filters to read an image in single or multiple passes. After the scan is complete, software is typically used to make color and contrast corrections and to crop and adjust image size. Scanners also have optical scanning recognition (OSR) programs that allow text to be scanned and converted into digital data, which gives one the ability to combine text and pictures with imaging software. Although manufacturers use their own drivers, there are some basic scanning features and procedures (see section on Scanning Steps).

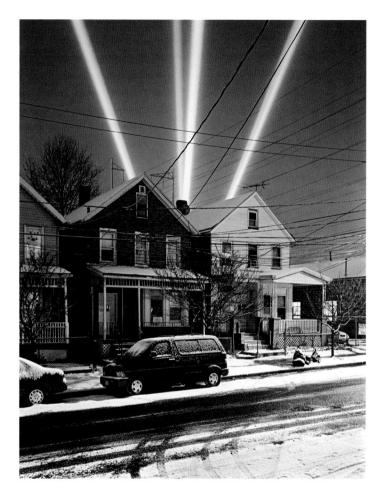

Flatbed and Film Scanners

Flatbed scanners, capable of digitizing images in a variety of resolutions, are the most common way to digitize a document and can be thought of as large, flat cameras. These devices allow the user to preview an image and make minor corrections before scanning. Although designed to digitize prints, some flatbed scanners can do a good job of handling color transparencies (color slides) or negatives, especially when coupled with quality software, which may be an option.

Film scanners are specifically designed to capture the minute details of small negatives and transparencies by transmitting light through an image. They are more expensive than flatbed scanners.

Table 3.6 Scanning Resolutions for Printing

Use	Scan Resolution
Internet	72 DPI
Newspaper	150 DPI
Glossy Magazine	300 DPI
Photo-Quality Print	300 DPI
Large Fine Art Print	4000 DPI and higher

Drum Scanners

Drum scanners are generally the most accurate way to digitize flat media. An image is read on a glass drum while being spun at several thousand revolutions per minute. Scans of both prints and transparencies made on these more expensive devices are more precise and translate images with greater detail than with traditional flatbed scanners. Some high-end flatbed scanners are capable of scanning prints, 8×10 inch transparencies, or film at a quality that can rival drum scans.

Scanning Guidelines

Although there are numerous types of scanners, some basic principles are applicable in most scanning situations. Scaling and resolution must be set at the time the image is scanned. The input settings draw reference from the original image, producing the bestquality scans. A common mistake is to allow the scanner's photoimaging software to automatically set the final size (scaling) and resolution, which may force interpolation to occur and degrade the final image. Select the appropriate resolution based on the intended use (see Table 3.6).

The best resolution for continuous-tone prints is dependent on the maximum DPI of the printer being used. Good scanning software will allow a user to input a scaling factor into a dialog box and then will automatically do the file size math. If your software does not do this, use the simple formula in Table 3.6 to calculate input resolution based on printer resolution and the scaling of the image.

Scanning Steps

 Open the scanning software. Often this can be done through imaging software, under File > Import > Name of the scanning software. Many scanners use an independent software application to drive the scanner. In this case, open the independent application and proceed to the next step.

- **2.** Set the scanner for Positive or Negative. Many scanners are dual use, with the ability to scan photographic positives (reflective) and negatives or slides (transparent). Make sure the scanner is properly physically configured for reflective or transparent materials and set to the proper medium before scanning.
- **3.** Select Grayscale or Color. Even though scanning in grayscale is possible, scanning in color often provides superior results because the scan is occurring in three channels (red, green, and blue) instead of one. If a black-and-white image is desired, simply change the saturation levels to remove all color with the saturation adjustment tool and print in RGB to maintain quality.
- **4.** Place the image/negative or object on the scanning bed. For flat artwork, be sure to place the image squarely on the scanning bed, as this will reduce the amount of post-scanning scaling and rotating.
- **5.** Preview the scan of the entire scanning bed. This will allow you to see the entire scanning area and the image to be scanned. Use the marquee tool to select the target area as closely as possible.
- **6.** Make tonal adjustments. Most good scanning software will create a preview of the image based on the area you selected with the marquee tool. All scanning software has settings to control the contrast, brightness, and color balance of images. Change these settings to get the previewed image color-

balanced as closely as possible before scanning. The most important adjustment to make is contrast. An image that has excessive contrast contains less information about tonal values. Slightly flat-contrast images contain more information in the highlight and shadows and generally provide better results in post-scan processing. After scanning, use your photo-editing software to make final color and contrast adjustments to an image.

- 7. Set the file size. Before scanning, decide what size your final print is going to be. Scanners display and define size in two ways: image size and resolution. Most scanning software will display the size of the area being scanned, multiplied by a scaling factor. Increasing the scale of the image increases the dimensions of the final scanned image. Increasing the resolution of the scan increases the potential quality of the image. Both operations increase the file size. As a general rule, the larger the file size, the more options you have in working with the finished scanned image. Know the limitations of your scanner and select the appropriate file size. There is no need to scan at a greater resolution than you need, as larger files are slower to work with and take up more storage space.
- 8. Scan the image.
- **9.** Save the file. Once your image is scanned, immediately save the file. If you regularly work in Photoshop, save it as a PSD. Keep these original scans protected, and work only with copies of these scans.

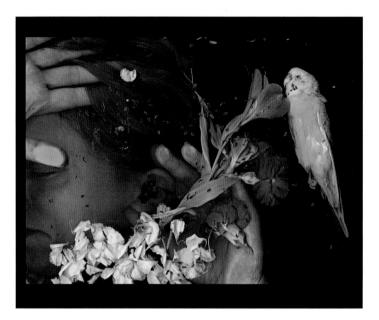

3.25 "This series, using a scanner as a camera, began with the death of two of my students and continued while war erupted in Lebanon. My scanner worked like a memoriam to my past and brought together politics and lost loves. Like an Australian Aboriginal songline, my scans became mechanisms for navigation: maps enabling me to find my way home. The subject held her pose for three minutes to combine a flash light and a clap light with the scanner sweep. Bottles of honey were poured onto glass covering the scanner. Bees, flowers, and guns were prominent to pose the question of how we decide to live out our lives, whether to destroy or to build up. Enjoying the interface of the organic objects with the coldness of glass, I thought about the space between old and new technologies and how it was a lot like drowning."

© Linda Adele Goodine. For Billy, from the series Wixson Honey, 2006. 30 × 40 inches. Inkjet print. Courtesy of Galerie Gora, Montreal.

FRAME GRABBER

A frame grabber is another form of input that enables one to capture an individual analog video frame and digitize it as a still image. The resulting image file can be handled just like one made by a still digital camera. Frame grabbers can be either stand-alone devices that plug into a computer port or a program function built into a video capture board or display adapter. Software can also be used with digital camcorders to grab an already digitized image.

Effects on Photojournalists and Event Photographers

Improvements in frame grabbing technology and in high-definition (HD) video camcorders have led newspapers to utilize this equipment and publish HD video stills on a regular basis. News photographers use HD camcorders as they would a still camera that has the added capability to shoot 30 frames per second. This allows them to record an entire sequence of an unfolding event and then later thoughtfully distill the climatic moment(s) that would otherwise be extremely difficult to obtain. Some still photojournalists have objected to such methods, but Richard Koci Hernandez, deputy director of photography and multimedia for the San Jose Mercury News, says: "It's just about the moment. When you see a picture that moves you, I don't care how they got it. Ultimately the lasting image is more important than how they got it." These developments make it likely that a future Pulitzer Prize in print journalism will result from a frame grab while also offering newspapers the means to include more video presentations on their websites. Other visual professionals, such as event and wedding photographers, will also likely adopt these methods.

EXERCISE Scan-o-Gram: Scale and Spatial Effects

Utilize a scanner to create an image made from found objects. Practice scaling the composition by following the steps listed earlier (in the section on Scanning Steps) to make the found objects larger than life.

Start by collecting a variety of two-dimensional and threedimensional objects, including text, which will fit comfortably on your scanner to create a 4×5 inch composition. Experiment with opaque, translucent, and transparent objects.

Next, create a background using a piece of any colored material cut to 4×5 inches or a photograph approximately that size. First, arrange the found objects face down in the middle of the scanning bed, and then place the 4×5 inch background material on top of the objects. Close the scanner top, preview the scanning bed, and select a scanning area that includes the 4×5 inch cut material that has been used for the background.

Once you are satisfied with the composition, set the scale at 200 percent to produce a final image that will be enlarged and printed to 8×10 inches. Now, determine the printer resolution, calculate the

input resolution needed, and set it before final scan. Finally, make a series of prints increasing both the scale and the input resolution (see Box 3.6), and compare the differences in the various prints. Look specifically for how scale changes the spatial relationship between the viewer and objects because they are now much larger than life.

Laurie Tümer, an artist who teaches at Northern New Mexico College, assigns her students a variation of this exercise, asking them to use the scanned object to create patterns and textures. Students make a second file of their original scan and create a pattern, multiplying it by copying, pasting, and using the transformation tools to reduce and rotate. Then they create a third file, importing the pattern and then texturizing it by continuing to reduce its size, copying, pasting, and transforming the object in scale and/or perspective. In addition, they practice adding and adjusting color, inversing colors to add interest to the texture, and punching holes through layers to reveal and conceal information (see Figure 3.26).

STORING DIGITAL IMAGES

After an image has been captured by the sensor and converted into pixels, the data is transferred to the camera's storage device. This can be a removable disk, such as a Flash Card, or a built-in device that stores the information in electronic memory. In the storage device, the image is saved as a single, self-contained computer file, much as conventional photos are saved on individual frames of film. Because images composed of a megapixel or more of information require a large file of data, digital cameras contain software that compresses, or shrinks, the size of the image file for easier storage. Raw files offer

3.26 Tümer informs us that Montoya, a Game Art Design student, chose to scan the skull on his wallet because it was similar to a character he was developing for a game. "Brandon learned about the hazard of overworking a piece and concluded the most energetic version was the one that took the least amount of time, but was done with the greatest concentration. As a new Photoshop student, Brandon found that having to repeat many basic procedures allowed them to become second nature while exploring design elements, which he now applies in creating games."

© Brandon Montoya. Untitled, 2006. 15 × 15 inches. Inkjet print.

more post-capture processing control but are generally not compressed and therefore take up more storage space. Cards with storage capacity of 1 gigabyte or larger are recommended in these situations.

At the same time, other camera software is generally used to automatically adjust the captured image to produce a naturalistic representation of the subject. For example, the edges of the pixels are digitally smoothed (sharpened) to make the image look more like a traditional photograph. Additionally, the overall brightness level of the scene is adjusted to deliver a normal contrast range.

Storage Media for Final Image Files

Besides hard drives, there are many expandable and portable devices for storage and transportation of information. From the 1970s to the early 1990s, the 5-1/4 inch floppy disk and later the smaller 3-1/2 inch floppy disk were the standard for storing files. Each disk held 400 to 800 kilobytes (KB) and 1.4 megabytes (1433 KB) of information, respectively. At that time, a typical word processing file might require 8 KB, but today an image file can easily exceed 100 MB (100,000,000 KB), requiring gigabytes of storage space. Storage devices are continually being developed, enlarged, and improved.

Regardless of which storage medium you initially deposit your image in, it is highly recommended that you back up important files on a storage device other than the computer you are working on. It is risky to have all your images on a single storage medium, as it may eventually fail, possibly be lost, or even get stolen. Your computer's hard drive spins at 7200 rotations a minute. A delicate reading arm hovers a fraction of an inch above the surface of the drive's spinning platters, moving across them at 60 miles an hour; one thud, and your

3.27 The images in this series are "collectives" from various sources. Parts of this image are still video captures from footage of a person repeating the line, "If I kiss you on the mouth, will you turn the other cheek?" These captures are montaged with an old photograph from human scientific and psychological experiments. Also included in the 'collective' is an extreme crop of two people kissing, taken from a magazine. These images of repetitive oral activities are laid over and sandwiched between direct flatbed scans of latex rubber stretched on a gilded frame. The drive in making these images comes from being able to manipulate and redefine a given image. I rely on the referent in the original to echo in the 'collective.' I want viewers to see the components and then to fuse them into whole. The act of experimentation becomes the process and the product."

Debra A. Davis. Repetition Increases Outcome, from the series Incidental Specimens, 2005. 13×10 inches. Inkjet print.

files can be damaged or lost. Your hard drive's likelihood of mechanical failure is 100 percent; it's only a matter of when. For these reasons, it is highly advisable to archive images in separate stand-alone devices, including large flash drives, on CDs or DVDs, or off premises, such as on a website.

The following are some storage options that have made a major impact on the digital medium.

Compact Disk (CD) and Digital Versatile Disk (DVD)

These inexpensive metallic disks, coated with a clear resin, use laser technology to optically record data and are standards for reliably distributing large quantities of information, text, images, sound, and video. Compact disks (CDs) hold approximately 700 MB of information, and digital versatile disks (DVDs) can hold from 4.7 GB up to

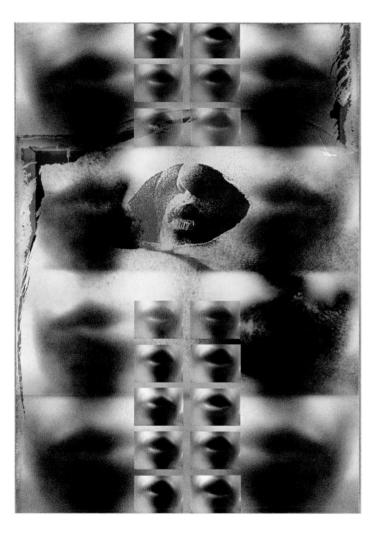

9 GB, depending on the type. CDs and DVDs can be written on once (CD-R, DVD-R) or can be rewritable (CD-RW, DVD-RW). There are competing formats for DVDs, so do the research to select the format most suitable for your needs.

Mechanical Storage

Hard disk drives, the most common and least expensive mechanical storage device, are metal disks coated with iron oxide that spin and rely on a synchronizing head to read and write digital information. The head floats just above the surface and magnetically charges the oxide particles to store the digital data. The down side is that over time, the moving parts wear out and fail, causing the drive to break (crash), which means they are not suitable for long-term storage. However, they are excellent for backup and short-term storage.

Internal Hard Disk Drives

Internal hard drives are where a computer's operating system (OS), programs and files are stored. When the computer is turned off, all saved data remains on the hard drive. Hard disk drives come in a variety of sizes, measured in gigabytes and terabytes.

External Hard Disk Drives

Small, portable, and mechanical, these external hard disk drives add often needed storage directly to the computer through various external ports. They are an ideal solution for transferring large digital files and for backing up valuable data. Many of these drives are hot swappable, which means they can be connected or disconnected without turning off the power.

Solid-State Storage: Hard Drives, USB Drives, Jump Drives, and Flash Memory Media

Solid-state storage is neither magnetic, like hard disk drives, nor optical like CDs or DVDs, but is electrically erasable RAM-like memory that is available for both internal and external applications. Access time is faster than a disk because the data can be randomly accessed and does not rely on a read/write head searching for data on a rotating disk. In addition, they use less power and are shock resistant, but have a higher cost per megabyte of storage than mechanical storage. Their lack of moving parts makes them more rugged and reliable than mechanical storage devices.

The most common solid-state storage devices are the flash memory cards used to record images in digital cameras and USB drives or Jump drives. Flash memory is nonvolatile, meaning it will retain data even when an electronic device is turned off, and comes in a wide variety of storage capabilities, physical shapes, and names. Flash memory cards generally require special adapters, known as *card readers*, which plug into standard computer ports. Some cards have a built-in adaptor that permits them to be directly plugged into a computer. USB flash drives only require a USB port and are about the size of a pack of chewing gum, making them handy for moving a few picture files for temporary storage.

Image Transfer

If your camera stores its images primarily on a removable memory card, the card can be taken out of the camera and inserted into a card reader or computer, which can then be used to access and manipulate the digital images. Cameras that store digital photos electronically usually have a connector cable that plugs into a computer for downloading. Cameras that use removable memory cards can also be accessed in this fashion. Others have special docking stations that download the data. Some can send the data to a computer with wireless technology (Wi-Fi) built into the camera. Additionally, there are Wi-Fi memory cards that can beam images to your computer or website.

LIVING PHOTOGRAPHY: AUTHORSHIP, ACCESS, AND THE WORLD'S LARGEST PICTURE BOOK

The vast majority of digital images are never printed. Instead, most remain in digital form and are viewed on a monitor or as an email attachment, web image, or other personal electronic device, PED. However, as with a conventional negative, the digital file can be used to make a paper print (see Chapter 8, Digital Studio).

The Web offers digital photographers the ability to "go live," encouraging people to freely interact with images in ways not previously possible. Uploading an image to an open website, such as http://flickr.com/, which permits free redistribution of posted material, allows others to see, comment, download, revise, and repost an image, so it is never permanently fixed. Unlike conventional media, these websites do not provide fixed programming, but instead rely on their users for content. A photograph no longer has to be a static picture on a wall, although that is fine too. Now images can be part of a dynamic collaborative process that harnesses collective intelligence, much in the same way that the open-source online encyclopedia Wikipedia (www.en.wikipedia.org) allows people to write and edit articles (see also www.opensource.org). This global conversation reflects the belief that a multitude of bloggers (people posting to websites known as *blogs*) can provide an alternative and even richer experience than even the brightest individual experts, thus altering classic notions of authorship. The phenomenon of group action that results in creating a collective new work can also be seen in "mashups," a website or web application that seamlessly combines content from more than one source into an integrated experience. It has roots in Pop music where DJs take a vocal track from one song and combine it with an instrumental track from another song to create a new composition.

This living process of ongoing human presence not only increases the possibilities for making new works based on multiple authorship and/or getting non-mainline work before the public, but also changes how images are circulated, experienced, and understood. The challenge with so much unfiltered information is being able to evaluate the accuracy of the information being delivered and to select what one wants to take in. In The Long Tail: Why the Future of Business Is Selling Less of More (2006), Wired editor Chris Anderson explains how this affects society at large, as he declares the death of "common culture" and presents the case that we are witnessing the decline of the commercial "blockbuster," which mass numbers of people see, read, or hear - a shift he feels is for the best. Anderson posits that the "emerging digital entertainment economy is going to be radically different from today's mass market," and "if the twentieth-century entertainment industry was about hits, the twenty-first will be equally about niches." The result of "shattering the mainstream into a zillion different cultural shards" is a vastly expanded universe of opportunities for makers and marketers to cast a wide net that is reshaping our understanding about what people actually desire to experience.

A real-world example of this phenomenon is the difference between Blockbuster and Netflix DVD movie rentals. At Blockbuster stores, 90 percent of their rentals are new releases. By contrast, Netflix, which allows customers to order films online and receive them by mail, does 70 percent of their business from their back catalog of more than 75,000 titles. Many of these titles are art-house films, documentaries, and other low-budget, little-known productions that might never have had a theatrical release and which previously would not have been available to the general public. This is indicative of a larger shift in the nature of cinema distribution: films now go to people rather than people going to films. And this is why Netflix and other media companies are now delivering movies as digital data directly to subscribers' computers.

Other commercial websites, such as www.cnn.com/pipeline, permit subscribers to view multiple unfiltered video streams of news sources from around the globe plus CNN's online video library. Additionally, sites such as www.youtube.com allow people to post and view videos ranging from late-breaking news (home journalism) through a variety of categories from art and animation to music videos and video games. William Henry Fox Talbot, who invented the negative/positive photographic process and dreamed of "every man [being] his own printer and publisher," would approve this updated scenario that includes moving pictures and sound and gives permission to everyone to become their own journalist and commentator.

The evidence of this phenomenon of expanded selection opportunities can be seen in the sharing of images on the Web. This trend broadens our notion of public space to include virtual space, and it has the advantage of bypassing traditional gatekeepers, such as museum curators and gallery owners, who often have a vested interest in promoting their stable of artists, which tends to keep alternative views from the public eye. Ultimately, as images become digital, the act of imagemaking and the viewing of images are converted into a larger community activity that essentially fashions a universal picture library, which becomes one very gigantic single image — the world's picture book — and gives it wide access through digital means.

Νοτε

1. Garry Winogrand, "Understanding Still Photography," in Garry Winogrand (portfolio) (New York: Double Elephant Press, 1974). 3.28 Examining what constitutes fact and fiction in a photograph by blurring the limits between reality and fiction, Hafkenscheid uses the innate characteristics of camera vision to make actual places look like model train layouts in which the tracks are set in an artificial landscape of fake cotton wool trees, plastic buildings, cardboard mountains, and little fake figures. "When looking at this landscape at a normal distance, I almost felt like God, high above this artificial world and in total control of it as well. If you looked close enough (eyes about 2 inches above the train tracks) though this world would start to look almost real again. I explore this illusion of real and fake through shallow depth of field to make some parts of the image soft and others in focus. The colors in the photographs are tweaked to look like old postcards and recall an idealized view of an immediate future typical of the 1950's."

© Toni Hafkenscheid. *Train Snaking Through Mountain*, from the series *HO*, 2001. 30 × 30 inches. Chromogenic color print. Courtesy of Birch Libralato Gallery, Toronto.

Polidori created mementos of the devastation that Hurricane Katrina brought to New Orleans, documenting the paradoxically beautiful wreckage. He entered the ruins to make photographs that serve as psychological witnesses, mapping the lives of the absent and deceased through the remains of their homes. "As photographic records, these exoskeletons are offered as a kind of visual Last Rites to chosen life trajectories that are no more and can no longer be." © Robert Polidori. 2732 Orleans Avenue, New Orleans, LA, from the series After the Flood, 2005. 50×66 inches. Chromogenic color print. Courtesy of Edwynn Houk Gallery, New York.

Chapter 4

Exposure and Filters

EXPOSURE BASICS

Proper exposure technique — acceptable shadow and highlight detail — is the technical prerequisite to the process of transforming ideas into photographs. Although digital imaging software offers numerous corrections tools, it is preferable to make original exposures as accurately as possible to avoid compromising image quality. The following exposure guidelines can deliver acceptable exposures under a wide variety of conditions with a minimum of fuss.

Camera Light Meters Are 18 Percent Gray Contrast

Built-in camera exposure meters are the device most of us initially employ to make our exposure calculations. All DSLRs have sophisticated thru-the-lens (TTL) metering system that makes getting a good automatic exposure in most situations a sure thing. However, there are particular times when you want to change the exposure mode from Automatic and make specific exposure decisions. The more you know about the camera's metering system, the greater the likelihood you will use it to achieve your desired exposure. All meters are partially blind; they see only a middle 18 percent gray reflectance. This 18 percent reflectance reading tells the photographer that if the object the meter is reading is a middle gray or averages out to be a middle gray, this is how the camera should be set for an average exposure. The meter is a device that measures only the intensity of the light; it does not judge the quality of the light or the feeling and mood that the light produces upon the subject. The best exposure is not necessarily the one the meter indicates is the correct exposure. The meter is a guide that reads the signs. It is up to the photographer to see, respond to, and interpret the light and decide what exposure will deliver the color, detail, feeling, and mood needed to express and convey the situation to the audience. Learning to recognize and

Table 4.1 Basic Metering Guidelines

1.	Make sure the sensitivity selector (digital ISO) is at the desired setting.
2.	Perform a battery check before going out to take pictures.
3.	When taking a reflected light reading, point the meter at the most visually important neutral-toned item in the scene.
4.	Get close to the main subject so that it fills the metering area. Avoid extremes of dark or light when selecting areas on which to base your general exposure.
5.	When it is not possible to meter directly from the subject, place an 18 percent gray card in the same type of light and meter off of it.
6.	In situations of extreme contrast and/or a wide tonal range, consider averaging the key highlight and shadow areas or take a reading off an 18 percent gray card under the same quality of light.

control the quality of light illuminating a subject is the aesthetic essential for making good photographic images. But first you must become skilled with the basic technical metering guidelines summarized in Table 4.1.

Reflective and Incident Light

There are two fundamental ways of measuring the amount of light in a scene. Virtually all in-camera meters are designed to read reflective light. *Reflective light* is metered as it bounces off the subject. This is accomplished by pointing the meter directly at the primary subject. A reflected reading from low midtones and high shadows delivers good general results in most situations. *Incident light* is measured as it falls on the subject. The meter is not pointed at the subject but toward the camera or main light source. Incident meters are not influenced by the multiple reflectance values of a subject; therefore, they do not require as much expertise to achieve satisfactory results. Most in-camera meters cannot read incident light without a special attachment that fits over the front of the lens. This adapter permits incident reading with most TTL metering systems.

How a Light Meter Works

Your camera's light meter reads all the light reflecting back from all parts of the scene shown in the viewfinder to generate a mean exposure from all reflectances within the entire scene. The meter's coverage area (the amount of the scene it reads) changes whenever you alter the camera-to-subject distance or use a zoom lens. If you move closer to your subject or zoom in on a detail within the scene, the suggested exposure (aperture and shutter speed settings) will probably be different from if you meter the scene overall from a distance. In an average photograph, the darkest area or surface appears dark because it reflects the least amount of light. The sensor reads less light as a darker value. Theoretically, the blackest areas or surfaces will actually reflect back a minuscule 3 percent of the light. The whitest areas of a scene reflect back the most light, but no surface or area will theoretically reflect back 100 percent of the light. Even the lightest surface or area will absorb approximately 4 percent of the light, thus reflecting back 96 percent and creating the lightest value, excluding mirrors or any high-tech surface or material.

These physical laws of reflectance help define the standard value of a photographic 18 percent middle gray. This 18 percent middle

118 0

4.1 Johan uses animals to mirror human fears and desires, as well as to allude to our inclination to anthropomorphize and domesticate the wild. Exposure is critical, as his final images are built from numerous separate exposures. This fantastical composition took six months to bring to fruition: the moose was photographed in four sections; wounds were created with a different piece of fur, various foods, and paint; birds were photographed in the studio; and the background is a mixture from Norway and Spain.

 \odot Simen Johan. Untitled #133, from the series Until the Kingdom Comes, 2006. 71 × 92 inches. Chromogenic color print. Courtesy of Yossi Milo Gallery, New York.

gray is the value that physically reflects back 18 percent of the light from its surface or area, creating a specific gray value that represents the absolute middle between all the blacks and whites in a scene. Look at Figure 4.1 and observe that 18 percent reflectance represents the median or average that is exactly 3.5 f-stops from the blackest value and 3.5 f-stops from the whitest value in any scene. The 18 percent reflectance or exposure is the exact middle between the black and white surfaces or areas governed by the theoretical laws of reflectance in any scene. A meter sees the world as if looking through frosted glass. By blurring all the details and eliminating the specifics, a meter is able to accurately measure a scene's overall average brightness. The result of this averaging method is that a photographer taking a photograph of an average subject illuminated by daylight will get a proper exposure 90 percent of the time. However, to make scenes that do not average out to 18 percent middle gray appear normal in your image, it is necessary to alter the exposure to lighten or darken the picture.

How a Histogram Works

A histogram is a simple graph that visually displays the distribution of reflected light in any scene, showing where the reflectance (brightness) levels are located. The right side of the histogram represents the brightest (96 percent reflectance) areas of the scene, and the left side represents the darkest (3 percent reflectance). The histogram can be found in the menu settings of your digital camera and is viewed on the camera's LCD display. Histogram viewing options may include superimposing the histogram over the picture, or it may be shown by itself. Display options also include a single black-and-white graph of reflectance, single graphs of the colors red, green, and blue (RGB), or everything shown simultaneously, as seen in Figure 4.2.

Using a Gray Card

Both reflective and incident meters can be easily fooled if there is an unusual distribution in the tones of a subject. For this reason, it is

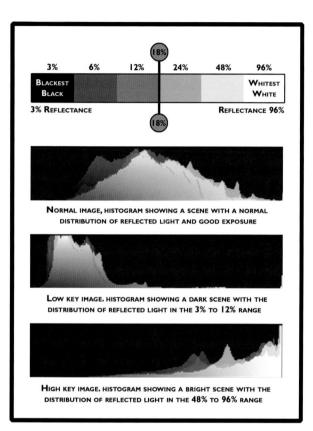

4.2 There is no such thing as a bad histogram. The distribution of the reflectances will either be clustered to the right, representing a high-key photograph, or gathered to the left, representing a low-key photograph. A histogram grouped in the middle only means there is a lot of reflectance (brightness) around the mean or 18 percent gray. A scene with an equal distribution of reflectances from 3 to 96 percent will show a more full-bodied histogram. Overexposure and underexposure will also affect the histogram and ultimately the brightness or darkness of that digital image file (see Figures 4.3 and 4.4). Once you become proficient at "reading" a histogram, you will be able to evaluate the quality of the exposure based on middle gray. A histogram shown with the image or superimposed over the image makes the histogram much more meaningful.

often desirable to ignore the subject completely and take your meter reading from an 18 percent gray card. The gray card provides a neutral surface of unvarying tone that is only influenced by changes in illumination. In this respect, it is like an incident reading, only it is measured by reflective light. The gray card is designed to reflect all visible wavelengths of light equally, in neutral color, and to reflect about 18 percent of the light striking it. To obtain accurate results, be certain the gray card is clean and not bent. Position the gray card in light similar to the principal subject. Point your reflective meter to fill as much of the gray card as possible; avoid casting any shadows in the area being metered. It is a popular misconception that the gray card represents the average reflectance of an ideal subject; actually, the average reflectance of a normal subject is about 9 percent.

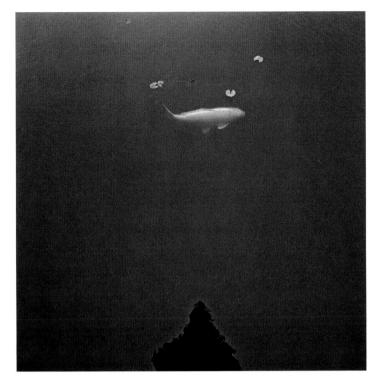

4.3 This low-key image has some highlights but is predominantly a dark and mysterious photograph. Its histogram would show values crowding to the left of the graph, indicating underexposure. All histograms show the distribution of the tonal values and thus are a tool to visually decide what adjustments, if any, need to be made to achieve the desired exposure.

© Keith Johnson. BBG Fish, 2002. 22 × 22 inches. Inkjet print.

Additionally, digital calibration targets can be purchased that allow one to do custom white balancing, accurate metering, and exposure monitoring through the camera's histogram function, all with a single shot.

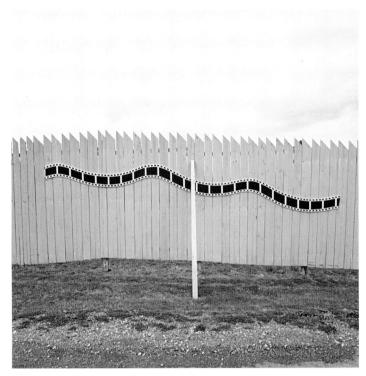

4.4 This high-key image has predominantly high values, with some middle values in the foreground creating a bright image. Its histogram would show values clustered to the right side of the graph, indicating overexposure.
© Keith Johnson. 9W, 2003. 19 × 19 inches. Chromogenic color print.

Camera Metering Programs

Matrix Metering/In-Camera Metering Methods

Most DSLRs have computer-assisted matrix metering. With this feature, the meter is programmed to recognize common lighting situations and adjust the exposure accordingly. Typically, the camera's

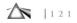

meter divides the scene into a series of weighted sectors and compares the scene being metered to the light patterns from numerous photographs in its memory. The meter may automatically shift between sensitivity patterns, depending on whether the camera is held horizontally or vertically. All these features make matrix metering effective in the majority of general situations. It can also be effective where the frame is dominated by bright or dark colors. Matrix metering also allows one to choose between different meter programs to automatically deliver highly accurate results, depending on the light; options include center-weighted, spot, highlight- or shadow-biased, and segment averaging. Metering modes are often displayed in the control panel and are easy to change.

The *center-weighted method* meters the entire frame but assigns the greatest sensitivity to light to the center quarter of the frame. It is an excellent choice for portraits and when using filters with an exposure factor greater than 1X.

The *spot method* measures light from a small zone in the center of the viewfinder. As it may be reading only 1 percent of the frame, care must be taken to read crucial areas of detail in the picture to obtain the desired results. When it is not practical for the photographer to get up close to measure the light on a subject, as with a distant landscape or a sporting event, the spot meter has the advantage of being able to measure the light from any number of key areas of the scene from a distance. It is ideal to ensure proper exposure when the background is much brighter or darker than the principal subject.

Using a Camera Monitor

The vast majority of digital cameras has a monitor on the back, commonly a liquid crystal display (LCD), in a variety of sizes, dynamic

ranges (the maximum contrast ratio of dark and light areas that can be accurately displayed without distortion), and resolutions. As noted in Chapter 3, because some monitors can be moved into a variety of positions, the photographer's framing options are increased: it is easy to compose while holding the camera above your head or below your waist.

These monitors have played a major role in popularizing digital cameras because they also conveniently permit you to instantly view and share images with those around you. They also have other characteristics that are innately different from conventional optical viewfinders. Unlike most optical viewfinders that do not show you exactly what the camera will record, cropping off 5 to 10 percent of a scene, a digital camera monitor can display 100 percent of the image that the camera will capture, permitting accurate, full-frame composition. In addition, a camera monitor can effectively show focus and exposure, and it offers a convenient way to compare changes in exposure and/or color settings as you bracket. The monitor allows the camera to be held away from your eye, making it viable to simultaneously compose while following live action. The maneuverability of adjustable camera monitors is also expedient for overhead and low-angle frame composition. The monitor also displays the camera's various menus, simplifying the navigation process of selecting modes and options.

On the down side, camera monitors use a lot of battery power, can be difficult to see in bright light and when glare and/or reflections are present (optional shades are available), and cannot deliver as high a level of fine detail as an optical viewfinder. All these factors may undercut the effectiveness of what you can actually see on a monitor, making precise exposure calculations difficult to determine. Also, the dynamic range of a camera monitor will not accurately show the levels of highlight or shadow detail contained in the actual image file.

Because of these traits, when critical focus is required, you should use the optical viewfinder (if it is available). The best way to achieve a general, overall, accurate exposure is by metering from a middle gray area of a scene, and not from the dark or light areas. Ideally, this is accomplished by metering off of an 18 percent gray card that is placed directly in front of the key subject in the same type of light. If this is not possible, look for a key area within the scene that comes close to representing an 18 percent gray, meter off that gray value, and use the monitor to review and make appropriate adjustments.

Electronic Viewfinder (EVF)

Some digital cameras have both a monitor and an optical viewfinder. Others have only a monitor or *electronic viewfinder* (EVF). An EVF is essentially a miniature second monitor inside the back of the camera that replaces the traditional optical viewfinder (see Chapter 3's section on Monitors). The photographer looks at the monitor through a small window and sees the scene from the same viewpoint as the lens. Thus, parallax error is avoided.

The desire to make cameras smaller and keep manufacturing costs down has resulted in an increase in the use of EVFs. Using an EVF on a camera is equivalent to looking at the world through a video monitor. Compared with an optical viewfinder, an EVF view is less sharp, colors less accurate, and the resolution generally too low for accurate manual focusing. The main advantage of an EVF is that it is internal and shaded, thus providing the ability to see picture files under very bright conditions when it is not possible to clearly see them on the camera's monitor. EVF Superzoom cameras boast powerful, but fixed (non-interchangeable) zoom lenses and only use an EVF, making them less bulky and heavy than a DSLR. The EVF shows the image directly from the image sensor on a tiny eyepiece LCD; thus parallax error is avoided. The electronic viewfinder also makes for very quiet, vibration-free shooting. The only shutter noise is an electronic sound effect, which can be turned off or on. While the EVFs are highly accurate in terms of showing you close to 100 percent of what the camera is seeing, what you are actually viewing is a video image that can be jumpy. Therefore, an EVF does not provide the clarity of a DSLR viewfinder and can make tracking a moving subject difficult (see the section in Chapter 3 on Monitors).

How a Meter Gets Fooled

Scenes containing large areas of light, such as fog, sand, snow, or white walls, deliver a meter reading that causes underexposure because the meter is fooled by the overall brightness of the scene. To correct the meter error, and additional exposure of between one and two f-stops is needed. Review the image on your monitor and make the necessary adjustments.

Scenes with a great deal of dark shadow produce overexposures. This happens because the meter is designed to reproduce an 18 percent gray under all conditions. If the predominant tones are darker or lighter than 18 percent gray, the exposure will not be accurate and must be corrected by the photographer. A reduction of one to two f-stops is often needed for dark subjects. Again, review the image on your monitor and make the necessary adjustments. An incident reading performs well in these situations because it is unaffected by any tonal differences within the subject. Bracketing of exposure (see the following section) is a good solution in both these situations.

4.5 "The series begins with photographs of the familiar: my own home and neighborhood. I use digital collage to bring in elements exterior to the confines of the photograph and integrate them as seamlessly as possible. The work places the landscape in a larger context that contains not only political, spiritual, and cultural narratives, but also the air within the scene, the weather and light. This situates each image within something larger than itself: the planets, stars, and solar systems hidden from sight yet still present behind every sky. To make the original exposure, with a 4 \times 5 inch view camera, I metered off the snow and overexposed by 1-1/2 f-stops to compensate for the brightness of the scene."

© Colin Blakely. *Rain Turning to Freezing Rain Overnight*, from the series *Domestic Weather Patterns*, 2004. 24 × 28 inches. Inkjet print.

Exposure Bracketing

Exposure bracketing begins by first making what you believe is the correct exposure. Then you make a second exposure 1/2 f-stop under that "correct" exposure. And finally, you make a third exposure 1/2 f-stop over the original exposure. In tricky lighting situations, it's a good idea to bracket two 1/2 f-stops in each direction (overexposure and underexposure) for a total of five exposures of the scene. Many DSLRs have auto-bracketing that will make a series of three exposures: normal, under, and over (usually ± 0.5 or ± 1 f-stop) in rapid succession. Do not be afraid to shoot a few more frames and review your results on the monitor. Bracketing can help a photographer gain an understanding of the relationship between light and exposure. Analyze and learn from the results so you can apply it the next time a similar situation is encountered.

Exposure Compensation

Many cameras offer an exposure compensation dial that will automatically provide you with the desired amount of correction. For instance, if you photographed a dark figure against a dominant light background, the exposure suggested by an averaged meter metering will produce an unexposed image. By setting an exposure compensation of +1.5, for example, the result will be more natural.

Manual Override

Cameras that have fully automatic exposure systems without a manual override reduce a photographer's options. The machine decides how the picture should look, how much depth of field it should have, and whether to stop the action or to blur it. If you only have an automatic camera, try experimenting with it by adjusting the shutter speeds, altering the ISO setting, or using the backlight control to change your lens aperture. Learn to control the machine rather than being its prisoner.

Hand-Held Meters

Once the in-camera meter is mastered, those wishing to learn more about measuring light may acquire a hand-held meter. When purchasing a hand-held meter, make certain it can read both reflected and incident light. Incident light readings are accomplished by fitting a light-diffusing attachment over the meter's cell. The meter can then be pointed at the light source rather than at the subject. Since it measures the light falling on the subject and not the light reflected by the subject, the incident reading is useful in contrasty light or when a scene has a large variation in tonal values. Many hand-held meters can also take spot meter readings or deliver readings when using an off-camera electronic flash.

Brightness Range

The brightness range of a subject (the difference in the number of f-stops between the key highlight and key shadow area of a scene) is one way to determine exposure. Today's digital cameras are capable of recording a brightness or dynamic range of about 64:1. In many cases, this forces you to either expose for the highlights and let the shadows go black, or vice versa. According to *Moore's Law*, Gordon Moore, a founder of the Intel Corporation, observed in 1965 that the number of transistors on a chip doubles every 18 months, and it has remained pretty much true. This means that future digital sensors will have a greater dynamic range, but what is one to do now to retain wanted detail?

Exposing to the Right

Bearing in mind what Russian-American writer Vladimir Nabokov (*Lolita*, 1955) observed — "In art as in science there is no delight without detail" — the general rule for average scenes is to expose for the highlights. This entails finding that spot where the scene retains detail in the brightness areas without them "blowing out" and losing detail. It is also known as "Exposing to the Right," as you want to ensure that the highlights fall as close to the right side of the histogram as possible.

High-Dynamic-Range/HDR

When the brightness range exceeds the limitations of your equipment, you can consider high-dynamic-range (HDR) software solutions. Suppose, for example, you want to photograph a room interior but want also to maintain detail in the view outside the windows. Usually you have to choose either the interior or the exterior view and allow the detail in the other to be lost. To overcome this problem, you can make an HDR image using multiple photographs, each captured with a different exposure of the same scene. In this case, you would place the camera on a tripod and make a correctly exposed view of the interior and then a second exposure for the exterior. Later you use HDR software to sort through the resulting images, which range from nearly black underexposed views to washed-out overexposures, to calculate the full dynamic range of the scene. Using that data, it then constructs a single, HDR image.

Basic Light Reading Methods

The brightness range method can be divided into four broad categories: average bright daylight with no extreme highlights or shadows;

brilliant, contrasty, direct sunlight; diffused, even, or flat light; and dim light.

Average Daylight

In a scene of average bright daylight, the contrast is more distinct, the colors look more saturated, the highlights are brighter, and the shadows are darker with good detail in both areas. Meter reading from different parts of the scene may reveal a range of about seven f-stops. Care must be given to where meter readings are taken. If the 4.6 "Natural light in a 'clear-cut' is about as harsh as it gets; the magic hour of light lasts only 2 or 3 minutes during the summer months at either sunset or sunrise. The light has nothing to filter through, nothing to bounce off of; all the trees have been stripped away. What was once an amazing natural lit forest has been turned into a graveyard of debris and downed wood. The trees tattooed on this man's legs were the only ones standing for hundreds of yards. It was a magical moment in the harshest of light, a moment of metaphor and striking paradox. I exposed for the highlight; shadows are often best left dark for me. This allows me to record the contrast and negative space I like in my images. When printing, I burned in the sky around the body to add to the heaviness I felt within the surrounding environment; and dodged the tattoos on his legs to help them pop off of his calves."

 \bigcirc Christopher LaMarca. Untitled, from the series, Forest Defenders, 2005. 11 × 11 inches. Chromogenic color print.

subject is in direct sunlight and the meter is in the shadow, overexposure of the subject will result.

Brilliant Sunlight

Brilliant, direct sunlight has maximum contrast and produces the deepest color saturation. The exposure range can be 12 f-stops or greater, which stretches or surpasses the ability of the sensor to record the scene (and which can be corrected with imaging software. These conditions result in black shadows and bright highlights. Color separation is at its greatest; white appears at its purest. Determining which areas to base the meter reading on is critical for obtaining the desired results. These effects can be compounded when photographing reflections off glass, polished metal, or water. Selective exposure techniques such as incident light or spot reading may be needed (see section on unusual lighting conditions later in this chapter).

4.7 Spagnoli's project of depicting large spaces bookends the history of photography by using pre-photography technology, an 8 \times 10 inch pinhole camera, whose results are digitized and adjusted in Photoshop. Spagnoli established a consistent central motif, the sun, and allowed the landscapes to form themselves around it, realizing that he "was breaking a fundamental rule of good photography by shooting into the sun. The pinhole eliminates typical optical aberrations produced by a glass lens. The effects you do get, the rays in particular, actually occur inside the camera box, making it an active pictorial space as well."

© Jerry Spagnoli. Marathon, 2004. 30 × 40 inches. Chromogenic color print.

A hood or shade may be needed to prevent lens flare (the scattering and internal reflection and refraction of bright light) which commonly occurs when an optical system is pointed toward intense light sources.

Diffused Light

Overcast days offer an even, diffused quality of light. Both highlights and shadows are minimal. Colors appear muted, quiet, and subdued. Whenever the scene is metered, the reading usually remains within a range of three f-stops. The apparent brightness range and contrast can be increased through overexposure.

Dim Light

Dim natural light taxes the ability of the sensor to record the necessary color and detail of the scene. Colors can be flat and monochromatic, and contrast is often problematic. Contrast can be extreme when artificial light sources are included within the scene. Contrast can also be lacking, with details often difficult to determine. Post-exposure corrections are often necessary. Low levels of light translate into long exposures; a tripod, a higher ISO setting (see section below on Long Exposures and Digital Noise), or additional lighting may be needed to make the desired picture.

Contrast Control/Tone Compensation

DSLRs have an image adjustment control for altering the image contrast and brightness at the time of exposure. The contrast of an image, the relationship between the distribution of light and dark tones, can be controlled by altering the tone curve. This is sometimes referred to as *tone compensation*. DSLRs offer a host of contrast management options. The *Automatic* or default option optimizes the contrast of each exposure by selecting a tone curve to match the situation. *Normal* uses the same curve setting for all images. *Low contrast* prevents highlights from being washed out in direct sunlight. *Medium*

4.8 "Shooting unobtrusively with a hand-held camera, like a tourist, in low light meant letting go of my expectations of what an image should look like and instead let it be its own thing that I worked with in Photoshop to bring out subtle detail and its 'surreal' qualities. These images play with popular mythologies and my own preconceptions as a participant in the natural history displays. I see the act of making these pictures as performative and an account of seeing, both with irony and sincerity."

© Dennis DeHart. Untitled, from the series (un)Natural Histories, 2004. 13 × 19 inches. Inkjet print.

low contrast produces slightly less contrast than *Normal. Medium high* produces slightly more contrast than *Normal. High contrast* can preserve detail in low-contrast situations such as in a foggy landscape. Some cameras allow a *Custom* curve to be created to deliver a unique look.

Light Metering Techniques

Metering for the Subject

Metering for the subject is another way to determine proper exposure. When in doubt about where to take an exposure reading, decide what the principal subject is in the picture and take a reflected reading from it. For instance, when making a portrait, go up to the subject or zoom in and take the meter reading directly from the face. When photographing a landscape in diffused, even light, an overall meter reading can be made from the camera position. If the light is hard (not diffused) or directional, the camera meter can be pointed up, down, or sideways to emphasize the sky, the ground, the highlights, or the shadows.

Exposing for Tonal Variations

Exposing for tonal variations is another method that can be used in calculating the exposure. A scene that has large amounts of either dark or light tones can give incorrect information if the exposure is based on a single reading. When making a picture of a general outdoor scene, a correct exposure can be achieved by taking two Manual light meter readings and then averaging them together. For example, suppose you are photographing a landscape, it is late in the day, the sky is brighter than the ground, and detail needs to be retained in both areas. First, meter a critical highlight area, in this case the sky, in which detail is required. Let's say the reading is f/16 at 1/250 of a second. If the exposure was made at this setting, the sky would be rich and deep, but the ground detail would be lost and might appear simply as a vast black area. Now meter off a key area in the shadow area of the ground. Say it is f/5.6 at 1/250 of a second.

4.9 The accurate capturing of the diffused light enabled Johnson to maintain the subtle color that generated the necessary visual ambiguity to make a smart, formal, and humorous examination of our interdependent cultural network. Johnson's framing pulls the eye into the frame, gently guiding viewers through deep-space perspective and an intruding foreground object. The resulting juxtaposition turns the sublime into the absurd while presenting the interaction of two energies, yin and yang, which cause everything to happen and cannot exist without each other.

© Keith Johnson Do Not Open, 2004 30 × 30 inches. Inkjet print.

This would provide an excellent rendition of the ground, but the sky would be overexposed and would appear white, completely desaturated of color, and with no discernible detail. To get an average reading, take the meter reading of the highlight (sky) and the shadow (ground) and halve the f-stop difference between the two readings. In this case, an average reading would be about f/8-1/2 at 1/250 of a second. It is permissible to set the aperture in between the f-stops, though DSLRs display the actual f-stop number, such as f/8, f/9, f/10, and so on. The final result is a compromise of the two situations, with acceptable detail and color saturation in each area.

If the subject being photographed is either a great deal darker or lighter than the background, such as a dark-skinned person against a white background or a fair-skinned person against a black background, averaging will not provide good results. If there is more than a five-f-stop range between the highlight and shadow areas, there can be an unacceptable loss of detail in both areas. In a case like this, let the background go and use post-exposure correction methods, or use additional lighting techniques such as flash fill to compensate for the difference.

Electronic Flash and Basic Fill Flash

Electronic flash operates by producing a veritable bolt of lightning between two electrodes inside a quartz-crystal tube that is typically filled with xenon gas. A quick discharge of high-voltage current from the system's capacitor excites the gas, and a brief, intense burst of light is emitted in the color temperature range of 5600 to 6000 K (see section below on Color Temperature and the Kelvin Scale). Many cameras have built-in flash units that are convenient but have limited capabilities. The range of the built-in flash is determined by the ISO

setting and lens aperture and will only cover certain focal lengths, such as 20–300 mm (see your camera manual for details). Flash can be extremely useful, as digital cameras tend not to perform well in low light without the benefit of electronic flash, producing significant noise at longer exposures.

Other cameras have dedicated external flash units designed to function with a particular camera. These provide automatic exposure control and expanded versatility. Professional portable and studio flash units are synchronized with a camera by means of a sync cord or a "slave" unit. The shutter must be completely open at the time the flash fires. Many DSLRs will not sync at speeds faster than 1/500 of a second (check your camera manual). If the shutter speed is too high, only part of the frame will be exposed. Systems can have multiple flash heads and variable power control that can be set to use only a portion of the available light. This allows you to control the intensity of the light, which is very useful for stopping action, bringing a subject forward in a composition, and creating atmospheric and flash fill effects. Filters can be placed over the flash head(s) to alter the color of the light for purposes of correction or to create a mood.

DSLRs offer a basic automatic fill flash option, but there are times when you may wish to alter this to achieve the look you desire. Fill flash is used to brighten deep shadow areas, typically outside on sunny days, but the technique can be helpful any time the background is significantly brighter than the subject. To use fill flash, the aperture and shutter speed are adjusted, either automatically or manually, to correctly expose the background, and the flash is fired to lighten the foreground. Bear in mind that there are two potential light sources that determine flash exposure. One is the ambient light and

4.10 In images that appeared as a Creative Time billboard project in New York, Minter used stop-action flash to recreate lush images she made for fashion magazines, substituting mud for water, transforming the nonexistent fashion ideal back to its messy, flawed, and highly human form. The billboards are an outgrowth of Minter's interest in blurring the boundaries between fine art and commercial art. Minter states: "I want to make a fresh vision of something that commands our attention and is so visually lush that you'll give it multiple readings, adding your own history and traditions to the layered content." The images attract and repel, but ultimately seduce. Complicit with our own secrets, we succumb to the guilty pleasure of looking at a tainted object of desire, stirring anxieties about our own imperfect bodies and our desires. © Marilyn Minter. *Shit Kicker*, 2006. 35 \times 50 inches. Chromogenic color print.

Courtesy of Baldwin Gallery, Aspen, CO, and Salon 94, New York.

the other is the light emitted by the flash — and you must always consider both. Also, remember to use the proper sync shutter speed (see your camera manual) and to check the operational lights on the back of your flash. If the green or equivalent light is glowing, then you are ready to properly expose the scene. Be sure to review each exposure on the camera monitor and make adjustments as needed.

A basic fill flash technique involves first taking an available-light meter reading of the scene, setting your camera's shutter to the desired flash synchronization speed, and then determining the f-stop. Next, divide the exposure f-stop number into the guide number (GN) of your flash unit, which can be found in your camera manual. The result is the distance (in number of feet) you need to be from your subject. Shoot at the available-light meter reading with the flash at this distance. For example, suppose the meter reads f/16 at a synchronization speed of 1/125. Your flash unit has a GN of 80. Divide 16 (f/16) into 80 (GN). The result is 5, the distance you need to be from the subject with an exposure of f/16 at 1/125.

A second fill flash method is to set the camera to make a proper ambient light exposure, using a correct synchronization speed. Note the correct f-stop that is required. Position or adjust the flash unit to produce light that is the equivalent of 1 or 2 f-stops less exposure, depending on the desired effect. If the flash produces an amount of light equal to the original exposure, the shadow areas will be as bright as the directly lighted areas. This equal balance of light will cause the modeling effect that normally defines the three-dimensional features of a subject to be lost, producing in a flat, featureless looking image.

A third technique is to determine the correct ambient light exposure at the proper flash synchronization speed and then vary the output of the flash by using a different power setting (half- or quarterpower) so the amount of flash light is correct for the subject-to-flash distance. If the flash does not have a power setting, putting a diffuser or neutral density filter in front of the flash head can reduce the output. You can also improvise by putting a clean white handkerchief in front of the flash head; each layer of cloth reduces the output by about one f-stop. Most external dedicated flash units can also make automatic fill flash exposures. Fill flash can also be employed selectively to provide additional illumination or with filters to alter the color of specific areas in the scene.

Red Eye

When photographing any living being with a flash unit attached to the camera, red eye can result. If your subject looks directly at the camera, and the light is next to the lens axis, light passes directly into the pupils of your subject's eyes and is strongly reflected back to the camera. This is recorded as a pink or red spot in the center of the eye because the light illuminates the blood vessels in the retina of the eye. If this effect is not desired, try one of the following: use the camera's red-eye reduction mode, have the subject look to one side of the camera, bounce the flash light, or move the flash unit some distance (6 inches or more) from the lens axis. This can be done by elevating the flash on a commercially available extender post or by getting a long flash synchronization cord and holding the unit away from the camera with one hand. The red-eye reduction mode fires a small light about 1 second before the flash, causing the pupils in the subject's eyes to contract and thereby reducing the red effect sometimes caused by the flash. You will find that the camera needs to be held still when the lamp goes on, and the 1-second delay makes this mode unsuitable with moving subjects or when a quick shutter response is needed. In any case, digital imaging software usually offers red-eye correction.

4.11 Using a fill flash (1/1000 of a second) in combination with a long exposure (1 second) while hand-holding the camera can produce unexpected results. Erf created this photograph in the late evening underneath a 100-year-old oak tree that required f/22 to push the exposure to 1 second. A sharp image of people at 1 second is impossible while hand-holding the camera, but using the flash acts as a fast shutter speed, stopping any of his subject's movement. The long exposure creates unusual motion effects, with the background dependent upon the movement of the photographer.

© Greg Erf. Summer Day, 2006. 8 × 10 inches. Inkjet print.

Unusual Lighting Conditions

Unusual lighting conditions cause exposure problems: uneven light, light hitting the subject from a odd angle, backlight, glare and reflections, areas with large highlights, or shadows such as inside doorways and windows, as well as light from computer or television screens. The wide range of tones in such scenes can tax the sensors' ability to record them. A photographer must decide what is important to record and how to get it done.

Subject in Shadow

When the subject is in shadow, the photographer must decide which is the most important area of the picture, which details need to be seen, and which colors are most intriguing. If the subject is in shadow, take a reflected meter reading from the most important shadow region. This provides the correct exposure information for that key area. Other areas, mainly the highlights, may experience a loss of color saturation and detail due to overexposure, which can be corrected with imaging software. At other times, there may be a key highlight striking the subject in shadow. The exposure can be made based on the highlight reading, letting the remainder of the subject fall into obscurity. Additional light, by means of flash and/or reflective fill cards, such as a piece of white foam core, can be used to put more illumination on the subject.

Subject in Bright Light

Should the main point of interest be in a bright area, take a reflected reading from the key highlight area or use an incident reading. A contrasty subject dealt with in this fashion provides dramatic, rich, and saturated color along with good detail in these bright areas. The shadows will lack detail and provide little visual information. Anything that is backlit becomes a silhouette with no detail under these circumstances.

Inexpensive digital cameras often overexpose highlights, resulting in a lack of detail. In contrasty situations, determine the areas that 4.12 "I photograph agricultural fires; therefore I have to be portable and able to move quickly. Part of the process of harvesting sugar cane is that the cane is first cut and laid in rows on the ground. It is then set on fire to burn the dry leaves off the stalks, which are then loaded and sent to a refinery. This photo is of the cane burning in the fields late in the afternoon. Because of the nontraditional light sources and unusual shooting conditions, there are many more decisions to be made about exactly how to best present the final image in terms of color and density. This image was exposed on film and proof prints are made in the darkroom. The film is then drum-scanned at very high resolution and the file is burned to a DVD. The final prints are made on a Lightlet machine, which shoots laser light onto traditional photographic paper."
© Larry Schwarm. Burning Sugar Cane, Bayou Tesch, Louisiana, 2004. 29 × 29 inches. Chromogenic color print. Courtesy of Robert Koch Gallery, San Francisco.

you want to retain detail and texture, and expose for them by zooming in, locking the exposure by depressing the shutter button halfway, reframing, and then making the photograph.

Alternative Solutions

If it is not acceptable to lose the details in the shadows, there are other alternatives. These include averaging the reflective reading, bracketing, using additional lighting techniques such as flash fill, or combining both a reflective and an incident reading. This last method is done by taking an incident reading, pointing the meter toward the camera, instead of reading the light striking the subject. This reading is not affected by extreme highlights. Then take a reflected reading with the meter aimed at the key subject area. Now average the two and bracket for insurance. When in doubt, the best insurance is to bracket and use imaging software to make additional corrections.

Long Exposures and Digital Noise

When making long exposures, such as before sunrise, after sunset, at night, and in dimly lit interiors, highlight areas have a tendency to burn out and digital noise increases. It is common to see high levels of digital noise that show up as specks or mottling, especially in the shadows. Digital noise can be described as "flecks" of visual static that appear as light snow in the image. These flecks are known as *artifacts*, and although they do not produce global color shifts, they can cause

4.13 "After the tragic events of September 11, 2001, our president encouraged us to go shopping as an act of solidarity to maintain our country's economy. The act of shopping has become a temporary salve of instant gratification, a means of expressing repressed desire, and within the malls of America, an escape into the unreal. Using the Mall of America in Minneapolis as the setting, I created an installation to question and reveal the nature of our desires as they are reflected and directed in the mall and in the character of the fetishized commodity. The figures are silhouetted by well-lit spaces to erase their identity while the name brands of stores are emphasized. I achieved this by setting my camera to shutter mode and metering for the highlights."

© Priscilla Briggs. MAC, 2006. 32 × 40 inches. Inkjet print.

color tinges around their edges (see section on Digital Aberrations in Chapter 3).

Reciprocity Law

The reciprocity law is the theoretical relationship between the length of exposure and the intensity of light. It states that an increase in one is balanced by a decrease in the other. For example, doubling the light intensity should be balanced by exactly halving the exposure time. In practical terms, this means that if you meter a scene and calculate the exposure to be f/8 at 1/250 of a second, you could obtain the same exposure by doubling your f-stop opening and cutting your exposure time in half. Thus, shooting at f/5.6 at 1/500 of a second should produce the same results as shooting at f/8 at 1/250. You could also double your exposure time and cut your f-stop in half, so that shooting at 1/125 of a second at f/11 is the same as shooting at 1/250 of a second at f/8. Table 4.2 shows some of the equivalent theoretical exposures if your exposure was f/8 at 1/250 of a second.

Table 4.2 Theoretical Exposure Equivalents (Based ona Starting Exposure of f/8 at 1/250 Second)

f-stop	Time in Seconds
f/16	1/60
f/11	1/125
f/8*	1/250*
f/5.6	1/500
f/4	1/1000

* Starting exposure.

This can be useful when you need to stop action, as you can swap a decease in aperture for an increase in shutter speed. Suppose you calculate the exposure to be f/8 at 1/125 of a second, but you know that you need 1/500 of a second (an increase of two full f-stops) to freeze the motion (see Chapter 6). Using the reciprocity law, you can then determine that you would need to open your lens aperture an additional two full f-stops to compensate, thus giving you an exposure of f/4 at 1/500 of a second.

FILTERING THE LIGHT

The Sun: A Continuous White Light Spectrum

The sun radiates "white" light, which is a continuous spectrum of all the visible wavelengths produced by the elements burning on the sun's surface. As these wavelengths are separated out by absorption and reflection, we see them as color. The shortest wavelengths appear as violet, the longest as red, and all the other colors fall somewhere in between. The human eye can only detect a tiny portion of the electromagnetic spectrum known as the *visual spectrum*. The ultraviolet (UV) wavelengths occupy the range just beyond the blueviolet end of the visual spectrum and are too small to be seen by the human eye. The infrared (IR) part of the electromagnetic spectrum begins just beyond the visible red wavelengths, which are too long to be seen with the human eye.

Color Temperature and the Kelvin Scale

The balance of the amount of color contained in a continuousspectrum light source that has all the visible wavelengths (red, orange, yellow, green, blue, and violet) in various amounts is measured as

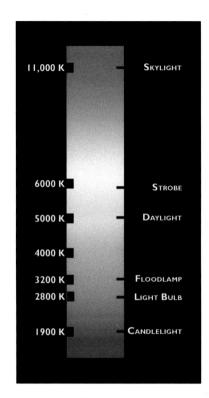

4.14 The Kelvin scale is used by photographers to measure the coolness or warmth of light. The bluer (cooler) the light, the higher the Kelvin temperature. This illustration shows the approximate Kelvin temperatures of common photographic light sources. Table 4.3 provides more specific details.

color temperature. Color temperature is expressed on the absolute (Kelvin) scale. The Kelvin scale starts at absolute zero, -273.15 C on the centigrade scale (usually rounded off to -273 C). Absolute zero is the temperature at which all molecular motion theoretically stops. The degree symbol is not used when expressing the color temperature

of a light source in Kelvin (K). The Kelvin temperature is determined by adding 273 to the number of degrees centigrade to which a black metal radiator would have to be heated to take on a certain color. A black body is used as a standard gauge since it does not reflect any light falling on it and only emits radiation when heat is applied to it. The Kelvin scale is to the color of light as the ISO scale is to the sensitivity of image sensor (Table 4.3).

The Color of Light

Although we think of daylight as being "white," it usually contains some color, depending on the time of day, the time of year, and the weather. Artificial light is rarely white. Our brain remembers how things are supposed to look and makes us believe that the light is white even if it is not, interpreting the scene for us.

White Balance

Digital cameras have built-in white balance control, which compensates for variations in the color of common types of light so that white and gray objects appear to have a neutral color balance. The color of a light source is described in terms of its color temperature, measured in degrees Kelvin (K). If the color temperature of the light does not match the white balance setting, the final image will have a color cast to it. Think of the white balance control as a built-in set of electronic filters that allow you to alter the color temperature of a variety of fixed values or can be measured and manually set.

Learning how to adjust and control the white balance is the best initial method for achieving the desired color balance of the final image. DSLRs can automatically or manually adjust the color balance

Table 4.3 Common Light Sources and Their Approximate Color Temperatures

Daylight Sources*	Color Temperature (K)
Skylight during summer	9500 to 30,000
Summer shade, average	7100
Summer sun and blue skylight	6500
Overcast sky	6000
Direct sunlight, midsummer	5800
Noon sun with clear sky (summer)	5000 to 7000
Noon sun with clear sky (winter)	5500 to 6000
Photographic daylight	5500
Noon sunlight (depends on time of year)	4900 to 5800
Average noon sunlight (Northern hemisphere)	5400
Sunlight at 30-degree altitude	4500
Sunlight in the early morning & late afternoon	4300
Sunlight one hour after sunrise	3500
Sunrise and sunset	2000 to 3000

* All daylight color temperatures depend on the time of day, season of the year, and latitude and altitude of the location. Sunlight is the light of the sun only. Daylight is a combination of sunlight plus skylight. The values given are approximate because many factors affect color temperature. OUTDOORS: the sun angle and the conditions of the sky — clouds, haze, dust particles — raise or lower the color temperature. INDOORS: lamp age (and blackening), voltage, type of reflectors, and diffusers affect tungsten bulbs, and all of these can influence the actual color temperature of the light.

Table 4.3 Continued

Artificial Sourcest	Color Temperature (K)
Electronic flash	5500 to 6500
Warm white fluorescent tubes	4000
500-watt 3400K photolamp (photofloods)	3400
500-watt 3200K tungsten lamp (photolamps)	3200
200-watt household lamp	2980
100-watt household lamp	2900
75-watt household lamp	2820
40-watt household lamp	2650
Gaslight	2000 to 2200
Candlelight (British Standard)	1930

+ The age and the amount of use of the bulb, lamp, or tube affect the color temperature.

of each frame electronically according to the color temperature of the light coming through the lens. Begin with *Auto* white balance for general light sources of 3500 to 8000 K. If the desired results are not achieved, then try one of the following: *Incandescent*, for use with 3000 K incandescent lighting; *Fluorescent*, for use under 4200 K fluorescent lighting; *Direct sunlight*, for use with subjects lit by 5200 K direct sunlight; *Flash*, for use with 5400 K built-in flash units; *Cloudy*, for use in daylight under 6000 K overcast conditions; *Shade*, for use with subjects in 8000 K shady conditions; and *Preset*, for use with a

gray card or white object as a reference to create a custom white balance. *Preset* allows the white balance to be fine-tuned to compensate for variations in the color of the light source or to deliberately introduce a slight warm or cool cast into an image. Raising the white balance setting can slightly compensate for light sources with a red or yellow cast, making an image look more bluish. Lowering the white balance setting can slightly compensate for bluish light sources, making an image appear slightly more red or yellow. Many DSLRs offer White Balance Bracketing, in which the white balance is automatically varied in a series of exposures.

Camera Color Modes

Digital cameras have image-processing algorithms designed to achieve accurate color, but there are variables within these programs and within the scene that may produce distinct color variations. DSLRs offer a range of application modes. For instance, one mode might be optimized to set the hue and chroma values for skin tones in portraits that will be used "as is" (no or minimal post-exposure processing). A second mode could be Adobe RGB color space which can give a wider gamut of colors, which is the preferred choice when images will be extensively processed. A third mode could be optimized for making "as is" outdoor landscape or nature images.

Color Saturation Control

Digital cameras usually have a saturation control for adjusting the intensity of color in the image for printing and/or manipulation in the computer. The color saturation or vividness of an image can be set to Normal, recommended for most general situations; Moderate, useful when post-exposure image processing is planned; or Enhanced,

for increased saturation, which can be useful in "as is" situations when no additional post-modifications are planned.

Hue Adjustment/RGB Color Mixing

The RGB color model used in digital photography reproduces colors using differing amounts of red, green, and blue light. By mixing two colors of light, a variety of different colors can be produced. For instance, red light combined with a small amount of green light produces orange. Mixing equal amounts of red and green will produce yellow. Combining various amounts of red and blue light can generate a range of colors from reddish purple through purple to navy. Combining all three can produce a range from white through gray. Arranging this progression of hues in a circle results in what is known as a *color wheel*. Using this method, the hue or color of a captured image can be slightly adjusted in varying increments. For example, raising the hue adjustment of red would increase the amount of yellow, making the resulting image more orange. Lowering the hue level would increase the amount of blue, making the resulting image more purple.

Why a Color May Not Reproduce Correctly

Camera image sensors are designed to replicate what the designers believe is an agreeable rendering for most subjects in a variety of situations. Since the sensors are not sensitive to colors in precisely the same way as the human eye, there can be times when it is impossible to recreate a specific color. Sensor designers concentrate on trying to successfully reproduce flesh tones, neutrals (whites, grays, and blacks), and common "memory" colors such as sky blue and grass green under a variety of imagemaking situations. As a result, other colors, such as yellow and orange, do not reproduce as well. Also, the ability to properly match the input to the output source, screen, print, or transparency plays a major role in determining how accurately colors reproduce (see Chapter 8).

Lens Filters

A photographic filter is a transparent device that can alter the quality and quantity of light. It is placed in front of the camera lens or in the path of the light falling on the subject. Filters that go in front of the lens must be of optical quality or they can degrade the image quality. Filters used in front of a light source do not have to be of optical quality, but they must be able to withstand high heat without becoming distorted, faded, or subject to combustion.

How Filters Work

Most filters are colored and work subtractively, absorbing the wavelengths of light of their complementary (opposite) color while transmitting wavelengths of their own color. The color of a filter is the color of the light it transmits. For example, a red filter is red because it absorbs blue and green light while transmitting red light. Although a filter transmits its own color, it also passes all or parts of the colors next to it in the spectrum while absorbing part or most of all other colors. A red filter does not transmit yellow light, but it does allow some light from yellow objects to pass. This occurs because yellow is made up of green and red. The red filter passes the red portion of the yellow while blocking the green.

Filter Factor

Filters are normally uniform in color but may differ in density (color strength). The amount of light absorbed depends on the density of

Filter Factor	Exposure Adjustment
1.2X	+1/3 stop
1.5X	+2/3 stop
2X	+1 stop
2.5X	+1-1/3 stops
3X	+1-2/3 stops
4X	+2 stops
5X	+2-1/3 stops
6X	+2-2/3 stops
8X	+3 stops

Table 4.4 Filter Factor Adjustments

Note: Cameras with TTL meters should automatically make the correct filter factor adjustment. When using a hand-held meter, you'll have to manually make the adjustment. The lens aperture may be set in between the standard f-stops to achieve accurate exposure adjustment.

the filter. Since filters block some of the light, they generally require an increase in exposure to make up for the light lost due to absorption. This compensation is known as the *filter factor* and is indicated as a number, followed by an X sign, which tells by how much the exposure must be multiplied. A filter factor of 2X means that one additional f-stop of exposure is needed; 2.5X shows 1-1/3 additional f-stops are necessary; 3X means an extra 1-2/3 f-stops are needed; 4X indicates two additional f-stops of exposure. To simplify matters, many manufacturers indicate how many f-stops are needed to increase the exposure. Table 4.4 shows the effect of filter factors on exposure.

Exercise			
	Intentionally make photographs under lighting conditions that		
	do not match the type of light for which the camera's white		
	balance is set. Then, under the same mismatch of conditions,		
	take corrective actions using white balance, flash, and/or filters		
	to make corrections. Compare your results. Discuss the		
	emotional effect that is created when the white balance and		
	light do not match. Might there be a situation when you would		
	intentionally create a mismatch? Why?		
	Observe any frequently occurring problem situations that a		

Observe any frequently occurring problem situations that a filter would help to solve. Base future purchases on your own shooting experiences, and get the equipment that lets you make pictures you desire.

Most thru-the-lens (TTL) DSLR metering systems give an accurate reading with a filter in place; otherwise, adjust the ISO to compensate. Some TTL meters can be fooled and give faulty readings with certain filters. Bracket and review your exposures in your monitor when using a filter for the first time. Table 4.4 also shows the amount of additional exposure needed for many common filters when working with a hand-held or non-TTL camera meter. Autofocus systems may not operate properly with heavy filtration, diffusion, or certain special-effects filters. If the system balks, switch to manual focus.

Neutral Density Filters

Neutral density filters (ND) are applied to reduce the intensity of the light by absorbing the same amount of all the wavelengths. ND filters

will not affect the color balance or tonal range of a scene. They have an overall gray appearance and come in different densities (ND2, ND4, and ND8) that will cut the light by one, two, or four f-stops. An ND2 transmits 50 percent of the light, ND4 25 percent, and ND8 12.5 percent. Kodak's Wratten ND filters, available in dyed gelatin squares, come in 13 different densities, ranging from 0.1 (needing 1/3 f-stop more exposure) to 4.0 (needing 13-1/3 more f-stops of exposure).

An ND filter can be used anytime the light is too bright to use a slow shutter speed or large lens aperture opening. An ND filter can be used to reduce the depth of field. This can be effective in outdoor portraiture because it permits you to use a large aperture to put the background out of focus, thus giving more emphasis to the subject. ND filters can be employed to get a slower shutter speed and produce intentional blur action shots. For instance, a slow shutter speed would let the movement of cascading water be captured as a soft blur. Another example would be moving the zoom control of the lens during exposure, for which a shutter speed of 1/15 second or slower is necessary while the camera is on a tripod. ND filters can also be useful in making pan shoots.

Dealing with Reflections: Polarized and Unpolarized Light

Normally, a light wave moves in one direction, but the light energy itself vibrates in all directions perpendicular to the direction of travel of the light wave. Such light is said to be *unpolarized*. Polarizing filters are designed to transmit only the part of each light wave vibrating in a particular direction; the rest of the light wave is refracted away from its original direction. The portion of the light that is transmitted is called *polarized* light.

What a Polarizing Filter Can Do

A polarizing filter is made up of submicroscopic crystals that are lined up like a series of parallel slats. Light waves traveling parallel to these crystal slats pass unobstructed between them. The crystal slats block light waves vibrating at different angles. Because the polarized light is all at the same angle, a polarizing filter is designed to rotate so it can block the polarized portion of the light.

Polarizers are usually a gray-brown color. Polarizers are used to eliminate reflections from smooth, nonmetallic, polished surfaces such as glass, tile, tabletops, and water, and they can improve the color saturation by screening out the polarized part of the glare. This can make a clear blue sky appear deeper and richer and have more contrast without altering the overall color balance of the scene. The increase in saturation results from a decrease in surface glare. Since most semi-smooth objects, such as flowers, leaves, rocks, and water, have a surface sheen, they reflect light, thus masking some of the color beneath the sheen. By reducing these reflections, the polarizer intensifies the colors.

A polarizing filter can also be more effective than a haze filter for cutting through haze because it reduces more of the scattered blue light and decreases reflections from dust and/or water particles. The net effect is the scene appears to be more distinct and sharp while also increasing the visual sense of depth and adding to the vividness of the colors. When copying original art and reproductions from books or when photographing glossy-surfaced objects, maximum glare control can be obtained by using polarizing filters in front of the light sources as well as in front of the camera lens. Evaluate each situation before using a polarizer, as there are situations where the purposeful inclusion of reflections can strengthen a photographer's underlying concept.

Using a Polarizer

When using a polarizing filter, focus first; turn the filter mount until the glare decreases and the colors look richer; and then make the exposure. The filter factor will remain the same, regardless of how much the filter is rotated. The filter factor varies, from about 2X to 3X, depending on the type of polarizer used.

The amount of the effect is determined by how much polarized light is present in the scene and the viewing angle of the scene. At an angle of about 35 degrees from the surface, the maximum reduction in reflections can be achieved when the polarizer is rotated to the correct position.

A polarizer may also be combined with other filters for special effects. There are polarizers with color available. These combine a gray and a single colored polarizing filter. Any color, from gray to the full color of the other filter, can be achieved by rotating the filter frame ring. There are also multicolored polarizers that combine a single gray polarizing filter and two colored polarizing filters. Rotating the filter frame ring alters the colors.

Linear and Circular Polarizers

There are two types of photographic polarizers: the old linear and the newer circular model. If your camera has a semi-silvered mirror, which includes all current autofocus DSLR cameras, the linear filter will produce underexposed and out-of-focus pictures. Circular filters

4.15 "I find the digital montage to be a superb foundation to raise questions around the ethics behind consumerism. Has consumerism reached a level of absurdity? Or is that label reserved for the moment when Starbucks begins to incorporate public park statues into their ad campaigns? Here I used a polarizer at the time of exposure to manipulate the reflections on the statue. This work allows me to visually explore the gap between what if and what is, for if I can use these ideas to create a farce, how much longer will it be until someone else seriously applies them."

© Frank Donato. *Starbucks*, 2006. 14 × 14 inches. Chromogenic color and inkjet prints.

work on all DSLR cameras without producing these undesirable side effects, but are more expensive.

Ultraviolet Light Filters

Ultraviolet, haze, and skylight filters were commonly used with film cameras because they absorb ultraviolet (UV) radiation and have no filter factor. Although UV radiation does not adversely affect digital image sensors, many photographers leave a UV filter on all their lenses to protect the lens surface from dirt, moisture, and scratches.

Special-Effects Filters

Special-effects filters produce unusual visual effects at the time of exposure (see Box 4.1). These same effects can be replicated, post-exposure, with imaging software, especially with after-market plugins (see section below: Digital Filters and Plug-ins). Such plug-ins simulate popular glass camera filters, specialized lenses, optical lab processes, film grain, exacting color correction, as well as natural and infrared light and photographic effects — all in a controlled digital environment. Be sure to exercise care and thought before using any special effects filters, however, as they have been chronically abused and overused by lazy imagemakers who lack genuine picture-making ideas and create only predictable and clichéd pictures.

Homemade Colored and Diffusion Filters

You can express your ingenuity by making your own filters for artistic purposes. Although homemade filters may not match the quality of

Box 4.1 Special-Effects Filters

- Center spot: Diffuses the entire area except the center.
- Changeable color: Used in combination with a polarizing filter. Rotating the filter changes the color, from one primary, through the midtones, to a different primary color.
- Color spot: The center portion of filter is clear with the surrounding area colored.
- Color vignette: Filters with colored edges and a clear center portion.
- Cross screen: Exaggerates highlights into star shapes.
- Diffraction: takes strong highlights and splits them into spectral color beams.
- Diffusion: Softens and mutes the image and color.
- Double exposure: Masks half the frame at a time.
- Dual color: Each half of the frame receives a different color cast.
- Fog: Delivers a soft glow in highlight areas while lowering contrast and sharpness.
- Framing: Masks the frame to form a black or colored shape.
- Graduated: Half the filter is colored and the other half is clear.
- Prism/multi-image: Repeats and overlaps the image within the frame.
- Split field: Allows differential focus within the frame.

commercially manufactured filters or software, they can produce unique results that would not otherwise be possible. A universal filter holder, attached in front of the lens, permits experimentation with a variety of materials and can also hold gelatin squares of commercial filters.

4.16 This exposure was made in Bermuda at Palm Gardens using a digital camera with a #87 deep red filter on the lens. "This print illustrates how recording the infrared spectrum, which our human eyes cannot see, can turn a typical scene into a fairytale-like image capturing the magic of the place. This technique allows a photographer to record how she/he felt about a location and not just how it was seen."

© Theresa Airey. The Wishing Well, 2004. 12 × 16 inches. Inkjet print.

All you need to make a filter is transparent material. Colored cellophane and theatrical gels provide simple and affordable starting places. Marking clear acetate with color felt-tipped pens is an excellent way for producing pastel-like colors. Photographing a light-colored subject against a bright background can heighten the pastel

effect. There are endless possibilities, since you can make split-field filters with numerous color combinations.

Photographing through transparent objects, such as stained glass or water, is another way to transfer color(s) and pattern(s) to a subject.

Homemade diffusion filters can be made from any transparent material, with each creating its own unique way of scattering the light and producing a different visual effect. Test some of the following methods to see which suit your needs:

- *Cellophane:* Crumple up a piece of cellophane, and then smooth it out and attach the cellophane to the front of your lens with a rubber band.
- *Matt spray*: On an unwanted clear filter or on a plain piece of Plexiglas or glass, apply a fine mist of spray matt material.
- *Nail polish*: Brush some clear nail polish on a piece of clear glass or an unwanted UV filter. Allow it to dry and it's ready to use. Painting different patterns and/or using a stipple effect will deliver a variety of possibilities. Nail polish remover can be used for cleanup.
- *Petroleum jelly*: Carefully apply the petroleum jelly to a clear piece of glass or a UV filter with your finger, lint-free towel, or a brush. Remove any that covers the sides or the back of the support so it won't get on your lens. The direction of application and the thickness of the jelly will determine the amount of diffusion. Use soap and warm water for cleanup.

Exercise

Filtering for Emotional Impact

Using one or more of the methods discussed in this chapter, or one of your own design, make a series of photographs that derive their emotional impact through the use of filters. Photograph a scene with and without the filter. Use your monitor to compare compensated versions with uncompensated ones. See what looks more engaging to you. Bracket and review your exposures to ensure acceptable results. It is very difficult to be a photographer without making many pictures. Mix and match results with software filters. Do not expect every frame to be a keeper. Ansel Adams reportedly said he was happy to make 12 good photographs a year.

- *Stockings*: Stretch a piece of fine-meshed nylon stocking over the front of the lens and attach it with a rubber band. Use a beige or gray color unless you want the color of the stocking to influence the color balance of the final image. White stockings scatter a greater amount of light; thus, they considerably reduce the overall contrast of the scene.
- *Transparent tape*: Apply a crisscross pattern of transparent tape on a UV filter. The amount of diffusion is influenced by the width and thickness of the tape.

Digital Filters and Plug-ins

Imaging software programs such as Photoshop have an abundance of digital filters that may be applied *after* image capture to mimic traditional photographic filters and/or to correct, distort, enhance, or

manipulate all or any part of an image. The best way to see what filters can do is to open up an image with your imaging software and go through the Filter menu. Some filters provide a pop-up dialog box that will allow you to see the default action, while others require the use of sliders to see the various effects. Most have a preview window that shows the filter's effect on the image.

The most commonly used filters for general photographic image processing are sharpening and noise reduction. For instance, *Gaussian Blur* is widely applied to reduce pixilization, image noise, and detail by softening a selected area or an entire image. It operates by smoothing the transitional areas between pixels through averaging the pixels next to the hard edges of defined lines and shaded areas in an image. *Lens Blur* can manage the widespread problem of too much depth of field by adding a controllable amount of blur to an image so that some areas in the scene remain sharply in focus while others appear to be out of focus.

A third-party filter, known as a *plug-in*, is a program written to be integrated into another application such as Photoshop. It is designed to plug into the application and provide additional functionality that was not originally available in the application. A plug-in can take many different forms: filters, image processing, file formats, text, automation, and more, with the most common being special effects. The special effect can be as simple as shifting a pixel to the right or as complex as altering the direction of light and shadow in an image.

Thousands of digital filters and plug-ins are available and can be viewed online. Many websites offer free downloadable demonstration trials. Once installed, these filters and plug-ins usually appear at the bottom of the Filter menu.

4.17 "The airport is an institutional space of expectation, anxiety, adventure, family and commerce. It is a place of personal greetings and good-byes and where people wait for hours in a self-contained world where you can shop, eat, and do business. My subjects are people stuck, waiting, in transition from one place or one state of mind to another. These are images of forced meditation and anxiety. The images are of our time and culture. A culture, which seems to be stuck in a historic limbo, waiting for the next plane, next adventure, next scandal, next disaster, next leader, next trend, or next moment. This image captures a TV crew shooting a spot for the local New Orleans news after Hurricane Katrina. The reporter looked artificial, and I played that up by heightening the color and adding a blur filter on her image in Photoshop. The airport lighting adds to the overall effect of the image, creating a familiar but uncomfortable space."

© Dale Newkirk. TV Crew, from the series Airport, 2006. 16 × 25 inches. Inkjet print.

Applying a filter or plug-in to a mediocre picture and converting it into something that looks like a Seurat pointillist painting will *not* make it a better picture. Filters and plug-ins should be thoughtfully applied to avoid making overbearing, hackneyed pictures. Filters and plug-ins have the potential to become seductive side trips that waste time and take you away from your vision. Take into account the proverb: "You cannot make a silk purse out of a sow's ear," or the more contemporary: "Garbage in, garbage out." You need to have a visually articulate and appropriate image to experiment with first. Filters and plug-ins should be thought of as tools capable of reinforcing well-seen images and not as lifesavers for trite pictures.

For further information, see Pring, Roger. *Photoshop Filter Effects Encyclopedia: The Hands-On Desktop Reference for Digital Photographers.* Sebastopol, CA: O'Reilly Media, 2005.

Fluorescent and Other Gas-Filled Lights

A fluorescent light source consists of a gas discharge tube in which the discharge radiation causes a phosphor coating on the inside of the tube to fluoresce. Although fluorescent light may appear similar to light from another artificial source, it is not. Fluorescent light possesses both a discontinuous and unbalanced spectrum. The color of the light depends on the type of phosphor and gas used. It has peak outputs in the green and blue regions of the spectrum, valleys or deficiencies in red, and gaps of other wavelengths, and its intensity varies as the gas moves in the tube. This makes it a discontinuous source, lacking the full range of wavelengths that are present in the visible spectrum. Fluorescent light is generally unsuitable for naturalistic color photography. However, there are "full-spectrum" fluorescent lamps with a high CRI (color rendition index) that have color temperatures of about 5000 to 6000 K.

If you photograph with an improper white balance setting under fluorescent light, the resulting image will have a green cast. This is not generally attractive, especially if you are making pictures of people. If a green cast is not what you had in mind, corrective action is required. Start by using the fluorescent white balance setting. If you are not satisfied with the results, try experimenting with different white balance settings and features. If problems continue, consider the following corrective actions:

- **1.** Use a shutter speed of 1/60 of a second or slower to minimize the flickering effect of the fluorescent lamp.
- **2.** Replace the standard fluorescent lights with tungsten lights or with "full-spectrum" fluorescent lamps.
- **3.** Place plastic filters over the tubes that will make them closer to daylight.
- **4.** Use flash fill to help to offset the green cast.
- **5.** Correct using post-capture imaging software.

High-Intensity Discharge Lamps/Mercury and Sodium Vapor Sources

High-intensity discharge lamps, such as mercury vapor rated at about 4100 to 4500 K and sodium vapor lights at approximately 2100 to 2500 K, fit into the category of gas-filled lights. These bright lamps are generally used to light industrial and public spaces. They are extremely deficient in many of the wavelengths that make up white

4.18 By replacing the natural color of this scene with an artificial one and adding digitally drawn components, Labate generates a tension through juxtaposing the camera's familiar description against the new language of digital imaging. On one hand, the image closely resembles a "straight" photograph, yet on the other, appears to be an obvious contrivance that hints at another level of reality suggestive of images made with photographic materials sensitive to the infrared part of the spectrum.

© Joseph Labate. Landscape #1152, 2006. 24 × 32 inches. Inkjet print.

light, especially red, making them almost impossible to correct. Try experimenting with different white balance settings and features, but the situation may require extreme amounts of additional filtration in front of the lens.

EXERCISE Filtering for Fluorescent Light

Photograph a subject under fluorescent light with no color correction. Next, under the same fluorescent conditions, try one or more of the suggested corrective actions. Compare the two. Which do you favor? Why?

Photograph a subject under unnatural and natural lighting conditions. Evaluate how the unusual colors affect your emotional and intellectual response. Which elicits a stronger response? Why?

Working where 19th- and 21st-century technologies and theories of color vision intersect, Carey first makes a cameraless image (a photogram). Next, she copies this image onto 4×5 inch color transparency film, which is scanned, manipulated in Photoshop, and then printed. At the intersection of all the geometric lines of this large-scale work, the cones and rods of the human eye try to process the dissimilar color wavelengths of light. This results in an afterimage, an optical illusion that occurs after looking away from a direct gaze at an image, which blinks back at the viewer.

 \odot Ellen Carey. Blinks, 2006. 44 \times 55 inches. Inkjet print. Courtesy of JHB Gallery, New York, and Paesaggio Fine Art, Hartford.

Chapter 5

Seeing with Light

NATURAL LIGHT

Physics shows us that light is ambiguous and paradoxical, possessing the qualities of both particles and waves. Light's multidimensionalism can reveal any subject's many diverse realities, which are as fleeting as light itself. Light's changing physical properties demonstrate that everything is in flux and nothing is as it appears to be, signifying the numerous ways any subject may be viewed and interpreted. An exceptional example of this principle can be seen in the surrealist paintings of Roberto Matta, who created new dimensions by blending cosmic and organic life forms.

The Thingness of Light

Every photograph is about light. Light is a plastic medium that is the key ingredient shared by every photograph and determines the look of every photograph you make. Light's authority defines the essence of a subject. Light is the glue that holds your image together. Light makes known the emotional and physical contents within your visual space and activates vision and meaning. Every image provides a different set of conditions in which we can experience light. If the light does not reveal the perceived nature of the subject, the picture will not communicate the content you wish to transmit to a viewer. In that sense, pictures are about what others are able to see in them.

Light is a form of visual grammar that can activate specific physical sensations and psychological sensibilities, which allow us to touch with our eyes. Light's diverse characteristics, analogous to how we use words to explain our world, offer imagemakers a wealthy descriptive toolbox to call upon. One way to think about it is to say that imagemakers use light as adjectives to bring out the attributes that best describe or modify their subjects. An excellent way to expand on light's broad depictive attributes to communicate expressive,

SEEING WITH LIGHT

emotional, metaphoric, and symbolic meaning is by observing its natural cycle. An awareness and knowledge of natural light is the first step toward the smart use of its substitute: artificial light. The possibilities of natural light are infinite and self-renewing. To study photography is to study light by emphasizing your visual results rather than the means of containing them. The type of equipment one uses is not important. What matters is learning to use your gear so it becomes an extension of your own vision. Begin to recognize what light artist and creator of *Roden Crater* James Turrell calls the "*thingness*" of light, the characteristics and qualities that natural light possesses throughout the day, and learn to follow and incorporate them into your composition for a complete visual statement.

Good Light

The definition of "good light" is solely dependent on a photographer's intent. There is no time of day or year when the sunlight is photographically better than another. However, it may be more suitable for a particular subject. At various times of day and in different seasons, light takes on a range of unique physical attributes, each with its own emotional and tactile qualities. Have you ever encountered a scene that you thought would make a good photograph, yet the results were disappointing? There is a strong probability that it was photographed at a time of day at which the light did not reveal the fundamental aspects of the subject that were important and attracted you to the scene in the first place. Try photographing the scene again at a different time of day. Keep in mind that discovering the best natural light for any subject is often just a matter of timing and waiting for the light to be "right." When a scene grabs your attention (and you don't have a camera with you), make a mental note of the time of day

5.1 "I am drawn to primeval landscapes with extreme weather and light conditions to cultivate a certain melancholy, which I carry within along with my enthusiasm for life. I photograph at night and in the rain because the light is very flat and the reduced amount of visual information under these conditions gives the composition more space. The reflective quality of the landscape is evoked through the reduction of light. You are perplexed and almost feel uneasy, and you have to take a stand on this mood confronting you. There is a stillness, a vacuum that leaves you only with yourself. The same thing happens later with a viewer that happens with me the moment I take the picture under these reduced light conditions; you pause for a moment. Time seems to be standing still."

© Olaf Otto Becker. *Haifossnebel, Iceland*, 2002. 45 × 54 inches. Inkjet print. Courtesy of Cohen Amador Gallery, New York.

and the weather conditions so you can return later and capture what you initially found intriguing. Just as writing is about rewriting, photography can be about rephotographing a subject until you get it the way you want it.

The Camera and Light

Your ability to function as a creative photographer depends on your knowledge of how to make your equipment work for you. A camera is a recording device, and it will not reproduce a scene or an experience without your guidance. The camera can isolate a scene; it can reduce it to two dimensions; capture a slice of time; and set it into a frame. What it does not do is record the sequence of events that led up to the moment you pressed the shutter button or registered your private emotional response to what was happening that sparked the urge to make the picture. This is the substance you have to learn to incorporate into your pictures if you expect to make photographs that stand on their own instead of snapshots that require explanation. The camera does not discriminate in what it sees and records, but you can, and must, make such distinctions to create successful images. Keep in mind that the camera, lens, software, and paper have but a single purpose: to capture and present light.

THE TIME OF DAY/TYPES OF LIGHT

Most photographers have heard the photographic adage, "Take pictures after ten in the morning and before two in the afternoon." This rule had nothing to do with aesthetics. Its purpose was to encourage amateur photographers to take pictures when the light was the brightest because early roll film was not very light sensitive. By breaking this rule, you can create some astonishing results.

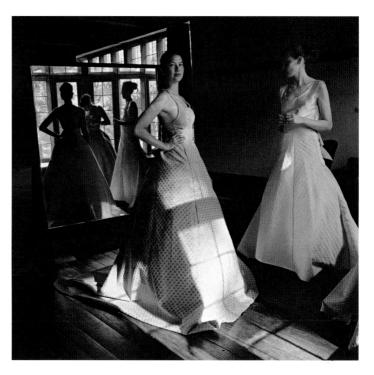

5.2 The family members and friends in Todd Harper's photographs reflect the influence of domestic scenes by painters Mary Cassatt and John Singer Sargent as well as those by Vermeer, Memling, and Pieter de Hooch. "I was impressed with how their painting could convey the beauty and fragility of the human experience. My pictures are about identity, familial relationships, and the unspoken things that make up the inner stories of our lives. Sometimes that involves waiting for a 'decisive moment' when the light is just right, and other times I use Photoshop in a process analogous to combining different sketches for a final painting to bring all the ingredients together."

© Jessica Todd Harper. *Chloe and Sybil and Becky*, 2005. 32 × 32 inches. Chromogenic color print. Courtesy of Cohen Amador Gallery, New York.

The Cycle of Light and Its Basic Characteristics

Begin by observing the cycle of light and noting its characteristics, especially in terms of color and shadow. The following are some of the basic qualities of the predictable phases of light that will affect your images.

Before Sunrise

In the earliest hours of the day, our world is essentially black and white. The light exhibits a cool, almost shadowless quality, and colors are muted. Up to the moment of sunrise, colors remain flat and opalescent. The intensity of the colors grows as the sun rises. Artificial lights can appear as accents and create contrast.

Morning

As soon as the sun comes up, the light changes dramatically. Since the sun is low and must penetrate many miles of atmosphere, the light that gets through is much warmer in color than it will be later in the day. The shadows can look blue, as they lack high, brilliant sunlight and because of the great amount of blue from the overhead sky. As the sun rises, the color of light becomes warmer (red-orange). By midmorning, the light begins to lose its warm color and starts to appear clear and white.

Midday

The higher the sun climbs in the sky, the greater the contrast between colors. At noon the light is white. Colors stand out strongly, each in its own hue. The shadows are black and deep. Contrast is at its peak. Subjects may appear to look like three-dimensional cut-outs. At noon the light may also be too harsh, stark, or crisp for many subjects.

5.3 "This image was constructed from three separate negatives made in the 'golden hour' of late afternoon light. I scanned the negatives and 'gently' assembled them in Photoshop, matching colors and aligning some angles to create the natural flow between the images. I purposely chose not to knit the images together to make a seamless panorama, feeling that viewers at the turn of the 21st century have assimilated disparate imagery that coexists simultaneously. I also wanted the 'constructed environment' to be very clear, as a metaphor for our lives and how we, in the digital, postmodern age have come to embrace dissonance."

© Thomas McGovern. The New City, #18, 1999–2001. 10 × 30 inches. Inkjet print.

Afternoon

As the sun drops to the horizon, the light begins to warm up again. This is a gradual process and should be observed carefully. On clear evenings, objects can take on an unearthly glow. Look for an increase in red. The shadows lengthen and become bluer. Surfaces are strongly textured. An increasing amount of detail is revealed as the level of the sun lowers.

Twilight/Evening

After sunset, there is still a lot of light in the sky. Notice the tremendous range of light intensity between the eastern and western skies. Often the sunset colors are reflected from the clouds. Just as at dawn, the light is very soft and contrast and shadow are at a minimum. After sunset and throughout twilight, notice the warm colors in the land-scape. This phenomenon, known as *purple light*, arises from light from the blue end of the spectrum falling vertically on you from the overhead sky. Observe the glowing pink and violet colors as they gradually disappear and the earth becomes a pattern of blacks and grays.

Night

The world after the sun has set is seen by artificial light and reflected light from the moon. The light is generally harsh, and contrast is extreme. Combinations of artificial light and long exposure can create a surreal atmosphere. Photographing under these conditions usually entails long exposures at a high ISO setting in combination with a tripod, a brace, or a very steady hand.

The Seasons

The position of the sun varies depending on the time of year and your geographic location in relation to the equator. This has a great impact on both the quality and quantity of the light. Learn to recognize these characteristics and look for ways to go with and against the flow of the season to obtain the best possible photographs.

Winter means a diminished number of daylight hours. Bare trees, pale skies, fog, ice, rain, sleet, and snow all produce the type of light that creates muted and subtle colors. Spring brings on an increase in the amount of daylight and the introduction of more colors. Summer light offers the world at its peak of color. Harsh summer light can offer a host of contrast and exposure problems for the photographer

5.4 "Public parks make an effort to reclaim natural beauty, yet at night a paradox is revealed: here are places that are natural yet lifeless, vacant, with beauty like a forced smile. Digital methods have eliminated the reciprocity effect arising from long exposure (8 seconds in this case) and minimize white balance difficulties caused by differing light sources at night. Replay on the camera's monitor provided immediate feedback that made pinpointing exposure easier. I view exposure as a source of raw material for manipulation as an editor, which can stretch out for as long as necessary to satisfy one's sense of authorship." © David Mount. Night Trees #7, 2004/05. 6-3/4 × 5 inches. Inkjet print.

5.5 "This project brings together my interest in the vernacular history of trees and stereo cards. I wanted a straightforward approach so I photographed during the winter when the trees are bare so that their typological characteristics were readily visible for study. I researched stereo cards, taking advantage of the George Eastman House online collection, which resulted in a grid presentation of 20 cards with different colors and card designs.

© Dennis DeHart. The Tree Series, from the series Tree Studies of Delaware Park, Buffalo, NY, 2006. 5 × 7 inches. Inkjet print.

to deal with. Fall is a period of transition that provides tremendous opportunities to show the changes that take place in color.

The Weather and Atmospheric Conditions

Just as there is no such thing as bad light, there is no such thing as bad weather for making photographs. However, there are specific meteorological conditions that produce lighting conditions that are better for particular subjects and for eliciting certain emotional and psychological effects. Fog can provide quiet, pearly, opalescent, muted tones. Storms can add dramatic intensity and an atmosphere of mystery. Rain mutes some colors and enriches others while creating glossy surfaces with brilliant reflections. Dust softens and diffuses color and line. Bad weather conditions often provide an excellent opportunity to create pictures full of brooding theatrical ambiance and intrigue. With a few precautions to yourself and equipment, you need not be just a fairweather imagemaker. Before going out into any unusual weather conditions, be certain your memory card has plenty of room, preset as many functions as possible to avoid exposing your camera to inclement conditions, and review this book's sections on camera, lens, and battery care in Chapter 3.

Fog and Mist

Fog and mist diffuse the light and tend to provide monochromatic compositions. The light can tend toward the cool side (blue). If this is not acceptable, adjust your white balance control, or photograph in the early morning or late afternoon, when there is the chance to catch some warm-colored light. If the sun is going in and out of the clouds, wait for a moment when a shaft of light breaks through the clouds. This can add dramatic impact and break up the twodimensional flatness that these cloudy scenes often produce.

Because the light is scattered, both colors and contrasts are made softer and subtler. If the scene appears too flat, adjust your contrast control. If you want to include a sense of depth in the mist, try not to fill your frame completely with it. Attempt to offset it with a dark area. To capture mist, expose for the highlights. Bracket, review your exposures on your monitor, and make ongoing adjustments.

In fog, take a reading from your hand in light similar to that which is on your subject. Then overexpose by 1/2 to 1 f-stop, depending on how intense the fog happens to be. Bracket and review your exposures.

Rain

Rain tends to mute and soften color and contrast, while bringing reflections into play. Include a warm accent if contrast or depth is desired. The shutter speed is important in the rain. The faster the speed, the more distinct the raindrops will appear. At speeds below 1/60 second, the drops blur. Long exposures will seem to make them disappear. Experiment with different shutter speeds to see what you can achieve. Keep your camera in a plastic bag with a hole for the lens. Use a UV filter or cellophane with a rubber band and a lens hood to keep the front of the lens dry. Keep the camera inside your jacket when it is not being used.

When working in constantly wet situations, get a waterproof bag to hold your equipment. Inexpensive plastic bag cases, available at camping stores or online, allow you to photograph in wet conditions without worrying about ruining your camera. Carry a bandanna to wipe off any excess moisture.

Snow

Snow reflects any predominant color. Blue casts and shadows are the most common in daylight situations. Use your white balance controls to help neutralize this effect. This technique also works well in higher elevations, where the color temperature of the light is higher (bluer).

Brightly lit snow scenes can fool a meter because there is so much reflected light. The meter thinks there is more light than there actually is and closes the lens down too far, producing underexposed images. Some cameras have a special exposure mode that is designed to compensate for brightly lit situations such as found in snow or at the beach. Another method to obtain good shadow detail is to fill the metering area with the palm of your hand, being careful not to get your shadow in it. Then open the lens up one f-stop from the indicated reading. When in doubt, bracket and review to learn which exposure works best for you. To bring out the rich texture of snow, photograph when the sun is low on the horizon.

5.6 "This series describes a cultural landscape in which the objects of our recreation and occupation merge with the natural world while subtly restraining it. Familiar spaces are transformed in winter not only by a blanket of snow, but also by a state of inactivity, offering glimpses of the sublime. Three-dimensional reality is flattened, functioning as an ideal positive/negative space. These minimalist scenes suggest, upon contemplation, the temporal nature of all things. In the midst of seeming monochromatic emptiness, layers of life and contrast slowly emerge."

@ Lisa Robinson. Solo, from the series Snowbound, 2005. 28 \times 36 inches. Chromogenic color print.

Snow Effects

Slow shutter speeds can make snowfall appear as streaks. Fast speeds arrest the action of the flakes. Flash can also be utilized. For falling snow, fire the flash from the center of the camera. The snow will reflect the light back, producing flare and/or spots. Snowflakes can be eliminated by using a synchronization cord and holding an auxiliary flash at arm's length off to one side of the camera. This captures the movement of the snow and provides a scene comparable to the ones produced inside those plastic bubbles that are shaken to make the snow fall. Want to stop the action of some of the falling snow while letting the rest of it appear blurred? Place the camera on a tripod, use a lens opening of f/8 or smaller plus a shutter speed of 1/8 second or longer, and fire the flash during the exposure. Bracket and review your exposures until you obtain enough experience to determine what will deliver the types of results you are after.

Dust

Dust can be a painfully biting experience to photographers and their equipment. Use a UV filter, plastic bag, and lens hood to protect the camera and lens. Use the same shutter speed guide for snow to help determine how the dust will be visually recorded. Dust in the sky can produce astonishing atmospheric effects. If turbulence is to be shown, expose for the highlights. This causes the shadows to go dark, and the clouds will stand out from the sky. A polarizing filter may prove very useful to darken the sky and increase color saturation. If detail is needed in the foreground, meter one-third sky and two-thirds ground with the camera meter and bracket one f-stop in either direction. Review and revise your exposures.

Heat and Fire

Heat and/or fire are often accompanied by glare, haze, high contrast, and reflection. These factors can reduce clarity and color saturation, but if handled properly they can make colors appear to stand out. In

5.7 "This old cottonwood tree was along a creek in a large pasture. A grass fire had swept through the area and the hollow trunk had caught fire and was acting as a chimney, burning the tree from the inside out. There were low, fast-moving clouds and a full moon that reminded me of the allegorical paintings of Albert Pinkham Ryder. The exposure is several minutes, with my hand shielding the lens except when a branch would fall, which would send up a shower of sparks. The actual time was about ten minutes, with perhaps an actual exposure of one minute. Fire is good and evil, soothing and terrifying, protection and threat, destruction and rebirth; it heats our homes and it can destroy our homes. Fire is universal."

© Larry Schwarm. Burning Tree with Ryder Sky, Chase County, Kansas, 2001. 29 × 29 inches. Inkjet print. Courtesy of Robert Koch Gallery, San Francisco.

bright situations, adjust your contrast to a lower setting. Do not point the camera directly into the sun except for brief periods of time. The lens can act as a magnifying glass and ruin the shutter, light meter, and sensor. Store the camera in a cool place. Avoid carrying unnecessary equipment if you will be doing a good deal of walking in the heat. Do not forget a hat and sunscreen.

Beach and Desert

Beach and desert lighting is similar to light under snowy conditions in that it is bright and uniform. The sun and sand act as giant reflectors, so expect to use a small aperture and a fast shutter speed. Beach and desert lighting can be so intense that it will fool your meter and underexpose scenes, making a white beach appear too dark. If your camera has a special exposure mode for such bright situations, now is the time to try it. If not, use an f/stop setting 1/2 to 1-1/2 times greater than what your meter recommends. For example, if your meter reads f/16 at 1/500 of a second, try f/11-1/2, f/11, and f/8-1/2 at 1/500 of a second. If necessary, adjust your contrast to a lower setting. Bracket, review, and make adjustments. The reverse problem can occur on water, which can be darker than average from the meter reading if there are no specular reflections from the sun on its surface. In this case, less exposure may be required.

Try using a polarizing filter, which will deepen the blue of the water and sky by reducing polarized reflections. Don't just make pictures only when the colors are at their deepest, as this effect can be overdone and make the water and sky appear artificially blue.

A major problem with beach photographs is a distracting slanted horizon line. It is perfectly okay to tilt your camera for creative effect, but pay attention to the horizon line and keep it straight by holding

EXERCISE Time of Day/Type of Light

The following assignment, The Nature of Light and Shadow, is based on an exercise Myra Greene created for her Photo Arts 1 class at Rochester Institute of Technology.

Objectives

- To help you realize that the true subject matter of many photographs is actually light or some type of modification of illumination.
- To heighten your awareness of some of the different qualities of light as they appear during various times of day, seasons, and weather conditions.
- To become aware that the light's direction, the angle at which it strikes a subject, can make a dramatic difference and impact in the way that a subject appears and influence the perception of a subject: You can emphasize or minimize certain subject details by thoughtfully using the direction of light.
- To help you to realize that light is one of the most essential elements that you must learn to see, use, and control in your photographs.

Procedure and Requirements

- 1. Set ISO to 100.
- 2. Use a tripod as needed.
- 3. Use only natural ambient light. Do not modify any existing lighting and/or use electronic flash or any other artificial light source.
- 4. Photograph during many different times of the day: morning, midday, and evening. Observe the quality of light at the various times and under various conditions sunny, clear, hazy, or cloudy — of the day and see how it differs. Observe the direction of the light. Side lighting can emphasize texture, and need not come from the side — midday sun is side lighting. Front lighting will usually come from close to the camera's position and will usually flatten the perspective of your subject. Backlight will define the shape of your subject but will usually obscure some details. Diffused and bounced lighting is quite different from direct light; it can soften your subject as far as the contrast is concerned, and texture is usually minimized. The important issue to think about is how light

EXERCISE Time of Day/Type of Light—continued

illuminates any subject and can transform even mundane subject matter into exceptional photographs. Keep a small notebook and record your observations about the lighting conditions each time you go out to make photographs.

The Subject: Your Environment

Explore the environment outside of your immediate surroundings. Investigate these three different themes by making a minimum of 30 exposures for each topic, from which you will then edit down to three final prints:

"Urban" ambience

"Residential" habitat

"Natural" surroundings

Remember that light is the main consideration for framing and vantage point but does not have to be the subject matter of the image. It is not enough to show just the differences in the quality of light at the different times of the day. Make pictures having strong compositions, and relate your observations to your viewers. Think of creative ideas that will couple well with various forms of natural light. Consider how to effectively compose within your frame and to choose an interesting vantage point. Enlist depth of field and/or motion to establish the tone of the image. Experiment with exposure. The only correct exposure is one that delivers the effect you want in your final image.

Submit

- 1. Contact sheets of all final exposures.
- 2. Three completely finished prints, of the appropriate contrast and density, with full-frame images and nothing cropped out.
- 3. One print should represent the "urban" environment, another print should represent the "residential" surroundings, and the third should represent the "natural" atmosphere.
- 4. A comment/observation and self-evaluation sheet at least one full page in length. Discuss the Nature of Light and Shadow as you observed and recorded it for this assignment, including your environment, any discoveries and new impressions, how the shoots went, your thoughts on the project and your process, and any other observations you think are pertinent. Evaluate your exposures, the quality of your image files, the contact sheets, and your three final photographs. Mention any problems you encountered technically, and last, but certainly not least, include a thoughtful analysis of your results.

the camera level. Use the line where sky and water or sand meet as your guide to what is level. Just before you press the shutter, glance at this horizon and make any adjustments necessary to level your camera. Review your exposure and continue to make corrections if needed.

ARTIFICIAL LIGHT

Add a Light

Once you understand the cycle of natural light, you might want to consider additional possibilities of controlling the light in your images. The simplest way is to begin working with a single artificial light with a bowl-shaped reflector on an adjustable stand having three folding legs and a center pole that can be raised or lowered. Edward Steichen, one of the most successful photographers of the 20th century, achieved precise control of over his camera, materials, and lighting by photographing a white cup and saucer over a thousand times, which took his vision in new directions.

The most common light is a photoflood that has a tungsten filament, which is similar to but more powerful than a household bulb. Photoflood bulbs are designed for use with indoor (tungsten) color settings and therefore produce a color temperature of 3200K. The bulbs are physically hot to work under, have short life spans, and their light output becomes increasingly red with use.

An excellent alternative is a compact daylight fluorescent spiral bulb (CFL), which is specifically designed for digital imaging. CFLs have a color temperature of 5000 K, are comfortable to work under, have a long life, and are energy efficient. A 25-watt CFL bulb's output is equivalent to 100 watts incandescent. A 55-watt CFL bulb's output is equivalent to 250 watts incandescent. Triple reflector heads can hold three CFLs, which produce an excellent source of cool, even, daylight. The light can be further softened by placing a diffusion screen, either of transparent material or translucent plastic, in front of the reflector. (See section on Color Temperature and the Kelvin Scale in Chapter 4.)

Whatever type of artificial light you use (adjust your white balance accordingly), it will possess the same fundamental characteristics as daylight. The direction of the light and the degree of its diffusion will determine whether you produce a hard-edged or soft effect. The larger the light source in relationship to the subject, the softer the quality of light it will create. Thus, the farther back you place a light, the smaller it will be relative to your subject and the harder the shadows will appear. The closer you set the same light to your subject, the broader the light will be, thus making it more diffused and softer in appearance. If you want dark and sharply defined shadows, use a directional light that is relatively far from the subject. If you want a soft and shadowless look, use a broad diffused light source close to the subject. Also, the position of the light and its distance from the subject will determine the amount of texture and volume (the amount of viewable space within the frame) in your image.

The Size of the Light

The size of your main light, also known as the *key light*, will control and define shadow and texture. A small light will produce hard shadows and emphasize skin texture. While this can be excellent for bringing out facial character, it is at the expense of conventional standards of beauty. Most people do not appreciate a portrait that

EXERCISE

Emulating the Sun

Apply what you have learned about natural light and utilize your single light source to replicate sunlight. Make a series of head and shoulder portraits of one individual against a plain white background as you move your single light source to imitate parts of the cycle of natural light; follow this by using back lighting and under lighting. Compare and contrast the results with those from Time of Day/Type of Light. Based on the similarities and differences within your own images, how might this affect your future lighting decisions? Incorporate your personal observations into the making of your future work. Once you feel comfortable working with one light, try adding a second and see what else you can accomplish.

reveals every line, hair, scar, or skin pore. Therefore, large lights are generally used in conventional portraits because they produce soft shadows, reduce skin texture, and make facial irregularities less noticeable.

The Placement of the Light

The placement of your main light will determine where the highlights and shadows will fall and how sharply they will be defined. Bear in mind that creating a three-dimensional illusion of space in a two-dimensional photograph requires highlight and shadow areas. While pronounced highlights and shadows increase the illusion of spatial depth, they can become too pronounced and thus become points of interest themselves and therefore compete with your principal subject.

Contrast/Brightness Range

The other characteristic of light that concerns a conscientious photographer is the contrast or brightness range. This represents the difference between the brightest part of a scene and the darkest part. Extremely brightly lit scenes may have a brightness range of eight or nine f-stops, making it difficult for a sensor to accurately record detail in both the shadow and highlight areas. On the other hand, a dimly lit scene may have only a one-f-stop difference between the bright and dark parts of a scene, resulting in images that are low in contrast range, metering the key shadow and highlight areas, and increase or decrease your contrast control to match the situation and deliver the view you desire. Review Chapter 4 for metering suggestions.

BASIC LIGHTING METHODS

Artist and educator Michael Bosworth provides these thoughts and examples (see Figures 5.8–5.14) of basic lighting methods for contemplation based on his experiences teaching studio lighting:

"Lighting reveals texture and form. Relatively featureless subjects may provide too subtle an illustration of the lighting techniques. Complex constructions and unfamiliar subjects can lead to abstraction. Students may have difficulty comprehending how the light source is functioning and how best to go about making changes. A simple, recognizable object featuring form and texture provides an understandable canvas on which to work with the light.

"One of the challenges in photography is seeing the world as color and tone with the impartiality of the light meter. Beginners may have difficulty separating an object's meaning from its surface. One of the challenges of making portraits is to see the light without being distracted by meaning,

5.8 © Michael Bosworth. Front Light, 2006. Dimensions vary. Digital file.

5.9 © Michael Bosworth. Side Light, 2006. Dimensions vary. Digital file.

empathy, and desire. A more banal subject offers fewer distractions while building the skills of photographic grammar. With experience, constructing a photographic image becomes a marriage of the treatment of a subject with its symbolism to create new meaning."

Front Light

We are accustomed to seeing things illuminated by the sun from above the horizon line. This effect, known as *front lighting*, can be recreated by placing your light slightly above the height of your camera lens, directly to the right of your camera, in front of your subject. It is equivalent to shooting with the sun to your back. Experiment with the distance of the light from the subject, keeping it initially within a 3–6 foot range. Front light is flat and only produces thin shadows, which keeps texture and volume to a minimum while retaining detail. Also, this is the type of light produced by your built-in camera flash.

5.10 © Michael Bosworth. High Side Light, 2006. Dimensions vary. Digital file.

5.11 © Michael Bosworth. Low Side Light, 2006. Dimensions vary. Digital file.

Side Light

Side light is created by placing your light level to your subject, directly to the side. Side light literally divides your subject in half and emphasizes texture. Traditionally, it is used for male portraits because it amplifies facial features and textures associated with rugged masculinity, such as chin clefts, jaw lines, whiskers, and wrinkles. Strong side light is similar to light directly coming from a window or a sunset, which produces long shadows and a dark side / light side relationship on a subject. Metering can be tricky, so average a close-up meter reading of the bright and then dark side, and then bracket, review, and correct as needed.

High Side Light

High side light is achieved by placing your light at about 45 degrees to one side and 45 degrees above the subject. It is considered the classic angle for portrait lighting because the light sculpts the face into a natural-looking three-dimensional form.

SEEING WITH LIGHT

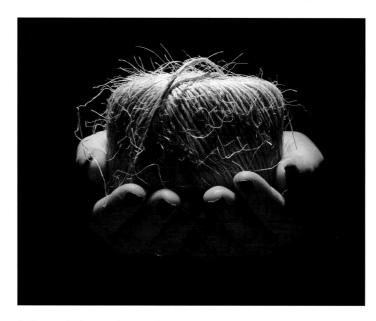

5.12 © Michael Bosworth. Top Light, 2006. Dimensions vary. Digital file.

Low Side Light

Low side light is realized by placing your light at about 45 degrees to one side and level or below level with your subject. Low angle light is effective for adding a sense of drama and mystery and emphasizing texture.

Top Light

Top light is produced by setting your light almost directly above your subject. It generates deep shadows in the eye sockets and under the nose and chin. It is similar to making portraits outside at noon when the sun is directly overhead. Shifting the light so its placement is high

5.13 © Michael Bosworth. Back Light, 2006. Dimensions vary. Digital file.

but in front of your subject will smooth out the shadows and the skin texture yet retain the emphasis on your subject's facial form.

Back Light

Back light is made by pointing your light directly at the back of your subject. It produces a rim of light, a halo effect, dramatically outlining the subject and emphasizing form and shape. The most extreme form of back lighting is a silhouette in which a subject shows no color, detail, or texture, just shape, making it highly abstract and theatrical. Carefully adjust the light so it does not shine directly into the camera's lens, unless you want lens flare. Also, check your viewfinder to be

5.14 © Michael Bosworth. Under Light, 2006. Dimensions vary. Digital file.

certain the light fixture itself is not in your viewfinder. Back light does a good job of separating the subject from the background but requires careful metering. If the meter sees mostly the bright light in the background, the exposure will be adjusted lower to compensate, resulting in underexposure. Bracket, review, and correct as necessary.

Under Light

Under light is created by placing your light directly below your subject. Since natural light seldom comes from below, this configuration makes unnatural looking shadows. It has often been used in horror and monster movies to suggest a menacing presence.

LIGHTING ACCESSORIES

Next are some common lighting accessories that can be useful in gaining more control over specific aspects of your lighting setup.

Barn Doors

Barn doors are a pair of black panels that mount on the front of a light source. They typically have two or four hinged flaps that move independently to control how narrow or wide an area the path of light covers.

Diffuser

When using bare bulbs, the light reaching a subject is strongest in the center and then weakens, getting softer as you move out toward the edges. A diffuser is a transparent disk that attaches to the front of your reflector for the purpose of softening the light and spreading it more evenly across your subject. The diffuser must be heat resistant when used with tungsten bulbs.

Gels

Gels are gelatin filter sheets used over light sources to either change the color of the light balance or create unusual lighting effects, such as altering your background color. There are polarizing screens that can be used in front of your light source to reduce glare and reflection. Gels can be taped to a reflector or placed in frames and mounted to the reflector or light stand.

Reflector Card

A reflector card is used to reflect or bounce light into shadow areas to help illuminate details. They can be made from cardboard, fabric, foam core, or metal, and are usually white, gold, or silver. The color of the card will influence the color of the light being reflected into the screen.

Snoot

A snoot is a tube (which can be made out of heavy paper) that is attached to the front of the light for the purpose of narrowing its beam in order to highlight specific areas.

Seamless Paper Backdrops

Seamless paper is a heavy paper that comes in long rolls, 3 feet and wider, in various colors to provide a solid-toned, nonreflective backdrop that can be extended down a wall or across a table or floor so you can make images without a visible break or horizon line. The roll is supported by two upright poles with a crossbar that runs through the hollow inner core of the roll. As the paper becomes dirty or wrinkled, fresh paper is unrolled and the old paper is trimmed off. All sorts of fabric and material can be tried to create different background effects and textures. You can make your own backdrop by painting on canvas, muslin, or other materials.

Studio Strobes

Standalone electronic flash units are powered by special battery packs and synchronized with the camera by means of a flash

5.15 In her quest to investigate the relation between people and their places and things, Yarnelle Edwards brings a lighting kit on location that includes lamps, bulbs, barn doors, black aluminum foil, stands, clamps, and clothespins. In this situation, she used a reflector to emphasize the Caravaggio-like effect of the early morning light that invites viewers into the intimate world of her subjects.

© Beth Yarnelle Edwards. *Dita and Nolwenn*, 2003. 30 × 38-1/2 inches. Chromogenic color print. Courtesy of Robert Klein Gallery, Boston.

synchronization cable, light trigger, or radio transmitter, meaning that only one flash unit needs to be synchronized with the camera, which in turn can fire the other units as well. Studio strobes operate at about 5500 K and provide a "cool" alternative to "hot" tungsten bulbs for controlled illumination and are excellent for capturing movement and stopping action (see Chapter 4).

5.16 Like a director of a fantastical film, Massard uses miniatures lit with studio lights to create deceptive illusions that encourage viewers to suspend and embrace the sense of illusion and artifice. Devoid of human references, the dramatic, misty, and moody environments suggest the Romantic canvases of Caspar David Friedrich. Here Massard also references Albrecht Dürer's archetypal woodcut *The Rhinoceros* (1515), which is not a realistic transcription as Dürer never saw the beast. Rather working in a manner similar to Massard, Dürer fabricated the image based on a mental schemata constructed from sketches and verbal descriptions. Conceptually Massard's fictional work points out how photography has co-oped painting's role and has traded in the presentation of actuality for the construction of aura.

© Didier Massard. Rhinoceros, 2004. Chromogenic color print. 70-1/2 × 89-3/8 inches. Courtesy of Julie Saul Gallery, New York.

"For 25 years I have created images about the various man-made transformations our civilization has imposed upon nature. I started making photographs about China when construction began on the mammoth Three Gorges Dam project. In my view, China is the most recent participant to fall prey to the seduction of western ideals — the promise of fulfillment and happiness. The troubling down side of this is something that I am only too aware of from my experience of life in a developed nation. The mass consumerism these ideals ignite and the resulting degradation of our environment intrinsic to the process of making things to keep us happy and fulfilled frightens me. I no longer see my world as delineated by countries, with borders, or language, but as 6.5 billion humans living off a single, finite planet."

© Edward Burtynsky. *China Recycling #7, Wire Yard, Wenxi, Zhejiang Province,* 2004. 39 × 49 inches. Chromogenic color print. Courtesy of Charles Cowles Gallery, New York, and Robert Koch Gallery, San Francisco.

Chapter 6

Observation: Eyes Wide Open

HOW WE SEE

Seeing is an act of perception that helps us to ascertain, experience, learn, and understand our world. It is an individual skill that is conditioned by our cultural standards, education, and physical anatomy. Western industrialized society depends on literacy to function. To be fully functional, it is necessary to be able to decipher messages that have been put into a written code or language. When dealing with images, another skill set is necessary to interpret the coded information, and we need to learn this language to be visually literate.

Literacy

Literacy is based on the quality and quantity of our stored information, yet at times we are reluctant to learn to read new images. Complacency leads us to favor the familiar and reject that which is different or new. Overcoming this fear and thinking for ourselves makes learning a more joyful and expanding experience. Fresh data adds to our information storehouse that can be called upon when dealing with new situations, thereby increasing our range of possibilities and outcomes.

Whatever type of communication is in use, a person must be able to understand the code. In the past, pictures showed something of recognized importance. Traditional picture-making used the act of seeing to identify and classify subject matter. This sort of typological illustration is all some expect of a picture-maker. Problems arise when something unusual or surprising appears and we have no data or method to deal with it. What we do not know or recognize tends to make us nervous and uncomfortable. This anxiety manifests itself in the form of rejection, not only of the work but of new ideas in general.

Learning to Look

Looking at a picture is not like glancing out a window and viewing a known world. Initially, imaginative looking needs to be a conscious and directed act that requires thinking, sorting, analyzing, and decision making. *Stimulating looking* is an evolving system of thoughtful examination and scrutiny that can be taught and learned. *Creative looking* involves getting in closer and determining what lies below the realm of physical appearance.

The Difference between Artistic and Scientific Methods

Western formal education does not place much value on learning visual language. For some people, the purpose of art is simply to be recognizable, pretty, and comfortable. Such people are not aware of a picture-maker's role within society as someone who can perceive, interpret, and offer a wider understanding of life. Yet these same people may desire the products brought forth by these innovative and resourceful explorations. People do not make fun of a scientist working in a laboratory even if they do not understand what the scientist is doing because society sanctions and rewards scientific activities. The major difference between art and science is that art offers an intuitive approach to explain reality, while science insists on an exact, objective, rational set of repeatable methods and measurements. Science says there is only one right answer; art says there are many correct answers. The magnificence of our contemporary arts and letters and the contributions citizen artists make to democracy is diversity of thought, which is why art thrives in open societies. It is the recognition of an artist's responsibility to have something to say, to echo the culture (or lack thereof) we are embedded in, and directly or indirectly awaken our thinking.

6.1 "I digitally scan microscopic plant and animal matter to magnify, document, and abstract an unseen hidden world of complex forms, textures, and bright vibrant colors. I am interested in how color, pattern, texture, and form of a living organism play a role in the natural selection process, an underlying silent code of visual signals. The scanner captures both sides of the micro-slide at the same time. The natural matter is, thereby, sandwiched in the light, giving the image a translucent appearance that would not be possible if I used a normal camera lens. I am fascinated by this cameraless approach that is similar to Anna Atkins's 1840s botanical studies; however, instead of Atkins's photogram, this contemporary version is a photoscan."

© Jennifer Formica. Wowbug, from the series Micro Nature, 2004. 14 × 11 inches. Inkjet print.

Visual Literacy and Decision Making

Our society does not stress visual literacy, and as a result many people lack skills to navigate in our media-saturated environment. With declining newspaper readership and more people relying on video clips as an information source, it is critical to teach people how to interpret these signs or they will not be properly equipped to go through a visual decision-making process. We then risk becoming "objects," easy marks for the gatekeepers of information to manipulate and susceptible to the superficial suggestions of advertising, the dangers of government propaganda, or just the plain fluff of celebrity. We simply react to situations by either accepting them or rejecting them. When we cease to question, analyze, and decide for ourselves, we have been effectively removed from the process.

A picture-maker can be an active participant in this decisionmaking process. Imagemaking offers opportunities to interact, comment on, and/or challenge what is going on in society. An imagemaker's work can stimulate others to thought and action. The entire photographic process can make life deeper, richer, more varied, and more meaningful. This process is a highly valuable asset, even if it cannot always be measured in tangible terms.

Seeing is a subjective and personal endeavor, and its results depend on a viewer's ability to decode the messages that are received in a symbolic form. A broad, flexible response allows viewers to understand that our culture determines the hierarchy of subject matter. Keeping an open mind enables us to uncover and negotiate the many levels and possibilities of new materials and to view the familiar anew. It boils down to what writer Anaïs Nin observed: "We do not see things as they are, we see them as we are."

6.2 "This series of photographs uses humor, performance, and snapshot aesthetics to produce a series of self-portraits in mundane situations with various celebrities. In these photographs, the divide between fact and fiction becomes blurred and reconstructed, as the private life of the celebrity becomes public domain. The banality of the individual scenes refers to the recent rise in popularity of the Reality Television genre and its ironies as it is packaged and presented as close to the viewer's livable experience, yet is completely scripted and controlled, or else rooted in absurdity. The images reflect our obsession with celebrity and the desire to make celebrity banal and see celebrities as ordinary people, which compelled me to use impersonators found on Craigslist rather than Photoshopping images of actual celebrities into the scene." © Diane Meyer. *Me and Tom*, from the series *Quiet Moments Spent with Friends*, 2005. 20 × 24 inches. Chromogenic color print.

Exercise

Imagemaker as Flâneur

Take on the role of flâneur, one who leisurely, yet alertly strolls through an urban environment. Take the time to investigate, examine, and observe the accidental, the fleeting, the strange, and the unknown. Circumnavigate urban settings as your whim dictates, giving yourself over to the "spectacle of the moment" while being vigilant for chance rhymes that may be lurking in every corner. Allow your poet's eye to generate the direction of your ideas and capture your findings for others to see. Remain open and respond to new, subtle impressions and situations while bearing in mind the essential design elements and how the light is affecting your choice of subject matter. In the spirit of critic and philosopher Walter Benjamin's view that the flâneur "goes botanizing on the asphalt," make lots of exposures that capture the physiology of urban life. Produce contact sheets of all your images and examine them for visual or conceptual threads that will allow you to stitch together a series of six different views of the chance rhymes in every corner of your wanderings.

For additional background information see Rebecca Solnit's Wanderlust: A History of Walking (2000), which has fine chapter about the origins of the flâneur.

Becoming visually literate is one small step we can take in accepting responsibility for discovering and affirming our own values. Ultimately, it is such individual baby steps that can have widespread effects. As people become visually educated, more aware of their surroundings, and able to see the world for themselves, they can participate more fully in making decisions that affect how their society operates.

WHY WE MAKE AND RESPOND TO SPECIFIC IMAGES

Why do we make pictures in a specific manner, and why do we react more strongly to certain images? Are you someone who favors an open, direct, and unadorned representation of reality or someone who prefers an expressive, individualized interpretation of reality? This section presents some ideas on these subjects and encourages you to draw and apply your own conclusions.

Victor Lowenfeld's Research

In 1939, Victor Lowenfeld began researching how people primarily know their world. Lowenfeld discovered that people could be divided into two basic groups: one that utilized their sense of sight and another that used their sense of touch. Through ongoing research, Lowenfeld determined that the first group took an intellectual, literal, realistic, quantitative approach to knowing their world, and he called this group "visual." The second group functioned in an intuitive, qualitative, expressionistic-subjective mode, which he described as

6.3 Waltzer's images of civic spaces — parks, piazzas, pools, and busy streets — evoke the spirit of a flâneur who witnesses and records a persistent rumble of change in the landscape. Using elevated vantage points and deep vistas, Waltzer "captures the resonant traces of mutable life, with its temporal rhythms and patterns of movement, as they intersect with the skeleton of place. Their structure, synchronicity, flow, and collective narrative reveal a layered history embedded in the visual landscape as detail and metaphor. Past and present reside simultaneously, narrating the transformative connections between a place and its inhabitants."

© Garie Waltzer. Eiffel Tower, Paris, 2005. 22 × 22 inches. Inkjet print.

"haptic." Lowenfeld went on to determine the major characteristics of each of these two creative types.

Visual-Realists as Imagemakers

Lowenfeld found that "visuals" tend to produce whole representational images, which is by far the most widely practiced and accepted form of imagemaking. Visuals are concerned about "correct" colors, measurements, and proportion. Visual-realists prefer to learn about their environment primarily through their eyes while their other senses play a secondary role. Generally, visual photographers preserve the illusion of the world. The visual-realist style is an unmanipulated and objective mirror of the "actual" world. It is concrete, unobtrusive, and concerned with what is physically there. These photographers are observers/spectators who use a camera to supply a surrogate set of eyes on the ground for the rest of us who weren't there to actually to a witness an event. They go for hard facts rather than abstract form, presenting ocular proof in which the subject matter is supreme. Documentary work is the most apparent style. Visual-realists tend to preserve spatial continuity by photographing at eye level, using a normal focal length, and avoiding extreme angles. Their style is open, subtle, recessive, or even informal while leaning toward the familiar and the unobtrusive.

Visual-Realist Photographic Working Methods

The code of the visual-realist is that of linear reality. Their pictures reflect concrete themes and often tell a story. The image is usually created at the moment the shutter is released, using straightforward methods that do not alter the original context and present a wealth of detail. Digital manipulation and cropping is kept to a minimum. No unusual techniques are employed except what is considered to be

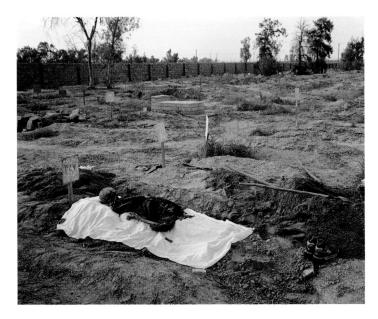

6.4 British war photographer Simon Norfolk arrived in Baghdad (after a \$1000 taxi ride from Jordan) ten days after American soldiers pulled down Saddam Hussein's statue. "Two hundred years ago young Englishmen were sent on a Grand Tour of Europe to extract philosophical meaning by gazing upon Antiquity's ruins. Now young American men are making a tour of smoldering ruins and drawing their own conclusions about the superiority of America, about the barbarism of locals, and the awesome power of technology." © Simon Norfolk. *Grave*, 2003. 40 × 50 inches. Chromogenic color print. Courtesy of Luisotti Gallery, Santa Monica.

in keeping with the current standards of showing reality. Many visualrealists may not do their own image processing or printing because they see their primary role as witnessing the world. They use photography to match reality, enabling us to see places and things that we are not able to experience for ourselves. Often they use their work to bring deplorable conditions to the public's attention, indirectly acting as a catalyst for societal change.

Haptic-Expressionist Imagemakers

Haptic comes from the Greek word *haptos*, meaning, "laying hold of." Haptics are strongly affected by their bodily sensations and subjective experiences, making them highly kinesthetic and likely to physically interject themselves into their work. They associate and apply emotional and subjective values to the color and form of objects and are not particularly concerned with duplicating physical appearances. A prime example of a haptic artist is abstract expressionist painter Jackson Pollock, who is known for his "drip and splash" style that transformed picture-making into dance. His manner of action painting allowed a direct expression or revelation of his unconscious feelings, moods, and thoughts onto canvas.

Haptic-expressionist photographers often alter, exaggerate, and stylize their subjects for emotional effect. They actively participate in the imagemaking process, inserting their presence, becoming part of the picture. Haptics explore and present their inner self, trying to liberate their internal vision rather than reproducing an image of the outer world. Being involved with a subjective and more personal vision, their approach often incorporates private symbols that deal with psychological and spiritual issues. This can make their work less obvious and more demanding of viewers, which can limit the audience appeal of their work.

Haptic-Expressionist Photographic Working Methods

The haptics break with expectation, ritual, and tradition to represent other planes of reality. Their style is more self-conscious and con6.5 "My work connects and reflects the passage of time." Madigan's daughter posed every summer from age 3 to 13 by lying on sheets of printing paper for 5 minutes in sunlight. The paper was put away and then re-exposed to the sunlight after a variety of plant forms were arranged on the paper, and then processed in gold chloride toner for permanence. The resulting images were scanned with a 4 × 5 inch digital back, and combined and manipulated in Photoshop to produce a seamless life-size image with a fantastical sense of reality that can be related to magical realism.

© Martha Madigan. *Graciela: Growth III*, 1993–2003. 40 × 24 inches. Inkjet print. Courtesy of Michael Rosenfeld Gallery, New York, and Jeffrey Fuller Fine Art, Philadelphia.

spicuous, placing importance on the unfamiliar. They emphasize form, stressing the essential nature of the subject rather than its physical nature. Haptic-expressionists deploy the camera flamboyantly, using it to comment on their subject. They make use of digital imaging software to heighten an image's response, having no qualms about altering a process and/or moving and rearranging a given reality to suit their needs. Often they crop the picture space, preferring a closer, more controlled, and directed composition. Haptics relish creating their own mini-universes. They frequently practice postvisualization, considering the digital studio a creative opportunity to carry on their visual research, saturating their images with visual clues and information to direct and lead viewers around their composition.

THE EFFECTS OF DIGITAL IMAGING

Although it is still too early to say with certainty, the rapid explosion of digital photography could be indirectly creating a homogeneous look to today's photographic images. Autofocus, auto-exposure, auto-

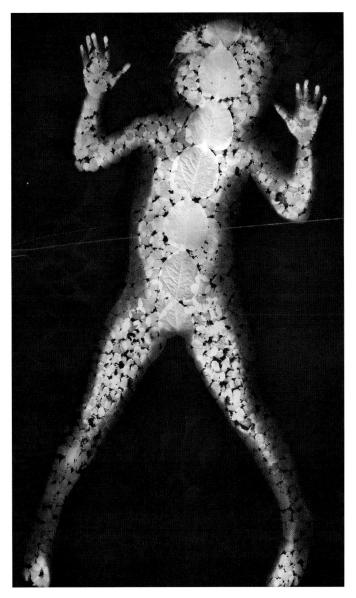

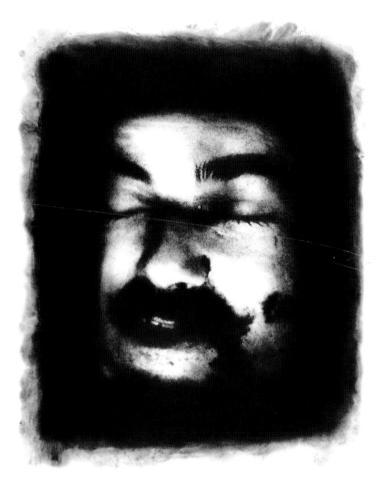

white balance, and auto-everything may unintentionally be pushing photographic imagemaking toward a mechanical visual-realist style and away from a haptic-expressionist style. One thing is for sure: the rapid dissemination of photographic images through the Internet, online archives, newspapers, magazines, and the prolific consumer

6.6 These images were made using a customized photographic process. This method takes appropriated imagery from an Internet archive, made of people after their murder, into the computer for processing. The imagery is then output to film to make silk-screen prints with water-soluble ink. Charcoal is then rubbed into the uninked surfaces of the paper, after which the water-soluble ink is dissolved to reveal paper to correspond with image highlights. "It was very important for me that the image be created by rubbing the image into existence (as in a Gravestone rubbing). I wanted to have contact with the surface of the image, to touch these victims' faces in order to make the image. The rubbing process for these images required me to vigorously work charcoal into the fiber of the paper, making my hands raw. These images marked me, they opened my skin, and made my hand incredibly sensitive to things it usually would not be sensitive to. It is my way of giving intimate physicality to the person imaged at their death through a process that uses an active and embracive human touch. Perhaps these ashen portraits become votive and aspirational in that way. They are meant to remind us of our common humanity, by way of our horrors. They ask us to remember, not in shame, but in earnest.

© Damon Sauer. *Death Rubbing: Unidentified Iraqi Civilian*, 2005. 28 × 22 inches. Charcoal rubbing on paper.

output that has arisen through affordable home digital technology is creating an evolution in the aesthetics of imagemaking.

Photography's Effect on the Arts

Photography has brought about groundbreaking changes in the arts. It initially freed painters and writers from having to laboriously describe objects and happenings and allowed them to move from outer matching to inner matching. It turned art toward the inner processes of creative expression, which helped lead to the development of modern, abstract, pop, and conceptual art. The explosive growth of digital imaging has given photographers the same options as other artists to control space-time realities.

The rapid changes in photo-based imagemaking make it extremely difficult to stay current. In this avalanche of transformation, it can be comforting to cling to what we know, but this attitude can block one's creative path. Investigative research is necessary in any field to keep it alive, growing, and well. Photographers should engage their curiosity, ask questions, and experiment by synthesizing their varied modes of intelligence, for that is what leads to new representational knowledge.

As both a photographer and viewer of photographic images, it is important to know that there is no fixed way of perceiving a subject, only different ways that a subject can be experienced. Concentrate on photographing your experience of what is mentally and emotionally important, what is actively in your mind, and what you care about during the process of picture-making. When looking at other photographs, especially ones that are unfamiliar or that you do not understand, attempt to envision the mental process that the photographer used to arrive at the final image. Regardless of approach, the visual photographers emphasize the "what" and the haptics the "how." Learn to recognize these two different fundamental outlooks and appreciate their unique ways of seeing and knowing the world.

Pushing Your Boundaries

Digital photography offers a rapid sequence of rediscovery. New images can alter the way we look at past pictures and affect future directions. Feel open to use whatever methods are necessary to make your pictures work, whether it is pre-visualization (knowing how you want the picture to look before making an exposure), postvisualization, a preprocess idea, or an in-process discovery. When making images, you do not think with your eyes, so give yourself the freedom to question the acceptance of any working method. Digital imaging is really a study of how a camera and a sensor see, so think of each step of the process as a time for exploration, not a situation to display your rote-memory abilities. Take some chances, don't be afraid to walk on the edge, and never allow others to set your limits. Something unexpected is not something wrong. If you don't like the result, push the delete button. Enjoy the process of making photographs. Don't turn it into a competition with yourself or others. There are major discoveries waiting to be made in digital imaging, so keep your definition of photography broad and wide. Listening to your genuine values and concerns places you on a course that allows your best capabilities to come forward and be seen. Do not get sidetracked by trendy art fashions, for they are not indicators of awareness, knowledge, or truth. They are simply a way of being "with it" for a moment. Keep in mind that talking about photography is not pho-

Exercise

Visual or Haptic

Decide whether you possess the general qualities of either the visual or the haptic way of imagemaking. Choose a subject and photograph it in that manner. Next, turn that invisible switch inside your brain and attempt to think in the opposite mode. Make a picture of the same subject that reveals these different concerns. Compare the results. How are they different? How are they the same? What have you learned? How might this affect the way you make, view, and understand images in the future?

tography, and words are not pictures. Keep your eyes on your destination, which is making pictures, and don't mistake the appearance of a thing for its essence.

AESTHETIC KEYS FOR COLOR AND COMPOSITION

The Color Key

When formulating an image it can be helpful to start with your own internal aesthetic keys, which offer a means of gaining access or understanding about how one is apt to visually order and decipher the world. Deciding what colors to include when putting together an image is crucial to its final outcome. We all have colors we tend to favor. Notice the colors that you have selected to surround yourself with. Observe the colors of the clothes you regularly wear and of the walls and objects in your room because they are a good indication of your color key. Your color key is a built-in automatic pilot. It will take over in situations when you do not have time to think. Everyone has one. It isn't made, but rather it has to be discovered. The color key reveals the character of a person. It is not a constant; it changes. At one point it is possible to be drawn to dark, moody hues; while later, bright, happy, and warm colors might be prominent. It is a balancing act that mirrors your inner state of mind. When the picture is composed, the framing establishes the relationship of the colors to one another. These decisions affect how colors are perceived. The colors selected are the ones that the photographer currently identifies with in an innate way. Review the sections on color symbolism (in Chapter 2) and the characteristics of light (in Chapter 5) to get insights into what your key colors might represent.

EXERCISE

One Color

Choose one color and one color only and make photographs of that color in a variety of lighting situations, including outside and inside, bright light and dim light, and under artificial and natural light. How is your interpretation affected by the quality of light and the context/environment? What happens when you fill the frame with that color? What if you pinpoint that color within the larger frame of the scene? How does varying the angles of view affect your color perception? Notice that there is much more to "blue" than blue, that there are multiple shades, hues, and values of a color, and observe how these differences can affect a viewer's response to the image.

The Composition Key

The composition key is an internal sense of construction and order that one applies when putting the parts of a picture together. Our authentic sense of design and style is a developmental process. It is a self-rendition in terms of picture structure and organization. It cannot be forced. You are it. It is incorporated into your work and is given back in your final image. Do you tend to place your principal subject in the center, to the right, or left of center? Is your visual emphasis placed on the top, bottom, or sides? Some universal compositional keys to begin looking for are the circle, figure eight, spiral, and triangle (see Chapter 2).

6.7 The images in Ventura's book, *War Souvenir* (2005), are based on his grandmother's memories of occupied World War II Italy. Ventura fabricates scenes, often based on historical evidence and photographs, to evoke tragic incidents that never existed. The use of a singular color scheme adds to the emotional depth and to the sense that one is seeing something that at first appears real, but continued viewing reveals it to be something quite different. © Paolo Ventura. *Yuscan-Emilian Apennines. The Body of a German Soldier Killed by Partisans*, 2004. 40 × 30 inches. Chromogenic color print. Courtesy of Hasted Hunt Gallery, New York.

6.8 Having photographed in New Orleans for nearly 25 years, Strembicki sought out objects, rather than citizens in distress, to represent the effects of lives lost, of culture washed away, and of the people displaced. "This water-damaged high school was symbolic to me of lost knowledge, traditions, and history. The ruined American flag was emblematic of the federal response to this disaster, while the mud is representative of ironic forces, which were never far off."

© Stan Strembicki. Ruined Flag, Lawless High School, Lower 9th Ward, from the series Post Katrina New Orleans, 2005. 17 × 24 inches. Inkjet print. Courtesy of Philip Slein Gallery, St. Louis.

Recognizing the Keys

Recognizing these keys is a way to make yourself more aware of your own inherent preferences, which then allows you to use these central inner guides to make better images. A good imagemaker can learn to make pictures in less than ideal conditions. The ability to see that there is more than one side to any situation helps to make this happen. For example, you could complain it is raining and not go out and make pictures, or you could notice that it is raining and see it as an opportunity to make the diffused, shadowless picture that has been lurking in the back of your mind. Color and composition keys offer guides for understanding how we visually think. They are not hard-and-fast picture-making rules. They also show us that there are many ways to see things. When you start to pay attention to how others view the world, it is then possible to see more for yourself.

Exercise

Color and Composition Keys

Learn to identify your personal color and composition keys. Do not expect to find them in every piece. They can be hidden. Doodles can often provide clues to your compositional key. Get together with another imagemaker and see if you can identify each other's keys. Go to galleries and museums and look through books, magazines, photo CDs, or online collections to find a body of work by an imagemaker that you find personally meaningful. Ascertain the color and compositional devices in this imagemaker's work. Now make an image in the same manner. Do not copy or slavishly replicate the work, but take the essential ingredients and employ them to make your own image. Next, compare the two images. Last, compare both images to your other work. Write down the similarities and differences in color and composition that you notice. What can you now see that you did not notice before making these comparisons? Now return to the same subject and make an image your way. Compare the results with what you previously have done. Has your thinking been altered in any way? Explain.

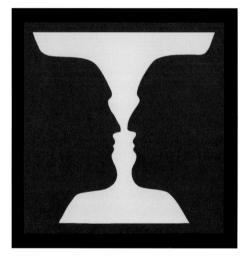

6.9 Figure 6.9 is a classic example of the figure-ground phenomenon, dating back to the 18th century. It demonstrates an ambiguous figure-ground illusion that can be perceived either as two blue faces looking at each other, in front of a yellow background, or as a yellow vase on a blue background. This illusion is important because it shows that perception is not solely determined by an image formed on the retina. The spontaneous reversal that you observe illustrates the dynamic nature of subtle perceptual processes, underscoring how your brain organizes its visual environment. What do you see first? Can you discern a different figure-ground relationship? What do you think most people see first? Why? What does this tell you about the role of contrast and contour?

FIGURE-GROUND RELATIONSHIPS

Figure-ground is the relationship between the subject and the background. It also refers to the positive-negative space relationship within your picture. *Figure* refers to the meaningful content of your composition. *Ground* describes the background of the picture.

The Importance of Figure-Ground Relationships

The principle of figure-ground relationships is one of the most fundamental laws of perception and one that is used to help us design our photographs. Simply put, it refers to our ability to separate elements based upon contrast — dark and light, black and white. When the figure and the ground are similar, perception is confusing and difficult, and viewers might have trouble determining what is important for them to look at in a picture. This often occurs when an imagemaker attempts to provide too much information in a composition. A viewer's eyes will tend to wander without coming to a point of attention. Such a composition lacks a visual climax, so viewers lose interest and leave the image. If you find yourself having to explain what you were trying to reveal, there is a strong possibility that your figure-ground relationship is weak.

Figure-Ground Strategies

When you observe a scene, determine exactly what interests you. Visualize how and where your content (figure) and background (ground) are going to appear in your final image. Put together a composition that will let viewers see the visual relationships that attracted you to the scene. Try experimenting with different lens focal lengths and a variety of angles to alter the areas of focus. Good imagemakers are good visual editors, so be selective about what you decide

6.10 Utilizing her training as a painter, Shaw photographs city street scenes looking for graphic relationships that explore the formal issues of shape and color. "I then flatten and subtract descriptive information during digital postprocessing. Viewers must then grapple with the confusion that happens as portions of the 'window' that is expected are broken or lost, thus moving my photography closer to the legacy of Hans Hoffman's and Joseph Albers's work and teachings about the interrelations of color and image."

 \odot Susan Shaw. *Houston Street*, from the series *Parallel Tracks*, 2006. 24 × 24 inches. Inkjet print.

to include in the picture. Find ways to both isolate and connect the key visual elements of the composition. Try using a higher shutter speed and larger lens aperture to lessen the depth of field. Experiment with focus and see what happens when spatial visual clues are reduced. Don't try to show "everything." Often showing less can tell the audience more about the subject, because they do not have to sort through visual disorder. Try limiting the number of colors in your composition. A color image does not have to contain every color under the rainbow. Keep it simple and stay focused on your primary point of interest.

EXERCISE Figure-Ground Strategies

Observe a scene and determine exactly what interests you. Visualize how your content, the object/subject (figure) of primary interest, and the background (ground) are going to appear in your final photograph. Put together a composition that will allow a viewer to see the visual relationships that attracted you to the scene. Use a zoom lens at various focal lengths and vary the camera-to-subject distance. Try different angles to alter the areas of focus. Be very selective about what you include in your frame. Find ways to both isolate and connect the key visual elements of the composition. Try using a higher shutter speed and larger lens aperture to lessen the depth of field. Experiment with focus and see what happens when spatial visual clues are reduced. Do not attempt to show "everything."

Bear in mind the motto: Less Is More. Often showing less can tell the audience more about the subject, because they do not have to sort through visual chaos. Intentionally limit the number of colors in your composition. A color photograph does not have to contain every color within our spectrum. Where everything seems to be of interest, nothing ends up being of interest. Maintain simplicity and make sure your audience gets your point. The key is to subtract the obvious and keep what is meaningful and significant.

Keeping these factors in mind, make two photographs of the same scene/subject. One should show a clearly definable figureground relationship. The other should portray an ineffective figureground relationship. Then compare and contrast the two. Identify the methods used to improve your figure-ground relationship. How can they be applied to further imagemaking situations? Now apply what you have learned by making an image that shows a simple but intriguing figure-ground relationship and another that creates a successful complex figure-ground relationship. 6.11 Inspired by his love of pop-up books, Allen replies on his ability to observe with the camera lens as he deconstructs and photographs old books. "I am mesmerized by the illusion of reality that vaults from a seemingly flat space whenever a page is turned. My subjects, weathered and long-discarded volumes, find new life as actors in the pictures that I direct and make. Their characters are developed by pulling and folding the various parts that have been carefully cut from a page or cover. Wire, tape, pins and other hidden means are used to hold the pieces in place before the camera. Lighting evokes drama and a shallow focus simulates the feeling of depth in pictures of books that mimic pop-ups."

© Thomas Allen. *Chemistry*, 2006. 24 \times 20 inches. Chromogenic color print. Courtesy of Foley Gallery, New York and Thomas Barry Fine Arts, Minneapolis.

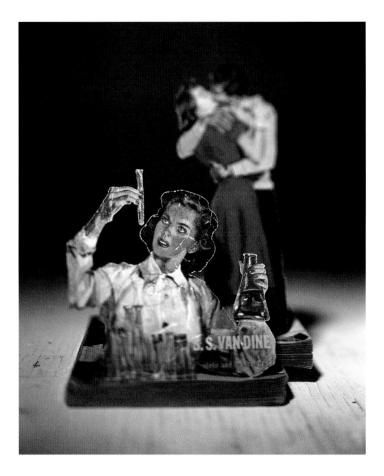

The core concept of the ON-AIR Project is that every single being in the universe will eventually disappear. Here Kim digitally superimposed eight different images of Sacheongwangsang, who guards the entrance of a Korean Buddhist temple, so that they are subsumed within a new, composite image that represents a form of disappearance or an identity.

 \odot Atta Kim. Sacheongwangsang, 8 Buddhas, from ON-AIR Project, 2003. 74 \times 92 inches. Chromogenic color print.

Chapter 7

Time, Space, Imagination, and the Camera

IN SEARCH OF TIME

We all know what time is until someone asks us to explain it; then, even physicists find the nature of time to be inexplicable. Time is more baffling than space. It seems to flow past us or we appear to move through it, making its passage seem subjective and incomprehensible. Yet a camera can purposely stop time and spatially add the aspect of physical dimension within a framed area of visual space, giving photographs exceptional properties that other visual media do not possess.

In his *Theory of Relativity* (1905), Albert Einstein proved that widely held concepts about time were not always true. For instance, Sir Isaac Newton's theory that time moves at a constant rate was proved erroneous after it could be demonstrated that time elapses at a slower rate for rapidly moving objects than it does for slowly moving ones. An example of this phenomenon would be an astronaut who goes on an extended space voyage. The returning astronaut would have aged only a few years while his earthbound counterparts would have gotten dramatically older. The belief that two events separated in space could happen at precisely the same time — simultaneity — has also been demonstrated to be incorrect. Whether two events *appear* to happen at the same time is contingent on the vantage point of the viewer, and no single observer has the inherent privilege to be such an authority. For Einstein, the concept of space as something that exists objectively and independent of things, including time, is a remnant of ancient, pre-scientific thinking.

Einstein's endeavors revealed even more extraordinary revelations about time. For instance, a clock will run faster at the top of a building than in the basement. In a nutshell, Einstein tells us there is no such thing as universal time and there is no master clock regulating the working of the universe. Time is slippery, relative, and subject to gravity and motion. Time and space are not simply "there" as a neutral, static setting for existence to unfold upon. Time and space are physical things, malleable and mutable, no less so than matter, and subject to physical laws. In quantum theory, what is physically real is said to be undefined until it is observed (interacted with). This quality of being undefined also applies to the "reality" of the future and of past events. According to quantum theory, by observing an event the observer literally determines the course time has chosen. These same forces of physics were at work in the arts and can be seen in Pablo Picasso's *Les Demoiselles d'Avignon* (1907), which altered Western notions of time and space to produce a rift dividing past and future that led to the blooming of modern art.

THE PERCEPTION OF TIME

We perceive our world through one or more of our senses. We see colors, hear sounds, and feel textures, but how do we perceive time? Could there be a special faculty, separate from the five senses, for detecting time, or is it that we notice time through perception of other things? And if so, how? What about the tension between organic time (nature) and mechanical time (culture) and the Western ideological associations attached to each?

How do such theories affect an imagemaker? If asked to imagine a photographic image, most of us would conjure up a small slice of frozen time that has been plucked from the flow of life with a frame (border) around it. Everything in the picture is stationary, there is no movement, and there will never be any change, as the brief capture remains permanently available for ongoing examination. This Western convention of reality, based on Renaissance perspective, commands that photographs, like trial evidence, be clear, sharp, and to the point of the matter. In popular culture, a photographic image's value is determined by the abundance and readability of the details. In this scheme, the actions of a camera with its lens are supposed to emulate the human eye with its lens and retina. Critical thinkers and visual artists have realized that photographs do actually not reproduce human vision, but rather show us a particular moment frozen in time, from a specific vantage point, usually in a rectangle, in which our head is still, one eye closed, and seen through a specific image/color management system. Such a petrified Cyclopsian view actually reverses the original intent. Instead of a camera showing us what our eyes would see, which is more like an egg-shaped field of view, we are now confronted with the notion that if our vision worked like a photographic process, we would indiscriminately see the world devoid of interpretation, without bias or prejudice.

This chapter concentrates on camera-based axioms dealing with the representation of space and time. Restricting your picture-making options for conceptualizing time and space to a linear, Newtonian point of view is to constrain your mind and your camera responses. This is not to discourage imagemakers from working in this established mode, but to encourage exploration in uncharted zones where time can be visualized as up, down, in, out, and around space.

Plato understood the importance of how we communicate when he said, "those who tell the stories also rule." Philosophers tell us that images rule dreams, and politicians tell us that dreams rule actions. An extreme example of that today can be seen in Rwanda where the Hutus labeled the Tutsis "cockroaches" and in 1994 proceeded to indiscriminately murder at 800,000 of them in a genocidal campaign in just 100 days. Similar tactics were utilized by the Nazis who dehumanized Jews by picturing them as rats, as part of an overall propaganda campaign that led to the Holocaust (Shoah). In *Orientalism* (1978), the cultural critic Edward Said referred to such "descriptions" of one group about another as "that great collective appropriation of one culture by another."

Photography's descriptive power has made it the principal visual medium from which most of us derive our impressions and responses about the world. Digital cameras and image processing software give imagemakers unprecedented access for such undertakings, with sequential images, multiple "windows," and bursts of video along with a seamless incorporation of text and sound playing a larger role in the overall process of representation, defining dreams, and taking action. Websites such as www.youtube.com allow people to share their self-produced videos and others such as www.jumpcut.com and Google video (www.google.com) offer simple tools for stringing together video clips and then adding soundtracks, titles, transitions, and unusual visual effects. Even CNN has gotten into the act, asking people to upload short reenactments of their favorite movie scenes for possible use.

CONTROLLING CAMERA TIME

Although it has been mathematically demonstrated how the rate of time can fluctuate based on velocity, these equations do not explain why time can seem to pass more slowly, or more rapidly, depending on our mental attitude concerning an event. This chapter challenges imagemakers to take on the great enigmas of time that flummoxed even Einstein, such as the striking divergence between physical time and psychological or subjective time. The emphasis is on what can be done at the time of exposure with a camera. It is also possible to either enhance or replicate these techniques with imaging software.

Relativity also informs us that time is not a series of moments - some not yet having occurred - but rather a block in which we exist at a specific position, much in the manner we exist at one point in space. The inconsistency between the frozen "block time" of physics and the flowing subjective time of the human mind implies a need to rethink how we represent time. Most of us would find it difficult to surrender our impression of flowing time and its accompanying ever-moving present moment. It is so basic to our daily experience that we cannot accept the possibility that it is an illusion or misperception, based on the limits of our senses. During cinema's infancy, the practice of "reversing" (time), running the film backward, offered a unique photographic experience that altered a basic concept concerning how we are instructed to perceive our world. Since the time of Aristotle, logically minded people have demonstrated that personal experience and/or intuition is not a reliable guide to scientific understanding.

By diverging from customary imagemaking standards, we can start to include new ways of thinking about and depicting time using digitally based images. Once an image is digital, it can seep out of the confines of its frame and become capable of being woven together into a much larger tapestry. The net effect of this collective intelligence of images is our ability to see things we could not see in a single image. Of course, this upsets the traditional apple cart, but that has always been one of the effects of new technology. It further democratizes the practice and generates new makers and new audiences for their work. See how you can take advantage of the following starting points to use your camera to investigate new ways of representing

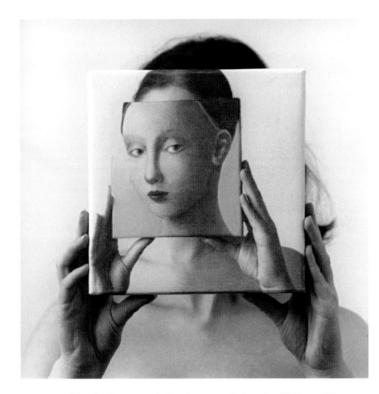

7.1 Inspired by the faces in early Renaissance paintings by Giotto and Piero della Francesca, Bram used the contemporary painting of Silva Willkens as masks and props to merge the identity of a model with the painted image. A digital component was entered in the middle of the process, when the original images were transferred to small canvases and then cropped and colored by Willkens. These became some of the props for the second photographic session. Bram's resulting photographs move forward and back through time and through the picture plane, between real and imagined personas, theme and variations in a visual fugue. All the original image-creation work was done in-camera.

© Richard Bram. Isabel Trio 3rd, 2000–2001. 40 × 40 inches. Inkjet print.

time and space (review camera concepts discussed in Chapter 3). In addition to the camera-based methods, there are countless ways in which imaging software can be applied to manipulate a picture's time and space relationships.

Exploring Shutter Speeds

Most of us have been taught that taking a good picture involves stopping all the action so that we can clearly see the subject, which means using a shutter speed of 1/125 of a second or higher. This approach is best typified by photographer Henri Cartier-Bresson's concept of The Decisive Moment (1952) in which he stated, "There is nothing in this world that does not have a decisive moment. To me, photography is the simultaneous recognition, in a fraction of a second, of the significance of an event as well as of a precise organization of forms that give that event its proper expression." The decisive moment can be thought of as the height of a formal visual performance, capturing the precise single instant in which the subject reveals its essence within the defined and formalized confines of the picture space. While Cartier-Bresson was a master of this picture-making strategy, not all photographs have to be about distinctly isolated moments of time. Rather, it is also possible that photographs can be a collection of numerous moments.

Extending the Action

One can begin experimenting with photographic notions of time by considering different methods of capturing motion. By adjusting the shutter speed (shutter priority) to a slower speed, thereby increasing the length of the exposure, you can boost the amount of time recorded by the photograph. When the amount of time captured is increased, subjects are likely to be more actively involved in the structure of the composition. This extended play of light on the sensor can have astonishing results. As light is recorded over a longer period of time, a new interaction of color emerges as the hues whirl together and blend into new visual possibilities, offering a different way of seeing and experiencing for contemplation. Use the camera display to review each exposure and make corrections, including shutter lag and digital noise, as needed.

Stopping the Action

Another possibility is to stop the action of an event by using a fast shutter speed (shutter priority) or flash in conjunction with a higher sensitivity (ISO). Consider freezing motion when it offers viewers an opportunity to see something that unfurls too quickly for the eye to fully comprehend. High shutter speed also provides a method of halting an event at a critical point of the action for additional analysis and study, thereby providing viewers with new ways of visualizing and thinking about a subject. This is what Eadweard Muybridge did in the 1870s when he photographed a horse with a series of cameras to prove that it had all four feet off the ground at one point while it was trotting, altering how artists portrayed running horses. Muybridge went on to complete a larger study, *Animal Locomotion* (1887), and did the same for the human figure in motion.

Anticipation and timing are critical for capturing the climax of an event. Whenever possible, study the action before making your exposures, familiarizing yourself with how the event unfolds so you can then depress the shutter button with forethought. When shooting stop-action images, select the appropriate vantage point and lens focal length, and then preset both the exposure and focus, using the small-

7.2 "Most of us escape into the magic of cinema. Ironically, there are no moving images in film. The mind is the great animator of the seemingly invisible stream of still frames. The revolution launched by the shift from analog (a recording technology) to digital (a rendering technology down to the level of a single pixel which made this image possible) affords an opportunity in transition to reexamine the historical properties, materiality, and evocative nature of movie film itself. This homage to Muybridge is both a celebration and an epitaph for a technology that has influenced and marked much of our storytelling over the past century."

@ William Larson. At the Vanishing Point, 2005. 22 \times 30 inches. Chromogenic color print.

est aperture to attain maximum depth of field. A wide-angle focal length allows more room for error because it has more depth of field at any given aperture than a normal or telephoto focal length. Use the image optical stabilization or anti-shake camera system if it is available on your camera. Optical stabilization will reduce image blur caused by hand and body motion and is especially useful when using long (telephoto) focal lengths in any circumstances. With any camera-shake compensating system, it's important to bear in mind that it cannot stop the motion of a moving subject.

Imaging software utilizes motion blur filters to mimic the effect of taking a picture of a moving object with a slower (longer) exposure time. It can blur an image in a specified direction representing your point of view (from -360 to +360 degrees), at a specified intensity representing any shutter speed below a 1/30 of a second, and at a specified intensity (from 1 to 999).

The telephoto focal length is useful for isolating action, as it will diminish the depth of field at any given aperture and therefore visually separate the subject from the background. Prefocusing, using autofocus lock, or using continuous autofocus all become options to consider to ensure the results are sharply focused.

The shutter speed needed to stop motion depends on the speed of the subject and its direction and distance from the camera (Table 7.1). The nearer the subject or the longer the focal length of the lens, the higher the shutter speed needs to be to fully arrest the action. A subject moving across the frame requires a higher shutter speed than one approaching head-on or at the peak of its action. The basic guideline is that your shutter speed should be faster than the inverse of the focal length of your lens. For example, if you are using a focal length of 200 mm, then your shutter speed should be 1/200 of a second or faster.

Table 7.1 Shutter Speed Needed to Stop Action Parallel to the Camera

Shutter Speed	Action
1/125 of a second	Most everyday human activities, moving rivers and streams, trees in a light wind.
1/250 of a second	Running animals and people, birds in flight, kids playing, balloons and kites, swimmers, and waves.
1/500 of a second	Automobile at 30 miles per hour, bicyclists, motorcyclists, sport activities such as baseball, football, and tennis.
1/1000 of a second	Automobile at 70 miles per hour, jet airplanes taking off, high-speed trains, skiers, and speedboats.

Stopping Action with Electronic Flash

The ability of electronic flash to stop movement depends on the duration of the flash. An average built-in flash unit usually gives the equivalent shutter speed of 1/250 to 1/500 of a second. High-end auxiliary flash units can be set at fractional power settings, which can supply much faster times, up to 1/10,000 of a second. Utilize image stabilization or anti-shake camera systems. Review your exposures and fine-tune as needed. This method can also be effective in dimly lit situations where the electronic flash rather than high shutter speed can be used to stop action.

Blur and Out-of-Focus Images

Blur and out-of-focus images are as natural to photographic practice as those that are sharp and crisp. The blur's lack of precise focus frees

7.3 "Philosopher Martin Heidegger described human existence as a process of perpetual falling, and it is the responsibility of each individual to 'catch ourselves' from our own uncertainty. This unsettling prognosis of life informs my present body of work. Using myself as model and with the aid of climbing gear and other rigging, I photograph the body as it dangles from dangerous precipices or tumbles down flights of stairs. The captured gesture of the body is designed for plausibility of action, which grounds the image in reality. However, it is the ambiguity of the body's position in space that allows and requires viewers to resolve the full meaning of the photograph." Although this image acknowledges the horror of the people who jumped from the Twin Towers on 9/11, "falling is a metaphor for life in general. Mentally, physically, and emotionally, from day to day, we fall. Even walking is falling: You take a step, fall and catch yourself."

© Kerry Skarbakka. *Office*, 2005, from the series *Life Goes On*, 2005. 60 × 72 inches. Chromogenic color print. Courtesy of Fifty One Fine Art Photography, Antwerp, Belgium, and Burt Michaels and Associates, Chicago.

an image from the restrictions of photographic correctness by offering another representation of reality, one that interjects a sensation of movement into a picture. This bends the traditional concept of photographic time, suggesting that an image can represent an awareness of the past, the present, and the future. The blur eliminates customary recognizable photographic detail, revealing another aspect of a subject's physical and emotional essence. The blur does away with the concept of a discrete parcel of framed time depicting the frozen past. The blur can suspend the fixed sense of photographic time and instead present the notion of changing time itself. Look at the work of Uta Barth and Hiroshi Sugimoto for motivation.

Start by deciding what shutter speed is needed to stop the subject's movement in relation to the camera's position (see Table 7.1). A slower shutter speed produces more blur and consequently more contrast between the moving and static areas of the composition. This can isolate a static subject from its surroundings. Consider which details are crucial and need to be retained. Determine whether it will be more effective to blur the background or the subject and the direction of the movement. Linear blur is the most common and can be effective when following horizontal or vertical action. Intentionally moving the camera in a circular motion will cause globular blur, which needs to be carefully controlled or it tends to become overwhelming. Disable image stabilization or anti-shake camera systems. Review each exposure on your monitor and make the necessary compensations.

Motion Blur Filters

A radial blur filter can be applied to an image to simulate the blur of a zooming or rotating camera and produce a soft blur. Motion blur filters can simulate the vertical or horizontal blur of any picture or selected element within any picture file. Blur filters have given the photographer extensive blurring techniques that can be applied after the fact to any sharp image or used to enhance real camera blurring techniques.

Lensbaby

Special accessory equipment, such as a Lensbaby, can be very useful in these picture-making situations. Used in conjunction with a DSLR camera, a Lensbaby allows you to bring one area of your image into sharp focus while the remainder is surrounded by graduated blur. You can adjust this spot to any part of your composition by bending the flexible lens tubing. The high-end model allows you to lock the lens in place by pressing a button on the focusing collar. F-stops are controlled by means of changeable aperture disks (see www.lensbabies.com).

The Pan Shot

A camera may be intentionally moved to create a blur. An effective way to convey lateral movement, while freezing the subject and blurring the background, is to make a pan shot. Begin with a subject whose movement and speed are consistent. To accomplish the pan shot, use a slow ISO, holding the camera comfortably in the horizontal position. Prefocus on the spot that the subject will cross, and set the desired shutter speed. For instance, 1/15 of a second can be used to pan a vehicle moving at 30 miles per hour, and 1/30 of a second for 60 miles per hour. Correlate the aperture with the speed, using the smallest aperture to get maximum depth of field. Frame the subject as soon as possible. Do not tighten up or hold the camera

7.4 Enfield used a Lensbaby at f/5.6 to throw the background out of focus and direct the viewer's interest to the woman, "who was a character inside and out," in the right corner of the frame. "Using the Lensbaby on a DSLR is technically easy. Once you use it for a while, you can figure out the exposures intuitively, but the focus can sometimes be a challenge to maintain."

 $\ensuremath{\mathbb{O}}$ Jill Enfield. Untitled, 2005. 13 \times 19 inches. Inkjet print.

with a death grip; stay loose. Make the pan clean and smooth by following the subject with your entire body, not just with the camera. Gently release the shutter as the subject fills the frame and continue to follow through with the motion until you hear the shutter close. Generally, take care not to crowd the subject. Leave it some open space to keep moving unless containment is the object. Review your exposure and fine-tune as needed.

For instance, if you are photographing a skateboarder, look through the viewfinder and watch as the skateboarder comes toward

you. When the skateboarder gets close, aim the camera at the skateboarder's chest. Gently push the shutter release and keep the camera pointed at the skateboarder's chest while he/she moves past you. If you held the camera steady, the skateboarder would be blurry, but since you moved the camera at the same pace as the subject, the result will be a picture of a skateboarder who is sharp, while everything else will be a motion blur.

When panning or using a slow shutter speed, it's important to have a steady hand: leaving the shutter open for a long time allows the motion of the camera to affect the final picture. This is why sports photographers use tripods or monopods. A monopod is a like a walking stick that connects to the bottom of a camera. It allows you to steady the camera while you're shooting and is a worthwhile investment for anyone shooting sports pictures or other moving subjects.

Experiment with image stabilization turned off and on. Some lenses with image stabilization systems have a special mode for use when panning horizontally with a moving subject and compensate only for vertical (up/down) shake. The system does not try to compensate for the intentional horizontal movement.

Many random elements can enter into situations involving extended exposures, making such circumstances a deliberate combination of intent and chance. With practice and review, it is possible to get an idea of what the final outcome will look like. The unpredictability of these situations adds to their fascination. By learning to pan at just the right speed, the subject should be fairly sharply rendered while the background is smoothly streaked, rendering a convincing illusion of motion. Review each image on your monitor and make modifications accordingly. After you become skilled at this technique, try incorporating some variations, such as panning faster or slower than the object in motion. Using a slow shutter speed and intentionally moving the camera in nonparallel directions from the subject can create further motion effects.

Equipment Movement

Equipment-induced movement can be purposely utilized to impart an exaggerated sense of motion. However, this technique can easily be abused by unthinking imagemakers. When equipment is used *in place of* an idea, the result is a gimmick. When a photographer has to resort to gimmicks, control of the situation has been lost, and tired, worn-out pictures result. Whenever equipment is used to *strengthen and support* an idea, the imagemaker is working with a valid technique and visually exciting images can result. Use your monitor to review and make adjustments as you go. Ponder the following methods:

- Use a wide-angle focal length for its ability to produce dramatic feelings of motion when photographing movement at close range and at a low angle. The exaggerated sense of perspective created by wide-angle focal lengths can generate distortion and make background detail appear smaller than normal, thereby losing its visual importance. Conversely, objects in the foreground seem larger and more prominent, making them more visually significant.
- Zooming during the actual exposure can create the illusion of motion, with blurred streaks of color extending out of the midpoint of the picture. It gives a stationary subject the feeling of momentum. To make this happen, put the camera on a tripod,

set the lens to its longest focal length, and focus on the critical area of the subject. Start at 1/15 of a second, and then make a series of exposures using even longer times (1/8, 1/4, 1/2 of a second). Be sure to change the aperture to compensate for changes in speed. Zoom back to the shortest focal length as the shutter is gently released. Make a number of exposures and review your results. Note the exposure data so that you know which combination produced each picture. Part of any learning experience is being able to use the acquired skill in future applications. It helps to practice the zooming technique without making any exposures until the operation becomes second nature. Once you learn the basic method, it can be combined with other techniques. Experiment with turning image stabilization mode off and on. Some lenses have a special mode intended for use when a lens is mounted on a tripod.

- The pan zoom technique requires a photographer to pan with the subject while zooming and releasing the shutter. The camera needs to be on a tripod with a pan head. One hand is used to zoom while the other works the panning handle and shutter. A cable release is helpful, as is an assistant to fire the shutter at your instruction.
- The tilt zoom technique needs a tripod with a head that can both pan and tilt. Follow the same basic zoom procedure, but use longer exposure times (start at 1 second). Try tilting the camera during the zoom while the exposure is being made, and then try working the pan into this array of moves. The long exposures give a photographer the opportunity to concentrate on a variety of camera moves.

7.5 For a series of portraits of people with physical scars representing transformative experiences, Henrich lit his models with studio lights. Then he used a 4×5 inch view camera with a scanning back to make exposures of up to 9 minutes to emphasize the digital artifacts, the subject's natural movement, and that of the moving background.

© Biff Henrich. No title, 2006. 67 × 48 inches. Inkjet print.

- A multi-image prism that fits in front of the lens is a possibility, but its use requires discretion because its overuse has produced many hackneyed images.
- Use a scanning back or scanner to record non-stationary subjects.

7.6 "The urban experience to me is largely about motion. I like to shoot fast and furiously with a simple low-tech tool — a Holga 120S plastic camera — and be immersed and swept up in, and along with, the tide of the moment. Either I am shooting people in motion or I myself am in movement around my subject. But then I'm very perfectionistic and exacting in the post-camera processing. The long overlapping images are created by only partially advancing the film between exposures. It delights me how these mostly unplanned juxtapositions capture my experience of a particular time and place and at the same time have an identity all their own." © Susan Bowen. *Citizen's Thermal Energy Plant*, 2005. 29 × 4 inches. Chromogenic color print.

Free-Form Camera Movement

Free-form camera movement allows you to inject a haptic, subjective point of view in which the camera tells the story and yet is part of the story by following the emotional undercurrent of a scene.

With a stationary light source, use a variety of slow shutter speeds (starting at 1/8 of a second) while moving the camera in your hand. Start by making simple geometric movements with the camera while visualizing the effect of the blending and overlapping of color and line. Using a wide-angle focal length will give you a larger area to work within. If your camera is a DSLR, try to sight above the viewfinder or to not look

at all, going by feel and instinct. The key is to inject just the right amount of movement that adds a new dimension to the subject without overwhelming it. Too much movement results in color patterns and lines that tend to become confusing. It's like moving down a river, and the picture needs to have that same kind of flow. Allow the camera to explore. Begin with a smooth, fluid, and mobile camera movement. Then try an irregular, or jerky movement. Next move in and out and around the subject. Now allow the camera to drift from one point to another. Be spontaneous. Go with a feeling of unpredictability, but review each exposure and make adjustments accordingly.

Moving lights can put color and motion into a static environment. With the camera on a tripod and using small apertures, make exposures at 10, 20, 30, or more seconds. Try not to include bright, nonmoving lights because they will become extremely overexposed and appear as areas with no discernible detail and plenty of digital noise.

Flash and Slow Shutter Speed

Most digital cameras have a slow sync mode, which automatically combines flash with slow shutter speeds to capture both the subject and background. Combining flash with a slow shutter speed allows you to juxtapose areas of movement and stillness within a scene, thereby blending a sense of ambiguity and mystery with motion. Start out when the ambient light level is low, such as in the early morning, evening, or on a cloudy day. The effects can be varied depending on the ratio of flash to ambient light exposure and by the amount of movement of the subject and/or the camera (if it is hand-held), or both.

Use your flash exposure compensation mode to increase or decrease the flash output. Usually increasing the flash output makes the main subject come forward and appear brighter. Reducing the output helps to prevent unwanted highlights and/or reflections. Generally, positive compensation (+) is used when the principal subject is darker than the surroundings, whereas negative compensation (–) is used when the main subject is brighter than the background.

Using an optional auxiliary flash unit will increase your working options. A basic starting point is to cut the ISO sensitivity by one-half and use this new rating to take a normal exposure reading of the scene (ambient light). Set your flash with the same modified ISO rating. Determine the flash exposure based on the distance of the key object(s) in the composition. If the ratio of flash to ambient light is the same, the color palette and contrast will be soft. As the ratio of flash to ambient light is increased, the color palette tends to become more saturated and the contrast increases. Use a shutter speed of 1/4 of a second or longer. The flash exposure freezes the subject, and the duration of exposure time determines the amount of movement that is recorded. Bracket your exposures, review them, and experiment with various types of movement until you gain a sense of how this interplay works.

Extended Time Exposures

Many digital cameras have built-in shutter speeds of 30 seconds or longer. To make even longer exposures, attach your camera to a tripod and set your shutter control to the "B" (bulb) setting or, if available, to the "T" (time) setting. In the B setting, the shutter remains open as long as the shutter release button is held down. In the T setting, the shutter opens when initially depressed and remains open until it is pressed a second time. Utilize the self-timer, a cable, or remote electronic release to avoid camera shake. Employ a small lens aperture or a slow ISO setting to make the exposure longer. For even longer exposures, put neutral density filters in front of the lens. Avoid bright, static sources of light as they will cause gross overexposure with no detail. Pay attention to image noise and battery drain.

Clouds, lighting, wind, and passing lights can introduce a sense of motion and create a mood. Other atmospheric effects, such as moonlight and star trails, can be achieved with exposures starting at about 30 minutes and up (see Table 7.2). Wide-angle focal lengths are recommended for increased coverage, and the location should be

 Table 7.2
 Star Trails Exposures*

Moon	Exposure Time
No Moon	1-1/2 hours minimum
Quarter Moon	1 hour
Half Moon	30 to 60 minutes
Full Moon	10 to 20 minutes

* Based on starting exposures at f/2.8, ISO 50.

away from the pollution of ambient light sources. Consider including a foreground reference, such as a building or a tree, for scale and sense of place. For maximum star trails, make long exposures on clear, moonless nights. If the moon is too bright, the star trails will not be visible and the image can begin to resemble daylight, although the light from the moving moon may fill in the shadows that would otherwise be cast by the sun in a daylight photograph.

Drawing with Light

Drawing with light offers the opportunity to create an illuminated artifice that has no direct reference to the natural world of light. Doing so requires setting the camera on a tripod with a medium to small lens aperture. Start with a subject against a simple backdrop in a darkened room. Prefocus the camera, as the autofocus may have problems in the dark. Use a small pocket flashlight or an LED flashlight with a blind (a piece of opaque paper wrapped around the flashlight a few inches over the lens) to control the amount and direction of the light. Leave the lens open (use the B setting with a locking cable release). By wearing dark clothes, one can quickly walk around within the picture and draw with the light without being recorded by the sensor. Visualize how the light is being recorded. As the final effect is difficult to anticipate, use your monitor to review each exposure and make adjustments accordingly. Vary your hand gestures with the light source to see what effects you can generate. Experiment with different color balance modes, such as tungsten, to see their effect. Colored gels can be applied to any light source to alter its color output. The gels can be varied to introduce a variety of hues into the scene. As experience is gained, more powerful light sources, such as strobes and floods, can be used to cover larger areas, including

7.7 Walker first used an 8×10 inch view camera to make a 2-1/2 hour nighttime recording of the rapidly vanishing grain elevators that were indicative of rural America's pre-global economy. Five years later he made a 35-minute exposure of the same night sky using a star tracker (a motorized clock drive), which allows a camera to record the stars as fixed objects rather than as star trails. The negatives were then scanned and montaged to create a representation of Walker's original viewing experience.

@ Chris Walker. Ash Grove, Missouri, 2:15 A.M., 2006. 6-3/4 \times 9-1/2 inches. Inkjet and platinum palladium prints.

outdoor scenes. Review your exposures as you go and fine-tune as needed.

Projection

A digital projector or a slide projector with a zoom lens can also be used to paint a scene with light (by placing a colored gel or gels over the lens)

7.8 "This work combines my captured memories to reconstruct the light and image of space, place, time, and emotion. This series is based on the afterimage (retinal memory), encountered while experiencing the images and patterns trees created against the fall to early spring landscape. I explore the juxtaposition of stark trees and branches against the luminous sky to create patterns and abstractions through multiple exposures by means of varying exposure time and aperture."

© Louis DiGena. Trees and Light, #2, 2002. 14 × 11 inches. Inkjet print.

or to project an image or images onto a scene to create a visual layering effect. Try using old images, making new images of the same subject, combining black-and-white and color images, appropriating images or text from other sources, projecting more than one image, projecting different images onto different parts of the composition, or varying the size of the projection. Amend your color balance according to the desired effect.

Multiple Images

Some digital cameras permit multiple exposures, but many are created later with postexposure imaging software because it offers more control. There are many avenues for in-camera exploration that can make image processing easier or provide additional postexposure options. With the idea of combining two images, photograph a subject in a controlled situation with a black background. Light the setup, mount the camera on a tripod, and calculate the exposure based on the number of exposures planned. A good starting point is to divide the exposure by the number of planned exposures. For example, if the normal exposure is f/8 at 1/125 of a second, two exposures would be f/8 at 1/60 of a second each. A camera with automatic exposure control can do the same thing by multiplying the ISO by the number of exposures and then resetting the ISO to that new speed or using the exposure compensation dial (–) to reduce the exposure. For stimulus, look at Duane Michals's multiple exposure images to see what simple planning can achieve.

To experiment with other ideas for making multiple images, try some of the following.

Vary the amount of exposure time. This can give both blurred and sharp images as well as images of different intensity within one picture.

Repeated firing of a flash provides multiple exposures when the camera shutter is left open on the T setting. Move the subject or the camera to avoid getting an image buildup at one place on the image sensor.

Painting with light involves leaving the shutter open while illuminating your subject with a small pocket penlight or an LED flashlight or headlamp, with one or more light sources fitted with a handmade opaque blinder. The blinder acts as an aperture to control the amount of light. Practice with one object in a darkened room, and then try working with a subject that moves. Start by setting your aperture at f/11 and your white balance for incandescent, or create your own preset using a white object as a reference. Consider experimenting with transparent color material over the penlight. Review your results and make adjustments. Photograph an urban night scene in which the first exposure is made at just after sunset, to capture the color in the sky, and a second exposure after the sky is completely dark, to record the building lights.

Make a close-up of the subject and double expose it with a broader view that brings environmental information into play.

Make two exposures of exactly the same composition, but make one exposure sharp and the second exposure slightly out of focus.

Make one or more exposures of a scene varying exposure time and aperture, and use imaging software to build a new picture.

Overlay any subjects that have something in common or images and text. For example, double expose a subject with a close-up of some key text about the subject.

Overlapping Transparencies

A simple way to work with more than one image without using imaging software is output images onto transparency material, which can be run through most printers. These transparent images can then be overlapped and arranged in various combinations on a daylightbalanced lightbox. Then these can photographed, either full frame or cropped, using the close-up mode or with a macro lens. Transparent color tints can be added to modify the atmosphere. Tints can be made from any transparent medium or by photographing discrete portions of a subject, such as the sky or a wall. Bracketing provides a range of color choices from supersaturated to high key. Review and fine-tune exposures as you work.

7.9 This image, one of hundreds made by overlapping transparencies on a lightbox and rephotographing them, was featured in the 9-foot Unseen Terror Tower fashioned from 1950s plastic Girder and Panel toy set pieces purchased on eBay.com. The tower's purpose is to evoke a dichotomous contrast between stability and fragility while offering an idiosyncratic micro- and panoramic visual mini-history of 300 such invisible and innate cultural fears, using the atomic bomb as its focal point. This image was also featured in a collector's edition of Atomic Playing Cards and in an edition of Atomic Calling Cards with a nuclear fact printed on the back of each, which gallery visitors were encouraged to take as a project souvenir.

© Robert Hirsch and Michael Bosworth. *Atomic Couple*, from the installation *Pluto's Cave — Unseen Terror: The Bomb and Other Bogeymen*, 2006. Digital file. Dimensions vary. Courtesy of Big Orbit Gallery, Buffalo, NY.

Rephotography

Rephotography is when a photographer returns to a previously photographed subject and attempts to make the exact picture again to show how time has altered the original scene. Precise records are

7.10 "Through changes in culture and technology, the previously stable identity of documentary photography is transforming. As a preliminary stage for this project, I take photographic slides of the landscape along the Rio Grande River. Then I collect objects, such as prickly pear plants, soil, clothing, and vinyl car seats, from the riverside and incorporate them into still-lifes that invoke the complexity of human experiences in this space. Next, working in a temporary field studio, the still-lifes are illuminated by projected photographic slides of the Rio Grande area. This assemblage of objects and imagery is then rephotographed using a 4×5 inch view camera. The result is a poetic hybrid that fuses documentary and expressive concerns, and through its artifacts, refers to a water and land environment being reconfigured by a host of critical issues including water politics, political discord, and economic inequities."

© Dornith Doherty. After the Rain, from The Rio Grande Project: Burnt Water/Agua Quemada, 2005. 32 × 50 inches. Chromogenic color print. Courtesy of Holly Johnson Gallery, Dallas, and McMurtrey Gallery, Houston.

maintained so the returning photographer can recreate the original scene. The original photograph and the new one are usually displayed side by side to allow a direct "then and now" comparison. Scientific examples include work done by the U.S. Geological Survey that

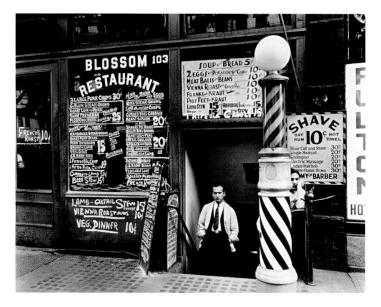

7.11 © Berenice Abbott. *Blossom Restaurant, Manhattan,* 1935. 8 × 10 inches. Gelatin silver print. Courtesy of The Museum of the City of New York.

shows the effects of erosion and other geologic time-related phenomena. A classic modern example is *Second View: The Rephotographic Survey Project* (1984) which, between 1977 and 1979, located and rephotographed over 100 sites of the U.S. government survey photographs of the late 19th century. A more recent example is Douglas Levere's project, *New York Changing* (2004), in which Levere rephotographed 114 images that Berenice Abbott originally made for her book *Changing New York* (1939) to reveal the nature of urban transformation and to demonstrate that the only constant is change.

In another form of rephotography, the photographer returns to the same subject over a period of time. Examples of this range from making a picture of yourself every day for a specific period of time

7.12 Guided by Berenice Abbott's 1930's *Changing New York* (1939), Levere returned to the same locations at the same time of day and the same time of year, documenting the evolution of the metropolis. The paired images reveal much about the nature of urban transformation, suggesting that in New York, the only constant is change.

© Douglas Levere. Everyware, CO., INC., Manhattan, from the project New York Changing, 1998. 8 × 10 inches. Inkjet and gelatin silver prints.

to Alfred Stieglitz's photographs of Georgia O'Keeffe that span decades. The relationship of the photographer and the subject is pursued over a period of time. The results represent the wide range of visual possibilities that can be produced from this combination owing to changes in feeling, light, and mood.

More recently, British artist Peter Hamilton has used digital and traditional media to create dialogue between the present and the past by producing site-specific installations, short films, and new media works that involve the process of rephotography to generate moving images from archive materials. Hamilton calls his work *Re:Photography* to not only suggest retaking a photograph, but also to question memories of place, perception of time, and how we analyze images.

Post-Camera Visualization

There are a number of post-camera visualization options one may contemplate to assist the imagination in representing time and space. Although this isn't an imaging software manual, the digital studio offers an imagemaker a post-exposure opportunity to expand and induce movement and time into an immobile scene. Many of these methods can be accomplished manually or with imaging software or using a combination of the two. Check with your imaging software for current technical steps.

Application of these post-visualization methods can shatter the photographic cliché that time is a mirror and render the appearance of nature into the hands of humans. These methods enable imagemakers to expand their modi operandi and explore new directions. These techniques include the interaction between positive and negative space, the interface between different aspects of the same event, the relationships between static structure and movement, and exchange between the viewer and the object being viewed. Such techniques point out that there is no such thing as objective vision, as too much subjectivity is impressed upon any image by the maker and then the viewer for it to have a single, fixed meaning.

Sequences

A digital camera's capability to capture short bursts of sequential exposures in both single frame and continuous shooting modes plus record brief video sequences makes it an ideal tool to explore the

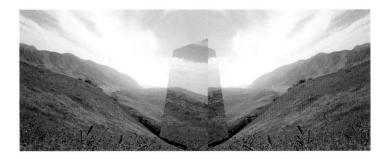

7.13 Jantzen is intrigued with parallel universes, space/time warps, and other manifestations of altered, alternative realities. "I used a mirror to reflect one direction in a landscape while photographing the other. I stage my landscapes at the boundaries of differing scenic features such as natural/man-made, mountainous/desert, hillside/beach to readily show two realities at once. In essence, each image shows two points of view; I (as the documentarian) am located between these two views. Essentially, I am in the image (sandwiched between realities) yet not visible. The resulting images are then digitally manipulated — recombined, layered — to convey the duality of reality."

realm of cinematic picture-making. A vitality of movement can be conveyed through the use of still pictures linked together to form a cinematic sequence of events. This picture arrangement is designed to function not individually but to create a new order as a group. Here each new frame implies a new episode, another step, a different perspective capable of transforming the representation and perception of photographic time. A good sequence must be able to provide information that a single image is incapable of showing. Sequential imaging may be chronological or might skip around in time for the purpose of emphasizing the interaction among the objects within a composition in which the space between objects becomes part of the same structure that comprises the subjects. Serial arrangements encourage forms to take on new meaning as they visually reverse themselves, making for ambiguous figure-ground relationships. These temporal interrelationships let sequences tell stories, present new information over an extended period of time, or supply different viewpoints. Duane Michals's work can also be studied to see how he utilized sequential images for storytelling.

Sequences can also take the form of visual allegory in which situations are specifically constructed to be photographed. Intriguing work in this genre by Duane Michals plays on the tension between the artifice of drama and photography's literalness. Extended sequences may also follow a close personal subject, such as Harry Callahan's images of his wife Eleanor and Emmet Gowin's extended family work in which viewers get to know Gowin's intimate world of close personal relations as exemplified in *The Photographer's Wife: Emmet Gowin's Photographs of Edith* (2006). Extended sequences may also pursue an idea, such as in Larry Schwarm's following exercise "Seven Deadly Sins", which he challenges his students at Emporia State University to interpret.

Using a Grid

A visual grid creates a uniform layout or pattern, like the lines on a map representing latitude and longitude, which divides an overall visual site into units and helps to determine a subject's location in time and space. A grid made up of squares has been utilized as a visual picture-making aid by artists since the Renaissance, but irregular shapes may also be used to evoke visual order. This network can act as a device to lead viewers through the details and visual relationships of your picture space. Gridded pictures invite audiences to spend more time looking because the sense of time is fluid and cannot

EXERCISE Seven Deadly Sins

Seven Seas, Seven Wonders of the Ancient World, Seven Days of the Week, Seven Dwarfs, Seven Sisters, Seven Falls, Seven Brides for Seven Brothers, House of Seven Gables, Seven Rays, Seven Virtues, Seven Years' War, Seven Chakras, Seventh Heaven, the number of holes in a Ritz cracker, and the Seven Deadly Sins!

In the sixth century, Pope Gregory the Great reduced the Greek list of the eight offenses to seven items, folding vainglory into pride, acedia into sadness, and adding envy, and came up with this list of the sins: pride, envy, anger, sadness, avarice, gluttony, and lust. About ten centuries later, the Church replaced the vague sin of sadness with sloth. The list now reads: gluttony, sloth, envy, avarice (excessive desire for wealth or gain — i.e., greed), temper, pride, and lust.

Make an image that illustrates each of the seven deadly sins. These images are to be viewed as a group, so they need to have a similar style or some sort of thread that weaves the group together. You can interpret any way you want, but steer clear of clichés and formula representations that we have all seen too many times.

be taken in all at once. Viewers must take numerous separate glimpses to build up a continuous experience, much as we see the actual world around us.

Photograph a subject so that the individual images collectively add up to make a complete statement. Experiment with different shooting modes. If available, turn on the reference grid in your

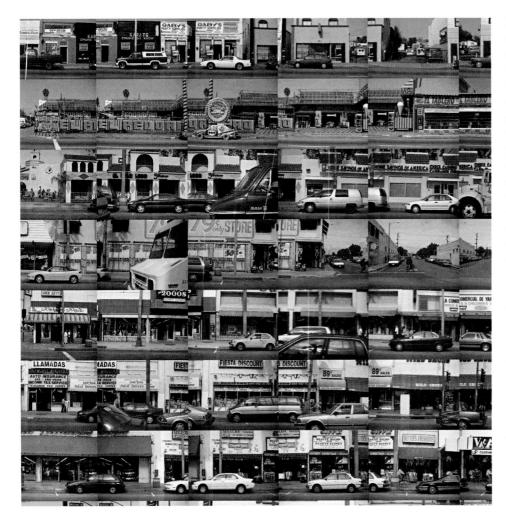

7.14 "Over the last fifteen years I have evolved a working method that addresses the visual complexities and simultaneities of the Southern California metropolitan area. I videotape the city in long continuous sweeps from a moving vehicle, either by following predetermined trajectories or by systematically rendering parallel streets. From these tapes I select frames and construct large-scale digital photographic files. The resulting prints are a collection of visual textures and phenomena that capture the appearances of neighborhoods. This visual sampling, when woven together in consecutive frames and bands, plays on frequencies of occurrence to reveal conditions and to suggest possible contexts for interpretation. The sequences may be read from left to right and top to bottom, much like a Eurocentric text, or dealt with as isolated but related image clusters where the eye travels across the visual field, much like it does when approaching a painting. I try to find ways to invite viewers to scrutinize particulars - to look at details in different places at almost the same time and to establish relationships between the them."

© Robbert Flick. *Along Whittier Boulevard* (detail), from *L.A. Document* series, 2006. 12 × 12 inches. Chromogenic color print. Courtesy of Rose Gallery, Santa Monica, CA.

viewfinder to assist in aligning objects in your composition. The pictures do not have to be made from one particular vantage point but rather from a general point of view. Study how cubist artists incorporated simultaneous multiple views of a subject into a single visual statement, and apply your observations to your own work. See if you can use this method to present your subject in a wider context. Notice if there is any change in the relationship of the subject and the background planes as they interpenetrate with one another. Does this create a new type of ambiguous, shallow space? If so, what effect does it have on how the subject is understood? Rely on your monitor for instant feedback. The actual image grid can be put together either by manually cutting and pasting or through imaging software, which has greatly simplified the process of making picture grids.

Many Make One

Many make one is the process of photographing a scene in numerous individual parts and then arranging these single sections of time together to form an image. The separate pictures of the original scene are not made from a specific vantage point but a general one that encompasses different points of view over an extended period of time.

Consider photographing from different angles and shifting the critical focus point to emphasize key aspects within each frame. Make prints at about 3×5 or 4×6 inches. Take all the prints and spread them out on a big piece of light gray or off-white mat board. The large size helps create impact from the sense of engagement that the ample space and the interaction among these multiple prints can produce. Start arranging prints into an entire image. It is fine to overlap pictures, discard others, and have open spaces and unusual

angles. Don't crop the single pictures, as maintaining a standard size acts as a unifying device. When the arrangement is satisfactory, attach the prints to the board. They do not have to be flush.

This picture-making method expands the sense of space and time that is often lost in an ordinary photograph. It breaks down the edges of a regular photograph. It expands the frame beyond the conventional four perpendicular edges and can bring the viewer right into the picture. These factors encourage viewers to spend more time investigating the overall image and its possible associations and connections. For inspiration, look at *Cameraworks David Hockney* (1984) to see how an artist can weave hundreds of single images taken from different perspectives at different times to fabricate a new sense of time, space, and place.

Contact Sheet Sequence

The contact sheet sequence is a modified technique of using many single contact-size images to make an extended visual statement. Pick a scene and imagine an invisible grid pattern in front of it. Photograph that scene using this invisible pattern as a guide. Use your imaging software to output a variety of contact sheets that you arrange in different sizes, spacing, rotation, columns, and rows to come up with an order that works with your aims. Eliminate any caption or metadata (text) below each image. If the contact sheet mode doesn't deliver the desired results, use your regular imaging software to create your own arrangement. If the white background isn't working for you, consider trying a custom background color.

Joiners

Historically, joiners were used in 19th-century photographic practice to construct panoramas. More recently, David Hockney popularized

the method and the term in the early 1980s. Joiners are created when two or more separate images of a scene are combined to make a whole. The subject can be divided into separate visual components and photographed individually, with the idea that each image should provide data about the subject that would not be possible if the subject were portrayed in a single frame. These additional exposures should alter how the subject is seen and therefore perceived. When making your images, pay attention to the following: your subject's relative position in time and space, changes in vantage point and 7.15 "These constructed portraits of Civil War reenactors in Northern Virginia are inspired by Paul Cézanne's flattened portraits of the 1890s and David Hockney's composites of the 1980s. The formal qualities of the grid symbolize how our identities are composites. The push and pull of each plane symbolizes how our own time interacts with the past and also references the pixilation of modern imagery. Each image is composed of at least four images: a flat-light version of the subject; a contrast-light version of the subject; a flat-light version of the background; and a contrast-light version of the background. All four images are brought into one file and stacked atop each other using layers. I align the images using layers of low opacity. For the subject images, the background is removed using mask and pen tool. A grid is created in Photoshop's Preferences menu, and each layer is masked to dynamically interact with the others."

© Shannon Ayres. Reenactor 03, 2006. 16 × 16 inches. Inkjet print.

angle, variations in subject-to-camera distance, and overlapping frames. Be sure to look up and down, and don't just pan/shoot in a straight line. Try photographing a moving subject showing the subject's movements as seen from the photographer's perspective; and then try moving the camera around the subject instead. Moving the camera in and around a subject tends to create a visual narrative as if a viewer is moving through the space. Make single prints, lay them out on a neutral colored mat board, arrange, fit, and/or trim, and then attach into place.

Slices of Time

The slices-of-time method is when a single scene or event is photographed a number of separate times to display the visual changes that can occur over a period of time. Unlike in rephotography, the imagemaker often makes intentional alterations in light and placement of

7.16 Kellner reconstructs the visual language of common architectural sights that present the shape of buildings and monuments in humorous and surprising ways. Influenced by photomontage and collage artists such as George Grosz and Aleksandr Rodchenko and the cubistic works of Picasso and Delauney, Kellner's methodical style involves the precise, sequential photographing of individual fragments of his subjects. The resulting contact sheet, involving anywhere from 36 to 1296 exposures, is printed in the same progression that the images were made to form the finished work.

© Thomas Kellner. La Sagrada Familia, Barcelona, 2003. 28 × 18 inches. Chromogenic color print. Courtesy of Cohen Amador Gallery, New York.

objects in each exposure. Consider photographing a scene with both stationary and moving objects so you can contrast the underlying patterns and rhythms of physical motion.

Prints can be butted together, overlapped, or cut into slices and pieced together. With practice, the pieces may be cut into a variety of different sizes and shapes. Keep each cut picture separate. Select one of the pictures to be the anchor print. Arrange it on a neutral colored mat board and begin to combine the slices from the other prints into the single base print. When complete, attach the slices to the board. Check out the sliced-up Polaroid images made by Lucas Samaras for encouragement. The process can also be done virtually, using imaging software.

Compound Pictures/Photomontage

Compound pictures can be made up of visual elements from various sources and media, including text, that are intertwined and then fused by cutting and pasting on a common support material, rephotographed, and outputted to obtain the final image. John Heartfield, a member of Berlin's Dada group, was a pioneer of photomontage as a political method. Heartfield produced over 200 anti-Nazi and anticonservative photomontages during the 1930s which were designed to be reproduced in newspapers and magazines, thus embodying the artist as an activist for social change. If it is rephotographed and outputted, it is considered a montage.

Photomontage offers an opportunity to produce pictures of astonishing juxtaposition and paradox, utilizing both manual and digital techniques. Consider exploring a theme, instead of a single subject, in which the overall collection of images provides an extended and deeper examination of a topic. Keep in mind two- and three-

7.17 In one long connected panorama, *The Apollo Prophecies* threads the line between fantasy and history by depicting an imagined expedition of 1960s American astronauts (portrayed by the artists). Landing on the moon, they discover a lost mission of Edwardian-era astronauts who greet them as long-awaited gods. Their inventive staged photographs of events that never happened playfully question the concept of historical truth. Mingling components of Jules Verne and Stanley Kubrick, the continuously joined images unfold into multiple episodes that intermingle artifacts from early 20th-century exploration with present-day space age gadgetry.

© Nicholas Kahn and Richard Selesnick. Lunar Landing (detail), from The Apollo Prophecies, 2004. 10 × 72 inches. Inkjet print. Courtesy of Yancey Richardson Gallery, New York.

dimensional materials that can be incorporated into your picture space through scanning. Think about experimenting with three-dimensional surfaces and/or nontraditional support materials and combining physical and digital methods.

Photographic Collage

Folk artists regularly combined different media together, but it wasn't until the early 20th century, when the cubists integrated other materials such as newspapers and sand into their paintings, that the method was named *collage* — French for gluing — and came to be recognized as a legitimate art form. Later the surrealists, including Max Ernst and Hanna Höch, made extensive use of collage because they viewed it as a way of liberating the unconscious mind to attain a

7.18 Pompe set out to recreate the sense of awe one feels while standing in front of an aquarium's massive amount of blue water. "Additionally, I wanted to focus and refocus on several groups of jellyfish simultaneously through peripheral vision, left then right, keeping the central image closest with the largest, sharpest jellyfish as the center of attention. To realize this, several aquarium shots were taken from various vantage points. The disparate segments were combined and arranged in Photoshop, taking care to keep the original, slightly dissimilar color density of each slice of time. The result reads not as one long image, but as discrete individual segments of time."

© Kathleen Pompe. Jellyfish at Monterey, 2006. 4-1/2 × 18 inches. Inkjet print.

state different from, "more than," and ultimately "truer" than everyday reality: the "sur-real" or "more than real."

A photographic collage is made when cut or torn pieces from one or more photographs are pasted together, often with threedimensional objects, to produce a final picture. It is not rephotographed, and no attempt is made to hide the fact that it is a highly textural assemblage. Now this practice can be performed digitally or manually, or a combination of both, with or without a sense of surface texture. Electronic collages, often built up through multiple layers, can be useful to supplement a reconstruction wherever authentic visual material is not available to produce convincing-looking fake pictures.

Consider making what the surrealists called *inimage*, a collage method in which parts are cut away from an existing image to reveal another image. The surrealists also invented *cubomania*, where an image is cut into squares and the squares are then reassembled "automatically" without regard for the image, or at random.

Three-Dimensional Images: Physical and Virtual

Artists have purposefully introduced threedimensional texture into media that were once considered exclusively two-dimensional. Three-dimensional images are often made by emphasizing one attribute of a subject — color, pattern, shape, or texture and having it physically come off the flat picture surface. This exaggeration in time and space calls attention to that aspect of the subject while deemphasizing its other qualities.

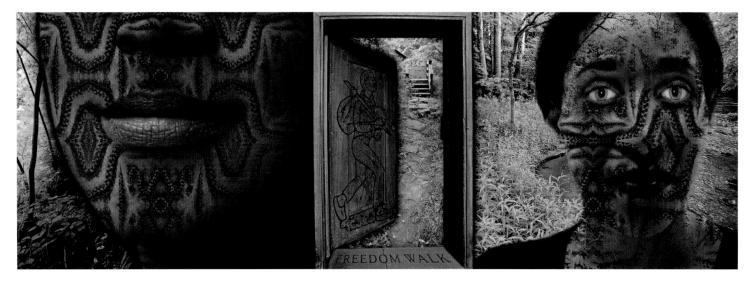

7.19 "I photograph knowing I am preparing a subject for compositing, which means providing myself with numerous visual options. The montages provide a space for a greater degree of metaphorical interpretation of the Underground Railroad sites, with use of period artifacts and documents as well as contemporary references. My goal is to comment on this complex history and provide an alternative access through a recontextualization strategy that invites questions and discoveries. The faces of two women covered with braided hair flank the crawlspace hideaway portal and the donor walkway title stone at the home of Underground Railroad conductor Levi Coffin in Fountain City, IN. The entry, layered with the running man figure (taken from the tombstone of William Bush, a runaway who became Coffin's assistant), opens onto the 'stairway to freedom,' leading through the woods up to the Rankin House in Ripley, OH. The forest and stream on the sides of the montage are in Lancaster, IN, near the hideaway cave used by Lyman Hoyt, another conductor who helped to provide shelter and safe passage for freedom seekers." © Stephen Marc. Untilled, from the Passage on the Underground Railroad Project, 2005. 18 × 52 inches. Inkjet print.

Sequential images can also be used with special imaging software, such as Photosynth, to create the illusion of three-dimensional space similar to the effect of viewing stereo images. Such programs utilize a series of photographs of an object or place, analyze them for similarities, and display them in a reconstructed three-dimensional space. Such reconstructions allow you to visually fly or walk through a scene at any angle and zoom in or out of it. In *Landscapes Without Memory* (2005), Joan Fontcuberta, using a landscaperendering software program, took the contours and tones of pictures by Cézanne, Turner, Edward Weston, and others and transformed them into three-dimensional clouds, mountains, rivers, and valleys that serve as the basis for new fantastical landscapes devoid of human existence. 7.20 "I work intuitively, first painting a panel and then applying photographic fragments onto the surface. The challenge is to marry paint with the photographic collage. It is like putting together a huge jigsaw puzzle without knowing what the final image will look like until it is done. The immediacy of the digital process gives me the freedom to make each puzzle piece as I see the need for it. A collage works best when the pieced photos make up something that is not literal, but rather form a metaphorical or poetic connection, either through subject or texture. This way of working allows me to process concerns such as the degradation of the environment, spiritual meaning in a world of polarized and extremist religions, and the stress of fear of aging, through my eyes and hands."

© Holly Roberts. Woman with Small Dog Watching, 2005. 48 × 24 inches. Mixed media.

Image-Based Installations

Image-based installations comprise an entire arrangement of objects, not just a group of discrete images/objects to be viewed as individual works, presented as a single work. Installations provide viewers with the experience of being in and/or surrounded by the work, often for the purpose of creating a more intensely personal sensory realization that can feature still and moving images, computer screens, music, sound, performance, and the Internet. Instead of framed pictures on a "neutral" wall or individual objects displayed on pedestals, installations address an audience's complete sensory experience, leaving time and space as the only dimensional constants. Traditional image theory is disregarded, and viewers are "installed" into an artificial environment that optimizes their direct subjective perceptions. Some

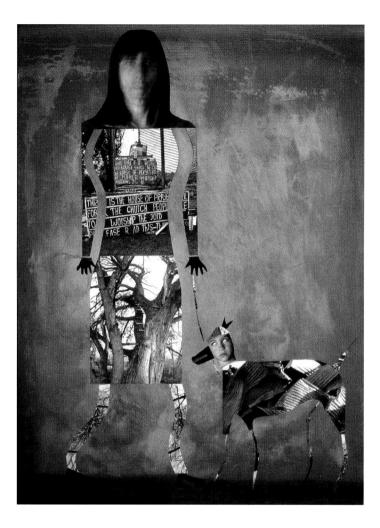

installations are site-specific, designed only to exist in the space for which they were created. The majority of installations is not salable and generally are exhibited and dismantled, leaving only photographic documentation as a record of their existence.

Precedents for installations can be found in the pop art era of the late 1950s and 1960s, such as Allan Kaprow's "sets" for happenings (temporarily transformed indoor spaces) or Red Groom's theatrical environments such as *Ruckus Manhattan* (1975). Recent examples include Christo and Jeanne-Claude's *The Gates* (2005) in New York's Central Park and Alvaro Cassinelli's *The Khronos Projector* (2005), "a video time-warping machine with a tangible deformable screen for untying space-time," which permits temporal control by allowing viewers to touch the projection screen to send parts of the image forward or backward in time.

Public Art

Art history has more examples of public than private art, ranging from the frescoes and sculpture of religious centers to the commemorative statuary found in our public squares. Traditionally, public art refers to works in any medium that have been planned and executed, with implications of community collaboration and involvement, with the specific intention of being sited or staged in the public domain, usually outside and accessible to all. Public art is not limited to physical objects; dance, poetry, and street theater have practitioners who concentrate in public art.

The dissolving of modernist notions of purity of form and the rise of government initiatives, such as the percent-for-art programs that require a certain percentage (usually 1 percent) of construction budgets for artists' projects in public spaces, have sparked interest in

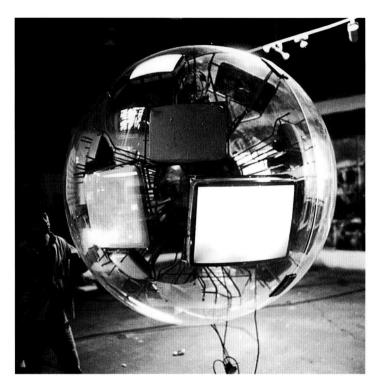

7.21 The Starns' video sculpture, consisting of 24 to 36 monitors configured into a sphere that is set within a Plexiglas shell, examines human culture's relationship to light (metaphorically) through the mystery of a nocturnal moth's attraction to light. Initial image capture is done with a fiber-optic lens attached to a high-speed camera, which allows the Starns to enter a world that is invisible yet all around us. The captured images are manipulated and reconstructed into a nonlinear 360-degree spherical film.

© Doug and Mike Starn. Attracted to Light: CRT Sphere, 1996 to present. Mixed media. Courtesy of the Bohen Foundation, New York, and the Anderson Ranch, Snowmass, CO. this area. New technologies and changing attitudes by artists who give up the absolute control of the studio and collaborate have made it easier to bring artworks outside the traditional context of museums and galleries and into daily life. Work is shown in centers of public transportation, city streets, or workplaces and is seen by people outside of the art and academic worlds, breaking down barriers of accessibility to contemporary art. Part of the fun and power of public art is its ability to enter into the space of everyday life by catching one by surprise — an audience not intending to be an audience, which often accidentally challenges the status quo.

Projects such as Robert Smithson's *Spiral Jetty* (1970), which reacts to and incorporates its environment, uses the freedom of an outdoor site to create a large work that would not be feasible in a gallery. Dealing with the theme of entropy and time, *Spiral Jetty* is a 1500-foot-long, 6500-ton, spiral-shaped configuration made up of basalt, earth, and salt that extends into Utah's Great Salt Lake. The temporal nature of this work is demonstrated by the fact that the fluctuating water level of the lake often submerges it.

Although not technically public art, many exhibition centers are taking a cue from this genre to commission artists to make work that is designed to be exhibited in public spaces, including publicly accessible buildings. For contemporary examples, visit www.creativetime .org/, whose specialty is commissioning, producing, and presenting adventurous, temporary public artworks of all disciplines throughout New York City (see Figure 7.22).

IMAGING SOFTWARE SOLUTIONS

After you have exhausted the camera-based methods, try some of the countless ways to use imaging software to manipulate a picture's time and space relationships. The following are offered as starting suggestions.

Using your imaging software, create a multilayered image based on a single exposure to alter the perception of time within the picture. Many variations are conceivable. For example:

- Reduce the size of the picture and layer it a number of times to form a single image. Let parts of each picture overlap to form new images.
- Vary the size of the picture through a series of layers.
- Deconstruct an image into vitual pieces and reassemble into a new image.
- · Generate a variety of different picture densities.
- Produce a full-frame layer and then start cropping pieces of the image and adding layers based on the different pieces.

Combination printing — compositing multiple scenes to form a new one — dates back to Oscar Rejlander's *Two Ways of Life* (1857), which jettisons the traditional picture vision and embraces a far more complex image of reality. This technique is easily facilitated with imaging software.

Changing the color balance can transform the picture's sense of time. Start with a scene that contains a basically monochromatic color scheme and simple linear composition. Mask one area of the picture with the normal color balance, and then alter the color balance and use that for the remainder of the image. Consider working with complementary colors. Also, look for situations where you can blend black-and-white with color.

Experiment and see what else you can come up with.

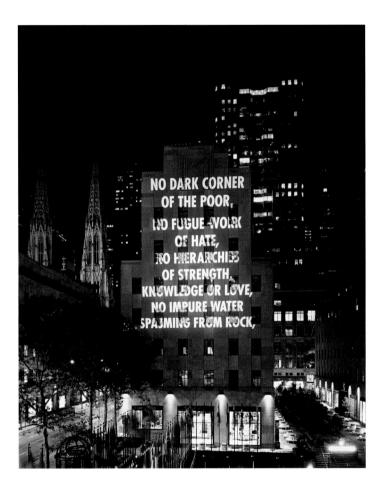

Recomposing Reality

Being able to appreciate nontraditional approaches to photographic time and space entails a willingness to set aside previous notions about photography. Whenever traveling into the unknown, we can hope to be rewarded with understanding, but this is not always the 7.22 Holzer's light projections of poems detail hope, pain, and longing that fuse location and projection and come from her belief that problems, especially those where the political and the personal are inseparable, only can be attended to with openness and equanimity. The moving projections, akin to credits scrolling at the end of a film, allow Holzer to work demonstratively with the ephemeral. The cityscape and surrounding architecture are involved; spaces, people, and time are included in an affirming gesture. "I show what I can with words in light and motion in a chosen place, and when I envelop the time needed, the space around, the noise, smells, the people looking at one another and everything before them, I have given what I know."

© Jenny Holzer. For the City, 2005. Projection on Rockefeller Center, NY. Presented by Creative Time, New York. Photo by Attilio Maranzano. Courtesy of Artists Rights Society (ARS), New York. Text: "Necessary and Impossible," from Middle Earth by Henri Cole. © 2003 by Henri Cole. Used/reprinted with permission of Farrar, Straus & Giroux.

case. Ironically, the information that is brought with you may prove to be invalid in new circumstances or may generate more questions than answers. Poet T. S. Eliot realized that time is something we cannot completely understand and is far from our control, as he wrote in his *Four Quarters: No. 3 The Dry Salvages* (1941): "Time the destroyer is time the preserver." Be prepared to expand your previous concepts of how reality can be represented and see where it takes you.

Many of life's important aspects are hidden from us because of their familiarity and our own predeterminations and lack of knowledge. When an urban dweller walks by a garden with plantings in it, the urbanite sees a garden with stuff growing in it. When a gardener walks by the same field, he or she sees something completely different. The gardener can identify the types of plants, what condition

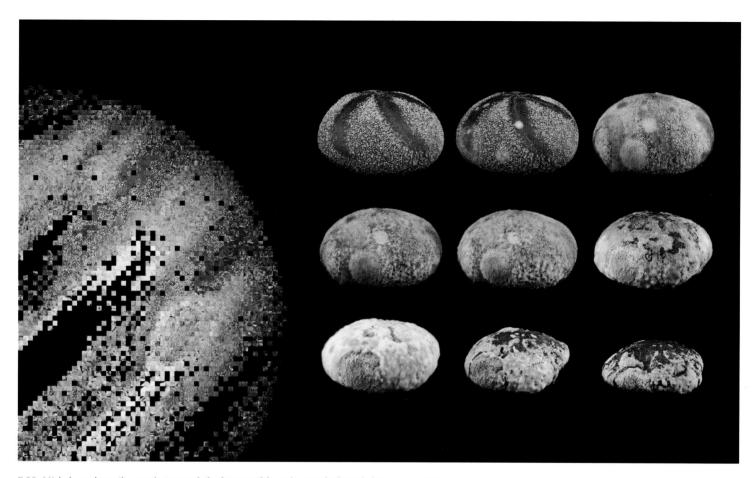

7.23 Michals explores the gap between daily domestic life and scientific knowledge. Sequential photographs of molding bread are used to create representations of the planets and solar system. "The photographs take the form of an amateur science experiment, documenting bread as it transforms from food into rot. Each sequence of images is then divided into about 2000 75-pixel squares. By cutting and pasting, these squares are then rearranged by color and tone to form a new image. The process echoes that of space imaging systems that take many photographs and assemble them in a grid to form one image. Although identical on the pixel level, the images simultaneously represent the everyday world that is grounded in direct observation of the visible and the world of science where complex instruments and calculations yield knowledge of the invisible while reminding us that these two worlds have never been so far apart."

 $\ensuremath{\mathbb{O}}$ Robin Michals. Jupiter, from the series Daily Bread, 2004. 22 \times 37 inches. Inkjet print.

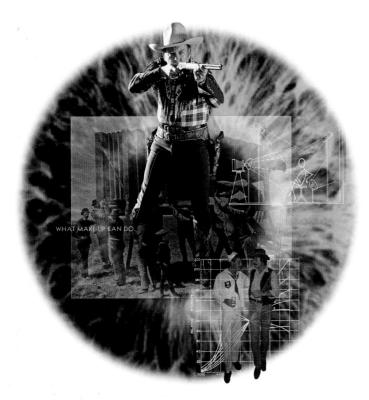

7.24 Baird explores how our visual world has been constructed by the invention and practice of photography. "I am interested in how the photograph became associated with notions of truth or evidence in our society, but I am also intrigued by the creation of an 'image-consciousness' that fuels both a consumer economy and help creates photographic standards or (rather) stereotypes. Our visual world is saturated by images designed to grab our attention amongst a dizzying display of competing visuals. We end up with overtly graphic and stereotypical images instead of achieving a deeper understanding of the world. What happened?"

© Darryl Baird. Aqueous Humor #23, 1998. 18 inch circular image on 20 × 24 inch paper. Inkjet print.

they are in, if they are being properly cared for, or if they need attention. Both are viewing the same scene, but the gardener's broader knowledge and understanding of what is there allows the gardener to read more of the scene's visual clues. This provides the gardener with a more complete and richer account of the scene. By extending our picture-making endeavors and knowledge, we can create new ways of looking at the world and enlarging our understanding of its complex interactions.

REFERENCES

For information concerning time and space, see the following:

Gleick, James. Faster: The Acceleration of Just About Everything. New York: Pantheon, 1999.

Goldsworthy, Andy. Time. New York: Harry N. Abrams, 2000.

Hawking, Stephen W. A Briefer History of Time. New York: Bantam, 2005.

Morris, Richard. *Time's Arrow: Scientific Attitudes Toward Time*. New York: Simon and Schuster, 1985.

Sheldon, James L., and Reynolds, Jock. Motion and Document Sequence and Time: Eadweard Muybridge and Contemporary American Photography. Andover, MA: Addison Gallery of American Art, Phillips Academy, 1991. 7.25 "The images from this series, "Blasted" tell the story of a simultaneous moment: how people and places exist at a certain point in time. The tension here is the inverse relationship between the virtual world and the actual world. A computer user may experience an exaggerated sense of self through extensive time spent in a virtual environment, thus forming a distorted sense of the actual, tangible world. This drawn out formation of self and time may lead a user to ask, "why seek information and fulfillment in the actual world when it can easily be found in the virtual world?" These photographs are not meant to answer this question, but rather serve as an observation of the condition. The people in the portraits are volunteers who contacted me through Craigslist.org, an Internet classified ad page that is available for many cities. I visited the homes of each of the volunteers and photographed them in their personal computer environments with only the illumination from the screen (averaging about 20 seconds). The quality of the color and contrast were perfected on screen and the print that was made was almost a perfect match, which could not have been achieved in a darkroom."

 \bigcirc James Rajotte. *Scott*, from the series *Blasted*, 2006. 30 \times 38 inches. Chromogenic color print.

Since the late 1980s, Muniz has recorded the camera images he makes by hand. Whether constructed in two or three dimensions, his work uses nontraditional materials ranging from chocolate, thread, dust, toy soldiers, and diamonds and often references well-known images. For this series, Muniz arranged paint color chips to create pointillist renderings of images from art history, in this instance a self-portrait of the painter Chuck Close, whose work has a close relationship to photography. Muniz questions photography's truth-telling capacity and explores how our culture of images impacts visual experience. His photographs blur the line separating abstraction from representation and calls into question what we see and how we see. In the process, Muniz shifts between roles as painter, sculptor, draftsman, photographer, writer, conceptualist, prankster, and critic.

© Vik Muniz. *After Chuck Close*, from the series *Pictures of Color*, 2001. 60 × 45 inches. Dye-destruction print. Courtesy of Sikkema Jenkins & Co., New York.

Chapter 8

Digital Studio: Where the Virtual Meets the Material World

DISPLAYING THE IMAGE FILE: TRANSFERRING IMAGE FILES FOR DISPLAY, WEB, OR PRINT

The act of photographing is a human practice that merges scientific technology and pictorial conventions with personal values, along with a desire to tell and share a visual account or story. Digital imaging not only makes picture-making and viewing instantaneous, but also makes picture distribution simpler and quicker by expanding the possibilities of how images can be outputted and circulated. A digital camera captures images as a series of pixels (see Chapter 3). A pixel is the smallest electronic element used to record light and is part of a larger camera sensor array (see Figure 8.1). The image sensor's ability to accurately record data, such as color and value, is measured

The author gratefully acknowledges Professor Greg Erf (www.gregerf.com) for his assistance in the preparation of this chapter.

in megapixels, with 1 million pixels equaling 1 megapixel. For example, a camera with a sensor array of 4000 (w) \times 3500 (h) picture elements (pixels) would be rated at 14 megapixels (4000 \times 3500 = 14,000,000 pixels).

The number of pixels is defined as pixels per inch/PPI. After the image files are downloaded to a computer, the computer's internal video card automatically converts the image files into display pixels that are shown in varying percentages of the original picture file. The most accurate display occurs when a picture file is displayed in even screen-resolution multiples such as 100, 50, and 25 percent. Uneven screen-resolution displays, such as 33 or 66 percent, will generally exhibit jagged edges because the computer will use anti-aliasing to approximate the partial pixels. When you want to utilize this digital data to make a print, the computer's printer software then converts the digital image file into dots per inch/DPI, enabling the virtual

8.1 Sensor pixel array of a digital camera (pixel size representative only).

image to be physically rendered onto paper by means of dots and inks (see Box 8.1). It is important to clearly understand the differences between pixels per inch (PPI) and dots per inch (DPI); these differences will be discussed in more detail later in this chapter.

The Display

Dot Pitch and Triads

Dot pitch (DP) or dot size is the measurement indicating the diagonal distance between the crystals in the liquid crystal display (LCD) or the phosphor dots of the same color in the cathode ray tube (CRT). (Although LCD and CRT displays are mechanically different, the dot pitch rating is still the same.) DP is one of the principal characteristics that determines the quality and size of the computer display.

In a standard display, the dot pitch layout produces what one sees on the screen. The dots are grouped in triangles of red, green, and blue (RGB) called *triads*, with each triad recreating the PPI from the digital file. The standard measure of the resolution for all computer displays is dot pitch (DP), *not* DPI or PPI (see Figure 8.2).

Although dots are the norm, the display crystals (LCD) or phosphorus (CRT) can take the form of rectangles or hexagons. The closer and smaller the dots are to each other, the more detailed and realistic the display image will look to the eye. A display's dot pitch is measured in millimeters (mm), ranging from about 0.15 mm to 0.30 mm and is fixed by the manufacturer and cannot be altered or changed. Theoretically, the lower the DP, the sharper the display image — that is, 0.25 mm has better screen resolution than 0.28. In reality, a dot pitch between 0.22 and 0.28 is considered good, and it will produce no more than 1 display triad for every 1-1/3 to 1-1/2 digital file pixels. This 1:1-1/3 to 1-1/2 ratio is needed before a computer display will look clear and sharp (see Figures 8.3 and 8.4).

Unfortunately, there is no industry-wide dot-pitch standard. Traditionally, DP was measured on the diagonal because it gives the most accurate representation of a display. However, some companies use

Viewing The Image File: Life to Print, pictures exaggerated

Life

Camera File

Display Resolution Web Print

Rods and Cones

Pixels Per Inch, PPI, Dot Pitch, DP.

Pixels Per Inch, PPI. Dots per inch, DPI.

Since 1839 photography has enabled people to eyes and brain can see, making image- higher the PPI making an integral part of our daily lives. Digitalization has vastly expanded the possibilities larger the file size. for making and deploying images worldwide.

Digital camera software allows variable settings, capture what their Large, Medium, and Small, for PPI. The setting (Large) the bigger the image appears on the display and the

Each triad of RGB elements represents more than one pixel from the camera file. Computer displays also only and never by support more than one display PPI setting. **Higher PPI settings** translate into display information appearing smaller on the screen.

Image management Printing software software accurately converts PPI controls display image size by PPI inches. The proper solution for accurate sizing of digital files for the web or display is to use paper. Printers

Pixels Per Inch. PPI is a universal measurement of the number of pixel elements refering to the width and height of all digital information. Picture files, digital files, digital cameras or display resolution refers only to the number of pixels, not the size of each pixel. The actual size of each pixel is determined by the recording or display device. 640 (H) \times 480 (W) is only the number of pixels used by each device and is not an exact measurement in inches.

(pixels) into DPI (dots) for printing. Printing requires the physical application of ink on to a receiving surface such as Pixels Per Inch, PPI, produce thousands of dots of different colors, shapes, and sizes.

1 1221

8.2

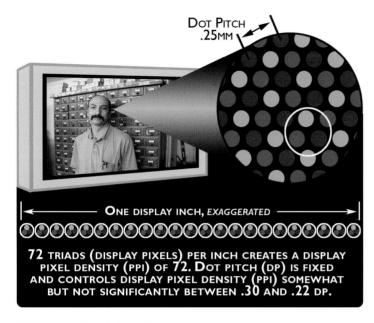

8.3 Red, green, blue triads and dot pitch.

a horizontal DP as a marketing tactic. By measuring only the horizontal component of the DP and disregarding the vertical or diagonal components, an inexpensive, low-quality display could claim an apparently small DP. Therefore, one should not choose a computer display based solely on dot pitch because there are other manufacturing and technical variables that affect display image quality.

Conversion of Image File Pixels (PPI) to Display Triads (Pixels)

Dot pitch (DP) and triads are the mechanical means video cards and displays use to convert and bring data from the digital image file to

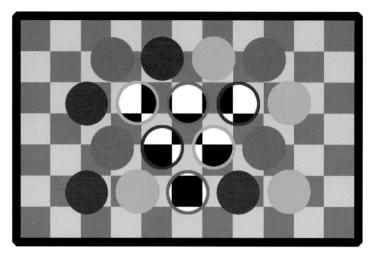

8.4 DP and PPI: Coexisting spaces: triads over pixels. In Figure 8.4, triads are placed over the pixel elements (grayed pixel squares) to show how dots and pixels coexist but are located in different spaces. The black-and-white pixel elements in the middle triads represent the overlap of the two spaces. The majority of the pixel elements (PPI) fall on one or more RGB display triads. This overlapping forces the video card to generalize the color and value of those pixels when they are displayed by a single triad, which is less than ideal for accurately reproducing the colors and values.

the computer display. All pixel elements (PPI) contained within the digital image file are made visible on the display through the use of a system of triads. Each pixel element or several pixel elements from the digital image file are represented on the display by a single triad, which is made up of a cluster of red, green, and blue dots (RGB).

Depending on the display, this cluster of RGB dots is made up of crystals from a liquid crystal display (LCD) or phosphorus from a cathode ray tube (CRT). Each electronically emits different levels of light and color that mix into a single display pixel element from the original image file. In this section's discussion of the computer display, the text will interchangeably use *triads* and *pixels* to make the same points. This symbiotic relationship between triads and pixels creates separate, but similar arrays or information. The electronic pixel information captured by the camera array is very different from the more mechanical array created from display triads. In reality, this conversion is not equal, which is why file resolution (PPI) and display resolution are two distinct and different measurements (see Figure 8.4).

Ideal Displays

The ideal display would have one crystal element (LCD) or one phosphor dot (CRT) for each pixel element contained in the digital file, with no need to use triads. It will likely be some time before computer displays reach this level of perfection, owing to technological limitations and cost factors. With current triad display technology, each triad incorporates many camera file pixels into one display triad (pixel) to make up the digital display.

With that understood, an ideal entry-level monitor should be at least 17 inches (diagonally), have a 0.28 mm diagonal pitch and a 0.24 or 0.25 mm horizontal pitch, with a true resolution of at least 1024×768 . A higher-quality monitor should have a 0.26 mm diagonal pitch or smaller and a 0.22 mm horizontal pitch with a true resolution of 1024×768 or better. The latest LCD superior-quality monitors have a 0.132 mm dot pitch and a density of 192 triads (pixels) per inch, which comes close to matching the resolution and sharpness of printed materials on a computer display. Current entry-level LCD and CRT displays have approximately a density of 72 triads (pixels) per inch.

In the future when LCD displays are capable of a 0.084 dot pitch, computer displays will reach the Holy Grail of showing 300 triads (pixels) per inch. This will enable displays to equal the resolution and sharpness of high-quality printed materials, which often utilize 300 dots per inch (DPI) as a standard. Until the basic display triad density equals the number of digital file pixels (1:1), you can expect visual compromises between your digital image file and what the computer screen displays, even at 300 display triads (pixels) per inch. Regardless of the display, always take into account that the dot pitch rating for any display only determines the quality of what you can see on the display and *not* the quality of a print you can make.

Display Resolution

The quality of a computer's video card determines the user's overall display resolution options. The most common display resolution settings (PPI) are 832×624 , 1024×728 , 1280×960 , and up to 1680×1050 and beyond. Since dot pitch is fixed, increasing the display resolution will not necessarily increase screen sharpness and in some cases it may reduce it. The optimum display setting is determined by the dot pitch and display size. The best resolution setting occurs when the dot pitch space and pixel resolution space work together to create a ratio of 1 display triad (pixel) to 1-1/3 to 1-1/2 file pixel (PPI). The reason the other resolution settings appear less sharp is because the triad is either sampling too many or too few file pixels (PPI) as it generates a specific value for each display triad (pixel). Increasing the display resolution setting only increases the number of pixels per inch (PPI), but not the number of triads, which remains constant. Higher resolution settings make images on the display appear smaller, while lower resolution settings make screen

Resolution	14 INCH	15 INCH	17 INCH	19 імсн	21 INCH
640 × 480	BEST	good	too big	pixelated	not usable
800 × 600	good	BEST	good	too big	pixelated
1024 × 768	too small	good	BEST	good	too big
1280 × 1024	very small	too small	good	BEST	good
1600 × 1200	not usable	very small	too small	good	BEST

Table 8.1	Best	Overall	Monitor	Resolution	Settings
-----------	------	---------	---------	------------	----------

Note: The display size is based on diagonal dimensions and standard 4:3 display proportions. Some laptops and large displays use wide-screen proportions (16:9) that are not represented, but similar correlations can be made.

images look bigger, often even huge, filling the display area with only a small fragment of the entire image. Refer to Table 8.1 for determining best overall resolution settings for your display.

Image Output: Display and Print

Although there are many variables that can influence how a screen image looks, most displays provide satisfactory viewing experiences. Nevertheless, what you see on your computer display may bear little resemblance to the final output. Preparing images for output to the Web or as prints requires the use and understanding of pixels per inch (PPI) and dots per inch (DPI). PPI always refers to pixel resolution for displays, cameras, and digital files. When preparing images for the Web, you continue working with PPI to size your images since the image will be seen on a computer display. However, when preparing digital images to make photographic prints, you must begin working with DPI as your digital file becomes a physical entity (see Box 8.1: PPI, DP, and DPI Functions).

8.5 Fixed triad and variable resolutions (note that sizes are representative only).

The Web: Pixels per Inch (PPI)

When preparing images for digital display on the Web, you must take into account that you can only control the actual color or size of your own images because each end user sets his/her own display resolution and color space. This is because Web and display graphics have no real-world physical dimensions. They are measured only in pixels (PPI), with their physical appearance dependent on the end user's video display settings. Consequently, when emailing or making Web images from your perfectly prepared 700 (w) \times 300 (h) PPI image, be aware that this digital image can appear in different sizes and color variances due to the display settings being used to view the image. Do not make high-resolution images accessible on a public website as people can download them and make their own exhibition-quality prints, bypassing a maker's ability to control image use and benefit from its commerce. Also, large image files dramatically increase download times on any website. See Box 8.2, Embedded Resolution Summary, for a review of how the photograph moves from life to the display or to print.

Print Resolution: Pixels per Inch and Dots per Inch (Embedded Resolution)

Preparing an image for printing is different from preparing an image for the Web. Unlike display and image management software that deals exclusively with PPI printing software, print drivers deal entirely with dots per inch (DPI). Print resolution or dots per inch (DPI) refers to the number of dots of ink a printer can apply per one inch of paper. DPI is variable, and many inexpensive printers average 1200 DPI. Image quality is increased when more and smaller dots are contained

Box 8.2 Embedded Resolution Summary

Learn the following concepts to avoid common image output problems.

- 1. PPI and photographic imaging software only manage file sizes (PPI) and help optimize sizing for output by keeping pixel dimensions constant, thus eliminating distortion or unwanted resampling or interpolation (see section below on Resampling or Interpolation).
- 2. Printing software only manages DPI and the options available for a specific printer. Incorrect management of the PPI and image sizing will reduce optimization of an image file.
- 3. Printing software and DPI must also be optimized, but DPI only enhances PPI.
- 4. Printing software and DPI selection cannot correct for poor PPI management and will actually emphasize any distortions created through bad PPI management.

within the same inch of physical space on the paper or support material. The most common color photographic output device is an inkjet printer, which sprays tiny dots of colored ink to create an image from a digital file. The more dots per inch, the more continuous the tone, resulting in a print that resembles a traditional chemically made silver photographic print.

It must be stressed that digital resolution (PPI) and print resolution (DPI) are not the same entities, and the differences must be clearly understood before advancing. Pixels per inch (PPI) measure the pixels contained within an image file or within a computer display. PPI has no real absolute size or resolution; it only defines a specific number of uniform pixels in each direction, width and height. Displays, cameras, and scanners all have individual PPI settings that are set by the user.

Dots per inch (DPI) is the measure of ink dots or clusters physically applied to paper using printing software, which also must be set by each user. True image resolution (DPI) only occurs when the electronic data in a digital file becomes an actual physical reality during the printing process. Printers and their software can create thousands of dots at different colors, values, shapes, sizes, and density to give viewers the clarity and sharpness required for high-quality photographic output.

Gaining a firm comprehension of how digital tools interpret and use PPI and DPI will prevent future headaches by optimizing your workflow. Think of PPI as digital (virtual) information and DPI as printer output (material) only (see Box 8.2). Digital image size (PPI) and digital display (PPI) reflect the number of pixels that will be used to create an image for an electronic digital display only. For example, an image size setting of Small (S) on a 6MB digital camera will produce a file that is 1504 pixels (w) \times 1000 pixels (h), or 1,504,000 total pixels or about 1.5 megapixels. This Small image setting would still be quite large when viewed on a display set at a standard resolution of 1024×768 . It would completely fill the display, and you could not see the entire image without using the scrolling sidebars. An inexpensive 2MB digital camera with a maximum PPI of $1200 \times$ 1600 is ideal for displaying images on the Web and email when scaled down but is insufficient for making quality photographic prints any bigger than about 4×5 inches at 300 PPI. Often, 300 PPI is used as

8.6 Printer driver accessing printer options and embedded resolution (DPI).

a standard file resolution to size and output digital prints, and the DPI of the printer is set to 300 to resemble silver prints.

DPI, also known as *embedded resolution*, can only be found and set through a computer's print command. Depending on cost and intended use, printers are mechanically different and have various user options. Printers require software called *print drivers*, which must be installed on each computer to operate the printer and give full functionality to printer options such as paper type and size, manual or tray feed, and most importantly, DPI. These options appear on your computer screen right after utilizing the Print command (see Figure 8.6).

Embedded resolution (DPI) does not affect the virtual image size (megapixels) of your image or its appearance on a computer screen. Those properties are determined solely by the imaging software in the Image Size dialog box using *Pixel Dimensions* and *Document Size* (see Figures 8.7 and 8.8). Settings in the Image Size dialog box help you optimize pixel dimensions with the preferred document or print size. The pixel count of the image file needs to be directly proportional to the final document or print size to optimize pixel information and avoid distorting the image. DPI settings found in printer drivers only determine the ink dots that will be physically applied to the paper. Properly managed image size proportions (PPI) combined with an embedded print resolution of 300 DPI can deliver digital prints equal to traditional silver prints.

Higher-resolution settings and large-megapixel cameras are specifically intended to generate higher PPI, which allows one to create larger photographic-quality prints that rival or even surpass the standards of traditional darkroom prints. Therefore, a 28.8MB digital camera with a maximum of 4800 (w) × 6000 pixels (h) or 28,800,000 total pixels can generate a more detailed large-scale print than a 3.1MB digital camera with a maximum of 1500 (w) × 2100 pixels (h) or 3,150,000 (see Box 8.3).

There is no hard and fast rule for determining the proper image resolution to utilize, but a good estimate can be made by first determining the final print size and then selecting a PPI setting that best fits how the image will be used. For instance, to make an 8×10 inch print at 300 PPI, you simply multiply the width and height times 300 to determine the proper PPI setting or camera needed. For example,

Box 8.3 Document Size at 300 DPI and Megapixels			
Document Size	PPI (w $ imes$ h)	Megapixels	
5" × 7"	1500 × 2100	3.1	
8" × 10"	2400 × 3000	7.2	
11" × 14"	3300 × 4200	13.8	
16" × 20"	4800 × 6000	28.8	
20" × 24"	6000 × 7500	45	
30" × 40"	9000 × 12,000	108	
60" × 80"	18,000 × 24,000	432	

This chart shows, for typical document sizes, the desired PPI and megapixels needed to create photographic-quality prints of a single-channel black-and-white image. An RGB color image will have three additional color channels and three times the information at the same PPI. The larger-format cameras listed (108 and 423 megapixels) are currently medium-format and large-format digital cameras.

to create an 8×10 inch photographic-quality image at 300 PPI, you would need a camera capable of shooting at least 3000 pixels (w = $10 \times 300 = 3000$) by 2400 pixels (h = $8 \times 300 = 2400$). Final DPI setting for printing is a personal choice, with settings between 150 and 300 DPI commonly used for most general purposes.

Properly Adjusting Image Size and Unchecking Resample Image

In all image management software, you will find a dialog box called Image Size which shows the relationship between *Pixel Dimensions*

		Image Size	
Pixel Dime	nsions: 1	7.2M	ОК
Width:	3008	pixels	Cancel
Height:	2000	pixels	(Auto)
- Document	t Size: —		
Width:	41.778	inches 🛟 ר	
Height:	27.778	inches 🗘 –	
Resolution:	72	pixels/inch	
Scale Style:	5		
Constrain I	proportion	IS	
🗌 Resample I	mage: [Bicubic	•

8.7 Image file showing Pixel Dimensions and Document Size. Resample Image is unchecked, which will always leave the pixel dimensions unaffected when any other changes are made. The resolution of 72 PPI in Document Size is sometimes the default that signifies a large document size in some management software programs.

(display size) and *Document Size* (print size). Before you adjust an image's width, height, or resolution, *uncheck* the *Resample Image* box and then proceed to make document size adjustments. By unchecking (leaving it blank) *Resample Image*, the software will always keep the proper relationship between width, height, and resolution of the original *Pixel Dimensions* or total pixel count of a given image file (see Figures 8.7 and 8.8).

To maintain optimum print sharpness during sizing, it is important not to alter the original pixel count when determining final docu-

8.8 Notice the increase in resolution and smaller document size compared with Figure 8.7, with no changes to pixel dimensions. The pixel count has remained constant because Resample Image is still unchecked. Only the document size has changed, thus keeping the pixel dimensions equivalent.

ment size. With *Resample Image* unchecked, this will not happen. When left checked, *Resample Image* can degrade print sharpness dramatically because it will randomly add or subtract pixels based on changes to *Pixel Dimensions*. However, when sizing images for the Web or email, leaving the *Resample Image* checked is sometimes preferred because it gives you more options to reduce or scale an image file, and most changes in *Pixel Dimensions* will generally not be noticed on a computer display because display densities are fixed and average a low 72 triads (pixels) per inch.

The Importance of Keeping Equivalent Pixel Dimensions

When learning camera exposure, one comes to understand the concept of *equivalent exposure*, which is the theoretical relationship between the length of exposure and the intensity of light. This paradigm states that an increase in one is balanced by a decrease in the other. For example, doubling the light intensity by using the f-stop will automatically be balanced by halving the shutter speed and vice versa. A similar equivalent concept holds true for changing the document size of digital images. Figures 8.7 and 8.8 show two Image Size windows for the same image file (note that the Image Size dialog box is located under Image in the top Main Menu). Figures 8.7 and 8.8 show equivalent pixel dimensions, but each has a different resolution (PPI) with corresponding changes to width and height and maintain equivalent pixel dimensions and file size.

Sizing a Digital File

As previously discussed, file size in megabytes (MB), file resolution (PPI), and print resolution (DPI) are three distinctly different measurements that need to be understood to properly scale, scan, and prepare images for display or printing. Although closely related, megabytes, file resolution, and print resolution are not a true measure of the actual image size when it is viewed on the screen or outputted to paper.

The size and quality of a final print are first determined by how many pixels were originally recorded by the input device such as a camera or scanner. Keeping the original pixel dimensions intact is absolutely crucial to maximize the quality of the final printed image. Digital cameras capture images based on the common settings of *Large, Medium,* and *Small.* Low-resolution settings, such as *Small* for the camera or 72 PPI for scanning, will produce a file usually under 1 megabyte which is fine for images that will only be viewed on a computer display, but is not suitable for photographic-quality printing.

Resampling or Interpolation

Resampling or interpolation is a set of mathematical logarithms automatically applied when the original pixel dimensions are changed for resizing. By checking the Resample Image box in the Image Size settings area, any changes to Document Size will automatically increase or decrease pixel dimensions proportionally. With an increase or decrease in pixel dimensions, the image software has to resample, also known as *interpolation*, by adding or subtracting pixels into the image. A computer will accomplish this by looking at adjacent pixels, making up new pixels based on an average of the original adjacent two pixels, and placing them between the original pixels. There are many interpolating logarithms that perform slightly different mathematical computations, but the end result degrades the original image file. This is because the resampling process cannot make up "real" detail (that is, cannot add information that was not originally there), but can only add pixels of similar color and value, which can result in an image looking soft and out of focus.

Figure 8.9 shows *Resample Image* checked and what happens to pixel dimensions when resolution is changed from 72 PPI to 300 PPI. Notice the change in megabytes from 17.2 MB at 72 PPI to 298.8 MB at 300 PPI. *Resample Image* will always keep the pixel dimensions and document size in proportion, but at a loss of print detail through interpolation. In spite of this, keeping changes to document size or pixel dimensions under 20 percent will likely have a negligible effect

	Image Size	
Pixel Dimensions:	298.8M (was 17.2M)	ОК
Width: 12533	pixels	Cancel
Height: 8333	pixels 🛟 🕊	Auto
Document Size:]
Width: 41.778		
Height: 27.778	inches	
Resolution: 300	pixels/inch	
Scale Styles]
Constrain Proporti	ions	
Resample Image:	Bicubic)

8.9 Sizing with resampling or interpolating occurs when Resampling is checked. Checking the Constrain Proportions box (see Figures 8.7 and 8.8) allows you to resize an image while keeping its proportions the same. When unchecked, an image can be stretched in either direction to customize the original proportions while Resample Image remains checked.

on print quality and may prove satisfactory. Nonetheless, dramatic changes to document size or pixel dimensions, as seen in this example, could produce unsatisfactory results regardless of resampling method.

The five most common modes of resampling that appear when the *Resample Image* box is checked are: *Nearest Neighbor*, *Bilinear*, *Bicubic, Bicubic Smoother*, and *Bicubic Sharper*. *Bicubic* interpolation is recommended because it gives the smoothest results, although it does

8.10 The display is showing resolution, not real inches. When you photograph or scan at a PPI higher than the fixed triad/pixel display density of 72 PPI, the image will appear huge when viewed on the display at the default 100 percent. The higher the PPI of the image file, the larger the image appears on the display. This image file has a PPI of 300. Notice there are 4 actual inches juxtaposed between inches 4 and 5 on the white display ruler: 1 display inch equals 4 actual inches at 100 percent at 300 PPI.

takes longer to compute than the other options. *Nearest Neighbor* is the fastest interpolation method, but it produces jagged results. *Bilinear* splits the difference between the *Bicubic* and *Nearest Neighbor*. *Bicubic Smoother* is used for better results when increasing image size or going beyond original pixel dimensions. *Bicubic Sharper* should give better results when reducing image size, although this method may produce an oversharpened image. If this occurs, use standard *Bicubic*.

It is worth reiterating that pixels per inch (PPI) and dots per inch (DPI) are two distinctly different measurements, which are often confused when scanning, scaling, or resizing a digital image as it is displayed on screen for printing. Figure 8.10 demonstrates what happens to an image that is photographed or scanned at a PPI higher than the display pixel density of 72 PPI and then viewed on the screen at 100% Document Size. In such instances, the screen image will appear much larger than anticipated, requiring scrolling to view the entire image.

Why does the screen image appear so big that you cannot see all of it at once? Imagine looking across a room with high-powered binoculars. Everything you observe looks much bigger than usual. The actual degree of enlargement is determined by the resolving power of the binoculars; objects appear to be closer or larger as the resolving power changes.

A large PPI file has a similar effect on a computer display. The greater the number of pixels per inch in any file results in a higher resolving power. The only way a computer display can show higher PPI files is by making the image bigger on the display. Current computer displays have a fixed resolution based on their dot pitch and have a triad (pixel) density averaging about 72 PPI. Hence, image files recorded at PPI settings higher than 72 PPI appear larger on the display in direct proportion to the PPI setting; therefore, the higher the PPI, the larger image display.

It is necessary to understand that document size determines the actual print size, and the PPI determines resolution within the document's size, but the display can only show resolution through magnification of the image. This is why large PPI image files always appear to overflow the display space. Regardless of how they look on the display, large PPI files will print as indicated by *Document Size*, even if the display size is gigantic. The rulers will show the image's true output (see Figure 8.10) and the zoom tool allows one to reduce magnification to view the entire image without scroll bars.

Making this even more vexing is the fact that video display cards have many possible resolution settings (PPI) that are set by individual end users, which further affects ratio or percentage differences between the display size and document size dimension based on display pixel density (DP). Do not spend time trying to extrapolate true screen measurement, because there are just too many variables and it has no practical physical effect on printing. The image will always print at the *Document Size*, but now at a higher print resolution of 300 PPI which has been set for this example.

Figure 8.11 is an image file with a resolution of 72 PPI. Notice the image is normally sized and the ruler shows 1 display inch is now approximately equal to 1 actual inch when viewed on the computer display. This happens because the display pixel density (DP) and the file resolution are now similar. The display pixel density is fixed at approximately 72 pixels per actual inch, and the image file is at 72 PPI. This is a 1:1 ratio between document size and scale when viewing at 100 percent on screen.

WORKING WITH A DIGITAL NEGATIVE: THE ORIGINAL CAPTURE

A helpful way to understand the relationship between picture size, pixels, and resolution is to think of pixel dimensions as representing the real size of a *digital negative*. It is called a digital negative because it fulfills the same function as a film negative in photography: it is not directly used as an image, but contains all the information required to made a final print. Any first-generation image file (jpg, tif, etc.) capture can be thought of as the digital negative and copied and saved separately into a separate folder devoted to this purpose. It is highly recommended that you retain the original, unprocessed, full-

8.11 When you photograph or scan at a low resolution of 72 PPI, it is equivalent to the fixed display density of 72 triads (pixels) per inch. When viewed on the display at 100 percent, the document size and image on the display will be comparable. Notice that 1 screen inch and 1 real inch are also comparable.

resolution file completely unaltered, alongside your copied version — that is, you should not edit, manipulate, scale, or size original images. Why? This makes it easier to use the image for different purposes later, and it also avoids the potential mistake of overwriting an original image with a faulty version. It also ensures that you do not accidentally erase the EXIF data that the camera stored with the image, which is your record of the date and time the picture was taken and the camera settings used.

Working with RAW File Formats and DNG

Quality digital cameras use the nondestructive RAW image file format which, once opened, can only be saved as another file format. This is an excellent feature because it ensures that the original capture stays intact, thus making the RAW file format ideal for permanent image file storage (see Chapter 3's section on Camera File Formats). RAW file formats are uncompressed raw data that only represent recorded light and density data for each pixel in the camera array. RAW capture data has no in-camera or pre-processing settings such as resolution, sharpness, color balance, or image size. A RAW file format image is the digital equivalent to the silver-based latent image, an exposed but unprocessed image that contains all the data needed to make a final picture. Professional photographers use the RAW format when they do not want the camera to apply any in-camera processing techniques to their original image file, preferring instead to make those specific decisions for themselves with post-processing software.

RAW files have to be opened and processed with proprietary software, which means that whoever works on those images must have that camera manufacturer's specific RAW software. Adobe is addressing this issue with its digital negative file format (DNG), a universal RAW file format extension that is embedded in their latest software applications. Thus far, Adobe's universal DNG file format extension has not been universally adapted. However, Adobe offers a free downloadable plug-in (see Figure 8.12) that will open any RAW file format in Photoshop and works well for RAW post-processing controls.

Resampling/Interpolation and the Digital Negative

To produce optimal digital prints from a digital negative (the original capture file), it is imperative that the *Pixel Dimensions* remain

8.12 Screen shot of Adobe's RAW plugin for post-processing RAW image files.

unchanged when adjusting *Document Size*. It is absolutely necessary to uncheck (leave blank) the *Resample Image* box to resize without interpolation so pixels are not added or subtracted from the original capture. In Photoshop, *resample* means the same thing as interpolation. With *Resample Image* unchecked (see Figures 8.7 and 8.8), the pixel dimensions or digital negative will always remain unchanged. When resolution is increased, the image size is reduced, and vice versa, keeping the digital negative intact. Usually one is forced to interpolate (*Resample Box* checked) an image file when the original pixel dimensions are too small to make a print at the desired print size and preferred resolution. When planning to produce large final prints, it is best to use the highest camera resolution setting or a higher megapixel camera to ensure maximum print quality without interpolation. Figure 8.13 shows the relationship between resolution (PPI), digital negative, interpolation, total pixels, and document size.

DOCUMENT RESOLUTION (PPI)	DIGITAL NEGATIVE	Pixel Dimensions	Total Pixels	DOCUMENT SIZE
72	UNINTERPOLATED	2000 × 3008	6,016,000	27.7 × 41.7 IN.
150	UNINTERPOLATED	2000 × 3008	6,016,000	13.3×20.0 in.
150 *	INTERPOLATED	750×1128	846,000	5 x 7 in.
300	UNINTERPOLATED	2000 × 3008	6,016,000	6.6 × 10.0 IN.
300 *	INTERPOLATED	3300 × 4963	16,377,900	11 × 16.5 IN.
600	UNINTERPOLATED	2000 × 3008	6,016,000	3.3×5.0 in.
1200	UNINTERPOLATED	2000 × 3008	6,016,000	1.6 × 2.5 IN.
1200 *	INTERPOLATED	8000 × 12,032	96,256,000	6.6 × 10.0 IN.

ONLY SCALE PROPORTIONALLY TO PIXEL DIMENSIONS

*These interpolated files will show some pixelization or loss of sharpness because the digital negative has changed from the orginal pixel size.

8.13 This figure illustrates the relationship between PPI, resampling/ interpolation, and print size. Notice that as the print resolution increases from 72 DPI to 1200 DPI, the print size is proportionately decreased to maintain the original number of pixels in the digital negative. Also note that resampled files will print at less than optimal quality because pixels were randomly added or subtracted to compensate for altered DPI or print dimensions, which did not remain proportional to the 6,016,000 pixels of the original capture.

TRUE RESOLUTION AND THE REAL WORLD

Join the crowd if you are confused about megapixels, resolution, DPI, PPI, image size, and file size, as not even the experts can agree about these topics. The crucial question at this stage is. Where does the "real" resolution of an image ultimately reside? There is no doubt that these digital matters are directly connected, but their interrelationship is strictly virtual, existing as unseen and untouchable digital data within one's camera, computer, or storage device. Due to technological limitations, not even the best display can show the true resolving power of any digital file. At this point, the best one can do is to view this digital data made up of ones and zeroes as a numerical array that defines resolution as pixel dimensions in our image management software program. Therefore, a hands-on, practical position is that an image's definitive resolution resides in the material world of the final print where DPI and printer capability give it physical presence. This is where the ink meets the paper and provides an electronic image with a tangible form in the real world.

Default Image Preview Confusion

All computers have a built-in image viewer for previewing images received through email or on disk. The Macintosh image viewer is called Preview; the Windows version is called Picture Viewer. Both disregard actual PPI and conveniently show images using any four of these options: *fit to screen*, *without scroll bars*, *document size*, or *actual size*. Only document size and actual size follow normal PPI conventions.

Digital Post-Production and Cataloging

Adobe's Lightroom and Apple's Aperture are image management software programs that provide a smooth and quick workflow. These

programs have automated, simplified, and streamlined many of the sizing, PPI, and DPI issues related to the configuration of images for both the Web and print. These programs are specifically designed to work with RAW image files generated directly from the camera, but also can work with all major image file formats. Aperture goes one step

8.14 An image window and its elements.

further, using the RAW format and its nondestructive saving features. Aperture saves the editing as a series of commands that one can later call up as "actions" to be performed on a "new" file. Additionally, these programs encourage good housekeeping through their asset management systems for archiving, cataloging, and displaying images (see Chapter 9's section on Post-Production Software).

The Image Window

To help keep track of all the variables in a digital file, software programs display many key pieces of image information. Figure 8.14

Box 8.4 Definitions of Information Displayed with a Digital Image File in Figure 8.14

- 1. Percentage of Viewable Image: Since a display can show only about 72 pixels per screen inch because of dot pitch (DP), the image program scales the image to show the difference between the image display and the document size (PPI). Figure 8.14 shows an image at 300 PPI. In this case, the software has scaled the image of the woman to fit the display and now only shows 16.7 percent of the actual pixels contained in the image. A display of 100 percent of the actual pixels would look similar to the enlarged portion of the man's face in Figure 8.10. A display of 100 percent means that one sees every pixel at a 1:1 scale, which would require the image to be much larger than the display; hence the display crops the image to show what it can at 100 percent.
- 2. File Size: This area shows the size of the file when it contains only one working layer or background.
- 3. File Size (with layers): Layers are transparent surfaces that can be individually placed on top of the original image or background, increasing the size of a file. You can move, scale, draw, edit, and paste onto any layer without disturbing the other layers or the original image. Adding layers while working allows you to work separately on the various parts of your image, which helps to organize and manage the workflow. An individual layer or layers can be

deleted without affecting any of the other layers. Flattening an image converts all layers back into a single layer, thereby reducing the file size. Images that are sent to high-quality printers often have to be flattened before printing.

- 4. Ruler: Imaging software usually includes an option for displaying a ruler alongside an image. The particular units a ruler employs can usually be defined by the user in the program's Preferences.
- 5. File Name: Most imaging software displays the name of the file near the top of the image window.
- 6. Extension: Extensions describe the file format to a computer's operating system. PCs and web browsers require that the three-letter file extension be included in a file's name, such as .tif or .jpg, or it may not be properly opened or displayed.
- 7. Name of Active Layer: Files can have many layers with individual names; the active layer name is displayed in the image window.
- 8. Image Mode: Imaging programs allow one to work in a variety of color modes including RGB, CMYK, Grayscale, Bitmapped, Duotone, or LAB. Some filters and operations can only be performed in RGB mode.

along with Box 8.4 identifies the data that typically surrounds the working image and describes its meaning.

The Bottom Line: The Best Setting to Get the Desired Results

Digital photography is an evolutionary development in the history of photography. Automated camera features have eliminated the technical constraints once associated with the medium, making it difficult to take a technically bad picture and thus allowing photographers to concentrate more deeply on picture-making. Creating visually exciting photographs remains about understanding the basics — quality of light, composition, and subject matter. Putting these three fundamental elements together in a precise and thoughtful way is still the main objective for most photographers.

So what are the basic technical guidelines one needs to know when making digital images? When making pictures that will only be seen on a computer display, set the camera to Auto, make JPG picture files, and you can expect to get satisfactory results 95 percent of the time. When making pictures for the Web, email, or simple documentation, one can use small-PPI files, JPG compression, and interpolation.

Serious photographers concerned with print output should consider using the RAW format and automated camera features when appropriate. The RAW format guarantees the highest resolution (PPI) available for that particular camera, delivering the best digital capture for post-processing. As previously discussed, the RAW format allows one to manage color balance, resolution, brightness, saturation, and exposure after capture. RAW file formats also keep your digital negatives intact without the risk of interpolation or overwriting. Keep in mind that RAW file formats with their post-processing capabilities are not a substitute for poor camera work or lazy seeing. Photographers who consistently make stimulating work comprehend and utilize the basic principles of composition, exposure, and focus because there are situations when one must override the automatic controls to get the desired results. Digital cameras with their instantaneous picture review give photographers a second chance to immediately scrutinize their exposures and correct mistakes as they work.

MAKING PHOTOGRAPHIC-QUALITY PRINTS

Inkjet Printers: Converting DPI to Dots

Photographic-quality inkjet printers are used to make continuoustone photographic prints. The design of an inkjet print head allows it to spray minuscule amounts of ink onto receiving material at resolutions of 1440 \times 720 DPI and higher. They can also deliver subtle detail with more accurate and saturated colors and print on a wider variety of materials than their less expensive office counterparts. These quality printers can use more permanent (archival) inks and include more colored inks, greatly increasing the range of colors (color gamut) beyond traditional analog color photography.

Droplet Size: Picoliters

Inkjet printers use different amounts and methods of applying inks to create photorealistic images. General-purpose quality inkjet printers use four inks: cyan, magenta, yellow, and black (CMYK), while higher-end photographic-quality inkjet printers often add colors such as green, orange, and lighter versions of cyan, magenta, gray, and black, plus matte black. Creating photo-quality prints depends on how many droplets fit within an inch (DPI) of space, and on the size and pattern of the ink droplets made by the printer head. When a photographic-quality inkjet printer makes an image from a 300 DPI file, it is not just depositing one droplet of ink for each pixel (PPI) or dot (DPI), but rather it places four or more droplets of ink to represent each pixel. Droplet size is the size of the smallest individual drop of ink that a printer can produce. The drop size is measured in picoliters (1/1,000,000,000,000 of a liter/one trillionth of a liter), and certain inkjet printers can vary the drop size. Droplet sizes may be as small as 1 picoliter for dye-based inks and 1.5 picoliters for pigment-based inks. As you would expect, the smaller the droplets, the greater the resolution of the print. Small droplets also allow you to generate smoother-looking prints with finer highlight detail and tonal gradations with less ink. Presently, eight-color inkjet printers use hundreds and hundreds of nozzles to apply varying degrees of color and value accurately, predictably, and with smooth gradations.

If you are interested in making black-and-white images with a broad dynamic range and fine tonal separation, use a printer with at least three black ink cartridges. Presently, the gold standard for black and white printmaking is to use a printer with at least four different black ink cartridges, or use a special third-party monochrome ink set, which provides four to seven black inks of various color tones and densities.

Inkjet printers must accurately control all those nozzles to properly set down droplets of ink that can persuade our eyes that it is seeing a continuous tone. Better inkjet printers can deliver excellent photographic quality between the range of 150 and 360 DPI. Generally, a setting of 1200 DPI will provide outstanding quality. Although these printers are capable of resolutions up to 2880 DPI, it is generally not worth the extra ink, printing time, and storage space to produce image files that are beyond the visual acuity of the human eye.

Paper: Uncoated and Coated

Uncoated (porous) printing papers are the most readily available papers and are best identified as the inexpensive xerographic, inkjet, or laserjet papers primarily used for printing text. Structurally, these papers are made of raw cellulose wood fibers that have been bleached and processed into the standard letter- and legal-size formats. These papers lack uniformity in absorbency, brightness, surface texture, and pH levels. They absorb more ink, which allows them to print and dry fast to the touch. Since more ink is physically absorbed into the paper, the colors appear duller and flatter than on coated paper. Uncoated papers are non-archival, being more susceptible to fading caused by environmental factors and exposure to light than coated papers, and are not intended for long-term use.

Coated papers (micro-porous) have special coatings that either modify or completely cover the cellulose fiber, thus giving the paper superior print results and archival qualities. These papers are designed to resist fading, although drying times can be somewhat longer. Coated papers come in a variety of traditional photographic surfaces, including high gloss, semi-gloss, flat matte, luster, and also in many canvas-like textured surfaces. Glossy papers deliver clear, vibrant color and give a broader apparent tonal range to black-and-white images. Many serious printers use expensive fine art papers with a matte finish because they minimize reflections when framed and have archival qualities. Such acid-free papers are buffered with calcium 8.15 Wilkins scanned photographs from history books and family albums purchased at flea markets that she altered by adding her own portrait in the place of the original person's face, placing herself in the past and in history. "Their purpose is to represent the inability of a picture to show a person's identity beyond what they looked like. As I want to fool the viewer into thinking they are seeing the 'original' photograph, I used matte paper adjusted to print as a warm-sepia color. The resulting images are framed in a very traditional style with a white window mat, just as historic photographs are presented in museums."

 \odot Kristen S. Wilkins. Us Girls, from the series Autoportraits, 2003. 10×7 inches. Inkjet print.

carbonate to prevent environmental acidification and contain no optical brighteners that can break down and change color over time. Nonporous polymer or vinyl-based printing materials are used for printing banners and decals but are not considered archival.

Before utilizing any new printing materials, it is a good idea to check the kind of coating or surface of the material and select the appropriate type of ink, making certain your printer can properly handle that particular combination. Look for compatibility information from the paper manufacturer. Begin with the printer manufacturer's paper and ink recommendations, generally their own brands, and then experiment with different materials. Many companies offer variety sampler packs that allow you to try different papers so you can see how the various possibilities work with your imagery and equipment. Look for an ICC profile for each ink/paper combination, as it signals that it has been tested and should work at least acceptably well. Avoid papers with optical brighteners, for they will deteriorate as the paper reverts back to it natural color, turning the prints yellow.

Inks: Dye and Pigment Based

There are two basic groups of inks: water-soluble dye-based, and pigment-based. Dye-based inks are capable of producing a broad and vibrant range of colors with a limited number of inks and are often used with porous (swellable) paper. They are also less prone to *metamerism*, which occurs when a color changes hue under a different light. They also do not produce low-sheen patches on glossy paper. Inexpensive inkjet printers use dye inks, and they should only be used when permanence is not a concern, such as for color proofing and short-term use. Photographic-quality inkjet printers can use pigment-based inks, containing pigments that make the inks more archival and fade resistant. Both coated and uncoated papers are used with pigment-based inks, with the latter taking longer to dry.

Print Permanence

There has not been enough independent empirical testing to accurately predict the permanence of inkjet prints, especially since the equipment and materials are constantly changing. To maximize longevity, use coated papers and the best-quality pigment-based inks available. When permanence is a major concern, evaluate the current array of inks and papers before buying a printer to make sure everything is compatible and able to produce the results you desire. Using papers and inks from different manufacturers is not suggested until experience is gained, because manufacturers only test, rate, and guarantee the permanence of their own system's products. Choosing inks and papers from different manufacturers may produce the visual results one is looking for, but the combination may not be archival (see Chapter 9 for factors affecting permanence).

Printing Systems and Output Concerns

Thermal/Dye-Sublimation Printing

Thermal or dye-sublimation printers work with RGB, CMYK, and grayscale images. In this process, the printer uses heat to apply three layers of primary color dye and a fourth layer consisting of a protective laminate, contained in thin plastic sheets, onto a piece of specially coated paper. The colors are not laid side by side as in a halftone process used to produce the images in this book, but are blended to create a continuous tone print, giving them a very smooth look with subtle gradations. Dye-sublimation prints, also known as *dye-sub prints*, are not archival; depending on the support material (paper base) and storage conditions, their life expectancy is up to 10 years before there is noticeable fading.

Thermal-wax printers are similar to dye-sublimation printers, melting thin coatings of pigmented wax onto paper. Some can print on a variety of papers, but their life span is even shorter than dyesublimation prints.

Desktop Inkjet Printers

Desktop inkjet printers are inexpensive and use water-soluble inks and plain paper to make color prints. Better-quality paper will yield higher-quality images. Some dye-based inkjet printers produce prints that are impermanent and can, without protection, fade within 6 months.

Iris Print

The Iris printer was the first high-end printer used in digital fine art reproduction. Iris prints are a type of inkjet print produced by spraying millions of fine dots of ink per second onto paper to produce consistent, continuous-tone, photorealistic output on paper, canvas, silk, linen, and other low-fiber textiles. Created on a spinning drum, these gallery-quality prints can be made on virtually any material that will accept ink. The Iris printer uses dye-based inks that produce highly accurate, vibrant prints with wide tonal values. Depending on the type of ink, paper, and coating, such prints could have a life span as little as 6 months, but generally Iris prints are made to last decades. Once the standard for high-quality fine art reproductions, Iris prints are now a niche process used to indicate a superior product. Nevertheless, Iris prints continue to be a standard measure for digital prints.

Giclée Printing

Giclée (pronounced *zhee-klay*), French for "spray" or "spit," is a fashionable phrase for inkjet printing, since technically even an inexpensive inkjet printer produces giclée prints. The term *giclée* was first associated with Iris printers and connotes the use of professional 8color to 12-color inkjet printers to produce high-end output. The name was designed to appeal to print connoisseurs and their expectations of an archival pedigree lasting for hundreds of years, but the process is not regulated and therefore carries no guarantees.

LightJet

A LightJet printer exposes a digital image directly to color or blackand-white photographic paper using red, green, and blue laser beams. The resulting images are processed in regular photographic chemistry and therefore possess the same surface and permanence properties as traditional photographic prints. LightJet prints are extremely sharp and very close to continuous-tone photographs because the LightJet's resolution would exceed 4000 DPI when compared to conventional half-tone printing.

Mural-Size Prints

The making and acceptance of high-quality photographic digital images is a reality for both the consumer and professional and is visible in the art world's embrace of big prints. Even though digital cameras can exceed the resolving power of 35 mm film cameras, enlarging limitations remain constant. Digital photography is not a panacea for making large prints from small cameras. A blow-up from a 35 mm equivalent DSLR will show a loss of sharpness due to increased pixilization in direct proportion to the enlargement size. Taking that into consideration, intriguing images can be made by purposely incorporating the higher levels of pixilization into the design of the final image.

As more affordable digital image sensors continue to become available in medium and large formats, film cameras will become commercially obsolete and used only for artistic practice. Until this last cost obstacle is overcome, the best practice for making big fine art digital imagery is to record the image on a large-format film and scan the film at the highest possible resolution. Such prints require film scans, in excess of 4000 DPI and up to 8000 DPI, along with professional scanners and printers. Often large digital prints are made with a floor model photo-quality inkjet printer capable of printing up to 64 inches in height and widths as long as the roll of papers will allow, which can exceed 100 feet.

Unusual Printing Materials: Mixing Media

The widespread availability of high-quality, large-format printers and an accompanying variety of printing materials invites the exploration of digital mixed media. Imagemakers have always experimented with the surface of the print, some by applying pigment to the surface, others by collaging images and materials to the print surface. All of these methods can be brought into play using digital imaging as well. In addition to traditional glossy paper, manufacturers have developed materials such as artist canvas that can be run through a digital printer and then be painted on with acrylic or oil paints like a conventional canvas. Materials, such as Polysilk cloth, a polyester-woven fabric with a ceramic-based coating, can convert an image into a flexible work that feels like silk. Lazertran allows images to be printed onto various types of waterslide decal material, which allows one to transfer an image onto many surfaces. One can even use several of these over each other because they are transparent. Other materials can be printed on and waterproofed, allowing them to be exposed to the elements or even washed. Images can also be printed on translucent and transparent films that can be used as backlit prints, as photographic negatives for other alternative processes, or in multilayered images. A liquid called inkAID can be sprayed or brushed to create a matte, gloss, or semi-gloss coating on unlimited types of surfaces on which to print, including traditional fine art papers, metal, plastic, and wood veneer. If you are using an unusual paper and want to run it through your printer, check the printer manual to determine the maximum thickness the printer can accommodate. Additionally, there is also iron-on inkjet transfer material that allows images to be easily transferred onto cloth.

8.16 "The images in the series often come from found snapshots of people posing with their pets or farm animals and generally combined with images I have taken of taxidermy animals. The title Wannabes addresses our urge to create lives and stories for animals that often mimic or mirror our own desires, as well as presenting those desires in a variety of forms such as piglets decorating a pair of children's pajamas, or a fish starring in a Hollywood production. Image manipulation is done in Photoshop, and the final images are printed onto a special waterslide decal paper, Lazartran, through the use of a Xerox copier. Finally, the image is baked on in a conventional oven, giving a waterproof, archival, usable finish."

© Deborah Brackenbury. Wannabes (Brother and Sister), 2004. 10-1/2 inch diameter. Mixed media.

Preparing a Digital Print for Mixed Media

The advertising industry has fostered digital media innovation. Store displays, such as advertisements found in supermarkets, are being produced on large-format printers. Imagemakers should be aware of the interests of the advertising industry when using these new materials. Advertisers want materials that are sturdy enough to stand up to public handling or being displayed outdoors, but are not particularly concerned with image longevity. Fortunately, many of the same qualities that allow an image to survive for months outdoors will permit those same prints to last years or decades when they are properly displayed indoors (see Chapter 9).

One thing that imagemakers can do to protect their images from damaging ultraviolet rays or when preparing images for mixed media applications, such as acrylic or oil paint, is to seal the surface with a spray or liquid coating. These coatings are water- or solvent-based and can be used with water-sensitive inks. Since many of these coatings can yellow or crack over time, researching and testing a particular combination before use is recommended.

Service Bureaus

The hardware and software necessary for many output options are expensive and require special skills and materials; using service bureaus with knowledgeable technical support is a viable option for imagemakers not doing high-volume work. Service bureaus, commercial printers, copy centers, and professional photography labs can scan and print images to meet your specific needs. Many specialize in high-quality and large-scale digital reproductions with the latest technology. The quality of the output always depends on the skill of the operators and the maintenance of equipment, but generally if it's not done to the customer's satisfaction, they will do it again until it is.

IMAGES AND THE COMPUTER WORKSTATION

As a camera translates a three-dimensional scene into a twodimensional representation, a computer seamlessly combines different media into a virtual representation, retaining the qualities of some and eliminating the traits of others. Any operation that one can do with a camera, paintbrush, or drafting set can be simulated on a computer.

Large, high-resolution image files require extra processing time and plenty of available hard drive space to operate efficiently. A 100 MB file should have at least five times that amount (500 MB) of free hard drive space to make use of the imaging software tools and filters.

The Color Monitor

All monitors use an additive RGB (red, green, and blue) color system. A monitor mixes a color by illuminating tiny dots of red, green, and blue dots called triads. By illuminating each of the dots to a different brightness, the monitor creates different colors. By mixing together various amounts of red, green, and blue light, it is possible to make almost any color. Additive colors get lighter when mixed, and by mixing all three together in balanced amounts, you get white light. Since light is transmitted from the image, the colors tend to be more saturated and luminous than a printed image that relies on reflected

8.17 Thompson's stripped-down comic book characters employ humor to deal with the ways in which power is enacted through small actions and are the result of a collaboration between photography and multimedia. "In my work the computer is a tool; a means to an end, rather than an end in itself, a way to generate a final form that exists outside the computer."

© Calla Thompson. Untitled, 18 × 18 inches. Inkjet print.

light in which portions of the rays are absorbed. Prints use a CMYK subtractive system to form an image on a sheet of paper, and any increase in pigment density will subtract the initial amount of light and produce a darker result.

There is an inherent visual difference between images seen on your monitor, other monitors, and output devices. Sophisticated monitors allow for color correction as well as contrast and brightness adjustments, but these only affect how the image appears on that particular monitor and not other monitors and/or paper output. Color management hardware and software, such as a monitor calibration spider and ICC profiles, are available to help control the color balance between monitors and output (see section below on Color Management).

How Monitors Display Color

Depending on the monitor size and the amount of video memory (VRAM), it is possible to see and manipulate millions of colors with image processing programs. All video monitors represent color by displaying minute RGB dots, which are displayed on the monitor as pure color. All other colors shown on screen are a mixture of pixels used to approximate the color needed. In addition to full color, images can be produced as grayscale, which produces 256 shades of gray, or bitmap images, which are purely black and white.

Bit Color

Bit depth describes the number of bits (the smallest unit of information on a computer) assigned to each pixel and refers to the number of shades of gray or the number of colors that can be represented by a single pixel. The greater the number of bits (2, 4, 8, 16, 24, 32, or 64), the greater the number of colors and tones each pixel can simulate (see Box 8.5). The bit depth of your computer's display is the number of different colors it can show at any given time. The size of the display and the amount of video RAM you have

Box 8.5 Bit Color
2 bit = black and white
4 bit = 16 colors
8 bit = 256 colors
16 bit = 32,000 colors
24 bit = 16.7 million colors/limit of human acuity
32 bit = millions of colors plus increased color depth
64 bit = billions of colors plus increased color resolution and
detail

on the graphics card control bit depth. The highest level of color a computer can produce is 64-bit color. Levels of 24 bits and above create color variations beyond the range of human perception. Even though human perception is limited to about 24 bits and below, 32-and 64-bit color can improve color accuracy and correction on screen.

In imaging software such as Photoshop, images contain either 8 or 16 bits of data per color channel. In an RGB file, an 8-bit/channel image has an overall bit depth of 24 bits (8 bits \times 3 channels = 24 bits); a similar CMYK file has a bit depth of 32 bits (8 bits \times 4 channels = 32 bits). Images that have 16 bits of data per color channel have a much greater color depth, translating to greater distinctions in color. In this mode, RGB files have a bit depth of 48 bits (16 bits \times 3 channels = 48 bits), and CMYK images have a bit depth of 64 bits (16 bits \times 4 channels = 64 bits). Currently, working in 16-bit/ channel mode severely limits the software's and the imagemaker's ability to manipulate an image. In 16-bit/channel mode, images can

only contain one layer, and many image filters and image adjustment functions are unavailable.

Color Management (ICC Profiles)

In 1993, a group of eight software and digital output device manufacturers formed the International Color Consortium (ICC) to establish and maintain a set of international color standards. The group introduced a standard device profile format, known simply as ICC, to define how different color devices, regardless of manufacturer, produce color images. An ICC profile is a file that describes how a particular device reproduces color (printers or monitors). These profiles map onto an image file the characteristics of different output devices with their limited color spaces, making the output of images from varying devices predictable and observable.

Controlling Color Space: Profiles and Lights

In a digital setting, every workstation has a unique "printable color space" sometimes known as *color gamut*. ICC profiles are small digital files that help the computer determine the actual viewable and printable color space of a device. These files are sometimes preloaded in an image or software program, but many need to be loaded based on the device and the media being printed on. Color space is determined by everything that goes into making the image, including the camera or scanner (input), the type of monitor (viewable color space), and the printer along with its specific combination of inks and paper (output). As each paper and ink combination has a different color bias, using an ICC profile for a particular paper/ink combination will help ensure that your print will match the color values of your image file. The ICC profiles "remap" or reassign a new color value to a digital

image when color values are detected outside the viewable or printable color space. Sometimes the shift is not severe or even detectable. The standard ICC profiles, called *generic profiles*, are designed as a "best guess" method of normalizing many variables over a wide array of possible environments and can do a good job. Factory ICC profiles are best and can reduce time and effort when color correcting, but they do not work in every situation. Custom ICC profiles can also be purchased and downloaded from most manufacturers' websites.

WYSIWYG: What You See Is What You Get

In a controlled working environment with well-maintained equipment, a good understanding of ICC color management can minimize the process of color correcting digital images. Begin by setting your color workspace to one standard and learn how it functions. Adobe RGB is often recommended because it generates a long, muted, and subtle color gamut that works well with most color printers. Finetuning or "tweaking" the color balance is an ongoing process. ICC profiles are based on the monitor settings, such as brightness, contrast, color temperature, tint, and RGB, and have their place in making critical work. In a controlled working environment with the proper software and color calibration equipment, the color calibration of the monitor to the printer can be done very precisely, allowing one to have *WYSIWYG* — what you see is what you get.

In a group lab environment where the monitor controls and room lighting are inconsistent, it is usually easier and quicker to first print a digital image file that contains both a grayscale and color scale chart. This print is compared directly to the monitor, and the necessary adjustments are made to the monitor to match the print. Although this color management style is not empirical, it works well to compensate for the numerous unexpected changes that constantly occur in a group work environment when the only constant is change.

Lighting in the Work Space

The light sources illuminating your work environment can affect decisions about adjusting the color and contrast of your prints. Halogen lights can throw off the accuracy of color meters used for monitor calibration. Incandescent bulbs produce a yellow light, while sunlight fluctuates in color, and regular fluorescent bulbs tend to be green, inconsistent in their output, and lacking in certain colors of the spectrum. The ideal digital studio is a gray space illuminated by diffuse 5000K light sources. Light bouncing off of brightly colored walls and objects, including your clothes, can affect the color outcome. Use a monitor hood to prevent light from directly striking the computer screen. A hood can be easily made from gray matte board. Keep the area around your monitor dim, but evaluate your prints in bright light that is the equivalent of the light that the print will normally be viewed under. As a final point, regardless of what any calibration program states, color response is subjective and it is our eyes that ultimately determine whether a color print achieves its desired results.

Digital Colors: CMYK and RGB

Many software applications allow for the manipulation of color according to its hue, saturation, or luminosity (HSL) or through a licensed color system such as Truetone or Pantone. These last two systems allow for the most understandable color manipulation on a computer. Process color, or CMYK, is the traditional printing method of lithographic printers. This set of subtractive primary color is the system used by most color printers. Many output devices cannot print all the colors a computer is capable of processing. Some software packages will alert you if a particular device cannot print a selected color. Computer users can make color separations for printing using the CMYK mode. When switching from RGB to CMYK, the computer dulls the screen colors to simulate a subtractive print. High-end multicolor printers rely on RGB to manage all their possible color options. Duotone effects, applying a second accenting color, are also possible.

Digital Memory

RAM

When a program opens, its contents are loaded into random access memory (RAM). The instructions a computer needs to perform its tasks are stored and processed in RAM chips, sometimes called *memory chips*, which come in a variety of formats, sizes, pin configurations, and types. The amount of RAM a computer has directly affects its performance and capabilities and is usually expandable. Most software applications include recommended minimum memory requirement settings. However, to effectively run a program may easily require twice the minimum amount of RAM; therefore, it is prudent to research programs before you purchase them.

ROM

Permanently installed in the computer, read-only memory (ROM) contains the basic operating instructions a computer needs to start up and to draw objects on a screen. Unlike RAM expandable memory, ROM is fixed and not alterable.

Hard Disk

The hard disk, usually installed inside the computer, is where applications and files are stored. Since image files are often larger than the available RAM, some software applications use the hard disk to temporarily store information. The program shuffles information from the hard disk (the *scratch disk*) into RAM, where it is processed. This enables the program to complete complex operations and functions, such as *undo* and *preview*. The scratch disk can take more than five times as much space as the original image because it stores several different versions of the image. The computer's hard disk must have enough free space to accommodate these temporary files, which is why some people say you can never have too much RAM.

SOFTWARE AND IMAGING APPLICATIONS

Although the computer is a powerful tool, it is essentially an empty vessel that is dependent on the instructions contained in software to carry out its applications. Images created on a computer do not have to be exclusively photo-based. The programs' own internal tools, integrated with devices such as pressure-sensitive graphic tablets and pens, allow users to simulate other media as well as create unique digital images.

Various types of software may be utilized at different stages in the imagemaking process. A single application can provide adequate tools for an imaging project, but it is often necessary to combine the strengths and tools of other software to create the desired outcome.

Raster/Bitmapped Software

Most software programs that are designed to process photo-based pictures operate with raster (bitmapped) images. Raster images only

exist in 2D space made up of length and width only, and objects can be manipulated along the X (left/right) and Y (top/bottom) axes. The advantage of a bitmapped image is that it can be edited pixel by pixel. Photo-based or raster image programs such as Photoshop do not keep individual objects as separate files; they only keep track of the individual pixels that make up any object in 2D space. New items should be applied to their own layer, at which time any alteration will affect that layer only and not the other layers or surrounding areas. Not all imaging programs operate in this manner. For instance, Apple's Aperture and Nikon's Capture NX save your image changes as instructions instead of layers, which allows the file sizes to remain small and thereby reducing working time and storage needs. Increasing the size of an image increases the number of pixels, spreading out the data. Reducing the size of an image eliminates pixels and both reduce the image's integrity.

Vector Graphics Software

Vector graphics (object-oriented) software programs offer a wide range of options for manipulating lines and polygons in 3D space. Vector graphics programs treat any drawn object as a 3D model that can be viewed realistically from any angle when rotated or scaled. Vector images exist in 3D space made up of length, width, and depth. These 3D models or objects will cast their own shadows and refract or reflect light from single or multiple light sources, just as any object would in the real world. Objects can be manipulated along the X (left/right), Y (top/bottom), and Z (front/back) axis. The disadvantage of a vector image is that it is more difficult to edit pixel by pixel. These 3D models can be colored, textured, stacked, reshaped, or

8.18 These pieces continue a content strategy of using digital imaging to place a male, suited figure (the artist) into improbable landscapes and imaginative spaces to comment on the contemporary social and political landscape. "This image describes my personal observation that it seems the more totalitarian the system, the higher the Goose Step. The term *premium glassware* comes from my experience as a child when oil companies rewarded a tank fill-up with a drinking glass. The technical challenge was using the 3D software in collusion with the 2D imaging software to make pieces relating to the idea of historical, decorated ceramics and glassware that could convincingly take their place in a contemporary space."

 \odot Gary Hallman. *Happy March*, from the series *Premium Glassware*, 2003. 36 × 48 inches. Inkjet print.

moved without affecting the background or any other surrounding object. Vector software is designed for modeling, drafting, and illustration applications and is not generally suited for working with photographic images, which are only 2D objects. **8.19** The top Main Menu categories and editable tool options.

	· · · · · · · · · · · · · · · · · · ·			Top Main Menu Categories					
Photoshop	File	Edit	Image	Layer	Select	Filte	r View	Window	Help
Brush:	• •	Mode	: Normal	•	Opacity: 100	% 🕨	📄 Auto Erase		

Let The Editable Options Bar that appears here is different with each active tool, Brush tool shown here

The advantage of vector programs is that you can scale without interpolation in a manner similar to that of working with Post-Script font files. A photographer would use a vector program to create a lensless image, a photorealistic 3D computer-generated image. For example, if a photographer wanted to add a dinosaur to a landscape picture, it could be created with a vector program and dropped into the scene.

BASIC DIGITAL IMAGING CATEGORIES AND TOOLS

Top Main Menu Options

The major imaging software programs possess common and unique categories and features located in the top Main Menu, which allow access to many of the editing functions. The most common basic categories are File, Edit, View, Insert, Layer, and Filter (see Figure 8.19). Within these categories there are hundreds of selections that, when used in combination with the toolbar, can create thousands of ways to manipulate an image.

Cut/Copy and Paste Function

Located in the Edit category in the top Main Menu, *Copy* and *Paste* are essential and powerful functions of the computer that allow one to replicate and move information. Cutting and pasting is possible between files made on different pieces of software as well as between documents made on the same software. Sometimes the data structure of the information is not compatible. However, most professional software applications have a set of procedures, usually located under File or Edit in the Main Menu, for converting and opening files produced by different applications.

Scale and Distort Functions

In the Edit category in the top Main Menu, *Transform*, *Scale*, and *Distort* are the tools that can influence depth perception by altering an image's original context or creating an image that challenges prescribed visual assumptions and expectations. For example, an image or a portion of an image can be foreshortened to simulate perspective or stretched horizontally or vertically to fit into a specifically defined area.

Overall print sizing controls are generally located in the Image category in the top Main Menu under *Image Size* or *Canvas Size*. Both these functions make an image larger or smaller when outputted. Altering the canvas size allows for the creation of blank drawing space or crops the image. Changing an image's size affects the overall dimensions of the image.

Digital Filter Function

An image may also be manipulated through a wide variety of filter effects located in the top Main Menu category called Filters. Typically, programs offer a wide range of common filter effects such as, blur, distort, mosaic,

pixilate, sharpen, reticulation, chalk, charcoal, and many other artistic effects. In the 19th century, photographers adopted the aesthetic strategies of painting as picture-making models. Today, third-party software manufacturers provide a similar service with special filter effects known as plug-ins (see Chapter 4), which offer additional digital tools to simulate drawing, painting, and photographic effects, such as the look of a particular film like Kodachrome or Tri-X (see www. alienskin.com). As the digital aesthetic continues to evolve, imagemakers will be less reliant on older media and filters that simulate past and nostalgic working methods, allowing a new and authentic digital syntax to develop and mature.

Toolbar Icons for Additional Photo Editing

Many of Photoshop's common editing tools have since migrated to other imaging programs. These tools can be found in a floating toolbar that defaults to the right or left side of your screen. Refer to the application's Help menu or the manufacturer's manual for complete and detailed descriptions of all tools. Depending on the program, many of the visible tools on the toolbar have hidden options that can be revealed by simply using Click-Hold or Option-Click on the visible icon. Also, each tool has editable options that are usually displayed in an Options bar underneath the top Main Menu on the screen when a tool is in active use. The Options bar is a convenient way to change numerous options related to the active tool's function, such as brush size, font size, type of gradient, transparency, and colors.

8.20 "This view camera image was taken of Strawberry Island in the Niagara River in Buffalo, NY. The resulting landscape was stretched into a shape where the vertical dimension was eight times normal. The scroll-like format squeezes the long, flat island into a compact shape, and the willow clumps are transformed into cypresses, seeming to recall Arnold Bocklin's painting *The Isle of the Dead* (1880)."

© John Pfahl. Isle of the Dead, 2006. 84 × 21 inches. Inkjet print. Courtesy of Janet Borden Gallery, New York.

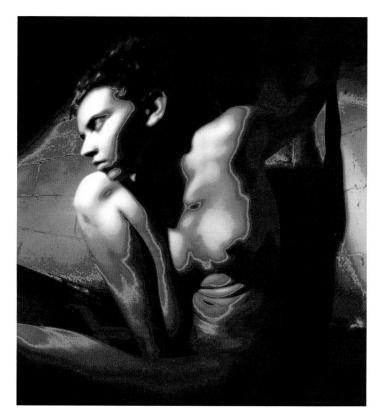

8.21 "I use the distortions of an oatmeal box pinhole camera with 8×10 inch black-and-white film and the colorizations created in Photoshop to create a series of visceral images that probe the unconscious mind. These images step away from the literal reality, choosing instead to speak with a Jungian expressionism. Objects and places juxtaposed with the model trigger a response that I react to while colorizing each image. Through successive pulling of curves, black-and-white values are replaced with color that ultimately connects with the dreamlike state of the finished image."

© Dan McCormack. Sara, 2005. 12 × 11 inches. Inkjet print.

COMMON TOOLBAR ICONS FROM PHOTOSHOP

Finding Tools

When a black arrow appears in the lower right-hand corner of a tool icon, there are more similar tools to be found by clicking and holding the mouse button on that icon. It may be necessary to adjust the tracking and scrolling speed of your mouse in your System Preferences to carry out certain image editing procedures.

Select and Move Tools

The Marquee tools are used for creating simple geometric selections in your images (rectangle, elliptical, and single row selections all are similar options). Since a computer cannot yet read your mind, use the marquee tools to indicate the area you want to work within. Once an area is selected, any adjustments, tools, or filters will be applied only to that selected area.

One of the most useful innovations in Photoshop was the inclusion of layers that can be found under Window in the Main Menu. By using layers, imagemakers can independently copy or move pixels on one layer to another layer (see section below on Layers). Layers then can be altered independently. The Move tool allows you to move selections or the entire contents of a layer to another layer for unlimited image control.

Lasso Tools

The Lasso is a freeform selection tool that, with practice and a steady hand, is excellent for selecting odd portions of an image that might otherwise be impossible to edit. Unlike the Marquee tool, the Lasso allows you to draw both irregular and straight-edged selections. The Lasso tools have three similar modes: Freeform Lasso allows one to draw complex, irregular selections in a manner similar to a drawing pen; Polygon Lasso allows one to draw simple, straight segments; and the Magnetic Lasso automatically follows the edge of an image based on color differences or contrast.

Magic Wand Tool

The Magic Wand selects all pixels of a similar color or tone to the pixel clicked, making it a good choice when needing to edit irregular areas of similar color in an image. The tool selects pixels within a certain tolerance that ranges between 0 and 255 tones, determining how closely to match colors; a higher tolerance makes a larger selection. Choosing a tolerance of 1 will select only pixels of that same color. A tolerance of 100 will pick all pixels that are 50 tones lighter and 50 tones darker than the pixel selected.

Crop Tool

The Crop tool is used to draw a rectangle around a portion of an image and discard all image information outside of that area. The size

of the rectangle can be adjusted before cropping and can also be tilted, rotated, and distorted by using control points on the edge of the selected object. Areas not selected appear darker, so it is easy to see exactly what will be cropped.

Drawing Tools

Brush and Pencil Tools

The Brush tool allows you to paint with the selected color. The size, shape of the brush, and edge sharpness can be changed in the Options palette. The blending mode, opacity, and flow of the brush can also be adjusted. Any Opacity setting lower than 100 percent will allow the underlying image to be seen. Flow determines how quickly the digital paint is applied. A lower setting produces lighter strokes. The Pencil tool allows you to draw a line in a specified pixel size. The Pencil tool creates sharper edges than the Brush because it leaves out the anti-aliasing (softening of edges) that the Brush utilizes.

The Retouching Tools

Healing Brush and Patch Tools

The Healing Brush tool is used to sample an area of an image and copy that sample to another area. The tool is useful in removing imperfections because the tool matches the colors of the sampled pixels with the area around the target imperfection. In addition to matching the color of pixels, the Patch tool matches the lighting, texture, and shading of the sampled pixels to the target receiving area, which can be valuable when doing restoration work.

Clone Stamp Tool

The Clone Stamp tool, like the Healing Brush, is used to sample pixels in one part of an image and clone (copy) them to another part of an image. As in the case of the Brush tool, the size, blending mode, opacity, and flow can be tailored to suit the task. The Clone, Healing, and Patch tools are excellent for removing dust spots and repairing damaged photographs.

History Brush Tool

The History Brush tool provides a freeform way of revealing a previous state of an image. It paints from an earlier or different version of an image onto the current version of the image. You can paint from any step found in the History palette. The History Brush is often used for retouching by applying a filter such as Dust and Scratches or Gaussian Blur (see Chapter 4), or when using the Healing Brush or Patch tool. After applying those effects, you can restore parts of the picture that you do not want to be filtered, healed, or patched by painting from a state prior to the changes and thus blending the old with the new.

The Eraser tools delete or alter pixels. When working on the background layer or with the layer transparency locked, the pixels will be changed to the background color. In other situations, the pixels are erased and become transparent. The Background Eraser samples the color in the center of the brush (indicated by a brush shape with a

crosshair) and deletes that color in the target area. The Magic Eraser

The Type tool is used to create horizontal or vertical type anywhere in an image or make a Type mask in the shape of type. Any font that is properly installed and available to your operating system can be created. You can format the text in numerous ways, including font, size, style, color, alignment, horizontal or vertical orientation, justification, kerning, indenting, leading, and line spacing. Additionally,

tool changes or erases all similar pixels within a certain tolerance (tonal range).

Fill Tools

The Paint Bucket tool fills an area with the foreground color. Like other tools with a tolerance setting, the Paint Bucket will replace all of the adjacent pixels that fall within the specified tolerance range. The Gradient tool works with the foreground and background colors to create a gradient between the two colors. It also allows you to apply graduated color fills or effects that blend from one color or effect to another.

The Dodge tool is used to lighten a portion of an image, such as an object in shadow. The Burn tool is used to darken areas of an image, such as in edge burning, where the corners are slightly darkened to help keep the viewer's eye from wandering out of the composition. The size of the tool, the range (highlights, midtones, or shadows), and exposure can be defined and controlled.

you can stretch and warp the shape of the text in a variety of ways.

Eyedropper (Color Picker) Tools

The Eyedropper and the Color Sampler can be used for gathering color data for adjustment and comparison purposes. The Eyedropper tool samples color of selected pixels to designate a new foreground or background color. The Eyedropper can be used in conjunction with the Info palette to read color values from your images as well as the X and Y coordinates of the cursor.

The Zoom tool increases or decreases the screen magnification of images, but not the printed size of the image. Changing the size of the image on the screen allows one to see the image in greater or lesser detail, which is invaluable when making detailed corrections.

Additional Photoshop Tools

Masks

When you select part of an image, the area that is not selected can be "masked" or protected from editing. When creating a mask, you isolate and protect areas of an image as you apply color changes, filters, or other effects to the remainder of the image. Masks are also utilized for complex image editing, such as gradually applying color or filter effects to an image.

Quick Mask is a temporary mode that is used to precisely define and edit selections, which can then be saved and used again. With Quick Mask, you can make selections using the Brush tools and then let color and opacity settings differentiate which items are fully selected and which are partially (semi-transparently) selected. It also allows you to preview your selection.

Layers

Layers increase the creative control and flexibility of image building by allowing you to work separately on the various image components, such as a background color, shapes, selections from other images, and text. By clicking on the Create New Layer button, new additional layers or levels can be added (see Figure 8.22). Thus, a final composite image can be made up of numerous layers that are stacked in an order hierarchy. This order can easily be changed by dragging a layer from within the Layer window to another level or position. Moving a layer to the top makes it the most accessible layer, and the other layers fall below it in descending order. The opacity levels are set for each layer independently when a layer is active and selected. The controlling opacity comes from the Opacity window located in the top right corner of the Layer menu. You can work on each layer as if it were an independent image without interference from any graphical elements that are on other layers. Each time you paste something into a Photoshop image, a new layer is created containing the new content, so creating new layers in your image is automatic.

Changing Mouse Pointer

When tools are selected, the mouse pointer matches the tool icon. Many of the drawing and painting tools are circles, which represent the selected width. Each cursor has a hot spot where the effect

8.22 Layers: You can create an unlimited number of layers and name them separately.

begins — for example, the tail of the lasso's loop for the Lasso tool is where the selection begins.

Option/Shift/Command Keys

Knowing when to the use the Option, Shift, or Command keys in conjunction with the active tool is necessary to use many of the tools and their functions. For example, using the Option (Mac) or Alt (PC) key with the Zoom tool changes the mouse pointer to a plus or minus sign, allowing one to zoom in or zoom out of the image on screen.

Box 8.6 Good Computer Data Habits

- Save Often: Problems with the power supply, misread data, and/or mechanical failure can make your digital data inaccessible. Frequently saving data, every 15 to 30 minutes, is the only way to avoid problems and frustration. When working on important projects, make copies on a reliable removable medium, such as a portable thumb drive, for safekeeping.
- Delete Old Files: A hard drive filled with old files can become a liability by preventing you from having an adequate scratch disk. Free up space by transferring nonactive files to a backup storage medium such as a hard drive or disk.
- Back Up: Make regular, at least weekly, backups on an external storage device, including off-site Web storage. Files can be corrupted by a computer virus (a malicious program designed to infect computers and destroy or interrupt data) or even through everyday use.

Also, using the Shift key with the Magic Wand allows you to add to your previous selection, allowing you to group many selections.

THE COMPUTER AS A MULTIMEDIA STAGE: MOVING IMAGES

Moving images, or video, represent time and space differently from still images. With video, a viewer tends to get involved within an open flow of events, while a still image is a distillation that invites a tighter viewing and interpretation. The assembling and editing of video images on a computer is known as nonlinear video. Software packages edit video by creating fragments called *clips*. A video clip

8.23 Original image capture. © Barry Andersen. *Sheep and Stand Stone, Avebury, England*, 1995. 10 × 12-1/2 inches. Inkjet print.

can be combined with sound, previewed, and altered in much the same way as a single image.

Cell animation programs, many of which are vector drawing programs, manipulate discrete objects and create the illusion of movement by showing sequential frames with incremental motion. The cell elements can be independently controlled, allowing the background to remain stationary while objects in the foreground display motion.

QuickTime movies incorporate a series of compression PICTS and allow moving images and sound to be created, stored, and

8.24 "I am interested in the interface of humans and the land and the beauty that often takes place in peculiar ways at this intersection. The original image had a bare, overcast, bright sky and the right side of the picture dropped to a cluttered, deep space. These things left the image unsatisfactory to me for years until I began using digital tools. I replaced the sky with a sky shot earlier in England. The picture changed dramatically. I then copied the left hillside, changed its shape, and added textural and color variations to improve the right side of the picture. I then replaced the color of the brown grass near the sheep with a greener color and removed the bird droppings from the stone. This picture is one of my most heavily manipulated pictures but utilizes pictorial methods generally taken for granted by painters. It was a major breakthrough for me of freedom from the lens-formed image."

 \odot Barry Andersen. Sheep and Stand Stone, Avebury, England, 2000. 10 × 12-1/2 inches. Inkjet print.

viewed. QuickTime movies compensate for the speed of your computer, keeping the sound properly synchronized with the picture.

Three-dimensional modeling programs are vector drawing programs that have the capability to render an object and simulate the effects of light. The completed object can be viewed from any angle and direction. Three-dimensional modeling programs are often coupled with an animation component that allows a piece to be presented as a movie.

THE INTERNET AND THE WORLD WIDE WEB

The Internet, also known as the Net, is a global, publicly accessible system of interconnected computer networks that transmit data by means of packet switching using the standard Internet Protocol (IP). The Internet is made up of millions of small business, academic, domestic, and government networks which, combined, carry information and services such as electronic mail (email), online chat, and the interlinked Web pages and other documents of the World Wide Web (WWW). By means of a modem, any computer user can send and receive digital data via the Internet to any other user who has a modem, even if the other person's computer is turned off. Online data services allow one to download an image file and electronically mail it to other users. The down side to the Internet continues to be the time it takes to transmit data, service interruptions, and compatibility issues, especially with image files.

The Internet and the World Wide Web are not one and the same: the Internet is a collection of interconnected computer networks, linked by copper wires, fiber-optic cables, and wireless connections, whereas the Web is a collection of interconnected documents, linked together through hyperlinks and URLs (Web addresses), which is accessible though the Internet. In addition to the multifaceted physical connections that make up its infrastructure, the Internet is essentially defined by its interconnections and routing policies that are the result of commercial contracts and technical specifications (protocols) that describe how to exchange data over the network.

Information Sharing: Search Engines and Weblogs

The Web offers a unique environment for sharing information, images, and other data. By means of keyword-driven Internet search engines, such as Google, people throughout the world can access vast and diverse amounts of online information. The World Wide Web has enabled a sudden and extreme decentralization of information and data to take place, making traditional encyclopedias and libraries seem quaint and arcane. Numerous individuals, groups, and companies use Weblogs (or *blogs*), which are basically easily updatable online diaries to share thoughts and images.

Digital Galleries

Digital galleries and artist websites have become major presentation venues for displaying images. Where once mainline brick-and-mortar art centers and big media had the power to make or break artists, the potential is now there for artists to utilize new digital media to their advantage and allow additional flowers to bloom.

Viewing images in a gallery setting is quite different from looking at images on a computer monitor or in a book. A 4×5 foot image carries a distinctly different message from one that is 8×10 inches. The computer screen changes these circumstances by making all images roughly the same size and having them viewed by transmitted light instead of reflected light. The aura of a gallery setting is replaced by the appearance of the desktop. Work made specifically for the Web has been embraced by important galleries and museums, such as the Guggenheim Museum, which has been commissioning and collecting online art into its permanent collection alongside traditional media. It has become a must for imagemakers and galleries to represent their work online, and as serious imagemakers expand their use of the Internet, the presentation, selection, and quality of images continue to develop and expand.

THE DIGITAL FUTURE

The rationale for working with any photographic process should be embedded within the context of the imagery being created. Since the 19th century, camera-based imagery has followed three mainline processes: silver, digital, and hybrid. The silver process is rooted in the hands-on chemical darkroom dating back to the origins of photography and offers the benefit that one's knowledge and equipment can last for many years. The digital system encourages quick and accurate image construction through the convenience of a dry darkroom, but demands a constant investment in learning and technology due to its ever-changing knowledge base and its attendant equipment. The hybrid approach combines desired aspects from both models to deliver results that may not have been possible within the realm of one method, but it is largely a stopgap measure that is diminishing in importance as the influence of silver wanes and digital waxes.

Critics charge that digital technology is a copycat medium that has a long way to go before it can be considered a mature visual medium, and digital imagemakers spend most of their time working through computer techniques instead of wrestling with conceptual issues. Digital imagemakers should bear in mind that these same issues and arguments were made about color photography a few generations ago. During the first few decades after World War II, the equipment and materials for color photography were beyond the means of the average photographer, who had to rely on technicians in commercial labs to print their images. Through the mid-1970s, the major art museums, such as the Museum of Modern Art in New York (MoMA), questioned the artistic merit and the archival viability of color photographs. Before MoMA photography curator John Szarkowski opened the gates of the temple by exhibiting William Eggleston's color images in 1976, the art establishment and most serious photographers looked down their noses at color photography as either being part of the vulgar world of advertising or off in the realm of kitsch family snapshots.

Detractors of digital imagemaking declare it has no soul because its operations are carried out by unseen electronic algorithms and not by the hand of the maker. If this lack of physical connection and chance operations are something that you want to experience or desire, find the opportunity to work in a traditional darkroom once you are comfortable with the digital basics to see how it affects you and your work.

In the end, none of this should matter, as it is the artistic and technical abilities of the imagemakers, their handling of subject matter, and audience reaction that will determine the direction and content of the work. Over the past few years, artistic, economic, and environmental concerns, along with a new generation of imagemakers who have grown up with digital technology as well as changing audience expectations have led to an unexpectedly rapid decline in silverbased photography. Digital tools are advancing at breakneck speed,

8.25 A careful combination of photography and drawing along with darkroom manipulations and text lead viewers to interpret the metaphors within the imagery dealing with astrology as a way in which humans attempt to know the unknowable. "Illegible text, arcane symbols, and random numbers force viewers to consider man's insatiable need to anticipate his own fate. Romantic 19th-century notions are enhanced by the nostalgia that accompanies historic photographic imagery. The process of traditional printmaking and the magic of the darkroom call into question what people are willing to believe in general and what they are willing to believe in a 'traditional' photographic image." © Carol Golemboski. *Planisphère Céleste*, 2003. 17-1/4 × 17-1/4 inches. Toned gelatin silver print.

making it both easier and more acceptable to work within the essence of classic photography by providing imagemakers with new and simpler traditionally based "correction" tools as well as providing powerful innovative means to alter the content of their vision. As the quality and variety of digital images open up, ingenious makers will to find new applications in art, business, entertainment, and science, creating new pathways for the digital image to travel and making it a ubiquitous part of daily life.

REFERENCES

- DiNucci, Darcy, et al. *The Macintosh Bible*. Ninth Edition. Berkeley, CA: Peachpit Press, 2004.
- Evening, Martin. Adobe Photoshop CS3 for Photographers: A Professional Image Editor's Guide to the Creative Use of Photoshop for the Macintosh and PC. Boston & London: Focal Press, 2007.
- Galer, Mark. Digital Photography in Available Light: Essential Skills. Third Edition. Boston & London: Focal Press, 2006.
- Galer, Mark, and Philip Andrews. *Photoshop CS3: Essential Skills*. Boston & London: Focal Press, 2007.
- Grotta, Daniel, and Sally Weiner. *Digital Imaging for Visual Artists*. New York: Windcrest/McGraw Hill, 1994.
- Long, Ben. Complete Digital Photography. Third Edition. Hingham, MA: Charles River Media, 2004.
- Mitchell, William J. *The Reconfigured Eye: Visual Truth in the Post-Photographic Era*. Cambridge, MA, and London: MIT Press, 1992.
- Ritchin, Fred. In Our Own Image: The Coming Revolution in Photography. New York: Aperture Foundation, 1990.
- Spalter, Anne Morgan. *The Computer in the Visual Arts.* Reading MA: Addison-Wesley Pub Co., 1999.

MANUFACTURERS' WEBSITES

Check manufacturers' websites for product details, tutorials, and customer support. Some of the majors include:

Adobe	http://www.adobe.com/
Apple	http://www.apple.com/
Canon	http://www.canon.com/
Epson	http://www.epson.com/
Kodak	http://www.kodak.com/
Hewlett-Packard	http://www.hp.com/
Nikon	http://www.nikon.com/
Olympus	http://www.olympus.com/
Sony	http://www.sony.com/index.php

8.26 Michael Light created a conceptual meditation on the nature of the atomic bomb by digitally "cleaning up" historic imagery into a textless artists' book that was published in six worldwide trade editions. "The challenge was to fashion a narrative that could modulate a viewer's emotions of an apocalypse in order to reveal something that was not previously seen or understood without generating 'war porn' from such intrinsically terrifying images. Digital tools made the entire process, involving both the book and then an exhibition, easier." The project title, *100 SUNS*, refers J. Robert Oppenheimer response to the world's first nuclear explosion when he quoted the *Bhagavad Gita*, "If the radiance of a thousand suns were to burst forth at once in the sky, that would be like the splendor of the Mighty One ... I am become Death, the destroyer of worlds."

© Michael Light. 045 Stokes, 19 Kilotons, Nevada, 1957 from 100 Suns, 2003. 20 × 16 inches. Inkjet print. Courtesy of Hosfelt Gallery, San Francisco and New York.

To craft this parody of the job market, Gitelson created a series of portraits corresponding to his idea of who might be answering each job posting. Gitelson sought out an intriguing setting for his models and carefully selected the props. "For the text portion of this piece, I scanned a page from *The Chicago Reader* want ads and inserted an imagined ad using Photoshop. I then printed the new page (with my ad in place), circled the ad that I had inserted, and rescanned the new image." The tongue-in-cheek text within the red highlighted box reads: ART DIRECTOR. Cool underground magazine is seeking a young and inexperienced artist to create page layouts. Our specialties consist of blown-out photographs and polaroids, hip music reviews and left wing political ranting. If you are between the ages of 28–30 and enjoy dressing casually, listening to music in the workplace, video games and going out for drinks at the end of the workday, this could be the job for you. Contact our offices at (773) 863-COOL (2665).

 \odot Jonathan Gitelson. The Art Director, 2003. 18 × 6-1/2 inches. Inkjet, page in artist's book, Dream Job, and as an interactive website.

Chapter 9

Presentation and Preservation

DIGITAL RETOUCHING AND REPAIR

After you've made a successful digital image, you might want to physically present it and most likely want to properly store it for future use. First, you should make sure that any visual defects, including dust marks, have been corrected before making final prints, which means using a few of the retouching and repair tools. Those same tools in your digital imaging software can also help you restore faded images as well as color negatives and transparencies (slides). Additionally, such software offers potent tools for retouching and repairing traditional photographic images. A moderately to severely damaged image can be scanned, electronically repaired, and then reprinted (see Figure 9.1). One of the most important advantages of repairing an image digitally is that, after the image is scanned, the original image is not touched and cannot be accidentally damaged further during the repair or retouching process. Some of the most useful software tools for image retouching and/or repair are described in Chapter 8.

ARCHIVAL PRESENTATION

Although manufacturers readily use the term *archival*, there is not accepted criterion of what archival actually means. What we do know is that every image has a natural life span, and the length of that life span depends on the particular materials and process used and the conditions under which the image is cared for. The purpose of archival presentation is to protect the image from physical harm and to guard against elements that accelerate the aging process (see the section on Print Preservation later in this chapter). This ensures an

9.1 In preparation to repair this damaged cabinet card photograph made by Hartley's Studios, Chicago, Illinois, circa 1890s, Greg Erf scanned both pieces of the torn image separately and then brought the scans together into a single file. Erf used the Healing Brush, Patch tool, and Cloning Stamp to copy the missing visual information along the tear and to cover up the white streaks from the areas immediately next to them. He then adjusted the contrast using Levels; color was adjusted using Color Balance, Hue, and Saturation; and then the image was finally sharpened.

image can last as long as physically feasible. A competent presentation job can enhance the visual appeal of a work, protect it, and send the message that this work is something worth looking at and protecting. Sources for materials and supplies are provided in Box 9.5 at the end of this chapter.

Presentation Materials

Mat board is the long-standing choice for providing a stiff backing and basic protection for photographic prints. Making thoughtful choices is essential as the color, quality, and texture of mat board will effect how viewers receive your images.

Mat Board Selection

To select the proper type of mat board, you should become informed about how various products affect paper support materials. Check with manufacturers for their latest products and their technical specifications. Consider the following factors: 1. Composition board is the most widely available and has the least longevity. Usually, composition board is made up of three layers: a thin top paper sheet, typically colored; a middle core layer, made of chemically processed wood pulp; and a bottom paper backing. The core layer is the product's weakness, because it contains a collection of acids and chemical compounds that break down and produce additional acid. These acids are transported in microscopic amounts of airborne water vapor onto the surface of your work. Here they begin attacking the image, often within a year or two, causing discoloration and fading. UV radiation from the sun and/or fluorescent lights can accelerate this chemical reaction too.

The same thing can happen when a work is backed with corrugated cardboard or Kraft paper. The acids in these materials invade the work from behind, and by the time it becomes apparent, there is irreversible damage.

- 2. Conservation-grade board consists of thin layers, all of the same color, known as plies. One type of board is made from purified wood pulp and is simply known as conservation board. The other type is made from 100 percent cotton fiber and is called rag board. Plain conservation board can be used for most archival operations, since it costs less, has equal longevity, and is easier to cut when making window mats. Most board is available in two, four, six, or eight plies. Four-ply board is good for most standard photographic presentations.
- Acid-free board is recognized as the board of choice. Paper products having a pH of 7 or higher are considered to be acid-free. The pH scale measures the most acidic (pH 1) to the most alkaline

(pH 14), pH 7 being neutral. The "acid-free" label is an important criterion, but there are a number of factors to consider when making a selection. This is because the term acid-free can be very misleading and at face value should not be considered the gold standard of a board's permanence. In fact, some manufacturers put only a piece of acid-free paper behind the wood pulp of composition board and then label their product "archival." Others have added regular wood pulp that has been heavily treated with alkaline calcium carbonate and refer to it as "archival." This is in spite of the fact that, over time, the impurities in the board deteriorate and form acids and peroxides, thus producing or returning to a highly acidic board. When selecting acid-free board, be sure to find out if all the materials in the board are 100 percent acid-free, as this will offer your work the most protection.

Buffered and nonbuffered board is presently being debated in the conservation community. Since our physical surroundings are slightly acidic, and because paper tends to become more acidic with age, manufacturers of premium mat board have been adding calcium carbonate to offset this tendency. Current research indicates that certain papers may be affected by the presence of this alkali buffer, and that for longest life, they should be mounted only on nonbuffered, acid-free board. This recommendation also applies to all color chromogenic prints processed in RA-4 chemistry, such as Lightlet prints.

265

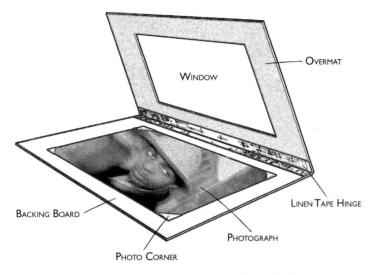

9.2 The construction of a typical hinged window mat. The use of photo corners facilitates removing the photograph from the mat without harming it.

Window Mat

The window mat, considered the standard enclosure for photographic prints, is made up of two boards, larger in all dimensions than the print. The top board, known as the *overmat*, has a window with beveled edges cut into it to keep the overmat from casting its shadow onto the print. This overmat is attached, with a linen tape hinge, along one side of the backing board. The print is positioned and attached to the backing board so it can be seen through the window (Figure 9.2). The mat gives the maximum protection to the print while it is being shown and also when it is stored. It provides a raised border to contain the work, and when the work is framed, it keeps the glass

from directly touching the print surface. If the window mat is damaged or soiled for any reason, it can always be replaced without damaging the print. An acid-free tissue paper can be sandwiched over the print surface for additional protection.

A mat can be cut with a hand mat cutter, such as a Dexter or Logan, which requires practice before using. Most people can cut a mat with a device such as the C & H mat cutter. For those who have only an occasional need of a mat, have a local frame shop make one for you.

Keep in mind the type of light the print will be viewed under when selecting mat board. Daylight tends to have a blue cast, incandescent light is orange, and fluorescent light is generally greenish.

To make a window mat follow these steps:

Dry and Wet Mounting

Traditionally, dry mounting was the most common way to present a finished print for display. It is a fast and neat method to obtain print flatness, which reduces surface reflections and gives the work more apparent depth (see also the next section on Cold Mounting). Prints can also be wet mounted with glues, paste (Gudy paste is archival), and liquid and spray adhesives, which can be useful when time is of the essence or when working with certain nontraditional materials.

There are a number of problems resulting from dry mounting:

- **1.** A finished print can be ruined by dry mounting through accident and equipment or material failure.
- **2.** After the print has been dry mounted, changes in heat and humidity, especially if the prints are shipped, can cause the

- 1. Clean your hands, working surface, and all materials.
- 2. Work under light similar to that under which the print will be seen.
- 3. Protect the cutting surface with an unwanted piece of board that can be disposed of after it gets too many cut marks. If you are planning to cut mats on a regular basis, consider getting a selfhealing cutting mat surface with a grid pattern and non-slip bottom.
- 4. Using a good, cork-backed steel ruler, measure the picture exactly. Decide on precise cropping. If the picture is not going to be cropped, measure about 1/16 to 1/8 inch into the picture area on all sides if you do not want the border to be seen.
- 5. Decide on the overall mat size. Leave enough space. Do not crowd the print on the board. Give it some neutral room so the viewer can take it in without feeling cramped. Box 9.1 offers a general guide for the minimum size board with various standard picture sizes.

Many photographers try to standardize their sizes. This avoids the hodgepodge effect that can be created if there are 20 pictures to display and each one is a slightly different size. It also allows you to swap prints and reuse the mat. When the proper size has been decided, cut two boards, one for the overmat and the other for the backing board. Some people cut the backing board slightly smaller (1/8 inch) than the front. This way there is no danger of its sticking out under the overmat.

6. In figuring the window opening, it is helpful to make a diagram (Figure 9.3) with all the information on it. To calculate the side border measurement, subtract the horizontal image measurement

from the horizontal mat dimension, and divide by two. This gives even side borders. To obtain the top and bottom borders, subtract the vertical picture measurement from the vertical mat dimension and divide by two. Then, to prevent the print from visually sinking, subtract about 15 to 20 percent of the top dimension and add it to the bottom figure.

- 7. Using a hard lead pencil (3H or harder to avoid smearing), carefully transfer the measurements to the back of the mat board. Use a T-square to make sure the lines are straight. Check all the figures once the lines have been laid out in pencil.
- 8. Put a new blade in the mat cutter. The C & H cutter uses a singleedge razor blade with a crimp in the top. Slide the blade into the slot and adjust it so that it extends far enough to cut through the board. Hand tighten only, using the threaded knob at the end of the bolt.
- 9. Line the markings up with the mat cutter so that it cuts inside the line. Check that the angle of the blade is cutting at 45 degrees in the "out" direction for all the cuts, to avoid having one cut with the bevel going in and the other with it going out. Practice on some scrap board before working on the real thing. When ready, line up the top left corner and make a smooth, nonstop, straight cut. Make all the cuts in the same direction. Cut one side of the board, and then turn it around and cut the opposite side until all four cuts are made. With the C & H mat cutter, start the cut a little ahead of where your measurement lines intersect and proceed to cut a little beyond where they end. With some practice, the window will come right out with no ragged edges. If you continue to make overcuts, simply stop short of the cut.

Be sure to angle the blade to agree with the angle of the cut. Sand any rough spots with very fine sandpaper. Erase the guidelines with an art gum eraser so that the pencil marks do not get on the print.

- 10. Hinge the overmat to the backing board with a piece of gummed linen tape (see Figure 9.2). The mat will now open and close like a book, with the tape acting as a hinge.
- 11. Place the print on the backing board and adjust it until it appears properly in the window. Hold it in place with print-positioning clips or a clean smooth weight with felt on the bottom.
- 12. Use photo corners to hold the print to the backing board. They will be hidden by the overmat and make it easy to slip the print in and out of the mat for any reason (see Figure 9.2).

Image Size	Mat Board Size
5 × 7	8 × 10
8 × 10	11 × 14
11 × 14	16 × 20
16 × 20	20 × 24

print to wrinkle or come unstuck from the board. This happens because the print and the board do not expand and contract at the same rate. Since they are attached and the board is stronger, the print suffers the consequences.

3. The adhesives in most dry-mount tissue are not archival and can have adverse effects on the print, causing it to

deteriorate. However, there is "archival-grade" dry-mount tissue made out of buffered paper.

- **4.** If the print is dropped face down, it is offered no protection and the print surface can be damaged.
- **5.** If the board is damaged in any way, there is a problem. Conventional dry mounting is not reversible or watersoluble, so it is almost impossible to get the print released undamaged from the dry mount. This makes replacement of a damaged board extremely difficult. There are low-heat drymounting tissues that claim to be heat reversible.
- **6.** Many papers, especially glossy inkjet paper, react negatively to heat. High temperatures can produce blisters, color shifts, mottling, loss of glossy finish, and/or smearing.
- **7.** Other methods of dry mounting with spray mounts and glues are not recommended because the chemical make-up

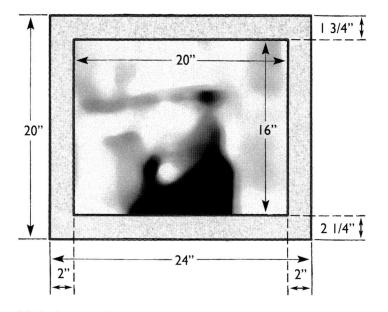

9.3 The dimensions of a window-type overmat for a 16×20 inch print on a 20×24 inch board. More space is usually left on the bottom of the mat than at the top to keep the print from appearing to visually sink on the board. The side borders are generally of equal dimensions.

of these materials can have an adverse effect on all prints over time.

8. Curators and collectors no longer dry mount work that is received unmounted. It is also not advisable to dry mount unless you made the print yourself or there is a duplicate available. If you still want to dry mount after considering these problems, use only a matte surface paper and follow the guidelines in the next section.

The Dry-Mounting Process

Dry-mounting tissue is coated with adhesive that becomes sticky when it is heated. This molten adhesive penetrates into the print and mounting board and forms a bond. It is best to use a tacking iron and a dry-mount press to successfully carry out the operation. A home iron is not recommended because it can create unnecessary complications.

When mounting an inkjet or laser print, be certain that the drymounting tissue has been designed for use with that particular paper or the print may blister and/or melt. Usually a specially formulated archival-grade temperature-reversible adhesive tissue is recommended. It provides a safe bond that will not attack delicate items such as inkjet prints, silk, tissue, and rice papers. Check before proceeding.

Use four-ply mounting board so that the print does not bend. Keep the color selection simple. Use an off-white or a very light graycolored board. The board should not call attention to itself or compete with the picture. To obtain maximum print life, use a nonbuffered, acid-free board. Regular board contains impurities that in time can interact and damage the print.

To maintain the integrity of large-scale prints, you may choose to dry mount onto rigid material such as aluminum. This procedure can be done commercially using a special laminate.

Use these steps in the dry-mounting process. The necessary materials are shown in Figure 9.4.

Cold Mounting

Cold mounting (pressure-sensitive) materials allow for quick and easy mounting of digital prints without heat or electricity. The premium

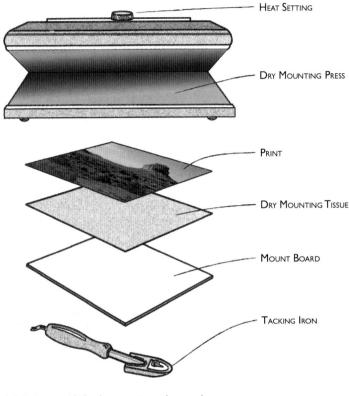

9.4 Basic materials for dry mounting a photograph.

material can be positioned and repositioned for accurate alignment before it is adhered, but may require its own special applicator which might not work with certain receiving materials such as foam core. Mounting sprays can also be used but must be applied with care because you get only one chance to exactly position the print on the receiving board. Cold and spray mounting are the least desirable methods in terms of their archival qualities. Little is known about how these adhesives might change over time, and they are difficult or impossible to reverse should future circumstances warrant removal. Therefore, they are only suggested when time is of the essence and long-term preservation is not a concern.

Floating a Print

Some prints do not look good matted or mounted. The board and/or borders interfere with the workings of the picture space. In such instances, "float" the picture following the guidelines below.

- **1.** Decide on the final picture size.
- **2.** Working on a clean, level surface, trim the print to these dimensions.
- **3.** Cut a nonbuffered, acid-free backing board or acid-free Fome-Cor to the same size as the print. Acid-free Fome-Cor will not chemically interact with the picture and is cheaper than archival board.
- 4. Cut Plexiglas to size.
- **5.** Sandwich together the Plexiglas, print, and board using a frameless device such as Swiss Corner Clips, and it is ready to hang.
- **6.** Clean the surface only with Plexiglas cleaner, as regular glass cleaner can damage the Plexiglas.

- 1. Make sure all materials and working surfaces are clean and level. Wipe all materials with a smooth, clean, dry cloth. Any dirt will create a raised mark between the print and the board.
- 2. Turn on the tacking iron and dry-mount press. Allow them to reach operating temperature. Check the dry-mount tissue package for the exact temperature because it varies from product to product and set the press to that temperature. Using a temperature that is higher than recommended will damage the print.
- 3. Pre-dry the board in the press. This is done by placing a clean piece of paper on top of the board (Kraft paper is all right but should be replaced after each mounting operation). Place this sandwich in the press for about 15 to 30 seconds (depending on the thickness of the board and the relative humidity). About halfway through this procedure, momentarily open the press to allow water vapor to escape, and then close it for the remaining time. This should remove any excess moisture.
- 4. Place the print face down with a sheet of mounting tissue at least the same size as the print on top of it. Take the preheated tacking iron and touch it against a clean piece of paper that has been placed over the tissue in the center of the print. This one spot should be just sufficient to keep the print and the tissue together. Do not tack at the corners.
- 5. Trim the print and tissue together to the desired size. Use a rotary trimmer, a sharp paper cutter, an X-Acto knife, or a mat knife and

a clean, cork-backed steel ruler. If you flush mount, the corners and edges of the print are susceptible to damage and it cannot be overmatted unless you crop into the image area.

- 6. Position the print on the board. The standard print position has equal distance on both sides and about 15 to 20 percent more space on the bottom than at the top. If there is not more space at the bottom, the print appears to visually sink or look bottom heavy when displayed on a wall. Carefully make the measurements using a good, clean metal ruler, and mark the board in pencil to get a perfect alignment.
- 7. Align the print and tissue face up on the board according to the pencil marks. Raise one corner of the print and, with the iron, tack that corner of the tissue to the board. Next, tack the opposite corner. Now do the remaining two. The tissue must be flat or it will wrinkle.
- 8. Put this sandwich of print, tissue, and board with a cover sheet of clean paper on top into the press. Make sure it is at the proper operating temperature for the materials. Close and lock the press and heat for the recommended time, usually about 30 to 45 seconds. Check the product for exact times.
- 9. Remove the sandwich and place it on a level surface under a weight to cool. Seal makes a special metal cooling weight for this purpose.

PRESENTATION AND PRESERVATION

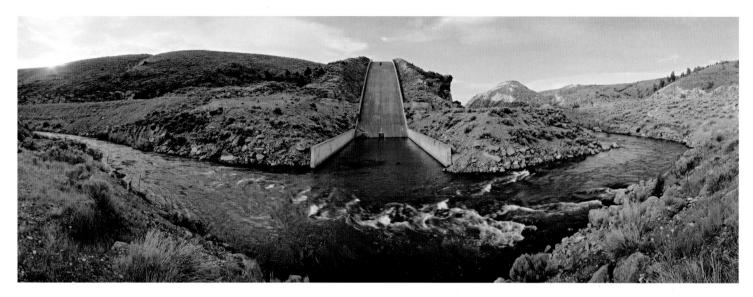

9.5 "This image, dealing with the ill-fated Teton Dam Project, was made with a rotating panoramic camera, the Seitz Roundshot. This camera enables me to recreate a photograph that allows the viewer to experience the scene as one would experience it in person. The preferred method of display is to mount the photograph onto a curved surface, which allows a viewer to stand in front of the photograph and have their entire periphery filled with the photograph. The installation hangs the image on an arc surface. The viewer stands at the center of the half-circle and is then surrounded by the 180 degrees of the photograph hanging on the wall." © Jonathan Long. *Teton Dam and Spillway, East Idaho*, 2005. 36 × 108 inches. Chromogenic color print.

Frames

Often a print needs a formal frame to indicate its completeness and set up a ceremonial picture-viewing space. Inexpensive neutral frames made of metal or wood are available at big box discount stores. Used frames of all sorts, shapes, and sizes can be found in second-hand shops. The purpose of a frame is to provide a recognizable, conceptual structure that accents the image and focuses attention inside the picture space. Avoid overstating the frame, unless it is done intentionally for a purpose. Generally, any frame that draws and keeps the viewer's eye, becoming a separate point of focus, is a detraction from the image it is presenting. Ask yourself, Where are your viewers spending their time? Looking at the frame, or looking at your picture in the frame?

Unusual Frames and Presentations

Unlike traditional photography, digital imaging does not have a strict set of formal post-processing traditions. This lack of expectations allows makers and audiences to be more open to special-use frames, such as

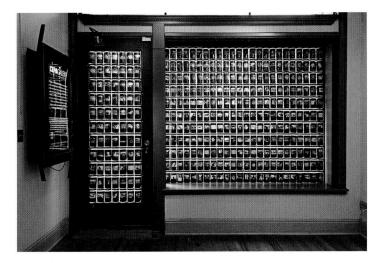

9.6 This installation is a stylized, three-dimensional image catalog representing the infinite and competing geography that has shaped the American culture and psyche from Coronado's time to today. The unusual presentation of over 900 individual jars, each containing an image with two of the same pictures printed on a black field, were placed in all the windows of CEPA's Flux Main Street Gallery to offer a "transparent" viewing experience similar to that of a stained glass window. See 9.7 for an example of the imagery in the jars.

© Robert Hirsch. *Manifest Destiny & the American West* interior (installation detail), 2005. Variable dimensions. Mixed media. Courtesy of CEPA Gallery, Buffalo, NY.

digital picture frames that allow you to upload a series of images and then play them back over and over on the frame's monitor. There are also times when makers purposely create images that are designed to be displayed in unusual containers or frames such as a magnetic frame or even a talking frame, which contains a mini recording device that allows you to record a brief sound message.

Portfolios

Although most digital images remain forever in their virtual state, there are situations, such as when visiting a curator or going on a job interview, when one needs to show actual prints. Although getting a digital print to look good is important, the size of the print is not of particular importance, because once you arrive at a good 8×10 inch print, making an 11×14 or 16×20 inch version is not difficult and it should not look any different. Consider building an 11×14 inch print portfolio of 20 images, something with turning pages and held in a good-quality case, which shows off the strength of your vision. Consider one that opens on three sides with a three-ring-binder mechanism on the spine, onto which you can clip clear heavyweight sheet protectors containing your images. Strive to keep it simple, consistent, and up-to-date.

Books: Print-on-Demand

The print-on-demand business, which started as a method for publishers to save money and resources, is becoming a tool for those who desire a bound document of their own work. Print-on-demand makes it possible to economically produce books singly or in small quantities, and new software simplifies the book design process. For people wanting something simple and straightforward, Kodak's EasyShare Gallery (www.kodakgallery.com) offers a way to produce your own simple books and/or put images on mouse pads, mugs, and tote bags. Websites such as http://blurb.com/ supply free, easy-to-use software so individuals can design their own more elaborate books on coated paper, bound with a linen fabric hard cover, and then wrapped with a dust jacket. Anyone who wants one can buy it, and Blurb will make a copy just for that buyer. www.Lulu.com is a combination printer

and order-fulfillment house that prints both color and blackand-white books, takes orders for them, and places them with online book outlets like Amazon.com. The net effect of this new industry is that it has cracked open the closed and unchanging business of publishing, turning the making of books into a means of expression that is less fixed and more interactive and possessing a greater diversity.

Images on a Screen: Web Sharing

The display screen has generated a mind-boggling, democratic outpouring of images that is rapidly replacing the gallery wall and the book page as the major venues for looking at pictures. Moreover, projected images are becoming a more prevalent presentation method in contemporary imagemaking. Web sharing on sites such as www.photobucket. com that link billions of personal photos, graphics, slideshows, and videos to hundreds of thousands of web sites from Facebook to Craigslist, can be a first step in freeing your images from your hard drive and getting them into visual circulation. Although sites such as http://www. smugmug.com cater to amateurs posting family snapshots, they also offer accounts with professional features that allow people to view, comment, and purchase watermark-protected images. The Websharing trend is also spinning off new ways of interacting with pictures. Websites such as www.snapfish.com allow individuals to organize their pictures, make albums and digital scrapbooks, edit and order prints, and have them delivered by mail or at retail locations. Websharing sites also make it convenient for people to link their images to blogs and social networking sites. Some people have explored mashups (a website or application that combines content from more than one source into an integrated experience), such as using Google's map service (http://earth.google.com) to "geo-tag" pictures and thus create travel albums with context and location by combining maps and photographs.

Website Design/HTML

Once you have a coherent body of work, consider building your own website or hiring an expert web designer to uniquely showcase your visual abilities. There are numerous website tutorials, templates, and web designer resources available on the Internet, which can assist in building a simple website. Study websites you find to be easy to navigate and possess cogent organization and intriguing features. Then incorporate these attributes into your design plan. A successful website involves a commitment, as it needs to be regularly updated or people won't return to it. Keep the focus of this website on your visual work, and leave your private life to http://www.myspace.com.

There are numerous online resources to learn about writing HTML, a simple, universal markup language that allows web publishers to create text and images that can be viewed by anyone on the Web, regardless of what kind of computer or browser is being used. HTML documents, also known as *web pages*, are what your web browser retrieves from web servers linked to the Internet. No special software is required to create an HTML page — only a word processing program and a working knowledge of HTML. Many imaging software programs offer powerful automated features that permit a simple website to be made and posted in minutes. Box 9.2 offers a list of online references that artist, educator, and website designer Michael Bosworth provides to his students.

Specific HTML software programs, such as Dreamweaver and GoLive, offer informative help menu options at the top of the screen.

274 0

Box 9.2 HTML References Online

 For an introduction to writing HTML, go to: http://www.w3.org/MarkUp/Guide/

- The Bare Bones Guide to HTML lists every official HTML tag in common usage. HTML tags are a text string used in HTML to identify a page element's appearance, format, and type. These HTML markup tags tell the World Wide Web browser how to display the text. You can find this guide at: http://werbach.com/barebones/
- For an overview of the entire process, go to: http://www.webstyleguide.com/
- Once a basic understanding is gained, you will want to learn about Cascading Style Sheets at: http://www.w3schools.com/css/css_intro.asp

They also provide excellent pop-up manuals and tutorials. Such programs offer their own program-specific site management tools that are not part of HTML or the Web, but are not necessary to know. The HTML pages created in such programs can be opened and edited in any WYSIWYG editor on any platform, but the site tools only work within the specific program. A WYSIWYG editor or program — an acronym for "what you see is what you get" (pronounced wizee-wig) — allows one to see what the end result will look like while the document is being created.

Print Preservation

There are additional methods of displaying finished prints. Whichever process or material you use, your images can achieve their maximum natural life span if you exercise a few precautions.

Materials to Avoid

It is wise to avoid having any of the following materials in contact with the print, as they can cause damage to your prints over a period of time: animal glue, brown envelopes or wrapping paper, cellophane tape, cardboard, glassine, masking tape, rubber cement, spray adhesives, white glues, and adhesive-coated pages and plastic covers in "magnetic" pressure-sensitive albums. Avoid contact with wood, shellac, varnish, and materials made with PVCs (polyvinyl coatings). Do not write on the back of a print with a ballpoint pen or a Sharpie as they can bleed through and stain the print.

Factors Affecting Print Stability

All the commonly used color printing processes are fugitive, meaning they fade over time. There are two main factors that affect print stability. The greatest enemy is light fading, which is caused by all types of ambient light and UV radiation. The duration, intensity, and quality of the light dictate the rate of change. The second adversary is dark fading, and it begins as soon as the image is made. It is caused by ambient relative humidity and temperature and occurs even if an image is sealed in a light-tight box. Both these processes affect the various color materials that make up an image, but not at the same rate, causing color changes and shifts over time.

Choosing the correct material for specific situations ensures their longest useful life. For instance, regular inkjet papers are not intended to be put on view in direct sunlight in a showroom or studio window. For such circumstances, use special display materials that are designed for the task.

Color Print Life Span

How long will my color pictures last? The answer is we do not know. Information about this question remains under debate, and there is no reliable set of standards or a database that provides definitive responses. Henry Wilhelm, an independent researcher in the field of photographic preservation, provides published tests of many digital and conventional materials, but it should be noted that his findings have not been substantiated by other independent research. For his latest test information, see www.wilhelm-research.com.

What we do know is that inkjet prints can last for a few months or as long other as ordinary color chromogenic photographs (the standard RA-4 wet color print process), depending on the printer, ink, and paper, but they are often more vulnerable to degradation than conventional prints, especially in terms of moisture. In terms of conventional photographs, Kodak claims that images on its latest chromogenic RA-4 color paper will be "acceptable" to most people after more than 100 years in a photo album, without extended exposure to light, and more than 60 years under normal ambient light conditions at home. Claims have been made that expensive, professionally produced pigment-based color prints will last 500 years without fading. With the ever-changing combinations of inks and papers, it is a good idea to check the Web for the latest findings.

Print Display Environment

Avoid displaying prints for extended periods under any bright light, as ultraviolet rays, including sunlight and fluorescent lights, produce more rapid fading. Tungsten spots offer a minimum of harmful UV. Fluorescent lights can be covered with UV absorbing sleeves. Some people have tried protecting prints with UV-filter glazing on the glass. However, Wilhelm advises that this will offer little or no additional protection for most types of color prints. Try to maintain display temperatures below 80 degrees F/27 degrees C. Protect the print surface from physical contact with moisture and from fingers, smudges, or anything that might cause a scratch or stain. Also take care in how prints are stacked in storage.

Storage Environment

Archival storage boxes, with a nonbuffered paper interior, offer excellent protection for color prints. Ideally, color prints should be stored in a clean, cool (50 to 60 degrees F; 10 to 15 degrees C), dark, dry, dust-free area with a relative humidity of about 25 to 40 percent. Avoid exposure to any ultraviolet light source. Use a sealed desiccant (a substance that absorbs moisture) if the prints are subject to high humidity. Keep photographs away from all types of atmospheric pollutants, adhesives, paints, and any source of ozone, including inkjet printers. Periodically check the storage area to make sure there has been no infestation of bugs or microorganisms.

For long-term print protection, consider the following procedures:

- **1.** Make new prints of old images on the latest archival material.
- **2.** Produce two prints of important images on stable material, one for display and the other for dark storage.
- **3.** Make copy prints or scans of all one-of-a-kind pictures, including Polaroids.

DIGITAL ARCHIVES

Digital data is a good candidate for long-term image storage because it can be easily and precisely duplicated. However, one must be aware of its shortcomings.

Transferring Film-Based Images to a Digital Format

To make a complete digital archive of your work, scan any film negatives and prints before storing them. To be useful, the original scans need to accurately capture color and detail. Many consumer film scanners do not have the resolution necessary to capture all the information in a negative or print, especially highlights and shadow detail. It may be worth the extra expense to obtain a top scanner or get high-end scans done at a service bureau. Bring snapshots to a photoprocessor with a high-speed scanner that quickly digitizes the images and burns them to a disk along with thumbnail printouts. Always back up the new files.

It is a wise idea to start using an image management program to organize your digital archive. There is an array of options available for sorting, cataloging, and archiving your digital images, from simple freeware to sophisticated professional programs. Check them out online to see what is appropriate for your needs.

Long-Term Storage and Migrating Digital Archives

A convenient way to move and save digital information is with a pocket flash drive. However, currently the most archival way to store electronic data is on CD-ROM. Many factors may contribute to the stability of the CD-R and DVD-R media, but their dye type is one of the more important ones. Based on test results for CD-R media, this expectation appears to hold true, even with mixed results for the

dye types. Disks containing phthalocyanine dyes (pronounced *thalosy-a-neen*) performed better than other dye types. Specifically, phthalocyanine combined with a gold-silver alloy as a reflective layer tested consistently more stable than all other types of CD-R media. Disks using azo dye as the data layer showed less stability in light exposure and temperature/humidity stress testing. Media using cyanine dye performed well when exposed to light but had problems when under temperature/humidity stress conditions. A few companies claim that their Gold CD-R, which uses a pure gold reflective layer to provide superior stability, has a life expectancy of at least 100 years. Check manufacturers' websites for the latest information. For a detailed U.S. government report, "Care and Handling of CDs and DVDs — A Guide for Librarians and Archivists," see http://www.itl.nist.gov/div895/carefordisk/CDandDVDCareandHandlingGuide.pdf.

Tyvek sleeves are recommended for long-term storage of CDs and DVDs.

A big issue is whether or not there will be a device to read CDs in 100 years. It is unlikely that current CDs and DVDs will be widely used 10 or 20 years from now or that current file formats will be compatible with software in the future. This is not justification to avoid digital storage. The ease with which digital information can be copied gives one a viable future option to migrate (copy) these images to newer and more archival hardware/software as it becomes available. Magnetic media, such as ZIP disks, are not recommended for long-term storage as they fade over time and can be damaged by heat, humidity, and magnetic and electrical fields. See Box 9.3, Guidelines for Handling Digital Media, and Box 9.4, Long-term Storage Recommendations for Disks. Also refer to Chapter 3's section on Storing Digital Images.

Box 9.3 Guidelines for Handling Digital Media

- Use a quality name brand to reduce risk of data corruption or other technical failures.
- Leave disks in their packaging (or cases) to minimize the effects of environmental changes. Open a recordable disk package only when you are ready to record data on that disk.
- Check the disk surface for dirt and imperfections before recording.
- Handle disks by the outer edge or the center hole.
- Do not touch magnetic recording surfaces.
- Avoid bending or flexing the disk.
- Use a non-solvent-based felt-tip permanent marker to mark the label side of the disk. If possible, only write in the clear center portion of the disk, as the recording layer (the area the laser "reads") is very close to the labeling surface of a disk.
- Do not use adhesive labels.
- Do not use a ballpoint pen to label a disk or allow the label or underside to be scratched.
- Keep dirt, food, drink, and/or other foreign matter from the storage media.
- Store disks in a dust-free environment in a vertical, upright position (book style) in plastic cases specified for disk use.

- Return disks to storage cases immediately after use.
- Store disks in a cool, dry, dark environment in which the air is clean at between 60 and 70 degrees F with a relative humidity between 35 and 45 percent.
- Remove dirt, foreign material, fingerprints, smudges, and liquids by wiping with a clean cotton fabric in a straight line from the center of the disk toward the outer edge. Do not wipe in a circular pattern.
- If a disk must be cleaned, use mild soap and water. Use diskcleaning detergent, isopropyl alcohol, or methanol to remove stubborn dirt or material. Blot it dry with a clean, lint-free, absorbent cloth and avoid rubbing the surface. Never use
 chemical solvents.
- Keep magnetic media away from strong electrical or magnetic fields.
- Annually read a sampling of the digital information to check for degradation.
- Copy the information to another disk or the latest new system every 4 to 5 years to refresh the data and migrate to newer, more archival software, hardware, and materials.
- Have one off-site backup storage facility, such as a website.

Additionally, innovative and powerful external hard drives plus the latest SATA drives are impacting storage practices by allowing more data to be kept at secondary sites, such as on a server, more economically and securely. Rapid change is synonymous with the digital world. What is important to bear in mind is that as technology advances, you need to migrate your digital archives to the most upto-date system of materials and devices. A temperature of 68 degrees F (18 degrees C) and 40 percent relative humidity is considered suitable for long-term storage. Lower temperature and relative humidity, along with Tyvek sleeves, are suggested for extended-term storage.

Box 9.4 Long-Term Storage Recommendations for Disks*		
Media	Temperature	Relative Humidity (RH)
CD & DVD	Less than 68°F (20°C) Greater than 39°F (4°C)	20% to 50% RH
* For archiving recordable (R) disks, use disks having a gold metal reflective layer.		

Post-Production Software

Aperture from Apple and Lightroom from Adobe are two new and competing professional software programs that focus on photo processing. The strengths of these new programs are universal control over entire images with color correction, image density, sharpness, and contrast using elegant interfaces. These new programs are focused on post-production, that is, with universally or globally enhancing image files after initial exposure. They also feature highly developed print and web management tools for ease of sizing and selection of PPI or DPI.

Both of these programs are designed to work with RAW image files made directly from the camera, but they can also function with nearly any image file format. They both take a "nondestructive" approach to image processing, allowing the image currently being corrected to be mirrored and set aside temporarily in the computer's memory where it is safely protected from being overwritten or lost while the file is being worked on. Aperture can save the steps applied to any image as actions that can be applied to other images for quicker production work.

Primarily, these new programs work globally on images, making universal changes to enhance image files with great ease. They can make automatic corrections to batches of images without even opening the image files, which is ideal for production work. The purpose and strength of these new programs is to allow quick, automatic color corrections, auto sharpness, and other auto enhancements of the digital negative with a single click of the mouse or with auto batch-file techniques, thus putting quick and powerful editing enhancements in the hands of professional digital photographers. Both programs provide efficient workflow patterns for high-volume digital output, making common editing and organizational tasks extremely efficient.

What is missing from Lightroom and Aperture is the ability to add, change, duplicate, or alter the content of digital image files. Missing are the many advanced tools, special effects, and filters that give an imagemaker precise and localized control over content and individual pixels that have proven indispensable for some photographers. This next generation of imaging software is focusing on enhancement of the "straight digital negative," whereas current professional imaging software has developed all the tools necessary to meticulously change and create new content, thereby producing imaginative photographic works.

Aperture and Lightroom do not seem likely to replace current advanced digital imaging software programs. Rather, they will shed light on the differences in approaches to photographic imagemaking. Photographers making images to show the world as they find it — "straight" without overt manipulation — can be satisfied with these new programs. Imagemakers interested in creating more abstract and expressive imagery by utilizing digital technology to either alter or combine multiple image files are not likely to prefer these programs, as both currently lack the tools to alter or add new content to the image files. Historically speaking, with the introduction of Lightroom and Aperture, photography again revisits the age-old question of how to best represent and communicate photographic reality and truth in the digital age.

Cataloging Your Image Files

Portfolio 8 from Extensis, View Media Pro from Microsoft, and Picasa, a free program from Google, are representative of several programs that help photographers catalog thousands of their images. It also should be noted that both Lightroom and Aperture provide advanced cataloging features as well. These photographic cataloging programs have the ability to add keywords to each image to help one instantly find, edit, and output any image in one's computer and/or storage device. Each time one of these programs is opened, it automatically locates pictures and folders. The cumbersome organizational tagging task is streamlined with simplified image identification and easy drag-and-drop techniques for adding keywords. Pictures can be organized using visual catalogs, and embedded metadata instantly views, sorts, and manages all your photos. These photographic cataloging programs recognize that digital images are just another form of digital information and can be managed by a single multifaceted program.

REFERENCES FOR DIGITAL ARCHIVES

- Kelby, Scott. The Adobe Lightroom Book for Digital Photographers. Berkeley, CA: New Riders, 2006.
- Krogh, Peter. The DAM Book: Digital Asset Management for Photographers. Sebastopol, CA: O'Reilly Media, 2005.
- McGechie, Estelle. *Apple Pro Training Series: Getting Started with Aperture*. Apple Pro Training Series. Berkeley, CA: Peachpit Press, 2006.

Schwartz, Steve. Organizing and Editing Your Photos with Picasa: Visual Quick-Project Guide, Visual QuickProject Series. Berkeley, CA: Peachpit Press, 2005.

DIGITAL PRINT STABILITY

Since the early days of digital imaging, the inkjet printer has been the mainstay of physical electronic output. When these printers became available to the artist market, imagemakers were impressed with the image quality but were disappointed with their image stability. In the 1990s, a cottage industry sprang up to market different inks and media for different applications, such as black-and-white printing, each one having its advantages and disadvantages.

Dye-Based Inks

Dye-based inks were the first to be developed by printer manufacturers and are the standard inks supplied by computer and office supply stores. Generally these inks have excellent color and saturation but have a tendency to soak into paper, thus making the ink less efficient and subject to bleeding at the edges, producing poor print quality. Dye-based inks fade rapidly because they are inherently unstable and may contain solvents or be applied on specialized paper coatings to promote rapid drying. Dye-based inks must be kept away from moisture as they can bleed, feather, or spot upon contact with liquids or soften and bleed in conditions of high humidity.

Pigmented Inks

Pigmented inks contain other agents to help the pigment adhere to the surface of the paper and prevent it from being removed by mechanical abrasion. Pigmented inks are helpful when printing on paper because the pigment stays on the surface of the paper. This is advantageous, as more ink on the surface of the paper means that less ink is required to create the same intensity of color.

Pigmented inks have a greater resistance to light fading than dyes, but generally have substantially lower color saturation and are not as readily absorbed into paper, which makes them prone to fingerprints, smears, and smudges. Pigmented inks combine the lightfastness of pigments with the brightness of dyes, thereby offering a good compromise.

While the prints tend to last longer and have good color saturation, both dye and pigment inks can appear mottled because of the uneven absorption of the ink. As dyes and pigments can absorb and reflect light differently (they have different spectral reflectance characteristics), they can appear to be a match in daylight but may look like different colors when viewed under tungsten or fluorescent light, a phenomenon known as *metamerism*.

Pigment Inks

Basically, conventional inks are oil-based dyes, while pigment inks are made of tiny chunks of solid pigment suspended in a liquid solution. According to their advocates, pigment inks offer deeper, richer, colors and have fewer tendencies to bleed, feather, or run. Pigment ink and acid-free paper combinations have received archival ratings of more than 200 years by testing laboratories. These labs perform accelerated fading tests using high doses of light and varying humidity to make predictions on how long an image will last before fading becomes substantially noticeable. These predictions have recently been questioned, however, because many have not taken gas fading — a pigment's ability to withstand fading due to prolonged exposure to airborne contaminants such as ozone — into account. Ozone is created by a variety of sources including cars, household cleaners, inkjet printers, and solvents and can fade pigment inks in months.

A word of caution. Inks are constantly being updated and altered. Many companies produce inks that are compatible with name-brand printers, but they may or may not possess the same ingredients and archival characteristics as the original factory inks. Therefore, let the buyer beware, and make sure your printing materials are suitable for your needs and long-term expectations.

Printing Media

Contemporary printers can print on a variety of different media, including gloss and matte paper, acid-free rag, canvas, cloth, and vinyl, among others. The material a digital print is made on often has a greater effect on its longevity and color reproduction than the inks. While acid-free papers are considered the best for image longevity, frequently print life expectancy predictions are based solely on specific inks and paper combinations. Coated papers are available that can improve the color gamut of inkjet prints, make them dry faster, and make them water resistant, but these coatings can destroy an ink's ability to withstand long-term fading. Also, a number of pigment and pigmented inks are not compatible with gloss papers because of ink absorption problems. Media and ink formulations are changing rapidly. You should research the latest information on specific inks and media before beginning your digital project, and consider reprinting images as new and improved materials become available.

Protecting Pigment Prints

With the present selection of inks and media, the best way to protect images is to keep prints made with pigments out of direct sunlight

and present them under glass using only acid-free papers and matting materials. Proper framing can also reduce a print's exposure to harmful atmospheric contaminants.

CAMERA COPY WORK

Preparing work for presentation often necessitates making photographic copies. A digital camera is an excellent choice for doing copy work. Pictures to be copied can be positioned vertically on a wall or laid on a clean, flat surface. The camera may be tripod-mounted or hand-held, depending on the light source and ISO sensitivity. Camera movement must be avoided to produce sharp results. For accurate and faithful results, be sure the camera back is parallel to the print surface and the lighting is uniform. Avoid shadows falling across the picture. Use a slow ISO setting (100) to obtain the most precise color rendition and maximum detail without digital noise.

Lens Selection: Macro Lens/Mode

The selection of lens affects the outcome. With a DSLR, a normal focal-length macro lens is an ideal choice. The characteristics of a true macro lens include a flat picture field, high edge-to-edge definition, and the utmost color correction. This combination delivers uniform sharpness and color rendition, regardless of focus distance, from the center and the edge of the lens.

Zoom lenses with a macro mode can be used, but tend to produce soft (not sharp) results. Bellows attachments, extension tubes, or auxiliary lenses, often referred to as *diopters*, usually supplied in sets of varying degrees of magnification, can convert a normal focal-length lens into a very versatile copy lens.

A macro lens or macro mode can also serve as a postmodern tool. Try rephotographing small sections of images using intrinsic

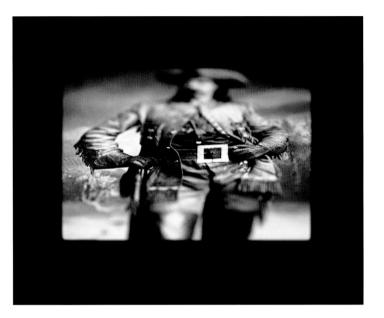

9.7 Copying work can be a time of creative interaction with the source material. Images can serve as models from which new scenes are envisioned using color, focus, light, and selective isolation. In this case, a macro lens was purposely used to generate distortion to give the image a new interpretation and meaning within the context of a larger project that explores the relationships between the people, land, and animals of North America's frontier.

© Robert Hirsch. Wild Bill, from the series Manifest Destiny & the American West, 2005. 40 × 60 inches. Chromogenic color print. Courtesy of CEPA Gallery, Buffalo, NY.

photographic methods such as angle, cropping, focus, and directional light to alter the original's context and meaning.

Copy Lighting

Good results can easily be obtained by using a daylight color balance setting and shooting the pictures outside, on a clear day, in direct

9.8 When copying work, two lights should be set up at equal distances on each side of the camera at 45-degree angles to the work being copied. Meter from a gray card, not off the surface of the work being copied. Make sure the color balance of your camera is set to match the color temperature of your light sources. Polarizing filters can be attached to the lights and/or to the camera to control reflections and to increase color contrast and saturation. Use daylight florescent bulbs instead of "hot" tungsten floodlights to minimize heat and control color balance.

sunlight, between the hours of 10 a.m. and 2 p.m., to avoid shadows, which can create an unwanted color cast.

If copying is done indoors, an ideal lighting source is photographic daylight fluorescent bulbs (5000K), which do not get hot and thus keep both photographer and subject matter at room temperature. Conventional photographic tungsten floodlights (3200K) can be used, but they do get hot and change color temperature as they age. Whatever your lighting source, be certain your camera's color balance setting matches the Kelvin temperature of the copy lights. For con-

9.9 During explores the disjointed isolation of air travel, avoiding namable spaces and landmarks in favor of placeless vistas. Positioning himself opposite of the landscape tradition that emphasizes the character and specificity of place, During describes his subject as "the no-place known as 'in transit.' This place is familiar only as tarmac, blurred lights, rainy windows and open skies. Everyone has been there. When you're passing through, anywhere can become that no-place."

© Arthur During. *Rain Lights*, from the series *Window Scat*, 2005. 36 × 48 inches. Chromogenic color print. Courtesy of Nelson Hancock Gallery, Brooklyn, NY.

sistent results, use two lights placed at equal distances on either side of the camera at a 45-degree angle to the picture being copied to produce even, glare-free light (Figure 9.8).

Exposure

Indoors or outdoors, take a meter reading from a standard neutral gray card for the most accurate results. Metering off the picture itself can produce inconsistent results. Let the gray card fill the frame, but

do not focus on it. For close-up work, the exposure should be determined with the gray card at the correct focus distance. Try to let the image fill as much of the frame as possible, without chopping off any of it. Use a tripod or a shutter speed of at least 1/125 of a second to ensure sharp results. Review your exposures and make adjustments as needed.

PRESENTING WORK ON A DISK

When sending digital images for review, make it easy for your work to be seen. Prepare files that open quickly on any platform. When appropriate, program the images to run in a slide show, which can be stopped to view individual images. Often a review process will involve a number of people, and they may need non-virtual, concrete references. With this in mind, include thumbnail and/or contact size printouts of what is on the disk. Also provide hardcopy of any text documents. Do not expect reviewers to print your files. Include an image checklist that gives the title, date, size, type of output such as inkjet print (if appropriate), of each image so it can easily be identified. Make sure your name is on the disk and that it is in a clean envelope with your complete contact information.

Ensure a Good Welcome

Digital files that are not properly made, correctly labeled and identified, or neatly presented will not receive a favorable welcome at a competition, gallery, school, or job interview. Viewing anyone's work via a disk is at best an imperfect process; therefore, it is essential to put forth your best effort in presenting an accurate approximation of your work. Be sure to include a cover letter and appropriate support materials, such as your résumé, an exhibition list, and a concise statement concerning the work. Make sure each image is clearly identified so the person on the receiving end can easily distinguish which images he or she may be interested in. A separate checklist, referring to the titled or numbered images, should be included, providing each image's title, size, presentation size, and method of output. Be selective, decide what is important, highlight important information, do not bombard the receiver with too much data, and don't inflate your documents with inconsequential, inaccurate, or misleading material.

Shipping

Put disks in clean disk envelopes or clear, nonbreakable cases. Put your name, return address, telephone number, email address, and title of the body of work on the disk envelope or case. Do not send loose disks. Use a padded envelope or include a stiff backing board in the envelope so that your materials cannot be easily bent. Enclose a self-addressed stamped envelope (SASE), with the correct amount of postage, to help ensure the return of your materials. Write "Do Not Bend" on the front and back of the shipping envelope. Do not send original materials unless they are requested. Valuable and irreplaceable materials should be sent by first-class mail with delivery confirmation or via one of the overnight package services. Note that the insurance coverage provided by standard overnight parcel services will only reimburse the material cost of making an image and not the value you place on it.

Copyright of Your Own Work

According to the U.S. Copyright Office in Washington, DC, it is not necessary to place the notice of copyright on works published for the

first time on or after March 1, 1989, in order to secure ownership of copyright; failure to place a notice of copyright on the work will not result in the loss of copyright. However, the Copyright Office still recommends that owners of copyrights continue to place a notice of copyright on their works to secure all their rights. The copyright notice for visual works should include three components: (1) the word "copyright" or the symbol for copyright, which is the letter C enclosed by a circle (©); (2) the year of the first publication of the image; and (3) the name of the copyright owner — for example, © Mary Jones 2009. Copyright notice is not required on unpublished work, but it is advisable to affix notices of copyright to avoid inadvertent publication without notice. It is illegal for photographic labs to duplicate images with a copyright notice on them without written permission from the holder of the copyright. For additional information, see U.S. Copyright Office, Library of Congress, www.loc.gov/ copyright. Take into account that once an image is digitally available, it can easily take on a life of its own, regardless of whether it has been copyrighted or not.

Courtesy of Google, this image spent much time at the top of their image searches for "rain." As a result, this image has been appropriated by thousands of MySpace users and bloggers around the world. Initially resistant to these permission-free appropriations, During has embraced this new fan base and has been collecting screen grabs showing his image as an expressive design element on hundreds of different blogs and personal websites. Ironically, it is the very placeless anonymity of During's images that appear to have led to their popularity on the Internet, with the same image illustrating a wide range of sites, from that of a sad Korean girl to one of kids in an evangelical rock band.

Where to Send Work

There is intense competition for exhibitions, gallery representation, and commercial connections. Be prepared to be persistent and steeled for rejection. Numerous publications and websites identify opportunities. These include *Photographer's Market* (www.writersdigest.com) and *Art in America/Annual Guide to Museums, Galleries, Artists*, 575 Broadway, New York, NY 10012, both published annually; *Afterimage* (www.vsw.org/afterimage); and *Art Calendar* (www.artcalendar .com).

Box 9.5 Sources of Presentation and Preservation Supplies

The following is a partial list of major suppliers of archival materials mentioned in this chapter:

Conservation Resources International www.conservationresources.com

Light Impressions www.lightimpressionsdirect.com

TALAS Division, Technical Library Services http://talasonline.com/

> University Products Inc. www.universityproducts.com

REFERENCES

American National Standards Institute (www.ansi.org). Request their catalog of photographic standards.

- Kaplan, John. *Photo Portfolio Success*. Cincinnati: Writer's Digest Books, 2003.
- Keefe, Laurence E., and Dennis Inch. The Life of a Photograph: Archival Processing, Matting, Framing and Storage. Second Edition. Stoneham, MA: Focal Press, 1990.
- Krogh, Peter. The DAM Book: Digital Asset Management for Photographers. Sebastopol, CA: O'Reilly Media, 2005.
- Logan, David. Mat, Mount, and Frame It Yourself. New York: Watson-Guptill Publications, 2002.
- Wilhelm, Henry, with contribution by Carol Brower. The Permanence and Care of Color Photographs: Traditional and Digital Color Prints, Color Negatives, Slides, and Motion Pictures. Grinnell, IA: Preservation Publishing Company, 1993.

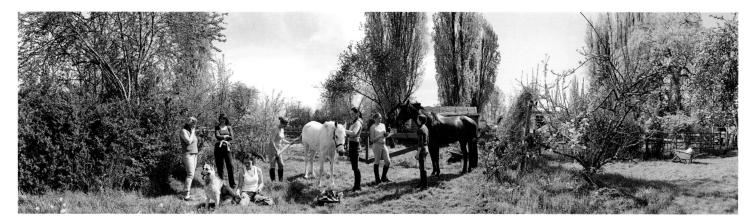

9.10 McFarland endeavors to reconcile a "true" notion of the real with the limited one captured by the camera lens. His work represents iconic notions about the local, linking them to the history of photography as a means of accessing the purity of our original experience. McFarland constructed this image by photographing this scene with a 4×5 inch view camera from morning through afternoon over the course of a spring season. The time of day transforms from morning light on the right side to afternoon light on the left. Scanning and then montaging vertical slices of numerous film images achieved the pre-planned presentation format of an extended horizontal image.

© Scott McFarland. Stables on Dr. Young's Property, 3226 W. 51st, Vancouver, 2005. 40 × 120 inches. Chromogenic color print. Courtesy of Regen Projects, Los Angeles and Monte Clark Gallery, Toronto/Vancouver.

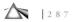

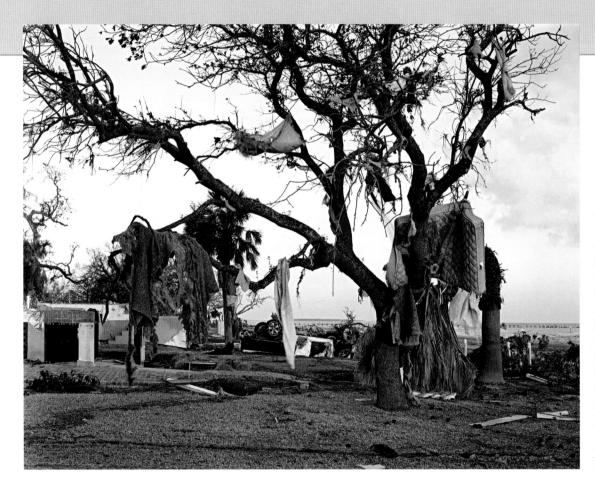

As part of his project, *American Power*, which examines America's cultural investment in energy, Epstein made this picture about 6 weeks after Hurricane Katrina had hit. This straight-on image is one of contradictions. The warm soft light stands in stark juxtaposition with the remnants of personal human items hanging from a bare tree in place of its leaves.

© Mitch Epstein. *Biloxi*, *Mississippi*, 2005. Variable dimensions. Inkjet print. Courtesy of Black River Productions Ltd. and Sikkema Jenkins & Co., New York.

Chapter 10

Seeing with a Camera

THE FRAMING EFFECT: VIEWPOINT

One of the fundamental tasks of any imagemaker is to define what the exact subject of the picture is going to be. The capacity to compose succinctly is what gives clarity and cohesion to a maker's experience. The decisions we make are sensitive to how choices are presented or framed. Being aware that this "framing effect" can influence decisionmaking, one should be attentive to the viewpoint, or vantage point, for it is a crucial basic compositional device that determines how an image is presented and in turn received by viewers. It is such an elementary ingredient that it is often taken for granted and ignored. The angle of view lets an imagemaker control balance, content, light, perspective, and scale within the composition. It also determines the color saturation and whether or not the hues form color contrast or harmony. This chapter is designed to encourage one to eliminate some of the self-imposed limits on the windows by which we visualize the world and to break away from the standardized conventions of representation and through experimentation discover additional ways of presenting your visual voice.

The monitor on your digital camera offers a useful tool for composing and/or reviewing an image (dependent on camera capabilities). Be sure to utilize it to its fullest extent.

Seeing Dynamically

Sunday snap shooters raise their camera to eye level and push the button. An imagemaker explores the visual possibilities of the scene and attempts to find a way to present the subject in accordance with a desired outcome.

How the world is framed is as important as what is in the frame. In *De pictura* (1435), Leon Battista Alberti codified the basic geometry of the linear perspective and instructed painters to consider the frame of a painting as an open window. With the exception of avantgarde work, this notion of the single frame has remained the staple of most imagemakers. Now, however, as an increasing number of digital imagemakers are working with a multitude of windows that can coexist and overlap, this classic concept of perspective is being challenged.

Varying the camera position, the window by which the scene is presented does not require any additional expense or equipment, yet it is the initial first step that can transform a subject and allow it to be seen from an innovative standpoint. It can give viewers more information, let a subject be seen in a way that was not possible before, and/or introduce an alternate point of view. Photo educator Fred Scruton of Edinboro University tells his students that such experiments can help them to break away from their customary sight angles and take them for a visual ride into unfamiliar territory, a ride that can increase their receptiveness to a distinctly photographic visual vocabulary.

Often we go heavy-eyed through the routines of life. We walk down a street without seeing because we have done it countless times before. We act like somnambulists, who know what to expect; everything is in place, with no chance for surprise. To actively see, you must be awake, aware, and open to wonderment and its companion astonishment. In *Art Matters* (2001), Peter de Bolla writes: "Wonder requires us to acknowledge what we do not know or may never know, to acknowledge the limits of knowledge. It is, then, a different species of knowledge, a way of knowing that does not lead to certainties or truths about the world or the way things are. It is a state of mind that, like being in love, colors all that we know we know." Wonderment can be experienced in the ordinary or extraordinary situations and brings with it a sense of amazement, astonishment, awe, and surprise. Being able to visually communicate these powerful feelings is a surefire way of engaging viewers.

When seeing dynamically, you are letting things happen and not relying on past expectations and clichés to get you through a situation. Seeing dynamically involves being conscious of color and space and learning to organize these elements in a persuasive manner. The more you look, the more you can penetrate a subject; in turn, the more you are able to see even more clearly, concisely, and deeply. Put into practice Russian ballet impresario Sergei Diaghilev's exhortation to his sometime artist collaborator Jean Cocteau: "Astonish me!"

Working Methods

Select a subject that inspires personal wonderment and that could produce an astonishing reaction from your viewers. Then proceed to use a combination of viewpoint and light to generate your visual statement. All sorts of questions should be running through your mind at this stage as part of the decision-making process. Answering them requires independent visual thinking and experimentation. Try not to compete with what you have seen others doing. Competition tends to lead to copying of ideas and style. Direct copying means no longer discovering things on your own. Watch out for envy too, as it can also take away from your own direction and inclinations. The most rewarding pictures tend to be those that are made from your heart as well as your mind. Box 10.1 presents some methods to consider. Use your monitor to review and adjust your exposures as you work.

Box 10.1 Viewpoint Working Methods

- 1. Begin with a conventional horizontal shot at eye level, metering from the subject. Walk around the subject. Crouch down, lie down, stand on tiptoes, and find a point that raises the angle of view above the subject. Notice how the direction of light either hides or reveals aspects of the subject. Move in closer to the subject and then get farther back than the original position. Now make exposures at a lower angle than the original eye-level view. Try positioning the camera right on the ground. Look through the camera's viewing system; move and twist around and see what happens to the subject. When it looks good, make another exposure. Repeat making vertical exposures.
- 2. Change the exposure. See what happens when you expose for highlights? What about depth of field? Will a small, medium, or large f-stop help to create more intense visual impact? How does altering the exposure affect the mood of the scene?
- 3. Decide whether to emphasize the foreground or background. How will this decision affect the viewers' relationship with the subject? Try both horizontal and vertical viewpoints.
- 4. Get behind the subject and make a picture from that point of view. How is this different from the front view? What is gained and what is lost by presenting this viewpoint?
- 5. Photograph the subject from the left and right sides. How is this different from the front and back views? What is gained and what is lost by presenting this point of view?
- 6. Make pictures from above the subject. How does this change the sense of space within the composition and one's sense of the subject?

- Experiment with different focal length settings. See what changes occur in the points of emphasis and spatial relationships due to depth of field as you shift from wideangle to telephoto focal lengths.
- 8. Get close. It is like walking by a pizzeria and seeing the pizzas through the window and thinking they may look really good. But if you go inside the shop and get a pizza right under your nose, then you're in business because you are experiencing it first hand. Look for details that reveal the essence of the entire subject and strive to capture them. This method of visceral simplification can speak directly and plainly to viewers.
- 9. Back away. Make images that make known the subject's relationship to its environment.
- 10. Introduce the unexpected into your visual thinking. Employ your instincts to make images of the subject without using the camera's viewing system. Go with what feels "right." This can be very liberating and can bring to the surface composition arrangements that your conscious mind may not have been able to contemplate.
- 11. Work to convey your sense of wonderment, as it is a conduit for eliciting viewer astonishment. The camera can give one a societal license to come close to the unapproachable in ways that may otherwise be regarded as unacceptable in daily social situations. Use this visual license to make the strongest possible statement without being irresponsible or infringing on the rights of others (see the section on the photographer's special license in Chapter 12).

Effectively Using Angles of View

When deliberating compositional possibilities, consider these five basic angles of view and some of their general qualities.

- Eye-level angle of views are more neutral, dispassionate, and less directorial than high- or low-angle ones. Eye-level shots tend to encourage viewers to make their own reading of a scene. It presents a more normal, everyday view of how we see the world. It is a favorite of visual/realistic photographers (see Chapter 5) because it puts a subject on a more equal footing with the observer. A normal focal-length lens setting is commonly used when working in this manner.
- A low-angle viewpoint increases the height of the subject and conveys a sense of verticality. It tends to present a certain sense of motion. The general environment is diminished in importance; the upper portion of the composition, such as the sky, takes on a greater prominence. The importance or visual weight of the subject is amplified. An individual figure becomes more heroic and larger than life. A subject can also appear more looming, dominating the visual space, bringing forth a sense of insecurity. Photographing a person from below can inspire anxiety, trepidation, or reverence. In a landscape, a low angle can generate a more intense sense of spatial depth by bringing added visual importance to the foreground.
- High angles have the opposite effect of low ones. High-angle shots can provide a general overview of the subject. The importance of the surrounding environment takes on added importance. As the height of the angle increases, the importance of the subject is diminished, and care must be taken that the

setting does not overwhelm a subject. High angles may indicate vulnerability, weakness, or the harmlessness and/or openness of a subject. A high angle can deliver a condescending view of a subject by making it appear powerless, enmeshed, or out of control. It reduces the height of objects, and the sense of movement within the frame is reduced, making it unsuitable for conveying a sensation of motion or speed. It can be effective for portraying a situation that is wearying or repressive.

- Oblique angles come about when the camera is tilted, making for an unstable horizon line. It throws a scene out of balance because the natural horizontal and vertical lines are converted into unstable, diagonal lines. An individual photographed at an oblique angle appears to be tilting to one side. Oblique angles are disorientating to the viewer. They may suggest angst, imbalance, impending movement, tension, or transition, indicating a precarious situation on the verge of change.
- A bird's-eye view results from composing high above a subject and can appear perplexing and disorientating to viewers. Ordinarily, we do not see life from this perspective; thus, a scene may initially appear abstract, obscure, or unidentifiable. A bird's-eye view enables viewers to hover over the subject from a Divine perspective. A subject appears inconsequential, reinforcing the idea of fate or destiny — that something beyond the subject's control is going to happen. Bauhaus master Lázsló Moholy-Nagy favored all-encompassing overhead views to represent "new, previously unknown relationships . . . between the known and as yet unknown optical." Haptic/expressionistic imagemakers favor compositions made from extreme angles as they confine an audience to an idiosyncratic point of view.

10.1 "My working process is one of image configuration, placing multiple images in relationships to each other to create a new spatiality. I use digital and physical methods, finding that using both gives me the most fertile ground — the huge 'vertical' stacks of imagery that are possible to store on digital media are vast, but locked into the 'window' of the computer screen. The physical tabletop, large and filled with small prints, is a vast array capable of being scanned by our built-in peripheral vision, but is limited by being composed of discrete physical objects. But by using both realms, the physical and the digital, I can make compositions that tap both. This piece was preconceived in its basic structure and content, the vast and subtle detail within a social substructure (the world of joggers). The images resulted from shooting sessions in which I stood on an elevated stadium-style bench structure and looked straight down at a well-used jogging path at the same time of day so that individual images from different sessions could be used together seamlessly."

© Paul Berger. WalkRun, 2004. 35 × 47 inches. Inkjet print.

Wide-angle focal lengths are often employed to further exaggerate the sense of space and direct the viewer's observation and attention in a specific direction. However, wide-angle compositions, such as those pioneered by cinematographer Gregg Toland in *Citizen Kane* (1941), can also be democratic in nature for they bring into focus all aspects of a scene, thus encouraging viewers to discover what in a scene is visually intriguing to them.

SELECTIVE FOCUS

Since its inception, photography has acted as a surrogate witness that captured and preserved people, places, things, and events. To meet this expectation, the majority of photographers has strived to make sharp pictures so that the subject details can be studied at leisure. The issue of focus played a critical role in defining serious 19thcentury artistic practice. During the 1860s, Julia Margaret Cameron's images helped to establish the issue of selective focus as a criterion of peerless practice. The making of "out-of-focus" images was considered an expressive remedy that shifted the artificial, machine-focus of a camera toward a more natural vision. Cameron considered focusing to be a fluid process during which she would stop when something looked beautiful to her eye "instead of screwing the lens to the more definite focus which all other photographers insist upon." Pictorialists, such as Robert Demachy and Gertrude Käsebier, placed importance on how a subject was handled rather than on the subject itself, and they utilized a soft focus to evoke mystery and deemphasize photography's connection with reality, which helped their work fit into that era's definition of what constituted art. Recently, photographers have again been actively experimenting with how focus can be altered to control photographic meaning.

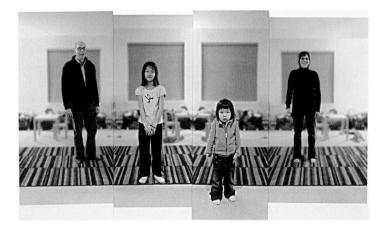

10.2 "Families come in all sizes, colors, lifestyles, beliefs, and mixes thereof. By photographing each family member separately and then collaging the results together, I am calling attention to the built environment and making it impossible for the viewer to accept this portrait as anything but a constructed image. Different perspectives, scales, and vanishing points clash as the laws of nature no longer hold. Here the background was blurred and various objects were removed and flipped in Photoshop to call attention to the subjects and make a more seamless composite. The modular aspect of the compositions allows for myriad opportunities to mix and match family members and create relationships and hierarchies that may or may not exist."

© Stafford Smith. The Royce-Roll-Lafayettes, from the series The Family Portrait Project, 2005. $5-1/2 \times 10$ inches. Inkjet prints.

CONTRAST

When making color images, the intensity and the relationship of one color to another within the scene plays a vital role in creating contrast. If you decide to make black-and-white images, then contrast is created by the difference between the darkest and lightest areas of the composition.

EXERCISE

Selective Focus

Make images that utilize selective focus to generate significant viewer interest by taking into account the following suggestions:

- Determine: What is the most important element of the scene? What do you want to emphasize or deemphasize? What do you want viewers to look at first and concentrate on?
- Manually focus on the key subject to be emphasized. Later experiment with different automatic-focus-area settings such as closest or single subject.
- Set the lens to its widest aperture to minimize depth of field.
- Use a normal or telephoto focal length as wide-angle focal lengths have more depth of field at any given aperture.
- Get in close to the principal subject. The nearer you are to the subject, the more critical focus becomes.
- Practice focusing back and forth as though tuning a string instrument. Go past the point you think works and then come back and decide the focal point.

- Try tilting the camera to see how oblique angles can affect the focus.
- Experiment with slower than normal shutter speeds while hand-holding the camera.
- Working in a dimly lit situation, make a series of exposures with the shutter positioned on the B (bulb) setting while using a flash. Holding the shutter down for a few seconds creates a single image with two exposures. The exposure from the flash will be sharp and still, whereas the ambient light exposure resulting from holding the shutter open will be soft and fluid.
- Review images on your camera's monitor and make corrections as you work.
- Utilize imaging software to manipulate the captured images' focus.

Complementary Colors

Complementary colors, opposite each other on the color wheel, generate the most contrast. The subtractive combinations of blue against yellow, green against magenta, and red against cyan form the strongest color contrasts. When looking at the reflected colors of a finished print, some people prefer to use the pigment primary combinations of red against green, blue against orange, and yellow against purple as the basis of their discussion. This allows photographic prints to be discussed with the same language as the other visual arts, such as painting.

It is thought that complementary colors produce contrast on account of fatigue in the rods and cones of the human retina. This is because the human eye cannot accommodate each of these wavelengths of light simultaneously. Think of it as a long, hand-held zoom lens going back and forth between its maximum and minimum focal lengths while trying to maintain critical focus on a single point. This is what the eye attempts to do when it sees complementary colors.

Cool and Warm Colors

Cool and warm colors can be very effective in crafting and controlling contrast. The cool colors tend to recede and generally appear to be more passive and static. Warm colors are apt to advance and therefore are considered active and vigorous colors. Dark colors against light ones produce contrast, too. A desaturated color put next to a saturated color makes for contrast. Pastel colors can impart contrast as long as there is sufficient separation between the colors on the color wheel.

Creating Color Contrast

A subject can be emphasized if it is placed adjacent to a background of a complementary color. Areas of contrasting colors can create a visual edginess that can give a sense of movement within a composition. Active and passive colors can compress and flatten a visual space and make patterns more noticeable. Warm and cool colors can be effectively used to control a sense of compositional balance. Dynamic tension can be built by introducing active colors alongside each other in the picture space.

DOMINANT COLOR

Dominant color occurs when the primary subject is color itself. The painter Paul Cézanne observed, "When color is at its richest, form is at its fullest." Painting movements such as abstract expressionism, color-field painting, and op art have explored the diversity of visual experiences that are created through the interplay of color. Color relationships can affect all the ingredients within the picture space. Colors can fashion calm or tension and/or make things look flat, recede, or build the illusion of depth. Dominant color may elicit intoxicating textures, drawing one's eye forcefully into an image. Works that exploit this effect use color itself to represent personal emotions, moods, or spirituality, adding drama and psychological depth that can breathe life into an image. Classic examples of the luminous application of color in an expressive manner can be seen in the paintings of Titian.

Be Straightforward

When putting together a composition, keep it simple and straightforward. Let one hue clearly dominate. Avoid incorporating too many

296 0

EXERCISE Color Contrast

Make photographs that incorporate one of the following color contrast effects:

- 1. Complementary contrast. Use colors that are opposite each other on the color wheel, such as a yellow building against a blue sky.
- 2. Primary or active contrast. *The juxtaposition of two primary colors can produce a bright, vibrant, and upbeat ambience.*
- 3. Passive contrast. A quiet, easy, restful mood can be achieved by using a neutral background as a staging area for the principal subject. A simple, dark backdrop can be employed to offset a light area and slow down the visual dynamics of the picture.
- 4. Active and passive contrast. Use a cool color against a warm one. Ascertaining the proper proportions of each is vital in making this effective.
- 5. Complex contrast. Complex contrast employs contrasting primary colors. Careful consideration must be exercised here or the point of emphasis can become confused and/or lost in an array of colors. With the proper treatment, the multicolored use of contrast can elicit visual excitement and provide a robust interplay of the objects within a composition and act as a connecting device between seemingly diverse elements.

10.3 "My work is about layering, experimenting, and embedding images together. Just as ideas about women's roles and stereotypes are embedded in our society, so have I layered figures and graffiti-painted textures. I montage female figures with these elements to question our society's preoccupations and stereotypes about beauty and sexuality. I combine two negatives to create an image that is compositionally and conceptually layered and complex. Graffiti has vivid colors, bold strokes, and is iconographic of sex, heightened awareness, and spirituality. Being able to print these images to mural scale makes them seem like they are walls in a gallery — it brings the outside to the inside and allows the viewer to step into the images' space."

© Carrie Notari. Mask, 2003. 20 × 24 inches. Inkjet print.

colors: this may produce visual confusion, as the assortment of colors competes to control the image space. The proportions of the colors within the scene will determine which is the strongest. For instance, a small amount of a warm color, such as red, can balance and dominate a much greater area of a cool color such as green. Dominance

can also be realized with a small area of a bright color adjacent to a flat field of color. A significant area containing subdued color can be dominant, too. Bear in mind that color value is relative and not absolute; therefore, it changes from person to person and situation to situation. 10.4 Here 8 × 10 inch color transparencies or negatives are scanned and digitally retouched by the photographer to explore vernacular culture through the works of art and commerce in the public arena. "The project celebrates expressive images of popular communication distinct from the conventions of mass media. I consider it a unilateral collaboration with anonymous designers, store owners, sign painters, homeowners, and 'outsider' artists. Photographically transformed, but documentary in nature, the photographs inspired by these unpredictably rich and widely varied languages of communication break down walls between the studio and the street, as well as the confines of one imagination."

 \odot Fred Scruton. Untitled, Pittsburgh, PA, 2005. 24 \times 20 inches. Chromogenic color print.

Sustaining Compelling Composition

Strong colors attract and transact with our attention. Take advantage of that transaction by employing a strategy that ensures that the dominant color preserves a working accord with the core point of interest. If color is not the overriding theme, then it should reinforce and enhance the subject. Don't let the two clash, or viewers may have difficulty determining the image's purpose. Avoid sending conflicting or confusing messages to the audience. You cannot paste a few features on a subject, call it a duck, and expect people to believe it. Maintain a clear objective and provide a well-marked visual path for the viewer's eye. Robust colors visually reinforce the importance of shape within your composition. Use tight, controlled framing to obtain dynamic graphic effects. Get in close and dispense with the nonessential elements. Consider using a neutral or a black background to make the color pop out even more.

Exercise

Dominant Color

Strategize and realize images that bring into play dominant color(s) to reveal form at its fullest and create an awareness of color space or evoke a psychological or spiritual sense without using any traditional symbols. Select one color or colors and fill your compositional space so that viewers experience the perceptual and physical space of that color or colors. Think of the sense of sound you get when listening to music on an iPod with high-quality ear-bud headphones. It's the same as reading a good book; you give yourself over to the experience the artist has created. In this case, convey that feeling through your use of color and then ask yourself, What new meaning is brought forth?

HARMONIC COLOR

Harmonic colors are closely grouped together on the color wheel. Any single quarter section of the color wheel is considered to exhibit color harmony. The most basic harmonic compositions contain only two colors, which are desaturated and flat in appearance. The lack of complementary colors makes seeing the subtle differences in these adjacent hues much more straightforward. Constancy and evenness in light and tone can assist in bringing forward harmonic color relationships. Deeply saturated colors that may be technically close to each other on the color wheel can still produce much contrast and interfere with the harmony. Therefore, start by setting the camera's saturation mode to normal or reduced levels and avoid using the enhanced color mode. Also, try reducing the camera's contrast mode.

10.5 "These images explore how our priorities dictate the transformation and use of the land. Although I am interested in the ideas surrounding the interpretation of images as well as those concerning the environment, architecture, and general planning, I prefer a less literal approach that conveys a mood or a feeling." Lutz made two scans from the same 8×10 inch negative, one for the highlights and midtones and another for the shadows, and combined them to maintain as much color saturation and detail as possible.

© Joshua Lutz. *Sheetz*, 2005. 30 × 40 inches. Inkjet print. Courtesy of Gitterman Gallery, New York.

Effective Harmony

Color harmony can easily be spotted in nature, but it is a highly subjective matter whose effectiveness depends on the colors, the situation, and the intended effect. The tangible visual effect is dependent on the actual colors themselves. Passive colors tend to be peaceful and harmonize more easily than the warm, active hues. For example, blue and violet are adjacent to each other on the color wheel and are harmonious in a restrained and subdued manner. On the opposite side of the color wheel are orange and yellow. These two colors harmonize in a much more animated and vibrant fashion.

In an urban, human-made environment, discordant, jarring, and unharmonious colors are encountered everywhere, as people willynilly place contrasting colors next to each other. Look for and incorporate neutral areas, which offer balance within the scene, and deemphasize differences among diverse colors. Exercising care in the quality of light, the angle of view, and in determining an appropriate proportional mixture of these discordant colors can bring a sense of symmetry and vitality to a flat or inactive compositional arrangement. Both contrasting and harmonic colors can be linked together by working with the basic design elements such as repeating patterns and shapes.

Pay close attention when framing the picture space, taking care to notice exactly what is in all corners of the frame. Eliminate any hue that can interfere with the fragile interplay of the closely related colors. Use your monitor to review each exposure. The utilization of soft, unsaturated color in diffused light is an established method of crafting harmonious color relationships. Repeating and/or weaving harmonic colors throughout the picture space, which also intensifies the patterns and shapes within the composition, may bolster harmonic effects. Look for common qualities in balance, rhythm, texture, and tone to connect the colors.

An atmosphere of color unity can be orchestrated by slightly adjusting the camera's color balance setting and/or by adding a small amount of filtration in front of the lens that matches the cast of the

10.6 Utilizing a waist-level finder, autofocusing, and a high ISO, Ulrich candidly makes formal and sharp visual records about our consumer-dominated culture of shopping, technology, and multitasking in daily life.

© Brian Ulrich. *Chicago*, *IL*, 2003. 30 × 40 inches. Chromogenic color print. Courtesy of Rhona Hoffman Gallery, Chicago; Julie Saul Gallery, New York; and Robert Koch Gallery, San Francisco.

color of the light in the scene and desaturating the hues through the use of diffused light or using a soft filter in front of the lens. These effects can also be achieved later with imaging software.

ISOLATED COLOR

The visual energy of a color depends greatly on its relationship to other colors and its placement within a scene rather than on the size of the area it occupies. Imagine a white, in-ground swimming pool

EXERCISE

Harmony

Make harmonic images from the following areas:

- 1. Natural color harmony. Pay close attention to the compositional location of the horizon line in the landscape. Organize a landscape that does not follow the traditional compositional rule of thirds. Photograph a scene that includes little or no sky. Make a skyscape with little or no foreground. Be on the lookout for symmetry in nature. One method to achieve balance is to look for repetition, such as reflections, to include in your composition. This can be especially effective when water is in the picture space. If the impression of harmony produced by cool colors feels too uninviting or standoffish, try adding a small area of a muted, warm complementary color. This can make the scene more visually hospitable and rekindle viewer interest. Look for a defining detail from the landscape that can represent what you are after in a condensed and simplified manner. Much time presenting less can let viewers see more, by encouraging more active engagement with the image.
- 2. Urban color harmony. *Locate a place where people have consciously and deliberately made an effort to blend*

human-made creations into an overall environment. Flat lighting can be used to play down the differences in the various color combinations within an urban setting. Smooth, early morning light can be utilized for the same effect. Search for an oasis of calmness and stillness within a hectic cityscape while avoiding the visual hustle and bustle of urban life that tends to yield visual chaos.

- 3. Still-life harmony. Organize a collection of objects that demonstrates your ability to control the picture space, including the background, the quality of light, and the camera position, to ensure a harmonic composition. Consider the sparing and subtle use of filters or color balance to enhance the harmonic mood.
- 4. Harmonious portrait. Make a harmonious portrait by simplifying the background, selecting clothes and props to go with the subject, and using neutral colors and similar shapes. Reflect on using soft directional lighting, as it can minimize complementary colors and convey an impression of unity. Placing tracing paper in front of any light source is a simple and inexpensive way to diffuse the light.

on a calm and clear afternoon reflecting harmonious blue-sky colors that are even, smooth, and unified. Now throw in a red beach ball. Pow! It generates a visual explosion that surprises the eye and instantly becomes the point of emphasis. Its solitariness stands out as a point of visual magnetism. Its atypical individuality within the unified space introduces needed variety into the composition.

Colors tend to be at their greatest intensity when they are viewed against a flat, neutral setting. Warm colors visually move forward, adding depth and spark into a flat picture. Take an overcast or dusty day in which the landscape appears nearly dimensionless; add a small amount of a warm color, and immediately contrast, depth, drama, emphasis, and variety arise out of this evenness and uniformity. Warm colors can also be deployed as dynamic backgrounds to balance and/or offset monochromatic subject matter.

Chance Favors a Prepared Mind

Delivering a powerful single color to the right spot at the right time often requires advance planning. Anticipating the moment greatly increases the chances of this happening. Being primed also enhances the likelihood of something useful happening, as chance favors a prepared mind. Coordinating the light, background, and proportion of a particular color means being at ease and confident about one's equipment and methods. Practice and readiness are prerequisites that allow one to benefit from a mixture of opportunities.

Carefully observe the situation and ask yourself questions such as, What focal length may best deliver the correct proportion of that single color into the composition? But don't get bogged down with your fixed ideas. Remain ready to improvise and go with the flow. For instance, if the focal length of your lens is not long (telephoto)

Exercise

Isolated Color

Based on the material in the previous discussion, make photographs that utilize isolated color to achieve their visual impact.

enough, will getting closer help you achieve the desired outcome? Remain open and receptive, and be willing to adapt and accommodate your plans to the reality on the ground without becoming overly irritated or disenchanted. Consider combining other approaches into your thinking. For instance, would incorporating movement generate additional visual interest? What might happen if you placed your camera on a tripod and used a slow shutter speed to interject a warm object in motion within a static monochrome environment?

MONOCHROME IMAGES

Some people believe a good color photograph has to show lots of colors. However, that is not necessarily the case. Often reducing the number of colors can create a more effective composition than bombarding viewers with every color in the rainbow.

Strictly speaking, a monochromatic photograph is one that has only one color, but in a broader operational sense, the genre includes any image that achieves its overall effect through the management of a single color, even if other colors are present. A case in point can be seen in Tim Burton's animated film *Corpse Bride* (2005), which makes impressive use of the play between monochrome and color scenes for dramatic and psychological effect.

10.7 By digitally erasing the barriers and surroundings of the human-made environment in which animals were captive (zoo cages or pens), Hunter creates a featureless landscape with animals to show them as empowered beings in a world without people. "The resulting photographs produce an unsettling landscape where the animal, lifted out of a humanizing context, can re-enter its own world."

© Allison Hunter. Untitled #7, from the series Simply Stunning, 2006. 30 × 50 inches. Chromogenic color print. Courtesy of 511 Gallery, New York.

The Personal Nature of Monochrome

Monochromatic images can be directly connected to our moods. For example, when we feel down in the dumps, we say we are blue — not orange or yellow. Utilize such associations when building your image. Monochrome simplifies a composition and so tends to elicit a more intuitive and subjective reaction than a full-color image with its empirical associations to outer reality. Monochromatic images are made not so much as a document to be read for information, but as a representation of an inner event that evokes a personalized sense of place and time. Monochromatic scenes can alter the customary flow of time and flatten the sense of visual space.

Exposure is critical to maintain the desired atmosphere and color. Monochromes do not have to lack contrast. Harmonious and subdued colors can be employed to give monochromatic impressions. When organizing a monochrome composition it is important to rely upon the play of light and shadow to create dramatic compositions when there is an absence of strong color. Also consider lowering the contrast setting on your camera when both the highlights and shadows are extreme for better exposure.

Color Contamination

When dealing with a "delicate" monochromatic image, be aware of environmental color contamination. This occurs when a colored object within the scene reflects its color onto other items within the compositional space. Color contamination can occur when a photographer's bright red shirt reflects back onto the principal neutral-colored subject. Objects within a composition often spill their color onto their adjacent neighbor. This is most visible when working with white items. It is also possible for a white object to make another white object appear to be off-white. Careful observation of the scene, its arrangement, and the selection of objects to be photographed is the best approach for dealing with this problem at the time of image capture. Imaging software can later be used to make adjustments, but with monochromatic images, such subtle corrections can be difficult to implement.

Aerial Perspective

Aerial perspective results from the atmospheric scattering of light, which mutes colors in distant scenes so the tones appear progressively

10.8 "The series focuses on our fascination with our own bodies. By isolating the point of focus, I invite viewers to imagine themselves in the same place behind the 'wall.' The flat monochrome color with its blue/green cast suggests the proneness toward age, whereas the cracked texture implies the fragility of the environment."

© Katya Evdokimova. The Silhouette, 2005. 16-1/2 × 12 inches. Inkjet print.

paler as the landscape recedes into space (see also the next section on Perspective). The blending and softening of colors that occur in aerial perspective can assist in forming a monochromatic scene. Be aware that aerial perspective also makes faraway objects appear noticeably bluer, which can be corrected at the time of exposure with a slight warming or yellow filter or later adjusted with imaging software.

PERSPECTIVE

Perspective allows imagemakers to give two-dimensional space the illusion of the third dimension and controls the sensation of depth. Light and shadow provide an initial starting point in creating a feeling of visual depth, but the actual illusion that one object in the composition is closer to the foreground than another results from the use of perspective.

Basic Methods of Perspective Control

The following are basic types of perspective control commonly exercised in photography:

EXERCISE

Monochromatic Color

Make photographic images that utilize monochromatic color concepts to capitalize on their visual strength. Purposely direct a monochromatic effect to elicit a specific mood.

Consider the following environmental conditions as starting points for monochromatic compositions in which both color and the details are naturally suppressed and simplified: early morning, late afternoon, fog, dust, pollution, rain and snow storms, smoke, iced or steamed windows, plus scenes illuminated by diffused light that have lower-than-average contrast.

Other methods that can be employed to mute colors include deliberately "defocusing" (putting the entire image out of focus); selective focusing; using a slow shutter speed and moving the camera while the shutter is open; various soft focus methods such as a diffusion or soft focus screen; and the use of filters. These courses of action can also be accentuated with post-capture software.

• Aerial perspective is the effect in which colors and tones become blurred, faded, and indistinct with distance, due to atmospheric diffusion. Colors and details in the foreground appear brighter, sharper, and warmer and have a darker value than those that are farther away. There is a proportional decrease in luminance and warmth with distance, which can be reduced by adjusting your camera's color balance or by using an 81A and 81B warming filter.

10.9 "Paramnesia is defined as the distortion of memory in which fantasy and objective experience are confused. Using my childhood as a touchstone, I recreate places from my past as well as their photographic referents. With this image I worked with two different scales to force the unusual perspective. The ladder is about $3/_4$ life size, which meant that the constructed wall of the hole had to be at a comparable scale. The images of the sky and jet are at a much smaller scale yet broader in overall size than the foreground. I shoot digitally during the construction of the diorama to get immediate feedback and then expose 4×5 inch film, which is scanned and worked in Photoshop to produce a final print."

© Bill Finger. 1973 — Age 12, from the series Paramnesia, 2005. 24 × 32 inches. Chromogenic color print.

- Diminishing scale creates the impression of depth through the assumption that the farther an object is from a viewer, the smaller it appears to be. By consciously placing something sizable in the composition's foreground and something smaller in the middle ground or background one can heighten the feeling of depth. It is also possible to fool a viewer's sense of depth by reversing this order.
- Position makes the visual supposition that objects, when placed in a higher position within the composition, are farther back in space than those toward the bottom of the frame. The same conventions that apply to diminishing scale apply to position.
- Linear perspective occurs when parallel lines or planes gradually converge in the distance. As they recede, they seem to meet at a point on the horizon line, known as the *vanishing point*, and disappear.
- Two-point linear perspective can be realized by photographing a subject from an oblique angle (an angle that is not a right angle; it is neither parallel nor perpendicular to a given line or plane). This can be seen in a subject with vertical parallel lines such as a tall building. When viewed from a corner, two walls of the building seem to recede toward two vanishing points rather than a single one. The closer the corner of the building is to the center of your composition, the greater the sense of depth, distance, and space. If the building is placed in one of the corners of the composition, it flattens one of the walls while making the other look steep.
- Overlapping perspective occurs when one shape in the picture frame is placed in front of another, partially obscuring what is behind it, and thereby giving the suggestion of depth.

- Selective focus is an excellent photographic method for creating the illusion of depth. To the eye, a critically focused object offset by an unsharp object appears to be on a different plane. Setting the lens aperture to its maximum (largest) opening will diminish the depth of field and facilitate the separation of the foreground from the middle ground and background. Also, using a longerthan-normal focal length (telephoto) reduces the amount of depth of field at any given f-stop. The longer the focal length of the lens, the less depth of field it will have at any given aperture. Since the depth of field is extremely limited, whatever is focused on appears sharp and defined, while the detail in the remainder of the picture appears nebulous and vague.
- Limiting depth can be attained by visually incorporating a welldeveloped sense of pattern into the composition, which tends to flatten the sense of picture space. Another option is to set the camera lens at its shortest focal length (wide-angle) and place it so close to a subject that it cannot be sharply focused, thereby spurring interest by unconsciously encouraging viewers to actively hunt for something sharp in the picture space.
- Perspective and focus can also be controlled and modified and given synthetic viewpoints with post-capture digital software.

Converging Lines

A common photographic problem when working with perspective is converging vertical lines. For instance, when making an image of the entire front of a tall building, it is possible that the camera may have to be slightly tilted to take it all in or that a wide-angle focal length is necessary; both of these choices cause the building's vertical lines to converge or move together. Convergence can be visually pleasing, as it accentuates the building's sense of height. But what if you need to maintain correct perspective and keep the vertical lines parallel and straight? It is possible to minimize this effect by moving farther away from the building and setting your zoom lens to a longer focal length. This is often not feasible in a confined urban environment. If you have a DSLR, the best and most expensive solution is a special perspective-control shift lens. Another option is a larger-format camera that has a raising front and/or a tilting back, which permits perspective correction. In the end, the most practical solution is probably post-exposure imaging software that allows for precise perspective adjustments.

Exercise

Create robust visual statements that make the most of the perspective control methods covered in this section.

Perspective

10.10 "The Test People depict a future time when a capacity for flight (or controlled antigravity) has been developed in humans. Its boundaries are being studied and tested in a semi-scientific manner. It is an awkward struggle for the test subjects to integrate these new possibilities for movement into the strictly gravity-based architecture of their domestic environments. Aspects of real war and gaming creep in. Stunt artists are photographed against a green screen, and alpha masks of them are created with Corel Knockout. The backgrounds are composites of floor-to-ceiling images of the space seamed together in Photoshop. The stunt artists' images are then added in and color balanced and stretched to match the range of color casts in the scene as well as the lens distortions."

© Sabrina Raaf. Over and Again, from the series Test People, 2004. 86 × 26 inches. Inkjet print. Courtesy of Wendy Cooper Gallery, Chicago.

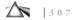

QUIET OR SUBDUED COLOR

Quiet color images often possess a uniform tonality and contain unsaturated colors. Soft, flat light mutes and produces subdued colors. Color can be made less intense or prominent by adding black, gray, or white by means of lighting and/or exposure or by selecting desaturated tones. Low levels of light reduce saturation. Delicate colors can occur in failing evening light, with shadows adding gray and black, generating a calm and silent atmosphere. Any form of light scattering, such as flare or reflection, introduces white, thus desaturating colors, and can produce a more serious ambience. Choosing a reserved background color scheme can make certain colors appear less saturated. Restrained colors can often be found in aged and weathered surfaces. A limited or low range of tones mutes color and can stimulate a sense of drama, mystery, sensuality, and an element of the unknown.

Operational Procedures

Some techniques to consider when working with subdued color include the following:

- Work with a limited color palette.
- Select a dark, simple, uncluttered background.
- · Concentrate on an overall low-key color scheme.
- Illuminate the subject from a low angle.
- Minimize background detail by using a higher shutter speed and a larger lens opening to reduce depth of field.
- Expose for the highlights, allowing the shadows to be dark and deep. Bracket and review your exposures until you achieve the desired effect.

- Deliberately compose the principal subject to block out a portion of the key illumination source. This generates a rim lighting effect, which also reduces the overall color contrast and tonal range.
- Work with a diffused or low illumination source, which also reduces the overall tonal range. This naturally occurs in fog, mist, and/or before and after storms.
- Try a diffusion filter or improvise with a piece of transparent, light-colored cloth or stocking.
- Utilize imaging software to make post-capture adjustments to colors and/or depth of field.

As there are unlimited software adjustment options, users typically incur a greater tax on their time by altering an image after it is made in-camera. The more you can do to get the desired image at the time of capture, the less time you will need to electronically manage and edit it.

HIGHLIGHTS AND SHADOWS

Convention dictates that photographs have ample highlight and shadow detail to convey a realistic rendition of reality. A camera's

EXERCISE Sub

Subdued Color

Make use of at least one of the working techniques mentioned to produce images that rely on quiet, subdued color for their impact. built-in exposure meter automatically carries out this function by averaging the difference between the light and the dark areas according to various programmable modes. However, there may be instances when one can make a more visually exciting interpretation by emphasizing one or the other. This can be achieved by exposing for the opposite of what you want to emphasize. For example, if you want the shadows to be very dark, you would expose for the highlight area in which you want to retain detail. This can be done by physically moving closer to the subject or by optically zooming in close so that the highlight area fills the frame; taking a light meter reading from this spot; setting the exposure based on this reading; and then moving or zooming back and composing the scene. Review your exposures and make adjustments until you are satisfied. To emphasize the highlights, expose for the key shadow area in the same manner.

EXERCISE Contrast

Find or create scenes that have a considerable difference in the highlight and shadow areas. Then make a a series of images of the same scene in which one image accentuates the highlight areas, a second the shadow areas, and a third that has detail in both. Analyze how and why each image works, and then decide which one satisfies you. What is it about that image that speaks to you? How can these findings be applied to other picture-making situations?

10.11 "I arrived in the United States as a refugee from Vietnam in 1975. As an American, my illusionary Garden of Eden was made unstable by the events of September 11. East of Eden is a manifestation of my need to offer, as a war survivor, my perspective on the present landscape of anxiety. The historical strategy of utilizing the landscape as a metaphor for nationalism and optimism as in the paintings of the Hudson River School provides the background for my thesis of reframing Eden in the context of a post-apocalyptic landscape. My intentions are not limited to the portrayal of death and despair, but also to portraying the hope and regeneration experienced by the inhabitants of the contemporary political and psychic landscape."

© Pipo Nguyen-Duy. *Mountain Fire*, from the series *East of Eden*, 2002. 30×40 inches. Chromogenic color print.

ATTRACTION AND REPULSION

People are attracted to individual and collective groups of colors and repelled by others. What is your preferred color or colors? Think about what colors regularly appear in your life, in the clothes you

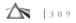

Exercise

Attraction and Repulsion

List the colors that you find attractive and are drawn to and those that you find distasteful and repellent. Then do the following:

- Make an image that revolves around your favorite color or combination of colors. What qualities do these colors possess that you find appealing?
- Make another picture that deals with a color or colors that you dislike. What are the characteristics of these colors that you find offensive?
- Change the color of a known object through the use of light or paint at the time of exposure or through the use of imaging software. How does altering the natural color affect your response to this object?

wear or in the decoration of your personal space. Do these colors frequently appear in your work? Given a choice, are there colors that you will avoid being around? Do such colors ordinarily show up in your images?

Surmounting Preconceptions

After making these images, study them and list the associations that come to mind regarding the colors. Did changing the natural color of an object affect your feeling and thinking about it? By purposely working with a color that you dislike, is it possible to change your relationship to it? Can one dissect one's preferences and overcome specific dislikes of color that result from instilled prejudices, inexperience, lack of insight, or the failure to think for ourselves? Do you really loathe the color ocher, or was it your mother's least favorite color? Asking and honestly answering such questions can help keep your possibilities open, giving you the personal freedom to explore your full potential.

COUNTERPOINTS AND OPPOSITES

Counterpoints are ideas or themes used to create a contrast with the main element. For instance, in music, an orchestra counterpoints the vocal parts. In the visual world, we can see color contrasts in our living environment, where off-white walls and wooden floors are counterpointed by black moldings. Hence, the overall visual impact is the result of all the colors that make up the scene.

Now consider an offshoot of counterpoints — that is, opposites, which are antithetical, complementary, or mutually exclusive positions. In ancient Chinese philosophy, this was defined as yin and yang, which describe two opposing but complementary primal forces found universally in all things. Yin, the darker element, is feminine, passive, dark — corresponding to the night, downward seeking, and symbolized by water. Yang, the brighter element, is masculine, active, light — corresponding to the day, upward seeking, and symbolized by fire (see Chapter 2).

More culturally familiar opposite concepts include old and new, happy and sad, young and elderly, large and small, soft and hard, high and low, bright and dull, messy and neat, sweet and sour, fast and slow, good and evil, calm and stormy, peaceful and warlike, hate

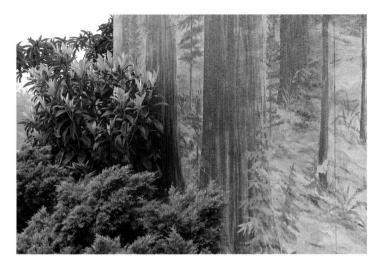

10.12 "Landscape, and our relationship to it, is always in flux. This change is evidenced in the many murals of nature painted in urban settings. The focus on scenery reminds us that the term itself derives from the theater. This connection to the artificial illuminates our contradictory relationship with nature, and clarifies the terms of what my artwork explores. I have photographed these landscape murals, using a 4×5 inch field camera, focusing on the intersection where the natural earth meets the manmade. Often in the image it is unclear where the boundaries of these two worlds lie. The two environments have been merged together to form a new landscape while drawing attention to the meaning of that term. The titles for these photographs are then taken from the GPS coordinates of the sites from which they have been made, further abstracting the pictures from their apparent sources. Additionally, I have gathered satellite images of the locations to form an alternate point of reference for the scene being depicted in the mural."

 \odot Jeremiah Ariaz. Latitude: 34:00632953 Longitude: -118.47721349, 2005 from the series Reconsidering Landscape. 16 × 24 inches. Inkjet print.

and love, apathy and decisiveness, individual and group, female and male, intimacy and distance, seduction and horror.

Opposites can also be purely visual, angular and flowing, or circular and sharp. Opposites may also be conceptual, relying on the play of contradictory states of being such as inner and outer reality or nature and the human-made.

EXERCISE Opposites

Make images dealing with the theme of opposites, such as those listed in the previous section, without utilizing wellworn symbols. Think abstractly and intuitively. Analyze your reactions to these pairs of contrasts. How do such juxtapositions affect your interpretation? Are they what you expected? Is viewer reaction consistent or is it individualistic? What does this tell you about the nature of apparent opposites? Is it possible that each contains the seed of its opposite and cannot exist without the other?

Demand remakes the world in paper and cardboard and then photographs the results. For this project, Demand used a digital program to cut each of the 900,000 layers of heavy gray cardboard, weighing 50 tons, which he used to build his grotto, layer upon layer. Wanting certain parts of the final photograph to lack definition, Demand actually built "pixels" in cardboard, tiny squares that deceive the eye into thinking the photograph is unfocused, whereas it is in fact reproducing the "reality" of the sculpted grotto. "Digital is just a technique of the imagination. It is opening possibilities that wouldn't have been there before. But I lose interest in a photograph once I see it is digitally made because it is all about betraying you in a way. I think my work has a lot in common with what digital wants, rather than being digital. Basically, it is constructing a reality for the surface of a picture."

Thomas Demand. Grotte, 2006. 78 × 173 inches. Chromogenic color print. Courtesy of VG Bild-Kunst, Bonn/Artists Rights Society (ARS) and 303 Gallery, New York.

Chapter 11

Solutions: Thinking and Writing about Images

here are innumerable ways of defining the creative process, but its hub is the result of critically thinking about an issue or problem that leads to a defined, concrete action. Visual thinking involves an imaginative and resourceful interaction between an imagemaker and a subject. Definition and description are central components of the process, for they allow us to acknowledge and take responsibility for a problem and its meaningful solution.

Problems arise from every aspect of life. They can spring from our private world of friends, loved ones, or family. They may come from our work-world situations of bosses and co-workers. Others we willingly take on or have thrust upon us from the outside world by educational, economic, political, and even accidental circumstances. We cannot try to solve every problem we encounter. We must be selective about which problems we choose to take on, or we will be overwhelmed and unable to accomplish anything.

A problem is a situation for consideration. It is a question for open discussion and should not be ignored or treated as a cause of anxiety. Defining the true nature of a problem paves the way for understanding, which can lead to a successful resolution of the problem. To obtain the maximum benefit from this book, it is necessary to begin thinking about how photographic images can be used to arrive at your specific destination. This can occur when the intellect and sentiment combine in taking an idea from the imagination to find the most suitable technical means of bringing it into existence. The imaginative and technical means can then successfully coexist and support each other.

11.1 "This work examines the problems of trauma and uncertainty carried from my upbringing as a Polish immigrant. The models are mannequins, and their faces are slide projections of images made of my father and myself. There is an undercurrent of helplessness and misdirection linked with schizophrenic parenting, excommunication, and constant movement. My elders believed that children did not have a choice. Frequently I heard a Polish equivalent of 'Children should be seen and not heard.' I am attempting to give these children voices."

© Ursula Sokolowska. Untitled #57, from the series Constructed Family, 2006. 30 × 30 inches. Chromogenic color print. Courtesy of Schneider Gallery, Chicago.

Photography does not imitate nature, as it is often said to do, but it does manifest personal realities. Photography can provide us with the means to create, invent, and originate ideas from our imaginations and bring our thoughts into the physical world. A final image depends on the properties of the specific materials involved in its creation. By gaining an understanding of the range of photographic equipment, materials, and processes, we put ourselves in a better position to control the final results of this collaboration of cerebral and material worlds.

Learning to control a process is the first step an imagemaker must master to transform an abstract idea into a concrete physical reality. To facilitate the transformation from mind to medium, an imagemaker needs to discover how to direct energy effectively through the available technical means. This text introduces an assortment of such methods, gives examples of how others have applied them, provides basic working procedures, and encourages each reader to make future inquiries. Once a person obtains a basic understanding of a process, creative control over it can freely commence with skeptical inquiry, active dreaming, and reflective philosophy, with or without regard to authority or tradition.

THINKING STRUCTURE: A PROCESS FOR DISCOVERY AND PROBLEM SOLVING

Once you have determined that a project is feasible, it is time to devise a plan to make it happen. Most people perform better when they organize their thoughts, with a point of departure and a specific destination in mind. The use of a thinking model can be helpful for instigating, clarifying, and speeding up the creative process. A struc-

Getting Started: Project Viability

Before embarking on any project, determine its viability by considering the following issues:

- Interest: What is my level of interest? Am I willing to spend my time, energy, and resources on it? Will I make an internal promise to see my idea through to completion?
- Selection: What knowledge do I have about this subject? Narrow down your choice and be specific about what you are going to include. Once you have begun, it is all right to rethink and change, contract, or expand the project as new information is gained.
- Audience: Will other people be interested in this subject? Can I engage and retain viewer attention without violating my personal integrity or that of the subject?
- Visualization: Is this a subject that lends itself to a robust visual interpretation? Subjects and themes that portray action or intense emotions are generally easier to visualize than intellectual concepts. Think of films, videos, and still images you appreciate and why they stick in your mind. In the main you

will likely discover their message and story are delivered principally through imagery, with careful use of dialogue and sound.

- Accessibility: Is this a practical project? Is everyone involved willing to cooperate? Does it fit into your time and financial resource budgets? Can you work at times that are accessible to the subject and yourself?
- Research: How can I learn more about the subject? What's available online? Look at the work of other imagemakers who have covered similar subjects. Analyze what they got right. What would you do differently? Discuss the subject with those directly involved to understand what they are thinking and feeling. Read what others have uncovered. Talk with people who have expertise with the subject. Write out your thoughts to assist in expanding and clarifying your understanding. Consider different approaches and ideas and how they can be tied in together. Use these pieces of information to generate your own ideas that can be visually expressed.

ture can reveal errors and inconsistencies and can assist in substantiating the suitability of a working method. Look for an open and flexible system that expands your thought process and unlocks new vistas and working premises to solve problems.

Although a structure provides the reassurance of starting out on a known road, there are many routes to most destinations. For this reason, using the same system model in every situation can lead to stale and unoriginal results. If a thinking process is overly confining and precisely spells everything out creativity ceases, boredom sets in, and repetitive, programmed outcomes result. Grabbing hold of known responses can be dishonest because they are someone else's answers. To avoid stale, off-the-shelf solutions, work with a model that encour-

11.2 Wildey's research enabled him to bring together a combination of old and new photographic imaging systems. Wildey modified a cargo trailer into a lighttight camera obscura that forms an image on a large sheet of acrylic hung at the focal point inside where a digital camera was set up on a tripod to record the projected image.

© Al Wildey. Camera Obscura Trailer, 2006.

ages experiments that can take you outside the system, including your own system of thinking. Systems that function well inspire the confidence to make choices without dictating exactly what to do in every situation. A good thinking model provides a channel for the free flow

11.3 Wildey's circular image, made using his cargo trailer Pinhole camera, represents his investigation of the landscape genre that "invokes a sense of 15th century photographic pre-history that serves as the catalyst for a distinctly 21st century conclusion."

© Al Wildey. Yield, 2006. 30 × 30 inches. Inkjet print.

of creative energies without diverting their strength by demanding rigid adherence to arbitrary procedures. Such a model can open up the possibilities of new visions and provide a means of imaging what you have discovered.

11.4 "This image was inspired by astronomical, planetary, medical, and microscopic scientific/digital imaging. I use my scanner like a camera and import anything I can, from objects and fabric to my own drawings to newspaper images, junk mail, old money, museum maps, and things from the Internet. Plus I create drawings in Illustrator and import them into Photoshop. In wanting to expand on what is possible in the digital medium, my greatest artistic challenge is to defeat my own tendencies, and open my mind to new possibilities; technically it is about maintaining patience."

© Brian Moss. Planets and Moons, 2006. 11 × 16 inches. Chromogenic color print.

The following pages offer a six-stage thinking model for the creative interaction between the imagemaker and the subject (see Table 11.1). Use it as a starting point, but feel free to expand, contract, analyze, and/or criticize this model. Improve upon it or modify it to fit your own prototype. The vital point is to reason, reflect, and determine what works for you to visually convey your concepts with

Stage	Actions
1. Thinking Time	This is the time for discovering and taking hold of crucial ideas. Get going. Don't procrastinate! Use a source notebook for idea generation.
2. Search for Form	Make a self-declaration accepting the situation and the challenge to give the abstract idea concrete form by visualizing all the possibilities.
3. Definition and Approach	Select equipment, materials, and methods that provide the best route for the visual development of the idea.
4. Bring It Together	Pull all your visual knowledge and resources together into a concrete vision.
5. Operations Review	Take an initial examination of your images to determine strengths and weaknesses, make corrections, and decide future actions, including whether your approach is still workable or whether you need to reevaluate and reshoot.
6. Evaluation	Review all steps by formulating questions that reflect your concerns, expectations, needs, and wants. Determine what does and does not work, analyze why, and decide what has to be redone and how to do it better.

Table 11.1 Thinking Model

images. Discovery demands the freedom to ask uninhibited questions and go in new directions because experimental work disrupts traditional modes of operation. Ideas about originality, subject matter, how images can look, process, and treatment should all be questioned during the creative process. An ideal thinking model encourages you to ask tough, provocative questions, not only of others, but also, and most importantly, of yourself.

A THINKING MODEL

Thinking involves a continuous processing of intermingling events and ideas in a way that often does not follow a precise order. Feel free to skip around or go back and forth between steps or to devise a method that is suitable to your circumstances. The steps outlined in this chapter can be thought of in circular, continuous cycle or in a linear manner, that is, of one step in front of the next until the destination is reached. They may also be considered in a hopscotch fashion of skipping around from one step to another, or by crisscrossing the steps. Don't hesitate to switch models if the one you are using is not working out.

Stage 1: Thinking Time

Thinking time commences when you experience the first conscious awareness of an idea. Ask yourself, Where did this idea come from? Sometimes you can trace it back to an external stimulus, such as talking with friends, watching a DVD, seeing something online, reading a book, or observing a situation. Other times it may be internal. It may be produced by apprehension or pleasure based on your memory of experiences and knowledge. It might be brought about through conscious thought directed toward a particular subject. It could strike without warning, seemingly out of nowhere, having either emotional or intellectual origins. It can arrive while you are commuting or in the middle of the night in the form of a dream.

What should you do when an idea first makes itself known? Don't lose it. Many ideas emerge only to get lost in the routines of daily life. Ideas can be the spark that ignites the act of creation. It does no good to have a marvelous idea if you cannot hold onto it. If you ignore it, the ember will die out. Whenever possible, preserve the idea by recording it without delay. If it is a thought, write it down. If it is a visual image, capture it. If you do not have a camera, make a thumbnail sketch. Don't be concerned about making a masterwork. Record what has piqued your interest and analyze it later. The essential thing is to break inertia and generate fresh, unprocessed source material.

Getting Ideas

Generating first-rate ideas to solve visual problems requires increasing one's awareness and ability to think independently. This conscious responsiveness demands the self-discipline of asking questions, acknowledging new facts, skeptically reasoning through your predispositions, and taking on the responsibility of gaining knowledge. Allow reason, logic, emotions, and sensations to enter into the process. Be prepared to break with habit and take chances as the process unfolds. See Box 11.1, Getting Ideas.

Listen to yourself and others to get preliminary courses of direction and information. Problem solving necessitates coming to grips with the true nature of the situation. Do not hold onto one idea, as absolutist beliefs can be crippling to creative problem solving. The quest for an absolute tends to get in the way of good imagemaking solutions. Be skeptical of people claiming to have all the answers. Simplistic, cookie-cutter solutions extend erroneous answers for the slothful and the unthinking. Suspending beliefs opens one to new ways of exploring and understanding life. The ability to accept the uncertainty of complexity and contradiction, instead of the assurance

Box 11.1 Getting Ideas

Here are suggestions that have helped other imagemakers generate new ideas.

- Stick to what you know. Make images of subjects you are familiar with.
- Discover something new. Make images of something with which you are unfamiliar but that you would like to explore.
- Look at other images including prints, posters, drawings, films, paintings, videos, comics, graphic novels, and websites. When an image makes an impression, figure out specifically what either appeals to you or disturbs you. Incorporate these findings as active ingredients into your way of seeing and working.
- Study the history of photography. H. G. Wells wrote, "History is a race between education and catastrophe." The present and the future cannot be understood without knowledge of the past. Arm yourself with knowledge. Look for concepts, ideas, and processes that appeal to your personal requirements and artistic direction as a springboard for future direction.
- Collect all sorts of materials that might be useful in making future works.

of certainty and simplicity, is characteristic of an intrepid explorer and a good problem-solver. Later you can compare your new knowledge and beliefs against the old ones. Often these comparisons will result in contradictions, but these, in turn, can generate innovative insights about the problem and lead to fulfilling solutions based on personal experiences and needs that combine the apt techniques for your vision.

Challenging Fear

The major block to getting new ideas is fear. Fear takes on endless forms: fear of the unknown, of being wrong, of being seen as foolish, or of changing the way in which something has been done in the past. Fear can be aggravated by procrastination and a lack of preparation. Apprehension brought on by trying to anticipate every possible consequence and end result deters creative development by misdirecting or restraining imaginative energy. It is okay to make mistakes; do not insist that everything be absolutely perfect. Gaffes can open conduits to new possibilities, and mishaps can be good fortune in disguise. It is better to take a chance and see what happens than to let a promising opportunity disappear. Beginners are not expected to be experts, so use this status to your advantage. Learning involves doing; therefore, make those extra exposures and prints to see what happens. Consider artist Christian Boltanski's Observation about how fear affects artists. "Good artists are usually the very young or the very old. The ones who are very young are so stupid that they have no fear. And when they are very old they aren't afraid any more. In the meantime, you are always, always, afraid."

Source Notebook and Journal Keeping

There are times when you cannot immediately act on your idea. In these situations, record it in a notebook or laptop. Take the time to transfer all your notes into the record so your ideas will be preserved in one place. A notebook may include articles, quotes, and images, found material, your own written and visual thoughts as well as any items that stimulate your thought processes.

Keeping a notebook can help you sort through experiences and define and develop ideas. Don't worry about following up on every idea. The notebook will help you sift through your ideas and decide which are worth following up. Consider your notebook a compass that can point out a direction in which to travel. A notebook can also provide a personal history of ideas for future reference. As your needs and interests change, an idea that you dismissed earlier may provide the direction you are currently seeking.

Keeping a journal in which you record reflections about events experienced each day can be an invaluable way to evaluate your per11.5 *Constellation Map* is a concept piece that was revealed as the process unfolded. "The greatest challenge was one of trust in the process. It began as a handwritten timeline of charted memories and life events made using tracing paper as overlays. Each event was then assigned a category based on a simulated Periodic Table of Elements I created. This Periodic Table of Elements had categories such as Emotional, Familial, Spiritual, and Transitional, which were broken down into more defined elements such as Guilt, Truth, Dreams, Confusion, and Rules. Once I had assigned all the elements, I scanned the tracing paper drawings and imported them into Adobe Illustrator, where I redrew each component. As this timeline plotting unfolded, the lines and points began to resemble star points and constellations, which I organized along a radial axis of time, much like the rings of a tree trunk."

© Sue O'Donnell. Constellation Map, 2005. 38 × 38 inches. Electrostatic prints.

formance, set goals, and find new ways to solve problems. Many people resist keeping a journal because they think they are not good writers, that someone will read their innermost thoughts, that their thoughts are petty, or that they have more important things to do. Instead of thinking of this journal as a diary in which you relate the day's events, think of it as a container for self-reflection, selfexpression, and self-exploration. Rather than retelling the day's events, use it to find a way to express your thoughts, which may be applied to directing a course of your vision.

The Success Game

Seekers should avoid playing the success game that relies on statistical results to determine achievement. If a photographer were to add up the number of frames exposed and compare it with the number of satisfying images produced, a typical average might be 1 percent. What is not reflected in an empirical average is the intangible joy

11.6 "I began to create large-scale posters as an extension of artists' books. I have used the work of Chris Ware, the Russian constructivists, and old cinema posters as sources of inspiration and have often accompanied my posters with short films.

© Jonathan Gitelson. What Does It All Mean?, 2004. 63 × 44 inches. Inkjet print.

involved in the imagemaking experience that requires the integration of abstract ideas and concrete operations. Good imagemakers find ways to overcome their doubts and make choices that lead to better pictures. Choice defines who we are, the direction of our work, how it is brought to life, and what viewers might derive from it. As Ansel Adams reflected, "Photography is a way of knowing."

Stage 2: Search for Form

When searching for concrete representations of an idea, both the problem and the challenge need to be acknowledged. The core problem is how to present the idea in a visual form that communicates your thoughts and feelings to the intended audience. The challenge is to create visual impact and feel satisfied with the outcome. This is the growth stage of the idea. You acknowledge the problem, take responsibility to commit your time and resources toward its resolution, and make an internal declaration to uncover the possibilities and see the project through to completion.

The Possibility Scale

Now is the time to mull over your previous experiences and knowledge. Start visualizing the idea in many different forms. Practice using the concept of the *artistic possibility scale*, which states that there are

no visual impossibilities, only different levels of possibility. It suspends traditional rationalism and its doctrine of the sovereignty of formulated, step-by-step technique and gives you the freedom to say, "If I can imagine it, there could be a way to make it happen." Think of the fantastic works by Leonardo da Vinci, Jules Vern, and H. G. Wells that anticipated future inventions and changes in society. The possibility scale embraces the notion that our mind is not wholly dependent on a conscious and formulated technique to achieve success by giving credence to the notion that there can be many answers to a question and numerous ways of reaching a destination. Give your imagination free rein and then analyze the strong and weak points of each visualization. Specifically ask yourself, How might digital imaging methods allow me to re-see the familiar? Envision how the choice of lens focal length, horizontal or vertical image format, point of view, quality of light, and post-camera image processing procedures might affect the final outcome. Let these pictures run inside the internal projection room of your brain. Do not limit your visualizations but look for elements that will provide continuity and unity to your vision.

Try breaking your normal routine and working habits to stimulate the problem-solving process. Turn off the bombardment of external stimuli and listen in silence to what is happening inside you. Sit down and chart out your ideas on a big piece of paper with a marking pen or soft lead pencil. Get beyond surface scanning and see more deeply before making any final decisions. This entails getting to the "real" problem and not getting sidetracked by its symptoms. It involves deciding where difficulties in your course of action may lie and narrowing down the focus of what you plan to cover. Keep asking "what if" questions: What if I use this ISO? What if I use this exposure

11.7 "What is the essence of a digital image? It is pure data, which is best revealed in the histogram. By looking at the color information, one can visualize the data. Here I recomposed a reproduction of Leonardo da Vinci's *The Last Supper* (1498) without changing any of the data. By using the information found in the histogram, I count the number of pixels associated with each color value. I then redistribute that value in another graphic form. The result is an image that would read the same but not look the same. This demonstrates the possibilities of how an image and meaning can change while the data remains constant."

© Bill Davis. The Last Supper, 2005. 5 × 10 inches. Inkjet print.

mode? What if I use this type of light? What if I use flash? What if I do post-capture manipulation? Take into account and weigh the possibilities and, above all, keep wondering about everything.

Stage 3: Definition and Approach

This stage defines the direction of the action to be taken to solve the problem. This involves analyzing the problem and determining its essential features and feelings. It includes taking the problem apart, doing research to discover all its ingredients, and working out their relationship to the whole. This is the time to question everything and to generate many possible courses to follow. Steer clear of falling in love with one idea or assuming you know the answer before completing this process. Go out onto a limb; defer judgment. Try techniques such as journaling or attribute listing which describe all you know about the problem, including the internal structure, patterns, and form of the problem and the breakdown of its individual parts.

After defining the problem, you can develop an engaging approach and pick the equipment, materials, and techniques that will enable you to speak in a convincing visual voice. Give thought to both previsualization (before the exposure is made) and postvisualization (after the image has been captured) methods. Mastering the methods will not guarantee persuasive results, but it will provide a means to overcome the limitations inherent in the mechanics of photo-based images. Put together all the solutions that have been considered, and keep an open mind to the alternatives. Keep a backup idea in case a detour is encountered. Do not be afraid to experiment, to take chances, or to try something that has not been done previously, as new ideas may present themselves during any part of the process.

Stage 4: Bringing It Together

This is when you muster your resources and put them into visual action. You are no longer thinking or talking about making pictures; you are actually involved in making images. Try out the visualizations you have generated and selected. Take pleasure in the process; it can be as rewarding as the final manifestation of the idea. Do not hesitate to make many exposures; use the camera as an artist uses a sketch-

11.8 Hackbardt's images address issues of the family. "Familial relationships are often described as one of flesh and blood, referring to a biological bond connecting family members, a bond which is sentimentalized as intense and lasting. However, within the family unit, interactions of blood and flesh actually both shape and threaten the family's form and content. While 'flesh and blood' refers to a biological notion of who qualifies as a family, the digital nature of the images suggests a family shaped by constructions, technology, and manipulation."

© Marcella Hackbardt. *Practical Knowledge*, from the series *Story of Knowledges*, 2006. 22×36 inches. Chromogenic color print.

book. These recordings are starting places for your visual ideas. The only way to know what something will look like photographed is by making photographs. Allow the act of photographing to lead you. Don't worry about making masterpieces or mistakes; that will be dealt with later. Keep photographing,

A likely working scenario first involves the pre-capture considerations of subject, quality of light, angle of view, focal length, and exposure determination. Next consider how you plan to use the image. Do you intend it for viewing on a screen or as a print? Ask yourself, Will I get the results I want from outputting a straight camera capture, or should I use imaging software to make major alterations to the image? Once the final look of the captured image has been determined, decide which procedures and materials to use, such as which paper type and surface to print on.

Stage 5: Operations Review

As you work, use your monitor to examine each captured image. If possible, after each shooting session, download your images to a larger screen for review. During this initial in-process evaluation, what do you see? Is this what you had in mind? What worked? What didn't work? Why did or didn't it work? What could be done to make the image more effective? Pinpoint specific sources of dissatisfaction. Can post-capture software take you where you want to go? Is your approach workable, or do you need to reassess, take a different course of action, and reshoot?

Stage 6: Evaluation

This is the step for reviewing everything that you have done. Formulate questions that reflect your concerns, expectations, needs, and wants. Get explicit and give thorough answers. In addition to the questions asked in Stage 5, ask yourself, Am I satisfied with the outcome? Why or why not? Did I accomplish what I set out to do? Have I deviated from my original approach? What methods did I use to accomplish my goals? If I were to reshoot this project, what would I do differently? Locate, define, and discuss sources of satisfaction and dissatisfaction. Have someone else look at the work and listen to what they have to say. Now ask the big questions: Do these images meet my goals? Is the final work aesthetically, spiritually, and technically satisfying? If the answers are yes, note the things you did that were helpful and apply them to future efforts. If the answers are no, it is time to reevaluate and reshoot. A large part of learning involves being able to deal with failure. Often we learn more from our failures than from our successes. Pablo Picasso said, "Even the great artists have failures." Do not get scared away. Keep making images.

How do you know when you have created a "good" image? Experience will help you to form your own methods of judgment based on personal experiences and input from additional sources. Some points to consider include: Were you able to define your internal thoughts? Did you find and master a technique that allows you to present the final photograph with the desired feeling and power? Have you gained insight and understanding into the true nature of the challenge? Has this experience been translated through the medium to the intended audience? What did you learn from viewer reaction? When the image fits the problem and the problem solver, a successful resolution has been achieved.

Satisfying work carries the mark of centered individual thought that results from a well-formed interior thinking process. Becoming a good imagemaker necessitates incorporating these attitudes into your visual outlook. Be alert for that defining moment in the process of photography that defies words — when there is nothing else, just you and the subject. If we could express everything we wanted in other media, there would be no need for the visual arts. When used in combination with awareness and intellect, good imagemaking allows us to express things that would not otherwise be possible. When this union occurs, superior images come into being. Once you are satisfied with the image, it is time to think about presentation. Will the image be stronger individually or in a group? Will it be shown on the screen, as a print, or both? If the final destination is a print, should it be mounted, matted, floated, framed, or shown in book format? Keep asking yourself questions and maintain an open mind. Do not seek perfection because it is impossible and you will not reach your goal. If the selected idea is not working out, be flexible and attempt something else. Don't get discouraged, as this is a time of discovery, growing, and learning. Make sure you learn from your successes by keeping a record of what has been done and how it was accomplished. This is empirical knowledge — repeatable results gained from experience.

THE PHOTOGRAPH AS A MATRIX

Although photography is a seamless medium, capable of capturing a complete image all at once, any camera-produced image is only the matrix for the final work. Does this make photography closer to music and theater than to drawing and painting? A drawing or a painting is what it is, a unique object, and copies of it are not the same as the original. On the other hand, music and theater exist and even gain power through their ability to be widely interpreted and modified. In his now canonical essay, "The Work of Art in the Age of Mechanical Reproduction" (1936), Walter Benjamin argues that, traditionally, a painting or sculpture intrinsically had traits he describes as "aura," originating from our recognition of its unconditional uniqueness. That is why people continue to line up for a glimpse of the *Mona Lisa*: not just to see it, but to stand in its acknowledged hallowed presence. In an age of technology, Benjamin recognized that this aura of matchless individuality is diluted by the ready availability of reproductions,

which makes it possible for us to see a work of art without ever locking our eyes on the original. Moreover, one of the native characteristics of the most influential art form of our times, photographybased imaging, is the absence of the "original." Unlimited copies and variations can easily be made from their matrix base. Their power resides in their ability to reproduce. Benjamin approved of such reproducible works without aura. He deduced that aura was an ambiguous, snobbish mystery maintained as a status symbol by the upper classes, and that its disappearance could pave the way for a new and more democratic art form: "The social significance of film, even — and especially — in its most positive form, is inconceivable without its destructive, cathartic side: the liquidation of the value of tradition in the cultural heritage."

SIZE MATTERS

Working with a matrix-based medium like digital imaging allows one to take advantage of one of Benjamin's speculations. Because the image is never fixed, the imagemaker is empowered to determine and alter the size of a print to suit various conditions and situations, which is significant because differences in size shift how we see and interpret images. Looking at a small print requires a sustained level of concentration. Small images force the mind to focus within a contained, narrow field of vision that allows the entire view to be taken in all at once and has long been one of photography's intimate delights. We read larger pictures differently, in a piecemeal fashion, bit by bit, in a manner similar to how we view films in a movie theater, which is different from how we read images on a television or computer screen. Big images reveal more detail which affects the visual equilibrium of the entire picture — where our eyes are drawn, how

11.9 Playing off the notion of the doppelganger, Connell fabricates digital doubles, razing the notion of an original, to question the shifting complexity of identity and to explore societal dichotomies such as masculine and feminine, caregiver and caretaker, straight and gay.

© Kelli Connell. Floating, 2005. 40 × 60 inches. Chromogenic color print.

they move within the image space, and where they finally come to rest.

Ultimately, superior results render your ideas and intentions visible. A successful solution is one that fits both the problem and the problem solver. Making this happen requires jumping in — chance favors the prepared mind — and becoming part of the imagemaking process.

COMMUNICATING CULTURAL KNOWLEDGE

Good problem-solving and technical skills will not communicate much to others unless they are connected to credible ways of thinking about the issues being imaged. The larger, overarching concerns traffic in the variety of purposes that photography performs in our lives and culture. Photography's relationship to reality is paradoxical. Conscientious work can provoke without coercing, while providing pleasure that is mediated by the viewer's judgment. In the recent past, works by such artists as Robert Mapplethorpe and Andres Serrano (see Figure 11.10) have been flash points for those who oppose the gay life style and support ending National Endowment for the Arts (NEA) funding to individual artists and alternative arts organizations. Some people have interpreted their images as advertisements for aberrant acts because they see the function of photography in a capitalist consumer society as selling a product, not as a vehicle for provoking controversial ideas. Artists such as Robert Heinecken have helped redefine the boundaries of photographic practice by asking, Does one have to use a camera to make significant photographic work? Critic Arthur C. Danto calls such a maker a "photographist," which he defines as "an artist who uses photographs for artistic means and whose function is partly philosophical reflection on the nature of the

11.10 In 1989, U.S. Senator Jesse Helms accused Andres Serrano of taunting the American public. Serrano's *America*, a mix of formalism and theatricality, presents over 100 archetypical portraits of Americans and is a wonderful rebuttal to Helms's finger-pointing. Presented bigger than life, backlighted by a quasi-divine aura, each subject looks highly glamorous. The photographs have an ironic component that mocks a certain type of kitsch portraiture. But as a group, the portraits project such an intense, vivid presence that it is hard not to feel moved by the democratic saga.

 \odot Andres Serrano. *Snoop Dogg*, 2002. 40 × 32-1/2 inches. Dye-destruction print. Courtesy of Paula Copper Gallery, New York.

kind of art it exemplifies." Other makers, such as Cindy Sherman and Carrie Mae Weems, use images to challenge our assumptions about gender, identity, and race.

The material covered in this text is designed to let you discover the many possibilities for photographic imagemaking. This information can help you to bring into existence that which never was. It starts to supply answers to the question, Why not? It raises the question, How can I get past merely recording the reflections of the surface? Such thinking disrupts the conventional assumption that the purpose of photography is to mirror outer reality. Unfamiliar images can make people uncomfortable because there are no prescribed guidelines on how to respond. Be prepared to discuss challenges when presenting unconventional work.

You can meet a challenge and use it to your advantage if you have done your thinking, are making images you care about, and have learned to control the imagemaking process so that it blends in and becomes a vital part of the visual statement. When the situation permits, take on the role of teacher and explain the information that was required to handle the problem in your particular way. It is likely you will learn more about your subject by trying to teach someone else about it. Nobody learns more about a subject than a wellprepared and patient teacher. It is also possible that the explanation will help your audience to see something new and unlock some doors of perception.

THE IMAGE EXPERIENCE: PHOTOGRAPHIC MEANING IS UNSTABLE

One of the paradoxes of photographic imagery is that its meaning is innately unstable, for it can only be deduced upon being seen. People do not need Photoshop to alter an image's meaning. Our minds naturally perform this task, editing information as we see fit, better and quicker than any computer program. Without captions describing the traditional Five W's — who, what, where, when, and why — photographs are defined within the context of a viewer's outlook. In a quest for meaning, audiences do not merely consume images but, like a Rorschach test, build and rebuild them, re-seeing them within their own comprehension of the past and the present and in real time. In this manner, an imagemaker's work can flow forward and backward in time while being connected to the present.

Compelling images, such as Leonardo's, that continue to fascinate and inspire people, convey the maker's ability to see similarities and forge connections when others see only differences. For instance, Leonardo observed the similarity between tresses of hair and flowing water, and drew both to show us the associations. In his notebook he wrote:

Observe the motion of the surface of water, which resembles the behavior of hair, which has two motions, of which one depends on the weight of the strands, the other on the line of its revolving; thus water makes revolving eddies, one part of which depends upon the impetus of the principal current, and the other depends on the incident and reflected motions.

His curiosity and extraordinary ability to look closely at life persuade us to see things as they are, to examine, and to *ask why* the world is the way it is and not to unthinkingly accept what is given. (For more on this topic, see Kemp 2006.)

Work that reverberates with viewers is often open-ended, requiring them to be more actively involved in shaping its meaning. Without being didactic, polemic, or illustrative, unrestricted images can inspire thinking that leads to deeper perceptions, insights, and understanding. Such unrestrained images can transport one into another realm for intellectual and emotional exploration without leaving our home environs, permitting us to be transformed while pursuing our personal freedom and individualism yet reminding us of our collective connection and responsibility to society at large.

Other times images may resist explanation. If an image could be explained in 25 words or less, we would not need the image - only the explanation. Imagemaking is not social science, and not every image should be expected to deliver an empirical meaning. Sometimes an image can be confounding, and it may well be precisely this mysterious perplexity that remains at the heart of the image experience. For some, such uncertainty can create the "image jitters," an anxiety of not "getting it." Learning to appreciate how images can function is a multifaceted process that involves aesthetics and culture, and one should not expect insight or understanding without doing the work of analysis, investigation, and assessment. Nobody will respond to every image, but one of the rewarding aspects about taking the time to examine hard-to-get images is that it allows you to become part of the creation and discovery process. You can derive your own interpretation based on such counterpoints as attraction and angst, bafflement and order, dreams and reality, while experiencing the enjoyment of discerning meaning for yourself and then informing others about your findings. Being amenable to a variety of meanings helps make us more mentally agile and tolerant of other viewpoints. The realm of images can provide thought experiments that boost, hone, and enhance our minds and being in the world. Keep in mind Oscar Wilde's remark: "The moment you think you understand a work of art, it's dead for you." Fantastic images are living entities that repeatedly draw viewers back to them because they can reveal things you don't know (see) were there until you need to know them.

11.11 Houghton began this work by looking at instruments of navigation as metaphors for how we find our way as individuals and how we use them to become who we are. "I love Galileo's spirit because he always found ways around what was forbidden. It seems like the way artists approach solving problems. Often we go at it from a variety of approaches until we find the way into the center. I enjoyed reading the conversations in Galileo's *Dialogue Concerning the Two Chief World Systems* (1632) [a comparison of the Copernican and the traditional Ptolemaic view of how our solar system works that led the Inquisition to convict Galileo of heresy and ban the book], which was like reading a play that unfolded before me, illuminating his approach to problem solving."

© Barbara Houghton. Constellation/Observation, 2003. 16 × 52 inches. Inkjet print.

WRITING ABOUT IMAGES

Solving visual problems involves learning the language of photography. One way of expanding your visual vocabulary and learning to recognize its *semiotics* (signs and symbols) is to write about pictures, for this will deepen your insight into your own working methods, predispositions, and influences and the diverse roles photography can perform. Begin by visiting top-notch, professionally managed online photographic collections or exhibition venues (see Box 11.2) and/or a brick-and-mortar library to browse through the photography and art books and periodicals. If you have access to exhibitions, plan on visiting a few different ones. Don't limit yourself only to photography; rather, select a variety of media, styles, and epochs. Spend time leisurely interacting with the work and recording your thoughts. When permissible, photograph works that intrigue you and/or acquire exhibition publications such as postcards and catalogs for reference. Next, write a structured review having an introductory premise, a body of well-thought-out observations and evidence, and a conclusion based on the data you presented. Begin by selecting work you find affirmative, engaging, and stimulating. Relate your observations and opinions and support

The American Museum of Photography	www.photographymuseum.com/
American Photography: A Century of Images	www.pbs.org/ktca/americanphotography/
CEPA Gallery	www.cepagallery.com/
George Eastman House	www.eastmanhouse.org/
J. Paul Getty Museum	www.getty.edu/museum/
International Center of Photography	www.icp.org/
The Library of Congress Print Room	www.loc.gov/rr/print/
LOC: American Memory Collections	http://memory.loc.gov/ammem/index.html
Light Work	www.lightwork.org/
Luminous-Lint	www.luminous-lint.com/
Masters of Photography	www.masters-of-photography.com/
Museum of Modern Art	www.moma.org/collection/depts/photography/index.html
New York Public Library	www.nypl.org/digital/index.htm
Photo-eye Galleries	www.photoeye.com/
The Photographers' Gallery	www.photonet.org.uk/index.php?archive
Smithsonian Institution	www.si.edu/art_and_design/photography/
Women In Photography International	www.womeninphotography.org
Zone Zero	www.zonezero.com/

Box 11.2 Online Photographic Collections and Exhibition Sites

them with specific details derived from your experience with the work. Imagine you are in a court; give direct evidence based on your first-hand account, not generalizations or unfounded information. If you have the means and know-how, include illustrations. Consider including the following topics:

• **Describe the work:** Description comprises the physical character, subject matter, and its form. Form entails how a subject is

presented (refer to Chapter 2). Can you determine the color and/or composition key? How are figure-ground relationships used? How do these qualities inform the overall nature of the work and the persona it projects?

• Evaluate the technique: What methods are employed? Is there anything unusual? Does the methodology work for you? Why or why not? Discuss exposure, use of light, along with printing and presentation methods used to generate the total

visual effect. Would you do anything differently? Why or why not?

- **Personal reaction:** Pay attention to your first reactions. What initially attracted you to this work? Did the magnetism last? Did the work deliver what you expected? Would you want to keep looking at this work over a period of time, as in your living space? Does the maker have a visual or haptic outlook (see Chapter 6)? How does this inform the nature of the work? Did you find yourself thinking or dreaming about the work later? Answer each question with a why or why not response.
- Interpretation: Ask yourself: Who made it? What is the point of view of the imagemaker? What was the maker trying to communicate? Does the imagemaker succeed? What is the larger context of the work? Who was it made for? Do the images stand on their own merits, or do they require an accompanying statement or explanation? What is your interpretation of the work? Does it present a narrative account, or is it an open-ended visualization? Does it appeal to your emotions or your intellect? If the work is in a group or series, evaluate how selected images work individually and in terms of the group. Do single images hold their own ground, or are they dependent on being seen in series? Does the imagemaker use any text? If so, which do you first gravitate toward, the image or the text? How does the text affect your perception of the image's meaning? How would your understanding of the piece be different if there were no text? Present clear, succinct, and persuasive arguments, giving evidence to back up your point of view.
- Integrate new ideas: Examine and define the work's attributes that appeal to and affect you. Be specific and cite examples.

Then consider how it might be possible for you to learn from and integrate these concepts into your way of thinking and working.

- Do the opposite: Go back to the same body of work and select work(s) that you find off-putting. Repeat the previous steps to uncover what adversely affects you. Identify specific points, such as content, color, or composition, and ask yourself what you could do to avoid incorporating such unwanted characteristics into your work.
- Seek out knowledge: Seek out someone who is knowledgeable and involved in similar work. Present the work to that person and conduct a friendly discussion. What are that person's views? Does that individual agree or disagree with your assessment? Do your opinions hold together and make a convincing case? Identify your persuasive and ineffectual points. How can they be improved? Can you see another point of view? What new territory did this other person open for you? How does this affect the way you view the work now?

Writing an Artist's Statement

When sending your own work out for review or exhibition, it is necessary to include a statement that concisely explains the conceptual aspects of your work. Essentially, an artist's statement explains why you do what you do and what your work is about. A precisely written statement can forge a connection between the artist and the audience, stimulating awareness and understanding of your work. Artists' statements vary in form, length, and substance. Take into consideration the following: your audience, your materials and medium, the subject of your work, the methodologies and theories that have influenced

11.12 "This project was one of the first leading to my exploration of the semiotics of the visual language of the photographic image. While I started using icons as image in this series, my exploration later led to the use of text as image. Text as photograph raises questions about the human thought process, the categorization of data, visual language processing, and our individual cultural/social conditioning. I am interested in the way in which the viewer contributes to the context and meaning of individual images."

© Susan Evans. Crime Scene, #4, from Crime Series, 1991. 8 × 10 inches. Inkjet print.

you, and your own background, purpose, and/or perspective. There are no simple formulas, but the subsequent steps have been put together with the assistance of imagemaker and educator Kathleen Campbell to provide a starting place for writing a concise, easy-to-read, one-page artist's statement.

ESSENTIALS OF IMAGE DISCUSSION

The following are suggested guidelines for participating in a group discussion about photographic images.

In terms of your own work, prepare talking points that will allow you to clearly and concisely state the intended purpose of your work. List questions about the areas you would most like to get feedback about. Ask yourself: What makes for constructive criticism? What constitutes negative commentary?

Follow your own rules when offering commentary on other people's work, and think *before* you speak and avoid getting personal.

When evaluating work consider the following:

- *Instant reaction:* Write down, but do not speak, your first free associations of what affects you, turns you on and/or off, and why. What is the first word or phase that comes to mind while looking at the work?
- *Physical description:* Objectively state what you see as if for the benefit of someone who can't see the piece.
- *Formal construction:* Analyze the composition, use of design elements, color, craftsmanship, and presentation.
- *Meaning:* Discuss relationships that the work evokes about your life experiences. Does the work have a narrative quality? What does the title or lack of title tell you? Use a noun or plain phrase to identify and name the work in terms of people, places, or things. Bear in mind a long-standing observation from the Talmud about how people interpret life: "We do not see the world as it is. We see the world as we are."

Guidelines for Writing an Artist's Statement

- 1. The purpose of an artist's statement is to clearly and succinctly explain and give your ideas credibility. Begin by listing what your ideas are and where they come from.
- 2. Reflect upon your own work and find patterns of interest, and then ask yourself the following: What kind of work do you enjoy making and looking at? Do you photograph landscapes or people? Do you prefer to set subject matter up or find it directly from life? Do you gravitate toward cool or warm colors? Do you favor simple or complex compositions? Do you consider yourself to be a visual or haptic person? What ideas, themes, or common denominators can you discover?
- Select an artist whose work strongly appeals to you and find out what that artist has to say. Review the procedures from the previous section, Writing about Images.
- 4. Do research. Ideas are built upon other ideas. Your work can share an idea with someone else and still be your own work. Artists get ideas from other artists, history, literature, philosophy, and politics. Where do your ideas come from? What ideas appeal to you? When you come across an idea or concept that is a magnet to you, write it down and then rewrite it in your own words, giving it your own personal perspective.
- 5. Can viewers interpret your image, not knowing what you intended and not having had your experiences? Keep in mind that an image is not the same thing as an actual experience. Generally, it is a two-dimensional representation of colors and shapes on a piece of paper. It is a symbol or a metaphor, but not the event itself.

- 6. Take into account that all images possess meaning, even if you find requests to explain your work annoying. People will make interpretations whether you want them to or not.
- 7. Learn the difference between denotation and connotation. Denotation is what images appear to be on the surface, such as a picture of a lake. Connotation is all the associations you can imagine people might "get" from the picture of the lake. There are pictures of lakes and pictures of lakes. Are yours cool and intellectual or warm and romantic? Make a list of all the connotations and denotations you can see in your work. Show the work to others and see what else they come up with.
- 8. Use metaphors, statements that are representative or symbolic of something else, especially something abstract. Literal statements lead toward literal interpretations. You are not "illustrating" your concept or idea, step by step, but fashioning a metaphor that involves your use of form and process to convey it (even if you do not discuss these in your statement). For example, darkness can be a metaphor for atmosphere. You do not have to hammer people with your intended meaning in your statement if the image(s) creates an interpretable metaphor. Metaphors also can have layers of meaning, so viewers can bring their own insights to the work.
- 9. A statement should provide a toehold for understanding the ideas behind your images. Don't tell viewers "what they should get" out of your work; rather, point them in a specific direction. By and large, images have more than one interpretation, so allow others the freedom to formulate their own interpretation. On the

other hand, this is not an excuse to avoid articulating your own analysis.

- 10. Make sure your words agree with what can be seen in your pictures. Do not write about things that are not there. If your words and images do not agree, either change the words or change the images until there is an articulate consistency between them.
- 11. Keep it simple and specific. Avoid making negative statements, writing too much, repeating or over-explaining, using vague generalities, making grandiose statements, or relying on jargon or incomprehensible language. Big words don't make up for weak ideas.
- 12. Discuss the technical process only if it is integrally related to your idea or is unusual and requires explanation.

- 13. Include a separate image checklist with the titles of your work (if any), their creation date, dimensions (height before width), process (such as inkjet print), and a general technical overview about the methods utilized to realize your vision. Provide detailed technical analysis upon request.
- 14. Ask others who are familiar with your work to evaluate your statement. Review, rewrite, and recheck the spelling, grammar, and organizational flow of your document. Writing involves rewriting, and the process of rewriting will also help you gain insight into your work. An artist's statement is a flexible document. You may have more than one for different audiences, and it should be reviewed and revised each time you use it.

• *World links*: Discuss connections of the work to culture, history, and society, and other artists or works you have observed.

JOHN CAGE'S RULES

John Cage was an American experimental music composer, writer, visual artist, and educator who used chance operations, in which

some elements are decided by chance, and Zen Buddhist beliefs to affirm life and wake us up to the very life we are living. Box 11.3 sets down some of his suggestions for getting the most out of any educational environment.

Cage's philosophy of being open to new experiences can be summed up by his remark, "I don't know why people are afraid of new ideas. I'm afraid of old ones."

Box 11.3 Some Rules and Hints for Students and Teachers or Anybody Else By John Cage

- RULE 1: Find a place you trust and then, try trusting it for a while. **RULE 2**: General Duties of a Student: and no fail. There is only make. Pull everything out of your teacher. Pull everything out of your fellow students. RULE 3: General Duties of a Teacher: Pull everything out of your students. RULE 4: Consider everything as an experiment. are different processes. RULE 5: Be self-disciplined. This means finding someone wise or
- smart and choosing to follow him or her. To be disciplined is to follow in a good way. To be self-disciplined is to follow in a better way.

- RULE 6: Follow the leader. Nothing is a mistake. There is no win
- RULE 7: The only rule is work. If you work it will lead to something. It is the people who do all of the work all the time who eventually catch on to things. You can fool the fans, but not the players.
- RULE 8: Do not try to create and analyze at the same time. They
- RULE 9: Be happy whenever you can manage it. Enjoy yourself. It is lighter than you think.
- RULE 10: We are breaking all the rules, even our own rules, and how do we do that? By leaving plenty of room for X qualities.

HELPFUL HINTS:

Always be around. Come or go to everything. Always go to classes. Read everything you can get your hands on. Look at movies carefully and often. Save everything. It may come in handy later.

11.13 The theoretical impetus for Towery's work comes from the postmodern idea that there is no such thing as originality. However, it is in Towery's artist's statement that one learns he is "recreating in miniature the iconic imagery of the early exploration era of photo history, which suggested the sublime power of the natural world.... In this case, Roger Fenton's "The Valley of the Shadow of Death," 1855. In addition, I have invented Timothy Eugene O'Tower, a fictional exploration photographer as a way of framing the work and to push the elements of fiction and simulacra. Using the veracity of photography, I create worlds where, at first glance, everything appears as it should. It isn't until further probing that we realize that our sense of scale is unnerved and we are left to figure out what is real and what is created. The images blur the line between truth and the imagination. Questions as to photography's authenticity and its relationship to truth in the digital age have become a movement within both the photographic and art worlds."

© Terry Towery. View of Crimean War Battle Scene, 2006. 9-1/4 × 12 inches. Platinum palladium print. Courtesy of Peer Gallery, New York.

11.14 © Lloyd Wolf. April Fool, 1992. 11 × 8-1/2 inches. Electrostatic print.

11.15 Since 1974, Wolf has made an annual April Fool's card that he mails to friends and family. He went from black-and-white prints, to color Xerox, and now to a scanner. The work is assembled upside-down and backward on the copy glass. Test prints are done and corrections made. They are outside the bounds of his professional documentary work. "There is no established aesthetic, no right way of making work like this, which I find liberating and fun. It gives me a reason and forum to experiment and not worry about making art, but to just make pictures. These are my annual report. Everyone else sends Christmas or Hanukkah cards, I celebrate spring."

 $\ensuremath{\mathbb{O}}$ Lloyd Wolf. April Fool, 2001. 11 \times 8-1/2 inches. Inkjet print.

REFERENCES

- Andreasen, Nancy C. The Creating Brain: The Neuroscience of Genius. New York and Washington, DC: Dana Press, 2005.
- Barrett, Terry. *Criticizing Photographs: An Introduction to Understanding*. Fourth Edition. New York: McGraw-Hill, 2005.
- Barthes, Roland. Translation by Richard Howard. *Camera Lucida: Reflections* on *Photography*. New York: Hill and Wang, 1981.
- Buster, Kendall, and Paula Crawford. *The Critique Handbook: A Sourcebook and Survival Guide*. Upper Saddle River, NJ: Pearson Prentice Hall, 2007.

- Kemp, Martin. Leonardo da Vinci: Experience, Experiment, and Design. Princeton: Princeton University Press, 2006.
- La Grange, Ashley. *Basic Critical Theory for Photographers*. Boston & London: Focal Press, 2005.
- Sontag, Susan. On Photography. New York: Farrar, Straus and Giroux, 1977.
- Sontag, Susan. Regarding the Pain of Others. New York: Farrar, Straus and Giroux, 2002.
- Booth, Wayne, Gregory Colomb, and Joseph Williams. *The Craft of Research*. Second Edition. Chicago: University of Chicago Press, 2003.

11.16 In this image showing the creation of an image, the professional artist is replaced by a group of high-school students being shown the rudiments of traditional darkroom photography. "The moment where a latent image becomes visible on the paper is a magical moment familiar to anyone who has witnessed its occurrence. It is also a moment that will become increasingly rare as chemical photography is replaced by digital image-making. This element is underlined by the fact that this is a technically 'impossible' photograph in terms of traditional photography. An exposure under the safelight of a darkroom would take too long for motion to be stopped, and as such additional lighting and digital techniques were required for the creation of the final image. As such it acts as both an homage and lament for a dying aspect of photography to which the medium has been inextricably linked since its inception."

Courtesy of Dyan Marie Projects, Toronto.

Working with a film crew, Crewdson builds pristine cinematic images by combining multiple exposures to depict the psychological pathos of suburban America where people anxiously stare into space seemingly searching for something they have lost or want to find. Crewdson, whose father was a psychoanalyst, remarks, "On some unconscious level, all my photographs project my own fears and desires."

© Gregory Crewdson. Untitled, Winter, from the series Beneath the Roses, 2005. 64-1/4 × 95-1/4 inches. Chromogenic color print. Courtesy of Luhring Augustine, New York.

Chapter 12

Photographer on Assignment

MAKING PORTRAITS: WHO AM I AND WHO ARE YOU?

Since Albrecht Dürer began a series of painted self-portraits in 1493 that provided insight into the changing nature of his character and beliefs over a lifetime, artists have expressed numerous inner concerns through self-portraits. Self-portraits allow artists to show awareness of their own appearance and traits, producing evidence of the intricacies of their lives. Self-portraits may continue gazing back at viewers in another place and time, long after their makers are dead. Self-portraits can be projections of the self that represent you as you are, or they can present hidden aspects of the self, sometimes revealing a secret self. Traditionally, self-portraits were used to demonstrate social status, talent, wealth, and/or religious beliefs.

More recently, Andy Warhol constantly relied on self-portraiture to reflect on his position and social status as an artist, performing a variety of roles that examine celebrity, disaster, and death. Cindy Sherman has made self-portraits cloaked in historical guises that confront and challenge archetypes and stereotypes, which have been formulated about the roles men and women play within society. Robert Mapplethorpe photographed himself to explore his sexual identity. Chuck Close has made over 100 self-portraits in a variety of media that merge manual and mechanical processes to explore the boundary lines between the abstract and the representational, the methodical and the subjective, and the personal and the public self.

Self-Portrait Research

Before beginning a self-portrait, it can be instructive to delve into the works of earlier artists who have explored the self-portrait and to note their research methodology, their lighting and compositional choices, and what ideas their works express. It is their ideas that continue to make their images worth studying.

Some traditional artists whose self-portraits can be instructive include the following:

- Leonardo da Vinci is said to have used himself as the model for Jesus in his painting of the *Last Supper*.
- Rembrandt's self-portraits were an outlet for feelings and ideas concerning the nature of human existence, which he could not express in the portraits of wealthy clients.
- Gustave Courbet embellished his self-portraits, transforming them into fantasies.
- Vincent van Gogh's self-portraits reveal an intensity of expression concentrated in the eyes as he seemingly "looked" for answers to questions that plagued him.
- Pablo Picasso's later self-portraits reveal the anguish of old age.
- Marc Chagall's self-portraits are memoirs of his Jewish childhood in Russia.
- Frida Kahlo's work served as a cathartic emotional release to the troubling events of her life.
- Jackson Pollock's drip and splatter paintings do not directly represent human figures, but the impulsiveness and spontaneity of his methods can be seen as a more realistic outpouring of his pent-up feelings than if he had used meticulous brushstrokes.
- Mark Rothko's abstract paintings may also be considered selfportraits for they express his deepest emotions. Rothko noted, "The people who weep before my pictures are having the same religious experience I had when I painted them."

Self-Portraits

Portraying oneself before the camera has been a staple of photography since its invention. Hippolyte Bayard (1807–1887), who invented a photographic process at the same time as Daguerre and was the first artist known to hold a photography exhibition, photographed himself as a corpse in 1840. Countess de Castiglione, a 19th-century fore-runner of Cindy Sherman, commissioned 400 to 500 photographs of herself in a numerous guises.

To begin a self-portrait, develop a concept or idea that will lead you through the process. A tried-and-true method of reacquainting yourself with yourself is to sit down in front of a mirror, alone, without any outside distractions and, with pencil and paper, make a series of contour drawings. Anyone can do a contour drawing: look into a mirror and draw what you see and feel without looking at the paper until you are finished. Based on what you learn from your contour drawings, formulate the direction of your self-portrait. Your images should express a sense of self-awareness and reveal something that is important for others to know about you and your attitude about life. While it is true that well-learned techniques help us to clarify our voice, it is our ideas that create powerful images.

Portrait of Another Person

Next, list the qualities in portraits that have stood the test of time, such as the enigmatic smile in Leonardo da Vinci's *Mona Lisa*, which continue to fascinate people and draw them into the picture. Lasting portraits avoid the obvious and, in doing so, require the viewer's involvement to extract meaning. Now, make a photographic portrait of someone you know that not only shows the appearance of the person, but gives artistic insight into the nature of this person's character.

12.1 "Photography is my identity — it is how I examine my self-image as an overweight female in her mid-20s dealing with the ever-present pressures from the outside world as it relates to this issue of self-identity. I have built a relationship between the camera and myself. Through this I invite viewers into my private day-to-day life, exploring vulnerabilities that I carry associated with a life-long struggle with my body image. I aim to raise questions regarding beauty, body image, and identity through a focused observation of my personal story, which translate to many cultural universals in our contemporary society." © Jen Davis. 4 A.M., 2003. 20 × 24 inches. Chromogenic color print. Courtesy of Lee Marks Fine Art, Shelbyville, IN.

Environmental Portrait

Make a portrait that shows your audience how an individual interacts with the surrounding environment. What does the background environment add to the portrait that a close-up does not? Concentrate on

12.2 Opton photographed more than 90 soldiers at Fort Drum, New York, shortly after their return from active duty in Iraq or Afghanistan. "My intention was to focus on the individual soldier's vulnerability and to look into the face of someone who'd seen something unforgettable. By the simple displacement of lying their heads down, we are reminded of each soldier's humanity. Working with a large-format camera, I was invisible under the dark cloth as my subject held still in this uncomfortable position. It is a quiet way of working. Each soldier was alone — captured with only his or her thoughts and the moment. With these portraits, the head becomes a straightforward object, a piece of fallen statuary. The implication of being shot down was not lost on these men and women, but the pose is also intimate — like seeing someone opposite you with his head on the pillow."

© Suzanne Opton. Soldier: Claxton — 120 Days in Afghanistan, 2004. 41 × 52 inches. Chromogenic color print. showing only one part of your subject's surroundings so that the importance of the individual is not diminished. In a traditional environmental portrait, the person being portrayed is placed in a setting that shares information about his or her life and/or interests. Typically, an individual may hold an object related to his or her profession or personal interest. Look at the work of Arnold Newman for formal environmental portraits, or the Farm Security Administration (FSA) photographers such as Dorothea Lange and Russell Lee, for more natural models.

When setting up such a shot, ask yourself, How and what does the setting and inclusion of any object add to what viewers can learn about the subject's life and interests? Also consider creating your own backdrop, either digitally or physically, which places a sitter in a unique location, perhaps one that the person would like to visit, be it Monument Valley, New York City, or the moon.

Another option is to use only objects in the environment to represent an individual who is absent.

FAUXTOGRAPHY: PHOTOGRAPHY'S SUBJECTIVE NATURE

In terms of how we know and respond to the world, photography plays a major role. Photography's inherent ability to transcribe external reality enables it to present what appears to be an accurate and unbiased validation of a scene or a moment. While photography is expert at depicting events, it also actively and/or subtly interprets happenings, as current societal values are continually integrated and interjected into them. In actuality, the purported impartial lens allows every conceivable distortion of reality to take place. Surprisingly, even in this digital age people are "shocked" when news photos turn out

12.3 "At the beginning of the 20th century, ten-year-old Jacques Henri Lartigue (see *Lartigue: Album of a Century*, 2003) made a photograph of the toys on his bedroom floor. What's useful about this reference is it invites the three of us — my four-year-old nephew who artfully arranged the dinosaurs; me, the photographer of his display; and a long deceased Frenchman — to dwell on the carpet and share the arcane secrets of childhood. The rest of you must remain outside — waiting, I hope, to join in."

© Doug DuBois. My Sister's Bedroom, 2004. 30 × 40 inches. Chromogenic color print.

to be manipulated. The phenomenon of tampering with news photographs for propaganda purposes, especially by Middle East terrorist groups, has become so prevalent that a new slang term, *fauxtography*, has been coined to describe it.

Previously, people assumed that artists depicted scenes using their imagination, freely adding or subtracting items, but photogra-

12.4 "These works are all inspired by summers spent in my studio located in an old funeral parlor on an island off the coast of Maine. For this image I created a cartes de visite with a logo for the fictitious Deschamps Old Funeral Parlor Photography. Gerard de Nerval was a 19th-century Romantic French poet who wrote a famous poem, which is the inspiration for this image. To realize my vision of a romantic, decaying, tower choked by vines, I combined photographs of a tree, a landscape, a sky, and various architectural details lifted from old stone buildings."

 \odot Francois Deschamps. La Tour Abolie, from the series Circa 1900, 2005. 10 \times 6-1/2 inches. Inkjet print.

phers were not supposed to do that. Now, digital imaging has blurred this profound psychological boundary. Still, we persist in bestowing the power and burden of veracity on photographs. We insist on carrying forward the belief that photography can recreate an original scene with absolute fidelity because that belief adds a sense of certainty, which makes us feel more secure in an uncertain world. This die-hard faith seems to rescue and save the past, often lending it dignity and romance, making us feel a little less mortal — but, like Swiss cheese, it is full of holes.

Truthiness and Wikiality

In the context of our times, we are conscious that a camera can capture infinitesimal detail, but we also recognize how it can be used to craft distortions or lies about a subject; that is, we know that camera images represent a highly "subjective truth" that can never be taken at face valve and always requires analysis. This topic of authenticity has received much cultural attention on television, particularly by political satirist Stephen Colbert who has popularized such buzzwords as *truthiness*, meaning "truth unencumbered by the facts," and *Wikiality*, derived from the open-source Wikipedia information website and meaning "reality as determined by majority vote." Citing how astronomers voted Pluto off their list of planets, Colbert points out that in user-created realities, such as Wiki websites, anything can become "true" if enough people say it is.

PICTURING SOCIAL IDENTITY

Before it was widely acknowledged that an imagemaker could control and manipulate a subject before the lens, photography had been used to impose a visual identity upon groups of people outside the domi-

Digital Truth: Human User Fusion

Artist and educator Bill Davis has designed a collaborative pedagogical project for his students at Western Michigan University. Its purpose is to visually demonstrate that digital truth is always in flux by having students "manufacture" an artificial face, in the manner of artist Nancy Burson (see Chapter 1), which is averaged from the digital images that all the members of the group take of one another. By having individuals modify their own image and fuse it with images of every user, they create a collective group face. In a studio setting, a simple headshot is made of each student, who is encouraged to wear his/her favorite t-shirt, hat, gloves, scarf, jacket, and/or jewelry. Students also sample and switch tattoos or product logos. Imaging software is then used to fuse these images into a single, pan-cultural, and diverse "Common Face." At the end of the project, each student finds traces of his or her own face, but must ultimately concede to the artificial life and image he or she has rendered.

nant culture, thus shaping how that particular group of people was perceived. Nineteenth-century ethnological studies, such as Englishman John Thompson's *The Antiquities of Cambodia* (1867) and *Illustrations of China and Its People* (1873–1874), brought back to Europe exotic images that confirmed preexisting attitudes, prejudices, and stereotypes held by the Western power elite. Thompson made pictures for people who considered "the other" as mentally inferior and technologically and socially primitive. His work reflected the values of the British colonial system, which believed in the "White Man's Burden," the right and the duty to govern other lands and enlighten the natives in the ways of Christianity and the Queen. Such practices helped to objectify and exploit the native populations, who had no control over how they were pictured or the context in which their pictures were distributed within the society at large. Government agencies, such as the U.S. Farm Security Administration (FSA), utilized outside photographers to inform the public about the plight of the rural poor and to showcase and gain support for the agency's work.

Depicting Social Customs

Concentrate on specific practices that give your group a shared, cohesive experience. Social customs and rituals involve the act of bonding and provide the collective glue that forms a common allegiance transcending individuality. They are a unifying force that allows us to blend into a community of shared ambitions, despairs, dreams, passions, and values. Self-controlled images of such inner rituals can give a group the power of ownership over how their communal visual image is characterized, identified, and defined by the society at large. Examine traditions that may have been intentionally concealed, and question why this was the case. Keep asking, What does it mean to be a member of this specific "circle"? Make photographs that question historical depictions and update your group's own stories.

Consider a strategy of depicting individual stories that possess the capacity to move outward and engage a larger narrative tradition by looking for collective human traits. This method recognizes that a sense of community is an ongoing process that requires the participation of each new generation to keep a story alive and relevant. The

12.5 "I like the idea that digital photography can allow me to make images that never existed. For this piece, I took photographs of all the subjects at the same distance from the camera under identical lighting and then combined them in Photoshop. My goal was to make a portrait of a person who did not exist, but seemed real."

© Raquel Coulter. Human User Fusion Female, 2006. 7-1/2 × 10 inches. Inkjet print.

picturing and preserving of social customs extends the time that participants can spend celebrating and contemplating their own values. By picturing core experiences, you can provide an infrastructure of social events that becomes part of the group's consciousness. Your images indirectly announce that what is of significance is of our own choosing and creation. This alteration in self-perception can help provide the confidence to deconstruct old myths and reformulate a community's social identity to met its current needs.

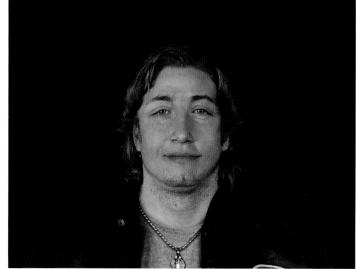

12.6 "Joe is the average student realized. He was created by combining equal parts of 20 Western Michigan University art students within Photoshop. I wanted him to look as real as possible. I spent a great deal of time detailing him. and before long I felt like I knew him. I could have sworn that I had met him somewhere before. I want viewers to think they are looking at a real person, only to discover that Joe doesn't exist."

© Steven Kuypers. Joe (Human User Fusion Male), 2006. 7-1/2 × 10 inches. Inkjet print.

Who Can Represent Us?

Imaging social identity raises some thought-provoking questions. Who has the right to represent a particular group? Must one be African-American to make work about slavery, a homosexual to comment about sexual preference, or non-Caucasian to discuss racial discrimination? Does having a direct link with a specific group automatically confer legitimacy to make images about that group? What

Portraits from Within

Your mission is to make images of members of your specific cultural subgroup(s) or of those with whom you have shared similar circumstances. The purpose is to provide a contextualized reading based on your experience as a member of a particular subculture that offers a new portrait that more closely reveals how your group currently sees itself. Your pictures should be centered on your bond with the group, which provides an innate sense of trust with the subjects. This view from within, rather than a gaze from without, should convey a sense of intimacy and openness between your subjects and yourself, visually communicating firsthand accounts of your group's social rituals and values.

about people who strongly identify with a group, but don't possess their recognizable characteristics? Can a white person document the blues? Can being a member of an inner circle cloud one's vision or purposely lead one to make propaganda images that falsely depict a group? Can you have a memory or claim something you did not directly experience? Can Jews born after World War II produce compelling commentary about the Shoah? Is it possible for outsiders to reveal things that insiders can't see or don't want shown, and do they have the right to do so? Who determines the validity of such experiences and bestows the credentials to make legitimate images? And

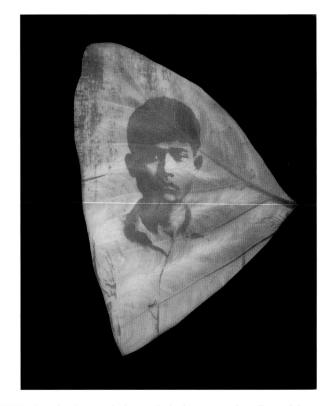

12.7 Danh makes images dealing with the long-term after affects of the Vietnam War using a process he invented for printing found photographs that have been digitized and rendered onto the surface of leaves by exploiting the natural process of photosynthesis. The leaves, still living, are pressed between glass plates with the negative and exposed to sunlight for a week to several months. "The image formation is due to chlorophyll, light, carbon dioxide, and water: the life source of plants and, consequently the Earth. The fragile works are then cast in resin, like biological samples for scientific studies." © Binh Danh. *The Botany of Tuol Sleng* #11, 2006. 11-3/4 \times 10-3/4 \times 1-1/3 inches. Chlorophyll print and resin. Courtesy of Haines Gallery, San Francisco.

12.8 "These photographic composites deal with the poetic impact of certain landscapes and aspects of classical architecture and art history on my life, and how these influences continue to remain in memory, resurfacing at unexpected moments. My photographs are autobiographical and represent my effort to clarify, to find meaning and significance in daily existence. Here I was undergoing chemotherapy. Often epiphanies occur while traveling, as I try to locate related images that express my feelings about particular landscapes. Sometimes these photographs are taken on separate visits, thus the name of the series, *Return Trips*. I am fascinated by the way photographs that are placed in proximity can become a whole that is greater than the sum of the parts." © Bea Nettles. *Hole*, from the series *Return Trips*, 2005. 23 × 17 inches. Inkjet print.

finally, can the values of one culture be superior to the values of another? Why or why not?

INTERIOR EXPERIENCE: THE SIGNIFICANCE OF DAILY LIFE

Photography shows and tells people about their world, and it is a prime communicator of knowledge and emotion. Photography reaches out in all directions, through television, magazines, newspapers, movies, DVDs, and, of course, the Web, encompassing everyone, even those who do not want to be touched. Although some people still think of photography in terms of its documentary abilities, capturing the exterior world, it also offers opportunities to explore our interior affairs and to depict how we see, interpret, and know our inner world.

Philosophical Belief: Optimism, Pessimism, and Existentialism

Use your camera vision to image an abstract philosophical belief. Determine whether your outlook is basically optimistic or pessimistic.

Interior Experiences

For this project, use your powers of camera vision to probe the inner realities of your mind rather than the outer reality of the street to make images dealing with the following themes:

• Inner Fantasy

Construct an image of an inner fantasy. Create a space where you are free to act out multiple and often conflicting and paradoxical identifications of the self. Consider both narcissistic and selfless fantasies and where to draw the line of acceptable cultural/social limits. Involve viewers in the psychic tensions between the inner and outer self, allowing them to experience the inherent fluidity of psychic life and its potential for change. Allow your creative energy to spring from yourself. Your own experiences and ideas communicated directly to another will be more meaningful and powerful than imitating someone else's approach.

Memorable Dream

Construct an image or a series of images recalling a visually noteworthy aspect of a memorable dream. Purposely set things up to be lit and photographed. Be your own producer and director. Utilize this control to achieve your desired results. Western philosophy is built on the notions of reason and progress, not to mention the American ideal of the "pursuit of happiness." But pessimists are skeptical about the concept of progress and see no point in seeking happiness, believing that, when it comes, it is usually by surprise. Being a pessimist is not about being depressed or misanthropic, nor does it hold we have a one-way ticket toward annihilation. Fundamentally, pessimism doubts that applying human reasoning to the world's problems will have a positive effect.

Another difference between pessimists and optimists is their outlook regarding time. Optimists see the passing of time as an opportunity to better the world. Pessimists consider it a burden and a tragedy. Passing time marks the physical decline of our body toward death and acts as a barrier that separates us from those we care about. Optimists see history as the ongoing rise of civilization. Pessimists believe that any seeming progress has unseen expenses, and that even when the world seems to be improving, it is not really getting better. Polio is cured, only to be replaced by AIDS. Airplanes make travel fast, but can drop bombs or be crashed into skyscrapers.

Existentialism rejects the belief that life has an inherent meaning and embraces the freedom of personal responsibility and choice, holding that responsibilities enhance rather than encumber our existence. Far from being nihilistic, it says most people take on responsibilities because doing so puts them in charge of their lives and defines just who they are. It embraces core American beliefs of individualism, self-reliance, and cooperation — in brief: we are what we do. For instance, most people who enter public service do so because they want to change things for the better, make a contribution. Even corrupt politicians confess they did not start out hungering for power

12.9 Derived from her mother's death when she was seven, Little investigates "ritual, excess, and trauma, most often through a presence and absence of the maternal body. Ritual can be seen to assist us in participating in the world around us. Within my work, ritual is functioning on a similar level; however, it is under the burden of grief and trauma, most often in response to the structural death of the mother and cultural rupture. It becomes a solitary act and an attempt to build a different kind of community — one that lacks familial history in a concrete way but instead is embedded within instinct or what I am calling the matrilineal ghost."

and wealth and hope they might be remembered for whatever good they did.

Use these theoretical counterpoints as visual toeholds to conceive of how to image something, an idea, which does not physically exist for one to photograph.

Psychological Drama

Image a psychological drama. Ask: What is it you want to conjure up? Do you need a literal, explicit narrative, or can your concepts be more figurative and obliquely implied? Are you raising questions or seeking answers? What conclusion would you like your audience to reach? Use your concerns, fears, or neuroses as opportunities for examination and growth toward resolution. Consider these possibilities: How can your pictures be used to confront something that you find perplexing and/or unsettling? Is it possible for the process of photography to lead you toward a new understanding of this situation? Can an image increase your knowledge about yourself? Can the act of picture-making produce a change in your attitudes about something or make you more sympathetic to a particular point of view? Avoid chasing yourself, by making the effort to break free of your habitual practices and see the situation with fresh eyes.

Social Issues

The duality of photography to politicize any social issue currently under debate while at the same time reflecting the values you so dearly hold to can create a dilemma. Such topics can deal with war, race, religion, gender, health, environment, or sexual orientation. Address an issue with which you have direct personal experience. Ask yourself if these images are being made solely to express your

12.10 Shambroom examines issues of fear, safety, and liberty in post-9/11 America by photographing official training facilities, equipment, and personnel involved in efforts to prepare for and respond to terrorist attacks. Portraits of emergency workers standing in the landscape dressed in their full gear hint at elegant full-length portraits of nobility. "The location of lighting and digital work create a sense of disconnection between the subject and the landscape. The light is contradictory (does not match in quality or direction), much as we see in the practice of 18th- and 19th-century Western portrait paintings." © Paul Shambroom. Urban Search and Rescue ("Disaster City" National Emergency Response and Rescue Training Center, Texas Engineering and Extension Service (TEEX), College Station, TX), from the series Security, 2004. 63 × 38 inches. Inkjet print.

History Revision

History is not a fixed entity, but is always in flux, being written and rewritten through one's personal filter of culture and identity. Taking familiar pictures and purposely setting them in a new context forces us to see things in new ways. Digital images are easy to review and revise, allowing us to express what we know and to create new territory to contemplate.

Imagemaker and educator Bill Davis brings this to the attention of his students by asking them to construct a layered image that never happened or to rewrite history. Davis encourages one to rethink by posing "what if" questions. What if the South had won the American Civil War? What if Hitler had been a successful painter? What if George Bush had lost the 2004 election? In the context of global warming, what might your home state look like in 50 years? What could a world map look like if the oceans and the land were reversed, and what would produce such a horrendous change? The first step is to create a History Revision Project Sheet and clearly write out your responses to the following:

- 1. List a moment in history that had a significant impact on you or on one or more future generations.
- 2. What is the most significant remaining image or series of images that illustrates this moment?
- 3. Envision history with a different outcome, and describe the outcome. Be visually descriptive.
- 4. List the images you are using from your chosen historical moment to redefine that moment. Will you need more than one image?
- 5. Illustrate your reconstructed history using your imaging software and your History Revision Project Sheet.

own feeling, or do you want others to seriously consider adopting your position or do you want to simply educate? Approaches can be varied to meet the needs of specific viewing groups. Think about the type of response and reaction you want the viewer to have. If you want viewers to be sympathetic, avoid ranting and figure out a more subtle approach that does not alienate people. Understatement and humor can often be more convincing tactics, as they allow viewers to let down their guard and actually look at what you have produced, which may result in unanticipated affirmative viewer reactions. If this is of no consequence, then blaze away.

FABRICATION FOR THE CAMERA: DIRECTORIAL MODE

In the past, most photographers went out and found things in the natural world to photograph. Today, many imagemakers reject this approach to photography and embrace nondocumentary practices by

12.11 "Digital imaging gave me the freedom to rewrite history by re-imaging Alfred Eisenstaedt's photographic icon that appeared in *Life* magazine. In place of a sailor kissing a nurse in New York's Times Square to celebrate the joy of V-J Day (Victory Over Japan, August 14, 1945) and the end of World War II, I altered the composition and substituted a man for the woman to question our society's acceptance of homosexuality. If the image were not of a good-looking man and woman, would it be as famous as it is today?"

© Christine Emmer. Kissing the War Goodbye Revision, 2006. Dimensions vary. Digital file.

Exercise

Fabricate an Environment

Fabricate your own environment. Arrange real people and objects in an environment for the purpose of photographing an event that you have orchestrated, where you have directorial and technical control. Give special thought to lighting and depth of field. Imaging software may be used to enhance your camera-based image, but not as the primary source of creation.

manufacturing images that do not exist in the real world. These imagemakers create and stage productions that may involve live models, arranged objects, and painted sets in which the lighting is controlled, the photographs made, and their self-created stage struck, leaving no evidence except the images of the event. In some cases, the final work may include both images and a three-dimensional installation.

The Social Landscape

The term *landscape* originates from the Dutch word *landschap*, meaning "landship." It represented a segment of nature that could be taken in at a glance, from a single point of view, and encompassed the land as well as animals, buildings, and people. Broadly, the landscape can be defined as an artificial collection of human-made spaces on the earth's surface purposely constructed to organize space and time. However, beginning in the 19th century, there was an aesthetic movement to segregate nature from humanity and its institutions. The results of this can be seen in the public belief in a pristine, unpopu-

12.12 "These aren't real landscapes but painstaking recreations in miniature. I take pleasure in bringing to life the narratives I draw from newspaper headlines, books, and absurd real-life situations. I try to maintain a sense of dark but humorous irony in the stories I tell by combining a sense of innocence with tragedy. My photographs serve as evidence to the viewer of the consequences of a world gone wrong. Not the objective evidence, per se, of a crime photograph, but the unfolding of life's dramas frozen with the cool objectivity of an architect's model of his own creation. What comes into view is the decisive moments in life where all the dangers and mishaps come together to create poetry."

 \odot Lori Nix. *Junkyard*, 2003. 40 × 70 inches. Chromogenic color print. Courtesy of Miller Block Gallery, Boston.

lated, transcendental environment, such as those depicted by the Sierra Club. This glorification of what it was like to be alone in an untouched world can be beautifully romantic, but it does not take into account how most people experience the landscape.

Present-day landscape images include broader parameters than in the past, often conveying a sense of place and time in relationship to human experience. Some imagemakers continue to impart the beauty and grandeur of nature by making images that give viewers a sense of looking at the scene without any political or social message. However, the most thought-provoking work is being made by those who show the "social landscape" fashioned by human aesthetics, desires, ethics, and necessities. The *social landscape* can be defined as a personalized response, expressing life through the ideas, personality, and social/economic/political concerns of the imagemaker, incorporating the informal artistic qualities of the snapshot to comment on "people and people things." The beginnings of this approach can be seen in William Klein's *Life Is Good for You in New York*... (1956), Robert Frank's *The Americans* (1958), Garry Winogrand's *The Animals* (1968), and Lee Friedlander's *Self-Portrait* (1970).

Within this context, the landscape becomes a symbolic convergence of physical, geological processes, and intellectual, cultural meanings. More than a slice of nature, the landscape develops into a portrait of the social face of our world, and imagemakers

EXERCISE Fabrication

Another option is offered by Professor Kathleen Robbins at the University of South Carolina's McMaster College of Art. Her assignment is as follows:

- Write a brief story, a few pages in length, describing a personally significant event or moment: "One day back in Yoknapatawpha," You can write about a particular event from your childhood or one from yesterday afternoon. Be descriptive and let it flow.
- 2. Watch your favorite movie. Notice individual scenes in the film that stick with you. How did the director film the scene? How does it begin and end? Are there breaks or interruptions in the time line? Imagine the relationship between this scene and the screenplay from which it was derived.
- 3. Review your own story. How would a director film your scene? Sketch out a simple visual storyboard.

4. Condense your storyboard into a single image. This image should typically depict the pivotal or climactic moment of your story. How are you going to execute this photograph? Plan the setting, the color scheme, the props, the actors, the lighting, and camera angle. Sketch that image.

5. Photograph the image you have sketched.

For ideas and inspiration look at the work of Janine Antoni, Boyd Webb, James Casebere, Gregory Crewdson, Anna Gaskell, David Haxton, Teun Hocks, Jan Kaila, David Levinthal, Tracey Moffatt, Sarah Moon, Patrick Nagatani, and Jeff Wall.

For more information, see Anne H. Hoy. Fabrications: Staged, Altered, and Appropriated Photographs. New York: Abbeville Press, 1987.

respond to this process of cultural change that imprints itself on the land. In this framework, the social landscape can be divided into three areas that shape our collective identities:

- The *cultural landscape* speaks to the ongoing issues of identity faced by all subgroups, including indigenous and immigrant peoples, and their relationship to the landscape.
- The *environmental landscape* examines the relationships between humans and their physical landscapes.
- The *political/social landscape* looks at conflict and social reform as reflected in people's everyday lives.

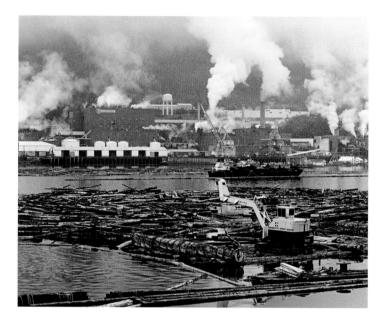

12.13 In 1985, some Americans were aware of Alaska's Inside Passage, but few knew it was the domain of the Tongass rainforest, the largest and rarest temperate rainforest in the world. Clear-cut logging had been eroding the wildness of the ancient forest, but the grassroots campaign against the logging gained momentum with the publication of Ketchum's *The Tongass: Alaska's Vanishing Rain Forest* in 1986. The book proved to be a formidable tool and became a key part of a three-year media campaign during which it was distributed to all members of the U.S. Congress. In 1990, the Tongass Timber Reform Bill was signed into law, the largest such reform regulation in American history, protecting one million acres of old-growth forest and creating five new wilderness areas. Nonetheless, the battle over millions of additional acres of Tongass forest continues on to this day.

© Robert Glenn Ketchum. Louisiana Pacific-Ketchikan, from The Tongass Rainforest Campaign, 1986. Dimensions vary. Dye-destruction print. Courtesy of Fahey Klein Gallery, Los Angeles.

TIME-HONORED THEMES

Still Life

A still life is a collection of inanimate objects and was popular in 17th-century Western painting. Still-life subject matter was readily available and did not move or tire, as a model would. Traditionally, painters selected natural items such as flowers, or wild game, and combined them with man-made domestic items such as books, tableware, and foodstuffs. The tradition of still life is found in the roots of photography. Daguerre and Talbot made still-life photographs, taking advantage of the inanimate arrangements during the long exposures necessary in early photography.

Still-life images allow imagemakers control over their composition's design elements and lighting effects. Today, still life is pursued by both artistic and commercial photographers and has laid the groundwork for advertising and product illustration photography. The challenge is to build an image, from the camera's point of view, which delivers a well-defined composition.

Still-Life Deliberations

Look at work created for artistic and commercial purposes by photographers and artists using other media, especially painting, including cubism and photorealism. Ask yourself: What is working visually in the images or artwork you found? What feels misplaced or is offbalance? Once you have examined the professionals' work, formulate your own still-life vision. Pick a theme that intrigues you, for it can provide a solid structure for completing the process.

Still life affords you the opportunity to work alone and to set your own pace, managing all the pictorial elements without the

12.14 Lee turned his scanner on its side, using it like a camera, to make images that appear to resemble 17th century Dutch still life paintings. However, things in the digital world are not always what they appear to be. Photographer Adam Harrison writes: "The lushness of the work are belied by the nature of his subjects. The fruit, flowers, insects and feathers within — all common features of historical still life paintings — are in fact all facsimiles bought at a dollar store. Where patrons used to commission still lives that would signify their wealth, and the objects that it afforded, Lee instead creates his abundant compositions from decorative kitsch. Through their translation, they become stunningly uneasy, displaying a dichotomy that is situated between a classical yet completely forward-thinking view of picture making that continues the tradition while imbuing it with new ideas and possibilities."

© Evan Lee. Still Life with Artificial Flowers and Insects (\$9), 2006. 12 × 14 inches. Inkjet print. Courtesy of Monte Clark Gallery, Vancouver/Toronto.

distractions and problems of working with live models. Photographing a still life can provide you with the time and privacy to concentrate on composition and lighting.

Collect and organize your objects and props. Pick a location, such as the corner of a room or a larger studio space. Make sure there is enough space to arrange your lights. It can be beneficial if you select a space where the setup can be left undisturbed, for it allows you undisturbed time to study, linger, and interact with your construct before you begin photographing. It also lets you go back and make adjustments after reviewing your first round of images. Select the background setting. It may be a seamless paper or a personal construct.

Pay close attention to the type of lighting that will best set the emotional and psychological stage for your image while revealing the natural properties of the objects of your still life. Consider which lighting scheme to use: natural, artificial, or a combination of both (see Chapter 5). Start with only one main light. What direction should the key light come from: front, side, top, or bottom? Play with different placements and distances from your setup. Do you need diffusers to reduce contrast or reflectors to bounce light into the shadows? Use a second light only to bring out the background or reduce shadows. When working with two lights, watch out for double shadows, as overlapping areas of illumination tend to produce visual confusion. Would colored gels or filters help produce the atmosphere you want? Where and how will you determine your exposure reading?

Stay loose, play with the objects, and try out different compositional arrangements. Look for combinations of colors, shapes, and textures that promote your theme. Continue reassessing your lighting

Social Landscape

Decide what subdivision of the social landscape you have the greatest affinity for. Then launch a cognitive investigation for appropriate subjects. Concentrate on the interrelationship between humans and nature and determine the essential visual qualities you want to convey. For instance:

- Explore the influences of landforms on human occupancy and vice versa.
- Find and study contemporary examples, such as Robert Adams, Edward Burtynsky, Catherine Chalmers, David Hanson, Robert Glenn Ketchum, and others who have visualized the social landscape.
- Examine how different attitudes and ways of life leave their imprint on the landscape.
- Look at how class, ethnicity, and gender affect one's relationship to the land.

- Scrutinize both the problems and the opportunities each issue presents.
- Determine how to represent the negative and positive effects of human activities.
- Study how allegorical symbols and other visual methods can transmit cultural values and perspectives.
- Assess how your aesthetic decisions, such as the use of depth of field and scale, will affect the visual outcome and viewer response.

Additional Information

Jussim, Estelle, with Elizabeth Lindquist-Cock. Landscape as Photograph. *New Haven, CT: Yale University Press, 1985.*

arrangements. Once the composition is set, concentrate on the prime characteristics you want your image to reveal and emphasize. Test various lens f-stops and focus points to manage depth of field and detail. Review exposures as you go and adjust accordingly. Could post-exposure imaging procedures enhance and strengthen your intended viewpoint? Also, give thought to how the final piece will be presented and viewed. Finally, when the opportunity presents itself, use a view camera to make a still life. This will provide hands-on experience with its adjustments (swings, tilts, and rising front), increasing your control over the final

12.15 The ParkeHarrisons utilize an austere and open-ended narrative to represent their concerns about the complex environmental crisis and the peculiar relationship between nature and technology. Their bleak palette and blood-fueled marking contraption infer a tale of loss, human struggle, and exploration within a harsh and indifferent landscape. © Robert and Shana ParkeHarrison. *Scribe*, 2005. 40 × 85 inches. Chromogenic color print.

image, especially with depth of field and perspective.

The Human Form

The human body has been a stimulating and controversial subject since photography's beginnings. Of course, some interest in the human body has always been solely prurient, as in the making of pornography, but the nude has a long history as a venerable subject for artists. The liveliness of this genre can be seen in the multitude of ways in which the human figure has been represented: as a cherub, a goddess, a warrior. Stylistically, the body has been a stage to depict beauty, culpability, gentleness, horror, innocence, magnificence, repulsiveness, and power, in complete, whole forms and fractured deconstructions.

In the early 19th century, the traditional male nude became a taboo subject (fig leaves had to be added to cover up the objectionable genitalia), causing artists to concentrate on the female form. During this era, it also became unacceptable to show pubic hair, a convention still enforced today in many locales. Only recently has the male form been reintroduced into the public arena, often with a chorus of disapproval, as with the work of Robert Mapplethorpe, whose graphic gay images provoked government censorship and funding cuts to the arts. Recently, cable television and the Web have opened the floodgates for mundane, provocative, and sometimes offensive images of the body.

THE DISPLAY: ANOTHER PICTURE REALITY

Digital images live electronically and often are only viewed on a screen, eliminating the physical attributes of an ordinary photographic print. Photographing images shown on a television or computer monitor provides an opportunity for the imagemaker to extend the meaning of the electronically displayed images instead of being a just passive spectator of these images. Your camera can directly capture these images as a single image or can be utilized to modify their original meaning by permitting these images to blend and interact with other images or environments.

Here are some guidelines for making images from a television or monitor display.

- **1.** Work with a clean, flat display to minimize distortion.
- **2.** Place the camera on a tripod. Adjust the focal length of the lens, filling the entire frame with an image or work with the Macro mode to concentrate on a small area of the display.
- **3.** Turn off the room lights and cover the windows to avoid reflections on the screen.
- **4.** When available, use a display hood or place a black piece of cardboard in front of the camera, with a hole cut in it for the lens. This technique will help eliminate camera and other reflections from being recorded.
- **5.** Adjust the picture contrast on the display/monitor to a slightly darker (flatter) than normal setting; this will produce a more accurate rendition.
- 6. Adjust the color to meet your personal needs.
- Most displays generate a new frame every 1/30 of a second. If the shutter speed is higher than 1/30 of a second, the leading edge of the scanning beam will appear on the picture

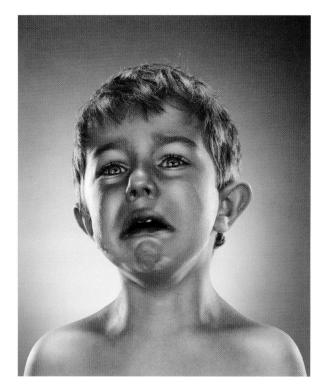

12.16 This series portrays a taboo subject — children in pain — and demonstrates the continued widespread acceptance of a photograph as a bearer of truth. We see a crying child and want to comfort it. Controversy followed this series. Greenberg says, "The children I photographed were not harmed in any way. Toddlers cry easily. I would give them a lollipop and then take it away. Children's emotions are close to the surface. They haven't learned how to hide their moment-to-moment feelings. This makes them compelling models to convey my message: I cannot fully protect my children from a world of human and natural disasters." © Jill Greenberg. *Grand Old Party*, from the series *End Times*, 2005. 50 × 42 inches. Inkjet print. Courtesy of Paul Kopeikin Gallery, Los Angeles.

Exercise	Human Form
Make a determination about the following topics before getting started. • Identify your underlying theme, how you can visualize it,	• What mood do you want to induce through your selection of colors and lights: dramatic, erotic, innocent, loving, provocative, romantic, secretive, sensual, or vulnerable?
and how you can go about creating it.	• Would a cool or warm color scheme be most effective?
 Select a human form that personifies your ideas. Are you going to provide context for your subject, or are 	• Will overall high-key or low-key lighting produce your results?
you going to objectify it?How does your approach mirror our cultural ideas and	• What about the angle of the lights? Do you want to reveal texture?
ideals?	• Will soft, indirect light, good for revealing subtleties of forr through tonal graduations, deliver what you are after? Or
• Do you want a naturalistic, real-world setting or one that is abstract and artificial?	would directional light, creating more contrast, darker shadows, and a bolder, more graphic mood meet your intentions?
• Do you want to present the entire figure or a portion of it?	
• What is the effect when you manipulate or deconstruct the human form?	• How can camera positioning and lens focal length be utilized to produce the psychological effects you desire?
 How can you use sections of the body to signify and objectify the whole? 	Should focus be sharp or diffused?Do you plan any post-exposure work?
• Will the figure be clothed, nude, or partially dressed?	 How will the work be presented?
• What type of background will be most effective?	Establish a good working rapport with the model(s). Explain to
• Will you require props? If so, how will you acquire them?	the model what you want to visually convey. Offer direction, but b

EXERCISE

Human Form

willing to take suggestions. Leave any hidden agendas or expectations somewhere else. Do not intimidate models into doing anything that they find objectionable. Concentrate on making photographs.

For more information and examples about the human form, see:

as a dark, slightly curved line. If you do not want this line in your images, select a shutter speed of 1/30 of a second or slower. Experiment with shutter speeds of 1/15 and 1/8 and review for effect.

If the image being photographed is static or can be frozen on the screen, try using the slower speeds to ensure the frame line is not visible. Once the correct shutter speed is selected, make all exposure adjustments by using the lens aperture. If screen lines are unacceptable, images can be captured with a film recorder that makes its image based on electronic signals rather than from a direct screen shot.

- 8. Experiment with different white balance settings.
- **9.** A DVD player or a software application, such as QuickTime, allows an imagemaker to control the screen images and provides the ability to repeat an image until it can be captured as desired.

Ewing, William, (ed). The Body: Photographs of the Human Form. *San Francisco: Chronicle Books, 1994. Gill, Michael.* Image of the Body: Aspects of the Nude. *New*

York: Doubleday 1989.

Pultz, John. The Body and the Lens: Photography 1839 to the Present. *New York: Harry N. Abrams, 1995.*

Alternative Approaches

Nontraditional screen representations can be made using the following methods:

- Vary the shutter speed slower and faster than 1/30 of a second.
- Hand-hold the camera at oblique angles to the display.
- Get close to the screen to exaggerate the image and limit the depth of field.
- Adjust the color balance of the display from its normal position.
- Vary the horizontal and vertical hold positions from their standard adjustments.
- Put transparent material, having a color, image, or texture, in front of the display.
- Fabricate a situation to be photographed that includes a screen image.

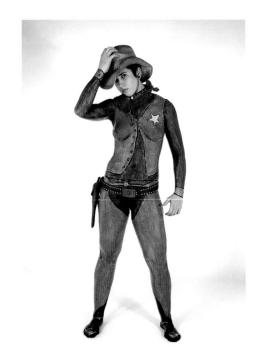

12.17 "I choose to portray these male types on a woman's skin to show the strength, beauty, and dignity of women. I use my body to make humorous and political statements, to break through doors that seem to limit women's ambitions and to inspire women to stand up and be seen equal to men in society. My body is fully painted in a studio setting with liquid latex to create each character. Once the body has been painted and dried (usually a five-hour process), a gloss protectant is then sprayed as a sealant. Only a few props are real objects. The body is presented nude to leave visible the focus of a female gender. After the photo-shoot and impromptu performance, the images are imported into Photoshop and transformed into fast stop-action video projections for the wall."

© Kelly Flynn. *Cowboy* 2, from the series *iLatex*, 2006. 30 × 20 inches. Inkjet print. Courtesy of Chelsea Galleria, Miami, FL.

- Incorporate the screen image with its surroundings or other events.
- Project an image onto the display.
- Movie theater screens, including drive-ins, provide a rich source of imagery.
- Use a magnet to distort the display image. But beware, as this may put the unit out of adjustment and require professional repair afterwards.

TEXT AND IMAGES

In Western culture, we equate learning and knowledge with words. Popular media feed us endless combinations of pictures and text (screen crawls), screens within screens of images, and flashy headlines simultaneously competing and playing off one another. With separate and discrete sets of symbols, the brain has to deal with contending sets of messages. This juxtaposition can be used to convey additional straightforward information, humor, irony, and surreal spatial arrangements or to create conditions of fantasy and meaning that would be impossible with only one set of symbols. These types of image/text combinations provide a rich opportunity to delve into psychological and other kinds of relationships between images and words. Notice how the meaning of an image can shift, depending the text that accompanies it. Wright Morris, who spent a lifetime investigating the synergy between photographs and words, concluded that "The mind is its own place, the visible world is another, and visual and verbal images sustain the dialogue between them."

Photographs are very good at conveying actions or generating commercial, inspirational, and patriotic visual myths, but not so good at explaining complex ideas. Combining images and text can help us bridge this communications gulf between images and spoken language. We tend to think pictorially, but when we need to communicate, we generally transform these images into thoughts and the thoughts into language. During this process, the nimbleness, plasticity, and texture of the image are often sacrificed. This process is further complicated as viewers interpret this translation in their own minds. Much like in the parlor game of *Telephone*, the transmission of errors and personal predilections makes it unlikely that the received message will match the one that was sent. This is because we build a physical outline of what we see from our own experiences and ideas, leading us in essence to either recognize or not recognize ourselves in all that we perceive.

Digital image messaging expands our communications capabilities by encouraging the seamless combination of images into the flow our e-mails and cell phone use. Visual "chain letters" of still and moving images are now a daily part of our online experience. Image messaging can generate new interactions and meanings as viewers respond by adding their own images and/or text to the mix. An example of this phenomena is Four: An Online Conversation in Pictures between four Canadian artist-photographers - Christopher Brayshaw, Adam Harrison, Evan Lee, and Jamie Tolagson. One participant makes and posts an image, which another participant replies to, and so on, endlessly. The project is a way of thinking back and forth in images, a creative call-and-response that could only work now, in this moment, in this medium. Conceptually, their collective action brings to mind Surrealism's Le Cadavre Exquise (Exquisite Corpse); the game of "Telephone;" 70s musical supergroups where everyone onstage is locked in a complicated dialogue/argument with everyone else; Jazz's collective improvisation. See: http://four2007.blogspot.com/

Imagemaker and educator Liz Lee assigns her students to investigate photographic images as an ambiguous and therefore vague framework of associations, stressing how they are capable of affecting emotions, expressing or activating memories, desires, and/or fears. The image defines an object in its visual form without ambiguity, but cannot make reliable statements about the possible meanings or implications of that object. It is impossible for any art form to portray objective reality. A photograph, more than any other art form, depends significantly on reality since the object must have existed in time and space in order to be photographed. Consequently, the photograph carries a reality-based message, but its meaning is often confused through the interpretation of the object represented. By interacting with text, a photograph can precisely specify emotional or intellectual content and provoke questions.

Working from this premise, Lee's students are asked to do the following:

- Research works by artists such as Robert Cummings and Hilda Schuman who purposely incorporate text into their imagery. Observe how others like Betty Lee and Carrie Mae Weems use text as a running narrative that accompanies an image, or how Robert Heinecken, Barbara Kruger, and Mary Kelly utilize words to disrupt the initial meaning of the image and cause viewers to question the nature of interpretation. Also pay attention to how font style delivers meaning.
- Locate three images that convey this idea and make copies of them. Make sure to include the name of the photographer, the title of the image (if there is one), and the type of photograph (silver-gelatin, tintype, chromogenic color print).

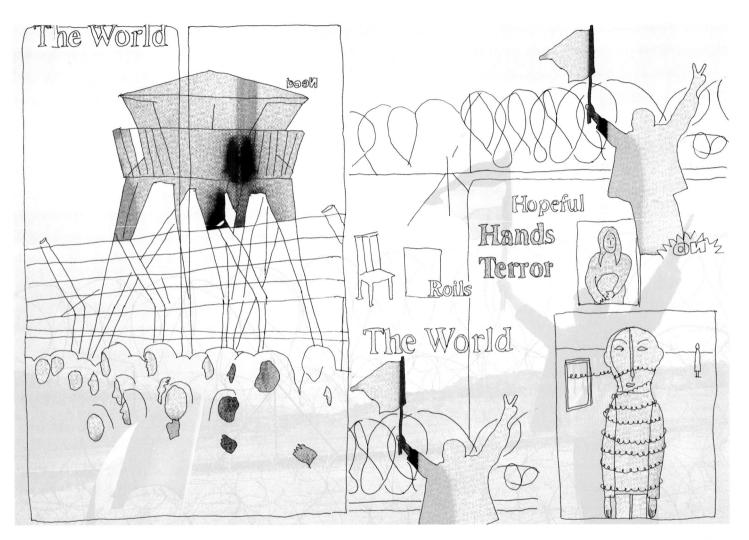

12.18 Zellen is concerned with the design, patterns, and structure of the urban environment. "Rather than document a city, I employ media-generated representations of contemporary and historic cities as raw material for aesthetic and social explorations to mirror the experience of navigating a charged metropolitan area. The drawings were tracing from newspapers where images from both sides of the page were simultaneously seen. The drawings were then scanned and collaged in Photoshop to explore the relationships between news images and the texts used to describe the events."

© Jody Zellen. Hands Terror, 2006. 30 × 40 inches. Inkjet print.

Text and Images

Think of situations where text can be used with a photograph to create an amalgamated meaning. A good way to practice and gain experience with this is by making collages, both manually and digitally, and appropriating (using) found images and text. After completing this exercise, contemplate making your own image and text combinations. Reflect on the methods suggested in Box 12.1 for combining pictures and text, and experiment with those that you think will work best for your idea. Additionally, take into account how text itself can be the principal subject of an image. For reference, visit websites such as www.thevisualdictionary.com which features a photographic catalog of words from advertising, graffiti, signage, and even tattoos.

Evaluate your completed images and discuss: What do you notice happening when you combine pictures and text? Does one overpower the other? Do you want to strike a balance between the two? Is there a blending or a duality of the two symbols? Should you give more weight to one than the other? How does the addition of text affect the way in which you read the work? Which do you examine first? In a literate culture, which has more importance? How can you effectively play one off the other?

If you want to ensure the supremacy of the photograph, use your words as a support and not as a crutch to hold up a weak photograph. Let them supply information that enhances your imagery. If this is not a concern, create arrangements that challenge the traditional relationships between pictures and words.

How does the meaning of an image change when text is added or the original text altered? What differences in effect do you see between manual and digital ways of working? Finally, as an imagemaker, how important is it to be led by images, the internal visual impulse, as opposed to words?

- Provide a concise explanation of why you think each image you have selected is a good example of text and image. In particular, analyze how the words and images interact, and write a brief interpretive paragraph on what you believe the photographer is trying to convey, visually and conceptually.
- Previsualize an image-text relationship about a topic that has been on your mind, and then make new images that you will use to create a final statement.
- The image may be a single 8 × 10 inch print; it may involve serial images or a more elaborate presentation format. Consider the many aspects of how text can be incorporated into your piece: the style, handwritten or typed? the font, serif or sans serif? Should the words exist within the image or be presented around the image or as a separate unit? Create a project that best represents your ideas and what you have learned about text and image (see Figure 12.20).

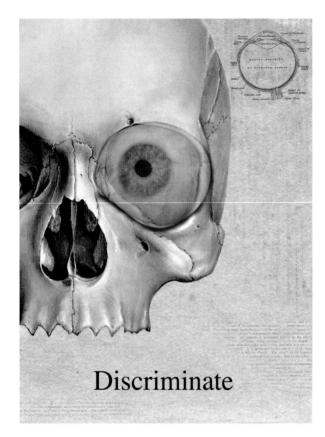

Photographer and educator Collette Fournier takes another approach, by having her students create a series of personal storyboard images based on prose, song, or poetry (including personal prose). The class researches the work of photographers who make strong black-and-white portrait narratives, such as Bruce Davidson, Mary Ellen Marks, Duane Michals, Harry Callahan, Gordon Parks, and Jerry Uelsmann. After studying these examples, students prepare a

12.19 "This series addresses the use of identifying language and symbolic representation by specifically portraying familiar and universal parts of our bodies literally transformed through the addition of cryptic and obscure messages. Through this juxtaposition of image and text, I seek to reveal an underlying ideological subtext: that images, even of body parts, cannot be viewed only through appearance or function, but through cultural, historical and political analysis. Our most serious semantic problem occurs in the everyday act of naming or describing things. The word is not the thing, just as the map is not the territory. The series becomes a comment on form, function, language, technology, and art."

Box 12.1 Methods for Working with Text and Images

- Include words within the original camera image.
- Cut and apply text from printed publications.
- Generate text on a computer, print it, and glue it on the image.
- Change color and font size.
- Add wording with press-on letters or a stencil.
- Use a rubber stamp set. Experiment with different colored inks.
- Write directly on the image. Try a variety of media.
- Insert text with imaging software.
- Set the copy separately from the image in the form of a caption or box.
- Employ text to expand the original meaning of the image.
- Utilize language to alter the original intent of the image.
- Using the text example of "Four: An Online Conversation in Pictures," (http://four2007.blogspot.com/) create your own online visual conversation.

storyboard based on their selected text. This is done to give students an appreciation of professional photography business practices, where storyboards are often the norm, and to teach them to previsualize imagery. From the storyboard, they produce five or six strong photographs that demonstrate their photographic knowledge of composition, design elements, rule of thirds, selective focus, and depth of field. Students are encouraged to superimpose text onto the imagery. The results can make an excellent portfolio piece, which demonstrates a combination of vision and technical skills.

ARTISTS' BOOKS AND ALBUMS

The incorporation of photographs into books began shortly after the invention of photography in 1839. Anna Atkins's *Photographs of British Algae: Cyanotype Impressions* (1843–1853) and William Henry Fox Talbot's *The Pencil of Nature* (1844–1846) are the earliest examples of how paper photographs were integrated into books. The images in these books were "tipped in," added by hand, as there was no satisfactory method for direct reproduction of photographs and text until the halftone process was perfected in the 1880s.

The *carte-de-visite*, French for "visiting card," was a 2-1/4 \times 3-1/2 inch photograph, usually a full-length portrait, mounted on a 2-1/2 \times 4 inch card, which was introduced in the early 1850s. The carte became a fad during the 1860s in America and Europe, with millions being made of individuals, celebrities, and tourist attractions. People exchanged and collected the cartes, keeping them in albums with special cutout pages for convenient viewing, which gave rise to the custom of keeping a photo album. People also personalized them. A outstanding example of this practice can be seen in the mixed media cartes of Lady Filmer (circa 1864), who cut and pasted cards into

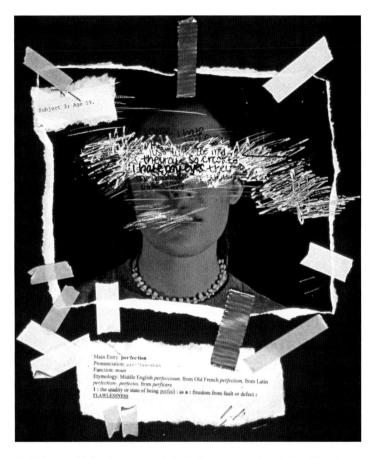

12.20 Lampack's haptic response to Lee's image and text assignment involved scratching negatives, typewriter paper, acrylic paint, masking and duct tape, and staples on a mat board.

© Jessie Lampack. Untitled (detail from triptych), 2005. 10 × 11 inches. Mixed media.

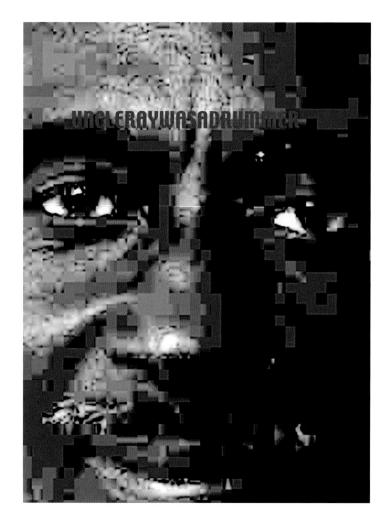

12.21 Fournier returned to a photograph she had previously made of a significant family member and decided to reinterpret it by thinking of it as a billboard and incorporating text that included important background information about this family member. Fournier carried out her plan by scanning the image, and then reworking, experimenting with both text and pixilation, to create "a photographic memorial of Uncle Ray who shared a special light in my life." © Collette V. Fournier. Uncle Ray Was a Drummer, from the series Digital Family, 2001. 14 × 11 inches. Inkjet print.

designs that were interlaced with watercolor and text, which can be considered an early prototype of an artist-made book.

In the late 1960s, experimental imagemakers began to cut and paste and make use of quick-copy centers, rubber stamps, and old, unwanted printing equipment as they rediscovered the artist-made book as a vehicle to express diaristic and narrative themes as well as those of dreams, friendship, love, sequential time, and social-political issues. Digitalization has made it easier for artist-made books to bring together photographs, drawings, marks, appropriated materials, and text into various designs. The digital format offers an intimate viewing experience in which one can control the time spent with each image and provides an affordable alternative method, controlled by the maker, of getting work out to a larger audience.

Digital imaging can include elements of performance through moving images and sound, which may be viewed on a cell phone or iPod. Interactive programs, found on CD-ROM, DVD, and on the Web, may require the viewer to make choices that determine the content, flow, or outcome of a work, which may be modified with each viewing.

There are workshops, classes, conferences, printers, distributors, and booksellers that specialize in artists' books (see Box 12.2). Addi-

tionally, special hinged paper, such as that made by Stonehinge Systems (www.stoneeditions.com), is designed for digital printing and has a companion digital album cover set, translucent interleaves, and binding hardware that simplifies production. Many online printing services also provide templates for making simple books, which are then printed.

ARTISTS' AND PHOTOGRAPHIC BOOKS: References

- Bright, Betty. No Longer Innocent: Book Art in America 1960–1980. New York: Granary Books, 2005.
- Drucker, Johanna. *The Century of Artists' Books*. Second Edition. New York: Granary Books, 2004. (Available from D.A.P., www.artbook.com)
- Holleley, Douglas. Digital Book Design and Publishing. Rochester, NY: Clarellen and Cary Graphic Arts Press, 2001.
- Lyons, Joan, ed. Artists' Books: A Critical Anthology and Sourcebook. Rochester, NY: Visual Studies Workshop Press, 1985.
- Parr, Martin, and Gerry Badger. *The Photobook: A History*, Volume 1. New York and London: Phaidon Press, 2004.
- Parr, Martin, and Gerry Badger. *The Photobook: A History*, Volume II. New York and London: Phaidon Press, 2006.
- Roth, Andrew, et al. *The Book of 101 Books: The Seminal Photographic Books of the Twentieth Century.* New York: Roth Horowitz, 2001.
- Smith, Keith. 200 Books, An Annotated Bibliography. www.keithsmithbooks. com.
- Smith, Keith. *The New Structure of the Visual Book*. Fourth Edition. www. keithsmithbooks.com.
- Smith, Keith. *The New Text in the Book Format.* www.keithsmithbooks.com. Smith, Keith. *Bookbinding for Book Artists.* www.keithsmithbooks.com.

Box 12.2 Sources of Photographic and Artists' Books

- Aperture 20 East 23rd Street New York, NY 10010 www.aperture.org
- Center for Book Arts
 28 West 27th Street
 New York, NY 10001
 www.centerforbookarts.org

• D.A.P. Distributed Art Publishers, Inc

155 Sixth Avenue, 2nd Floor New York, NY 10013 www.artbook.com

- Light Work 316 Waverly Avenue Syracuse, NY 13244 www.lightwork.org
- Nexus Press
 535 Means St.
 Atlanta, GA 30318
 www.thecontemporary.org
 - Photo-Eye Books 376 Garcia Street Santa Fe, NM 87501 www.photoeye.com
 - Printed Matter 535 West 22nd Street New York, NY 10011 www.printedmatter.org

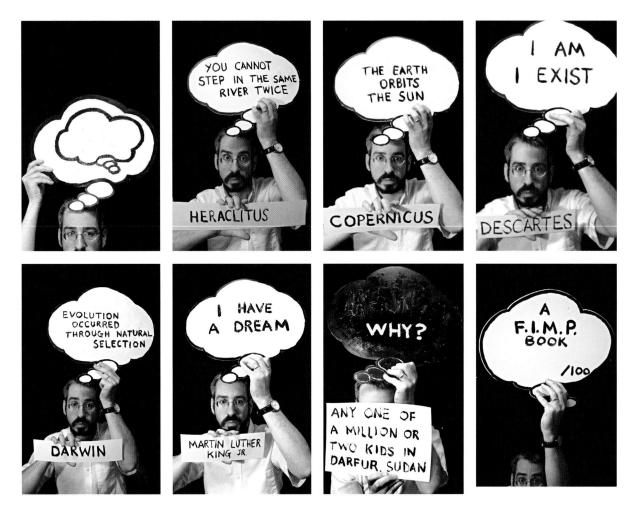

12.22–12.29 "Thinking about Thinking is one of over 60 artist's books that I have made for my Fiji Island Mermaid Press 'artists' book of the month club.' Much of my work indirectly addresses questions about how we know what we know, and the stories we tell ourselves to make sense of the world. I wanted to make images in which a 'thought balloon' was a physical object occupying the same space as the depicted thinker, and everything was composed in the camera at the time of capture. A thought balloon was constructed from foam-core, with the text painted and repainted for each page. The images were printed out, glued to a 'master sheet' to make an eight page spread that is slightly smaller than a standard sized piece of paper, and Xeroxed onto 32 pound resume paper. The pages were trimmed to size, folded and sliced to make a tiny 2.5 × 4 inch book, and signed."

© Mark Snyder. Thinking About Thinking, 2006. 2-1/2 × 4 inches Electrostatic print. Courtesy of Fiji Mermaid Press, Pittsburgh.

Book of Your Own

Create your own book that can be outputted using digital means. Start by selecting a theme. Keep it simple, work with the familiar, and give yourself a condensed time frame. For instance, decide to make a record of a weekend trip. Photograph the people you are traveling with and those whom you meet. Photograph signs as well as exterior and interior views of all the places you visit. Break out of the single image concept. Consider photographing the foreground, middle ground, and background of a scene and later digitally stitching the images together, or try making sequential images that record the passing of time. Include a map of your route, a written account of a conversation, or anything that intrigues you. Collect articles, business cards, menus, postcards, and tourist pamphlets. Use a small memo book to record your thoughts. Upon your return, digitize these materials by scanning or photographing. Be spontaneous. Make lots of pictures. Review the previous section Text and Image to get ideas for integrating words and pictures.

Select your own paper size and color, and bind them to make your own book. A simple binding method is to take a handheld hole punch and measure three equally spaced holes (on the left side or top) and punch. Using the first as a guide, punch the remaining pages in the same manner. Small metal key rings or heavy thread can be used as binders. As experience is gained, consider tackling other themes and altering the presentation format.

SELF ASSIGNMENT: CREATION AND EVALUATION

Some of the best photographs are made when imagemakers pursue their own inclinations. Seize the opportunity to make those pictures you have been dreaming about, and then measure your plan against what you accomplished.

Evaluation Guide — Before Making Images

Before you make any images, think about and respond to the following:

- **1.** Write a clear, concise statement of the specific goals you intend to accomplish.
- **2.** Describe and list your purposes, both objective and subjective, and how you plan to reach them.
- **3.** What problems do you anticipate encountering? How do you propose to deal with them?

Guide to Evaluation — After Photographing

After making your images, answer these questions:

 Achievement: How many of the stated objectives were obtained? How well was it done? Are you satisfied? What benefits have you gained? What new knowledge have you acquired? What new skills have you developed? Have any of your previous attitudes either been changed or reinforced? Has the way that you see things been altered?

374

- 2. The unexpected: What unforeseen benefits or problems did you encounter? Did anything happen to alter or change your original plan? How did you do with the unplanned events? Was there anything that you should have done to make better images that you did not do? How will this help you in the future to be a better imagemaker?
- **3.** *Goals compared with achievement*: Compare your final results with the original list of goals. What did you do right? What did you do wrong? What are the reasons? What would you do differently next time? Were the problems encountered aesthetic, technical, or logistical in nature? Which were the most difficult to deal with? What have you learned? How has it affected your working methods? Measure how well the objectives of the assignment were met. What grade would you give a student on this project if you were the teacher? Why? Be specific.

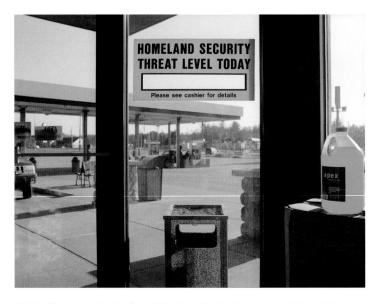

12.30 After the 9/11 attack in 2001, President Bush encouraged U.S. citizens to boost the American economy through shopping, thereby equating consumerism with patriotism. Ulrich's self-assignment, the Copia Project, was a direct response to that advice, "a long-term photographic examination of the peculiarities and complexities of the consumer-dominated culture in which we live. Through large-scale photographs taken within both the big-box retail stores and the thrift shops that house our recycled goods, Copia explores not only the everyday activities of shopping, but the economic, cultural, social, and political implications of commercialism and the roles we play in self-destruction, over-consumption, and as targets of advertising."

© Brian Ulrich. *Black River Falls, WI*, 2006. 30 × 40 inches. Chromogenic color print. Courtesy of Rhona Hoffman Gallery, Chicago; Julie Saul Gallery, New York; and Robert Koch Gallery, San Francisco.

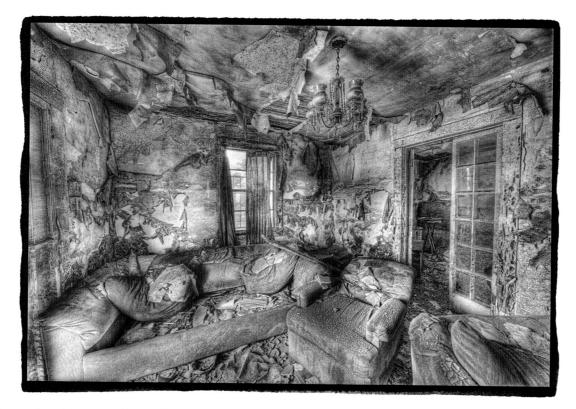

12.31 "When photographing the interiors of homes, businesses, schools and churches in post-Katrina New Orleans, the challenge was two-fold: first, to present with dignity and grace the trauma suffered by the citizens of New Orleans; second, to apply photographic techniques that would allow me to present the dark and contrasty interiors in a way that was normally impossible. I achieved this with High Dynamic Range imaging (HDR), a combination of shooting and software techniques that lets one capture extreme brightness ranges (dark interiors with bright sunlit windows) that would overwhelm film or a single digital capture. The final prints are lush with shadow detail and gloriously detailed highlights." "In this instance I mounted my camera on a tripod, set the ISO at 100, turned Noise Reduction on, locked the mirror up, and shot in manual exposure mode with a remote release to make a bracketed series of exposures running from about 2 minutes to 1/30 sec. at f/19. Later I combined the bracketed exposures into a 32-bit image in Photoshop, using the ToneMapping plugin from HDRsoft as well as various other adjustments to graphically illustrate the destruction of the places where the citizens of New Orleans lived, worked, learned and worshipped. While there is an unabashed beauty and intrigue to many of the images, my primary goal was to personalize the city's destruction in a powerful and detailed way." For details visit: www.DanBurkholder.com.

© Dan Burkholder. Pink Living Room, New Orleans from the series The Color of Loss, 2006. 20 × 30 inches. Inkjet print.

Tümer states that this work "provides visualizations of ubiquitous synthetic pesticides. I borrow a technique developed by the environmental scientist Richar Fenske that uses fluorescent tracer dyes, UV light, and a camera to give farmworkers simulated pictures of their pesticide exposure after applications. I apply the tracer technique to explore what it implies for those of us who are not farmworkers, but are exposed daily to the same pesticides in our homes and neighborhoods through applications and drift. As theatrical simulations, often involving over 50 separate images, they function in the realm of the imagination, illuminating what often appears as constellations charting the chemical's movement and settling. In his book Beauty in Photography (1981), Robert Adams addresses the paradoxes of beautiful images about unattractive subjects by discussing how Lewis Hine struck a perfect balance between this tension by showing what was bad so we could oppose it and what was good so we would value it."

Addendum 1.1 Laurie Tümer. Glowing Evidence: In My Study A&B, 2006. 23 \times 39 inches. Lenticular print.

Addendum 1

Safety: Protecting Yourself and Your Digital Imaging Equipment

ERGONOMIC WORKSTATIONS

Many desks and computer-related equipment have hard, angled leading edges that can come in contact with your arm or wrist. These hard edges can create contact stress, affecting blood vessels and nerves, possibly causing tingling and sore fingers. One can minimize contact stress by:

• Padding table edges with inexpensive materials such as pipe insulation

- Using a wrist rest
- Purchasing computer furniture with rounded desktop edges

MONITOR EMISSIONS: ELF/VLF

Extremely low frequency (ELF) and very low frequency (VLF) emissions are types of electromagnetic radiation created by monitors. Some research studies have linked these emissions to an increased risk of cancer or miscarriage. Keep your eyes at least 18 inches away from the screen and avoid prolonged exposure. Low-emissions monitors are available, as are filters for the screen.

EYESTRAIN

Eyestrain can be reduced by working in a properly lit room and by keeping the screen free of dust and clear of reflections. Periodically shift your focus from the screen to an object at infinity to rest your

eyes. When possible, close your eyes for a few minutes and allow them to relax.

PROPER POSTURE/LOWER BACK PROBLEMS

Sit in a fully adjustable ergonomic chair with your feet flat on the floor or on a footrest. The top of your monitor should be at eye level (see Healthy Computer Working Positions). Another option is to use a sit-to-stand desk that has adjustable heights so it is possible to work standing upright, which can greatly help those with back problems.

CARPAL TUNNEL SYNDROME

Carpal tunnel syndrome, caused by repetitive movements and improper keyboard and mouse use, is characterized by numbness and tingling in the wrists and hands. In advanced stages, the syndrome can cause permanent nerve damage. Keeping your wrists flat, straight, and at a height equal to your elbows will help prevent injury. Learning how to operate the mouse with your non-dominant hand can also help reduce repetitive movement stress.

TAKING BREAKS

Taking a 5-minute break and getting out of your chair every hour will help keep you sane and prevent fatigue. Try mixing noncomputer-related activities into your digital routine. At your desk, yoga exercises, which can be found on the Internet, are suggested.

NEUTRAL BODY POSITIONING

When you add up the number of hours you spend every year working with computer equipment, it becomes apparent that it is to your benefit to figure out the best way to set up a computer workstation. To accomplish this, it is useful to understand the concept of neutral body positioning, a comfortable working posture in which your joints are naturally aligned. Working with your body in a neutral position reduces stress and strain on the muscles, tendons, and skeletal system and decreases your risk of developing a musculoskeletal disorder (MSD). The following are the U.S. Department of Labor's Occupational Safety & Health Administration's (OSHA) guidelines for maintaining neutral body postures while working at your computer workstation:

- *Hands*, *wrists*, and *forearms* are straight, in line, and approximately parallel to the floor.
- *Head* is level, or bent slightly forward, forward facing, and center balanced. Normally your head is in line with your *torso*.
- *Shoulders* are relaxed, and *upper arms* hang normally at the side of your body.
- *Elbows* are kept close to your body and are bent between 90 and 120 degrees.
- Feet are firmly supported by floor or a footrest.
- *Back* is fully supported with appropriate lumbar support when sitting vertical or leaning back slightly.
- *Thighs* and *hips* are supported by a well-padded, ergonomic seat that is usually parallel to the floor.
- *Knees* are about the same height as the hips, with the *feet* slightly forward.

First putting on his safety goggles, Friedman's curiosity prompted him to cut golf balls in half to see what these 'super ball' cores looked like. "To my surprise, what I found inside inspired me to consider that I could discover, in the unlikeliest of places, the same things — metaphor, unpredictability and stunningly beautiful formal qualities — that made me passionate about my other photographic work that employs readily identifiable subject matter. The balls can be experienced as macro/micro pictures, as aerial photography, as landscapes, as scientific studies, as medical specimens or on emotional and highly personal levels. The pictures, seemingly both inscrutable and easily decoded, rely on shape, texture, repetition, and scale to elicit audiences comments about scale, symbols, ambiguity, spirituality, and Pop Art. Incidentally, I do not play golf."

@ James Friedman. 408, from the series Interior Design, 2007. 36 \times 36 inches. Inkjet print.

CHANGE YOUR WORKING POSITION

Regardless of how good your working posture is, it is not healthy to work in the same posture or sit still for prolonged periods of time. It is suggested that you change your working position frequently throughout the day by carrying out the following activities:

- Stretch your fingers, hands, arms, and torso regularly.
- · Make small adjustments to your chair, backrest, and footrest.
- Stand up and walk around for a few minutes periodically.

For additional information, visit OSHA's site at: http://www.osha.gov

Then go to etools/computerworkstations/positions

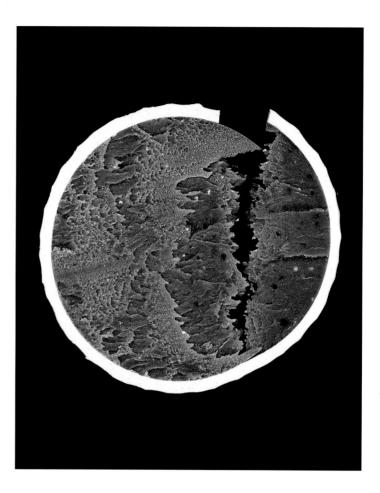

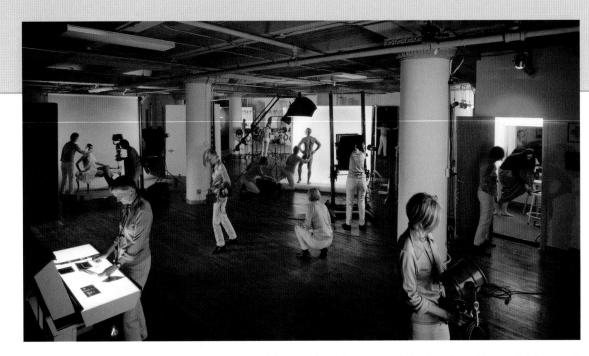

"The subject of People at Work is the double nature of labor at all levels of the social hierarchy — a round of tasks, often with no satisfying meaning, and a field for the exercise of aptitudes. By composing digital photographs that compact the varied tasks of individual workers into a single frame, I seek to communicate simultaneously the frenzied tedium of a wide variety of occupations and the intensity of effort that people put into them. The color images come about through a practice of taking photographs with a 4×5 inch camera of individuals whom I direct to perform the tasks associated with their jobs, at their workplaces. I scan the photographs into the computer and then digitally composite them into images that show at once all of the significant tasks associated with each job. The result in each case is a concentrated look at a person at work that conveys both a sense of frantic alienation and an amazement at the feats performed by workers in what are often considered the most ordinary, routine, and undemanding occupations. For most people, work has elements of both depravity and dignity. I seek to make that tension come alive, so that we can appreciate one another's endeavors at the same time that we question their intrinsic worth."

© Nathan Baker. Photography Studio, from the series People at Work, 2004. 40 × 50 inches. Inkjet print. Courtesy of Schneider Gallery, Chicago, and Koch Gallery, San Francisco.

Addendum 2

Careers

hotography offers a wide variety of challenging career opportunities, especially for independent-minded individuals. There are about 130,000 working photographers in the United States today. Due to the growing demand for photo-based images in our society, photography jobs are predicted to rise about 10 to 12 percent through 2012. People interested in pursuing a photographic career are typically imaginative, visually curious, possess a good sense of design, and enjoy making their own photographs and acquiring technical knowledge to improve their craft. High school students should have a general academic background and pursue courses and creative activities in the arts, computer science, and journalism, including working on the school newspaper and yearbook. They can also take workshops or after-school or summer classes in photography and art. Students can demonstrate their ability by preparing a portfolio of their work to show to prospective colleges and universities.

Many colleges and universities offer photography courses, and some have programs that lead to degrees in the subject. A number of art schools and technical schools also offer instruction and practical training in photography. Information about photography careers and accredited programs can be found online at www.photography schools.com. Information is also available from the Professional Photographers of America at http://www.ppa.com/

THE WORKING PHOTOGRAPHER

Photographers work in many different industries. A large number of them are *freelance* photographers — that is, they are self-employed. They may own their own businesses, or they may work for limited periods with a number of different employers.

Commercial photographers take pictures for advertisements or for illustrations that appear in books, magazines, websites, or other publications. These photographers work with subjects as varied as architecture, food, equipment, and fashion.

Freelance photographers are independent-minded people who succeed by combining their photographic knowledge with expertise or interest in another arena. For example, a photographer who loves

CAREERS

nature can profit by making animal and landscape photographs. Within this field, one might further specialize in a single area such as underwater photography. Others make photographs and/or write for photography magazines and educational publishers. Photographers who find their own specialty or niche often start their own business. These self-employed individuals, known as *freelancers* or *independents*, take a career path that can be demanding but also very fulfilling. They must be excellent problem solvers and possess the skills of a businessperson as well as the artistic attributes of a photographer. Currently, over half the working photographers are self-employed.

Fine art photographers produce photographs that are sold as fine art. These photographers exhibit their work in museums and sell their pictures through commercial art galleries and at art festivals. Fine arts photographers rarely can support themselves solely through their art, and so they often take other jobs.

Industrial photographers take pictures for industrial purposes, of such subjects as company officials or machinery, which are used in project analysis, technical documentation, or annual reports.

Portrait photographers take pictures of people and of special events in people's lives. Some photographers in this field specialize in one type of portraiture, such as children, families, or weddings. Portrait photographers must like working with people and know how to pose their subjects to create pleasing effects.

Photojournalists take pictures of events, people, and locations for newspapers and other news outlets. They must be skilled at seeking out and recording dramatic action in such fields as politics and sports. A photojournalist must be prepared to travel and work quickly under the pressure of a deadline. *Scientific photographers* work in a number of specialized areas. Major fields of scientific photography include *medical photography* and *engineering photography*. Medical photographers may work with such medical equipment as microscopes, X-ray machines, and infrared scanning systems to help diagnose and treat disease. Engineering photographers help improve the design of equipment and structural materials. These photographers sometimes use high-speed cameras to "stop" the action of machines and to make visible the flaws in metal, plastic, and other materials. Others use photography to make new discoveries about space and our solar system.

GETTING STARTED

Many young people start their careers by working as photographic studio assistants. They may help collect props, prepare sets, arrange products to be photographed, and process images. Working under a successful professional is a time-honored way of learning the business and provides real-life training for opening one's own business in the future. A growing number of galleries and museums employ people knowledgeable about fine art photography and photographic history to manage their photography collections and organize exhibitions. Many photographically minded people work in website design and desktop publishing. Careers also are open to people who can teach or write about photography. Other areas include photo processing and printing, photo editing, image library maintenance, equipment manufacturing, sales of equipment and supplies, and equipment maintenance and repair. Technically minded people can follow paths in research and development of new photographic equipment and products.

Index

Abbott, Bernice, 201 Abe, Koya, 27 Abrams, Terry, 47 Adams, Ansel, 11, 25 Adams, Bill, 41 Adamson, Robert, 7 After Chuck Close, 218 Airey, Theresa, 143 Albums, see Artists' books and albums All Things American, 55 Allen, Thomas, 183 Along Whittier Boulevard, 204 Altamura, Mauro, 50 Andersen, Barry, 256 Angle factor, calculation, 81–83 Angles of view, types, 292, 294 Aperture overview, 77-78 software, 278-279 April Fool, 335, 337

Aqueous Humor #23, 216 Arbus, Diane, 12 Archival presentation, see Presentation Ariaz, Jeremiah, 311 The Art Director, 262 Artistic possibility scale, 321–322 Artists' books and albums historical perspective, 369 references, 372 sources, 370 Ash Grove, Missouri, 197 Aspect ratio, selection, 96 Asymmetrical balance, design, 44 Atomic Couple, 200 Attention span, design, 35-36 Attracted to Light: CRT Sphere, 212 At the Vanishing Point, 189 Audience, finding, 20 Autofocus, 83-94 Ayres, Shannon, 206

Back light, 164-165 Back Light, 164 Baird, Darryl, 216 Baker, Nathan, 37, 380 Balance, design, 44, 46 Banding, 94 Barn doors, lighting, 165 Bathroom with Twin Pop, 86 Batteries cold weather care, 101–102 life, 100 tips, 103 types, 101 Bayer filter mosaic, function, 65-66 BBG Fish, 121 Beach, lighting, 157, 160 Beam, Richard, 188 Beauty, defining, 21–22 Becker, Olaf Otto, 150 Beginner's mind, Zen, 33-34 Benjamin, Walter, 325

Berger, Paul, 293 Bermuda Square, 51 Beuvs, Joseph, 19 Bias, photography, 6 Billboard 2006, 41 Biloxi, Mississippi, 288 Bit color, 244-245 Black River Falls, WI, 373 Blacklow, Laura, 30 Blakely, Colin, 124 Blinks, 148 Blooming, 94 Blossom Restaurant, Manhattan, 201 Blur artistic use, 190-191 equipment movement, 193-194 extended time exposures, 196-197 flash with slow shutter speed, 195-196 free-form camera movement, 194 image stabilization, 98 lensbaby, 192 motion blur filters, 191–192 pan shot, 192-193 BMP, file format, 75 Books, see Artists' books and albums Bosworth, Michael, 161–165 Botsven, Ethan, 49 Bowen, Susan, 195

Brackenbury, Deborah, 242 Breisach, Kristi, 55 Briggs, Priscilla, 134 Brightness range average daylight, 126 brilliant sunlight, 126-127 contrast control. 127-128 diffused light, 127 dim light, 127 exposing to the right, 125 high dynamic range, 125 lighting, 161 overview, 125 Burger King, 54 Burkholder, Dan, 375 Burning Sugar Cane, Bayou Tesch, Louisiana, 133 Burning Tree with Ryer Sky, Chase County, Kansas, 157 Burtynsky, Edward, 168

Cage, John, 334, 336 California Fire, 40 Camera care, 102–105 components, 62–63 digital cameras adjustable parameters, 64

Bushwack Series VII, 47

batteries. see Batteries color filter array, 65-66 image sensors, 65 memory, see Memory pixels, 66 resolution, 66, 90-92 selection, 74 file formats, see Digital image files function, 61-62 imaging system, 63 lens, see Lens system monitor, 92-93, 122-123 sensitivity, 94 types of digital cameras back, 71 compact camera, 69 digital single lens reflex camera, 63, 68-69 disposable camera, 71 hidden camera, 73 homemade, 72 instant camera, 71 medium-format camera, 70 multimedia camera, 73 overview, 68 panoramic camera, 71 phone camera, 73 pinhole camera, 71-72 sequence camera, 71

stereo camera, 71 toy camera, 71 underwater camera, 71 view cameras, 70 web camera, 73 zoom, 93-94 Camera copy work exposure, 283-284 lens selection, 282 lighting, 282-283 Camera Obscura Trailer, 316 Camera Work, 10 Cameron, Julie Margaret, 6 Camus, Albert, 20 Caponigro, John Paul, 45 Careers, photography areas, 381–382 entry, 29, 382 overview, 29, 381 Carey, Ellen, 148 Carpal tunnel syndrome, prevention, 378 Cartier-Bresson, Henri, 25 Casolari, Samantha, 47 Cassini in Saturn's Shadow, 15 CCD, see Charged-coupled device CFA, see Color filter array Chalmers, Catherine, 26 Charged-coupled device (CCD), image sensor, 65

Chemistry, 183 Chicago, IL, 300 China Recycling #7, 168 Chloe and Sybil and Becky, 151 Christenberry, William, 13 Circle of confusion, digital versus film cameras 79 Citizen's Thermal Energy Plant, 195 CMOS, see Complementary metal-oxide semiconductor CMYK, 246-247 Colbert, Stephen, 345 Collage, photographs, 208-209 Color attraction and repulsion, 309-310 balance, 44, 46 camera modes, 96 CMYK, 246-247 contrast complementary colors, 296 cool and warm colors, 296 creating color contrast, 296 dominant color usage, 296-299 harmonic color, 299-300 hue adjustment, 138 isolated color, 300, 302 reproduction, 138 RGB, 246–247 saturation control, 137–138

subdued color, 308 symbolism, 57 Color filter array (CFA), function, 65-66 Color key overview, 178 recognition, 179-180 Color photography, historical perspective, 13 Color temperature Kelvins, 135-136 light source differences artificial sources, 137 natural sources. 136 Combination printing, historical perspective, 8 Commercial symbols, 53 Compact fluorescence bulb, 160 Complementary metal-oxide semiconductor (CMOS), image sensor, 65 Composition key overview, 178 recognition, 179-180 Compound pictures, 207 Confesions of a Jew, Double Page, 30 Connell, Kelli, 15, 326 Constellation Map, 320 Constellation/Observation, 329 Contact sheet sequence, multiple images, 205

Contrast colors complementary colors, 296 cool and warm colors, 296 creating color contrast, 296 control. 127-128 Convergence, perspective, 306–307 Copy work, see Camera copy work Copy, digital image software function, 249 Copyrights, 284-285 Cosmic symbols, 5 Coulter, Raquel, 347 Counterpoints, 310-311 Couple, 34 Cowboy 2, 363 Creative looking, 170 Crewdson, Gregory, 340 Crime Scene #4, 332 Critics, role, 28 Cultural knowledge, communication, 326-327 Cultural symbols, 53 Cut, digital image software function, 249 Daguerre, Louise-Jacques-Mandé, 5 Danh, Binh, 348 Darkroom lesson, 339

Davis, Jen, 343 Davis, Tim, 105 The Death of Naturalistic Photography, 9 Death Rubbing: Unidentified Iraqi Citizen, 176 DeHart, Dennis, 128, 154 Demachy, Robert, 9 Demand, Thomas, 312 Departure point, design, 35 Depth of field control. 80 overview, 78-80 Deschamps, Francois, 345 Desert, lighting, 157, 160 Design attention span and staying power, 35-36 beginner's mind concept, 33-34 communication, 33 departure point, 35 language of vision, 37-38 native characteristics of photography, 38 principles balance, 44, 46 emphasis, 39, 41 proportion, 41-44 rhythm, 46 scale, 41 unity, 39 variety, 39 privilege of photography, 36-37

process, 34 subtractive composition, 34-35 visual elements line, 46-48 pattern, 51-52 shape, 48 space, 49-50 symbolism, 53-57 texture, 50-51 Diffuser, lighting, 165 DiGena, Louis, 200 Digital camera, see Camera Digital image files BMP, 75 DNG, 77 EPS, 75 GIF, 75 JPEG, 75-76 lossless versus lossy compression, 75 opening, 77 overview, 74-75 PICT, 75 PNG, 75 RAW, 76 storage, see Storage TIFF, 76 Digital imaging advantages over film, 32-33 arts impact, 175-178

Davis, Bill, 322, 353

Davis, Debra A., 111

disadvantages, 33 distribution of images, 64-65 historical perspective, 13-16 Display computer monitors, 243–246 dot pitch, 220, 222 ideal properties, 223 image size adjustment, 227-228 photographing of electronic displays, 360, 362-364 presentation, see Presentation printers, see Printers resolution, 223-227, 234-237 Distort, digital image software function, 249 DNG file format, 77, 232 resampling, 232-233 Do Not Open, 129 Documentary, historical perspective, 10-11 Doherty, Domith, 198 Dominant color, usage, 296-299 Donato, Frank, 141 Dot pitch, 220, 222 Dots per square inch (DPI) dot conversion, 237 pixels per square inch comparison, 67 printer resolution, 67, 225-227 visual resolution, 67-68 Douglas, 6

DPI, see Dots per square inch Dreamland Speaks, When Shadows Walk, #7, 9 Drinking, 26 Dual Galaxies, 45 DuBois, Doug, 344 During, Arthur, 283 Dust, light effects, 156 Dye-sublimation printers, 240

Ebenezer Ekuban, 42 Eiffel Tower, Paris, 173 Einstein, Albert, 29, 185 Eisenstaedt, Alfred, 354 Electronic viewfinder (EVF), 121 Emerson, Peter Henry, 8-9 Emmer. Christine, 354 Empathy, interesting photographs, 20-21 Emphasis, design, 39, 41 Enfield, Jill, 6, 192 EPS, file format, 75 Epstein, Mitch, 288 Equipment, importance of quality, 29 Equivalent exposure, 229 Erf, Greg, 132 Evaluation, 8 Evaluation after shooting, 373-374 before shooting, 373

Evans, Susan, 332 Evdokimova, Katya, 304 Every Part From a Contaflex Camera, 31 Everyware, CO., INC., 201 EVF, see Electronic viewfinder Exhibition sites 330 EXIF, 93 Existentialism, 350, 352 Explanation, photographs, 28 Exposure, see also Light meter bracketing, 124 camera copy work, 283-284 compensation, 124 determination, 88-90 extended time exposures, 196-197 lighting bright light, 132-133 long exposure and digital noise, 133-134 subject in shadow, 132 manual override, 124-125 Extended depth of field, 80 Eyestrain, prevention, 377-378

Fabrication overview, 353–354 social landscape, 354–356 Fauxtography, 344–345 Fear, challenging, 319

Female Blackbird, 74 Figure-ground relationships importance, 181 strategies, 181-182 Files, see Digital image files Filters digital filters. 144-145 digital image software plugins, 249-250 factor adjustments, 138-139 homemade filters, 142-144 neutral density filter, 139-140 polarized filter, 140-142 principles, 138 special effects filters, 142 ultraviolet filter, 142 Finger, Bill, 305 Fire, light effects, 156–157 Firmware, camera, 100 Fisheye lens, 87 Fishing Boats, 47 Flâneur, 172 Flash electronic, 129-130 fill flash, 130-131 modes, 98-99 red eye reduction, 98, 131 stopping action, 190 Flick, Robbert, 204 Floating, 326

Floating, prints, 270-271 Flower #61, 7 Flynn, Kelly, 363 Focal length angle of view equivalencies, 81-83 definition. 80-81 film camera equivalencies, 81-82 rule, 81 Fog, light effects, 155 For Billy, 108 For the City, 214 Foreign matter, avoidance in camera, 95 Forgetfulness, 3 Formica, Jennifer, 170 f-stop, shutter speed relationship, 78, 134-135 Found Photo Album, 20 4 A.M., 343 408.379 Fournier, Collette V., 369 Frame grabber, applications, 108 Framing effect angles of view, 292, 294 overview, 289 seeing dynamically, 289-290 viewpoint working methods, 290-291 Frank's Awesome Tie Dye, 36 Friedman, James, 379 Freylander, Barry, 17

Front light, 162 Front Light, 162 Frylender, Perry, 17 Fuss, Adam, 38

Galloway, Stephen, 39 Gathering, 72 Gel, lighting, 165 George, xviii Giclée printing, 241 GIF, file format, 75 Gitelson, Jonathan, 262, 321 Globes of Our Time, 56 Glowing Evidence: In My Study, 376 Goldberg, Barry, 42 Golden Mean, design, 42-44 Golemboski, Carol, 259 Goodine, Linda Adele, 108 Grammar, photography, 5 Grammia virgo, 52 Grand Old Party, 360 Grave, 174 Greenberg, Jill, 360 Grid, multiple images, 203, 205 Grotte, 312 Group discussion, images, 332-334 Group f/64, historical perspective, 11 Gum Ball, 12 Gursky, Andreas, 32

Hackbardt, Marcella, 323 Hafkenscheid, Toni, 115 Hallman, Gary, 248 Hands Terror, 365 Happy March, 248 Haptic expressionist imagemaking, 174 photographic working methods, 174–175 Harmonic color, 299-300 Harper, Jessica Todd, 151 Harrison, Adam, 339 The Harry's Family at Ragdale, 58 HDR, see High dynamic range Heat, light effects, 156-157 Henderson Adele, 56 Henrich, Biff, xii, 194 High dynamic range (HDR), 125 Highlights, emphasis, 308-309 High side light, 163 High Side Light, 163 Hill, David Octavius, 7 Hirsch, Robert, 10, 200, 273, 282 Histogram picture quality, 92-93 principles, 119 History revision, exercise, 353 Hole, 349 Holzer, Jenny, 213 Houghton, Barbara, 329

Houston Street, 181 HTML, see Web publishing Human User Fusion Female, 347 Human User Fusion Male, 347 Hunter, Allison, 303 Huston, Robert, 18

ICC profiles, see International Color Consortium profiles Ideas, getting, 318-319 Image enhancement, modes, 96 Image stabilization, 98 Importance, photographs, 19 Incident light, 118 Inkjet printers, 240 Inspiration, sources, 29 Interior experience philosophical belief, 349-350, 352 psychological drama, 352 social issues, 352-353 International Color Consortium (ICC) profiles color gamut, 245 generic profiles, 246 what you see is what you get, 246 Internet, see Web publishing Internship, job offers, 29 Interpolation, see Resampling Iris printers, 240–241

Isabel Trio 3rd, 188 Isle of the Dead, 250 Isolated color, 300, 302

Jantzen, Ellen, 202 Jarrell, Randall, 25, 28 Jellyfish at Monterey, 209 Johan, Simen, 119 Johnson, Keith, 51, 121, 129 Joiners, multiple images, 205–206 Journal keeping, 319–320 JPEG, file format, 75–76 Junkyard, 355 Jupiter, 215

Kahn, Nicholas, 208 Kaminski, Kevin A., 101 Kandice, 73 Kellner, Thomas, 207 Kelvin scale, color temperature, 135–136 Kennedy, Marie R., 34 Kenny, Kay, 9 Ketchum, Robert Glenn, 357 Kim, Atta, 184 Kirsch, Russell A., 13–14 Kissing the War Goodbye Revision, 354 Kitchen Tension, 15 Kruck, Martin, 99 Kuypers, Steven, 347 Labate, Joseph, 146 LaMarca, Christophe, 126 Lampack, Jessie, 368 Landscape #1152, 146 Larson, William, 189 Larson, Sally Grizzell, 22 Last Peace Demonstration. 17 The Last Supper, 322 Lee, Evan, 31, 357 Lee, Liz, 4, 367 Le Gray, Gustave, 7 Lemm, Sebastian, 19 Lens system aperture, 77-78 care, 103 depth of field, 78-80 filters. see Filters focal length, see Focal length focusing, 83-84 lens types fisheye, 87 macro. 87 normal, 85 telephoto, 86-87 wide-angle, 85-86 zoom, 84-95 mirage analogy, 77 shutter, see Shutter shutter speed and f-stop, 78

Levere, Douglas, 201 The Lie That Leads to Truth, 14 Life Goes On, 191 Light brilliant sunlight, 126-127 camera copy work lens selection, 282 color temperature artificial sources, 137 natural sources, 136 contrast/brightness range, 161 daylight cycle and light quality, 152-153 diffused light, 127 environmental condition considerations, 156-157, 160 good light, 150-151 seasonal differences, 153–154 thingness of light, 149-150 weather considerations, 154–156 Light, Michael, 261 Lighting accessories, 165-166 camera copy work, 282-283 color temperature, 137 natural, see Light placement, 161 size of light, 160-161 sources, 160 techniques back light, 164-165

front light, 162 high side light, 163 low side light, 164 side light, 163 top light, 164 under light, 165 work space, 246 LightJet printer, 241 Light meter brightness range average daylight, 126 brilliant sunlight, 126-127 contrast control, 127–128 diffused light, 127 dim light, 127 exposing to the right, 125 high dynamic range, 125 lighting, 161 overview, 125 fooling, 123 gray card, 119-121 gray contrast, 117-118 hand-held meters, 125 incident light, 118 light sources fluorescent lights, 145-146 high-intensity discharge lamps, 146 metering modes, 95-96, 121-122 principles, 118–119

reflective light, 118 techniques, 128-129 Lightroom, software, 278-279 Limited depth of field, 80 Line, visual element, 46-48 Literacv communication, 169 visual literacy and decision making, 171 - 172Little, Adriane, 351 Long, Jonathan, 272 Looking, stimulated versus creative, 170 Louisiana Pacific-Ketchikan, 357 Lowenfield, Victor, 172-173 Low side light, 164 Low Side Light, 163 Lunar Landing, 208 Lus, Loretta, 2 Lutz, Joshua, 299

MAC, 134 Macro lens, 87 Madigan, Martha, 175 Magical symbols, 54 Maid Service, 37 Manifest Destiny & the American West, 273 Many make one, combining images, 205 Marathon, 127 Marc, Stephen, 210 Mask. 297 Maskell, Alfred, 9 Massard, Didier, 167 Mat board selection factors, 264-265 window mat. 266 Matrix metering, 95, 121-122 Matrix, photograph as, 325 McCormack, Dan, 251 McFarland, Scott, 287 McGovern, Thomas, 152 Me and Tom, 171 Meaning determination for photograph, 21 information required for conveyance, 25 instability, 327-328 time, space, and scale relationships, 26 Means, Amanda, 7 Meat Packer, 79 Medium, importance of knowledge, 24-25 Memory buffer, 99 random access memory, 247 read-only memory, 247 storage, 100, 247 Metadata, 93 Metzker, Ray, 34 Meyer, Diane, 171 Michals, Robin, 215

Minter, Marilyn, 130 Mist, light effects, 155 Model Home, Plano, TX, 99 Monitor camera, 92-93, 122-123 computer, 243-246 Monochrome images aerial perspective, 303-304 color contamination, 303 personal nature, 303 Montoya, Brandon, 110 Mood, effects on photograph, 24 Moore's law, 125 Mortensen, William, 11 Mosch, Steven P., 71 Moss, Brian, 317 Motivation, photography, 3-5 Mount, David, 153 Mountain Fire, 309 Mounting cold mounting, 269-270 dry mounting, 266, 268-269 technique, 267 Mozart, Wolfgang Amadeus, 29 Muntz, Vic, 218 My Sister's Bedroom, 344

Naturalistic Photography, 8 Nègre, Charles, 7 Nettles, Bea, 349 Neutral density filter, 139–140 *New City, #18*, 152 Newkirk, Dale, 145 Nguyen-duy, Pipo, 309 *Nha Trang, Vietnam*, 32 *Night Trees #7*, 153 Nin, Anais, 171 *9W*, 121 Nix, Lori, 40, 355 Noise, reduction, 97–98 Norfolk, Simon, 174 Notari, Carrie, 297 Notebook, source notebook, 319–320 Number 7, 22

Observational Drawings: Eye, 367 Observational Drawings: Hand, 4 O'Donnell, Sue, 320 Office, 191 Opposites, 311 Optimism, 350 Opton, Suzanne, 343 Original image files, see DNG; RAW Oropallo, Deborah, xviii Over and Again, 307 Overlapping transparencies, multiple images, 199 Owens, Bill, 99 Panorama contact sheet sequence, 205 joiners, 205-206 many make one, 205 Parr, Martin, 62 Paste, digital image software function, 249 Path, I, 45 Patriotic symbols, 54 Pattern, visual elements, 51–52 Pearce, Jeannie, 74 Pentaprism, camera function, 63 Personal symbols, 54 Personal truth, definition, 22 Perspective control methods, 304-306 converging lines, 306–307 Pessimism, 350 Pfahl, John, 250 Photography Studio, 380 Photomontage, 207-208 Photo-secessionists, historical perspective, 9 Photoshop elements of image window, 235-237 image manipulation before software, 6-14 toolbar icons command keys, 255 drawing, 252 layers, 254

masks, 254 overview, 250 retouching, 252-254 selection, 251-252 Pink Living Room, 375 Picasso, Pablo, 324 PICT, file format, 75 Pictorial Effect in Photography, 8 Pictorialists, historical perspective, 9 Pixel definition, 66, 219 equivalent exposure, 229 resolution, 66-67 triad, 220, 222 Planets and Moons, 317 Planisphere Celeste, 259 Plumb, Colleen, 79 PNG, file format, 75 Polarized filter, 140-142 Polidori, Robert, 116 Pompe, Kathleen, 209 Portraits environmental portrait, 343-344 meaning extraction, 342 self-portrait, 341-342 Postmodernism, historical perspective, 13 Postvisualization, historical perspective, 11 Practical Knowledge, 323

Presentation archival presentation digital archives, see Storage mat board selection factors. 264-265 window mat, 266 materials to avoid, 275 mounting cold mounting, 269-270 dry mounting, 266, 268-269 technique, 267 overview, 263-264 disk images for review copyrights, 284-285 organization, 284 shipping, 284 display environment, 276 floating prints, 270-271 frames. 272-273 life span of prints, 275-276 portfolios, 273 print stability factors, 275 print-on-demand, 273-274 resources. 285 retouching, 263 storage environment, 276 vendors, 285 Web, see Web publishing

Preservation, see Storage Previsualization, historical perspective, 11 Printers dots per square inch dot conversion. 237 resolution, 67, 225-227 droplet size in picoliters, 237–238 dye-sublimation printers, 240 giclée printing, 241 ink types, 240 inkjet printers, 240 iris printers, 240-241 LightJet printer, 241 media mixing, 242-243 murals, 241 paper, coated versus uncoated, 238-239 performance, 240 service bureaus, 243 Problem solving overview, 313-314 thinking structure, 314-318 Project viability, assessment, 315 Projection, drawing with light, 197-198 Proportion, design, 41–44 Proust, Marcel, 27 Psychological symbols, 55 Pure Oil Sign in Landscape near Marion Alabama, 13

Quality, output, 25 Quiet color, 308

Raaf, Sabrina, 307 Radial balance, design, 44 Rain, light effects, 155 Rain Lights, 283 Rain Turning to Freezing Rain Overnight, 124 Rajotte, James, 217 RAM, see Random access memory Random access memory (RAM), 247 Raster images, software, 247-248 RAW file format, 76, 232 resampling, 232–233 Read-only memory (ROM), 247 Reciprocity law, shutter speed/f-stop relationship, 78, 134-135 Red eye, reduction, 98, 131 Reenactor 03, 206 Reflective light, 118 Reflector card, lighting, 166 Religious symbols, 55 Repetition Increases Outcome, 111 Rephotography, multiple images, 200-202 Resampling digital images, 227-231 original files, 232-233

Research classic photographs, 18 history of photography importance, 26-27 limitations, 27-28 Resolution digital camera, 66, 90-92 display, 223-224 file size impact, 227 manipulation, 234-237 printer, 67, 225-227 scanner, 106 Web, 223 Resuscitation #1, 351 RGB, 246-247 Rhinoceros, 167 Rhythm, design, 46 Road Trip, 62 Roberts, Holly, 211 Robinson, Lisa, 156 Roetter, Joyce, 55 ROM, see Read-only memory The Royce-Roll-Lafayettes, 294 Ruined Flag, Lawless High School, Lower 9th Ward, 179

Safety

carpal tunnel syndrome, 378 emission filters, 377 ergonomic workstations, 377

eyestrain, 377-378 posture and body position, 378-379 San Andreas' Fault. 202 Sara, 251 Sasha and Ruby, 2 Sauer, Damon, 176 Savedge Anne C., 72 Scale design, 41 digital image software function, 249 Scanner drum scanner, 106 flatbed scanner, 105-106 guidelines, 106 operation steps, 106-107 principles, 105 Scatter, 39 Scheer, Joseph, 52 Schneider, Betsy, 12 Schwarm, Larry, 133, 157 Scott, 217 Scribe, 359 Scruton, Fred, 298 Seamless paper, backdrop, 166 Searchlights, 105 Selective focus, 294 Selesnick, Richard, 208 Self-Portrait, SPECT Scan #10, 55 Self-portrait

۲

contour drawings, 342 research, 341-342 Sensitivity, digital camera, 94 Sequences, multiple images, 202-203 Serrano, Andres, 327 Shadows, emphasis, 308-309 Shambroom, Paul, 352 Shape symbolic associations, 56-57 visual element, 48 Sharbakka, Kerry, 191 Sharpening mode, 97 Shaw, Susan, 181 Sheep and Sandstone, Avebury, England, 256 Sheetz, 299 Sheridan, Sonia Landy, 14 Sherman, Cindy, 13 Shit Kicker, 130 Shutter lag, 88 modes. 88 Shutter speed action shots extending action, 188-189 stopping action, 189-190 blurring, 195-196 camera movement, 88 control. 87-88 f-stop relationship, 78, 134–135

rule, 87 software manipulation, 213-214, 216 Siber, Matt. 54 Side light, 163 Side Light, 162 The Silhouette, 304 Size adjustment, 227-229 artistic impact, 325-326 image resolution and file size impact, 227 Slankard, Mark, 86 Slices of time, multiple images, 206-207 Smith, Adam, 35 Smith, Stafford, 294 Smith-Romer, Helene, 58 Snapshot aesthetic, definition, 12 Snoop Dogg, 327 Snow, light effects, 155-156 Snyder, Mark, 372 Social identity depicting social customs, 346-347 legitimacy of representations, 347-349 overview, 345-346 Social landscape, 12, 354-356 Sokolowska, Ursula, 314 Soldier: Claxton, 343 Solo, 156 Space, visual element, 49-50

Spagnoli, Jerry, 127 Special effects filters, 142 Spencer, Nancy, 72 Stables on Dr. Young's Property, 287 Star trails, extended time exposures, 196-197 Starbucks, 141 Starn, Doug, 212 Starn, Mike, 212 Status symbols, 55-56 Still life deliberations, 357-359 human form, 360 overview. 357 Stimulated looking, 170 Stone, Jim, 36 Storage digital archives cataloging, 280 long-term storage, 277-278 transfer of film images, 277 digital media camera cards, 109-110 CD, 111 DVD, 111-112 flash drives, 112 good data habits, 255 handling guidelines, 278 hard drives, 112

overview, 110-111 transfer. 112-113 life span of prints, 275-276 prints, 276 print stability dye-based inks, 280 factors, 275 media effects. 281 pigmented inks, 280-281 protection of prints, 281-282 vendors, 285 Strand, Paul, 10, 38 Strembicki, Stan, 20, 179 Stripped Down, 101 Strobe, lighting, 166 Subtraction #1, 19 Subtractive composition, design, 34-35 Success, game, 320-321 Summer Day, 132 Symbolism classification of symbols, 53-56 color. 57 shapes, 56-57 symbols and associations, 57 Symmetrical balance, design, 44 Tabby Ruins #3, 71 Taft, Steven, 73

Talbitzer, Sheilia, 21

1395

Talbot, William Henry Fox, 7, 23-24 Tarver, Ron, 45 Teaching Cage's rules, 334, 336 photography, 29 Telephoto lens, 86-87 Teton Dam and Spillway, East Idaho, 272 Text, photography, 364, 366, 368-369 Texture balance, 46 visual element, 50-51 Theory, role in contemporary photography, 28-29 Thinking About Thinking, 371 Thinking model bringing it together, 323-324 definition and approach, 322-323 evaluation, 324-325 operations review, 324 search for form, 321-322 thinking time, 318-321 problem solving and structure, 314-318 Thompson, Calla, 244 Three-dimensional images image-based installations, 211-212 public art, 212-213 sequential images, 210

TIFF, file format, 76 Time concepts, 185-186 controlling camera time blur and out-of-focus images, 190-197 drawing with light, 197-198 multiple images, 198-202 overview. 187-188 post-camera visualization, 202–209 shutter speed, 188-190 perception, 186-187 Top Light, 164 Top light, 164 Towery, Terry, 335 Transform, digital image software function. 249 The Tree Series, 154 Train Snaking Through Mountain, 115 Trees and Light #2, 200 Triad, 220, 222 Turner, Laurie, 376 Turrell, James, 150 TV Crew, 145 2732 Orleans Avenue, New Orleans, LA, 116 Two Ways of Life, 8

Uelksmann, Jerry, 12 Ulrich, Brian, 300, 373 Ultraviolet filter. 142 Uncle Ray Was a Drummer, 369 Under Light, 165 Under light, 165 Unity, design, 39 Universal Class Face, 18 Untitled, 38, 50, 110, 126, 128, 192, 210, 244, 298, 368 Untitled #5. 21 Untitled #7, 303 Untitled #57, 314 Untitled #133, 119 Untitled Film Stills, 13 Untitled Winter, 340 Urban Search and Rescue, 352 Us Girls, 239

Variety, design, 39 Vector images, software, 248–249 Ventura, Paolo, 179 Video, data management, 255–257 View of Crimean Wall Battle Scene, 335 Viewpoint, see Framing effect Visible spectrum, 135 Vision language of vision, 37–38 resolution, 67–68 Visual-realist imagemaking, 173 photographic working methods, 173–174

Wade, Cara Lee, 14 Walker, Chris, 197 Walker, Kara E., 18 WalkRun, 293 Wall, Jeff, 60 Waltzer, Garie, 173 Wannabes, 242 The Wealth of Nations, 35 Web publishing blogs, 257 digital galleries, 257–258, 330 resolution, 223 resources and prospects, 113–114, 258–259

search engines, 257 sharing sites, 274 site design and HTML, 274-275 Weston, Edward, 11 What Does It All Mean?, 321 White balance, control, 95, 136-137 White Horse, Black Horse, 72 Wide-angle lens, 85-86 Wild Bill, 282 Wilde, Oscar, 26-27 Wildey, Al, 316 Wilkins, Kristen S., 239 The Wishing Well, 143 Witt, Jeffrey A., 8 Wolf, Lloyd, 335, 337 Woman with Small Dog Watching, 211 Work space lighting, 246 safety, see Safety

World in a Jar: War and Trauma, 10 Wowbug, 170 Writing artist's statement, 331–332 topics in image analysis, 329–331

Xcape #6, 99

Yarnell Edwards, Beth, 166 Yield, 316

Zellen, Jody, 365 045 Stokes, 261 Zipper, 49 Zone System, historical perspective, 11 Zoom lens, 84–95

optical versus digital, 93-94